The Graphic Works
of the Impressionists

Jean Leymarie

The Graphic Works of the Impressionists

Manet, Pissarro, Renoir, Cézanne, Sisley

Catalogue by Michel Melot

Harry N. Abrams, Inc., Publishers, New York

Translated from the French Les Gravures des Impressionnistes
by Jane Brenton

© *1971 Arts et Métiers Graphiques*
English translation © *1972 Thames and Hudson Ltd., London*
Picture reproduction rights reserved by SPADEM, Paris

Standard Book Number: 8109–0154–4
Library of Congress Catalogue Card Number: 72–160222
Printed and bound in Holland

INTRODUCTION

Of the illustrious septet of major painters who together constitute impressionism in the widest sense of the term – Manet, Degas, Monet, Pissarro, Renoir, Cézanne and Sisley – only five are included in this collection. Two do not figure for precisely opposite reasons: Degas, because the breadth and distinction of his graphic work merits a volume to itself within the series, and Monet, because he resolutely turns his back on engraving, there being no evidence at all that he experimented in any of the various techniques of print-making. Cézanne and Sisley made serious use of the art but only on rare occasions, Cézanne's contribution being limited to nine plates and Sisley's to six. Nor can Renoir be regarded as a true devotee, preoccupied as he was with painting, and yet even he could not hold out against the prevailing trend. Somewhat belatedly he yielded to pressure from friends or publishers and, from 1890 onwards, proceeded to demonstrate his instinctive mastery with the engraver's needle and the greasy chalk. As evidence of his activity he left fifty-nine plates sparkling with life and charm. In fact there can be little doubt that, of the artists represented here, Manet and Pissarro are the two who have made the most significant contribution to the graphic arts, even though working on entirely different lines and with different sources of inspiration. His illustrations apart, Manet produced a hundred or so etchings, lithographs and wood engravings. No matter what the process, all carry Manet's unmistakable stamp and the prophetic sense that this is a language he would have used more extensively had he received the slightest encouragement to do so. In even more difficult circumstances and almost total isolation Pissarro experimented ceaselessly over many years to perfect his skill. He accumulated in secret more than two hundred plates, scarcely bothering to pull proofs even though he would frequently produce ten or more states of a single etching.

Monet's systematic and unexplained refusal to interest himself in engraving, even though all the friends about him were in some degree attracted by it, and in the case of Degas and Pissarro obsessed, has without doubt contributed to the low regard and misunderstandings under which impressionist engraving has languished. Monet is the purest representative, and indeed is quite often regarded as the sole representative of true impressionism, in the sense of painting executed out of doors and subject to sunlight and atmospheric vibration. 'When I stand before a Monet canvas,' Berthe Morisot declared, 'I am always sure which way I should hold my sunshade.' The impressionists substituted a unity of light and colour for the unity of matter and light on which the tonal painting of Courbet or Corot, himself a notable innovator, was founded. Sunlight became the fundamental stylistic principle because it is in real life the universal flux to which visual appearances are reduced when caught in the freshness of the instant. Light blurs the clarity of the outlines and disintegrates the density of matter, dispersing the motif into vivid dabs of colour that flicker in the radiance of the atmosphere. This might indicate a paradox, which Monet's refusal to participate would appear to substantiate, between the graphic requirements of engraving and the open aesthetic of impressionism. Yet energy of line is far from lacking in Monet's canvases, he did after all start life as a caricaturist; it is directly embodied in the organized rhythm of his brushwork and gradation of colour. And the impressionist movement as a whole could claim an exceptional draughtsman in Degas and a persistent draughtsman in Pissarro. Contrary to prevailing opinion, impressionism did not reject drawing, it created its own type of drawing to suit its purposes,

a new calligraphy that has the properties of flexibility, allusion and discontinuity, that is responsive to colour, light and movement and can capture the fleeting moment. Indeed aquatint and lithography, the most malleable of the engraving techniques, positively encourage this shorthand style that unites the tonal variations on the white paper without firm outline or relief. Thus we will see that there was, beyond mere coincidence, an intimate connection between the revival of original engraving in France and the birth of the modern, that is to say impressionist, vision. For the stylistic innovations of impressionism, even the vibration of colour, are readily translated to the sensitive register of the printed plate. Indeed they were on occasion given their first, or at any rate their clearest expression in engraving.

The advance of impressionist engraving was thus held back not so much by internal difficulties or supposedly inherent contradictions as by external obstacles. And the long neglect it has suffered reflects the indifference of collectors and critics, the consciously experimental and private nature of its practice by the artists involved, and the infrequency of public exhibitions. At the time when Manet and the impressionist generation were embarking on their artistic careers, the official Salon had some two or three hundred prints on show, about a tenth of the number of paintings. These were almost all reproductive engravings, for at the time the École des Beaux-Arts rated the art so low and thought it so limited that only one technique was taught, the burin. Bracquemond created a scandal at the 1863 Salon by submitting a work commissioned by the state, the *Portrait of Erasmus (Portrait d'Erasme)* after Holbein, in the form of an etching rather than a burin engraving. Notwithstanding the artist's high reputation, the print was barred from the exhibition but was then shown with some success at the famous Salon des Refusés, of which Manet with his three etchings in the Spanish style, as well as three spectacular canvases, was undoubtedly the leading light. Manet exhibited three more engravings at his one-man show in the avenue de l'Alma in 1867 and five at the Salon of 1869.

In 1874 the independent artists in revolt against the academic tradition, who had united to form the Société anonyme de Peintres, Sculpteurs et Graveurs, held their first collective exhibition; it was on this occasion that they received their historic name, impressionists. No engravings were exhibited, in spite of the comprehensive title adopted by the group and the inclusion among its members of such specialists in the art as Bracquemond and Lepic. It was not until the third collective exhibition in 1877 that Degas ventured to submit 'three drawings done with greasy ink and printed'. At the fifth exhibition in 1880 Degas and Pissarro, the two most fanatical engravers, showed a few samples of their work, 'experiments, states and plates', as Degas specifies. Finally, at the eighth and last exhibition in 1886, five etchings by Pissarro were included.

The two events crucial for the development of engraving during the period that concerns us, events to which we shall return later, were the establishment in 1862 of the Société des Aquafortistes, which played a vital part in giving Manet the encouragement he so much needed, and the establishment in 1889 of the Société des Peintres-Graveurs, which revived the flagging enthusiasm of Degas and Pissarro, providing a focus for their efforts and welcoming their colourful influence. Directly or indirectly it attracted new recruits, Renoir and Sisley among the older generation, and young men like Lautrec and the Nabis group. The interval between the foundation of the two societies was a time of consolidation, corresponding exactly to the period of developing mastery and confidence in the impressionist style of painting. Pissarro took part in the first two exhibitions of the Société des Peintres-Graveurs in 1889 and 1890, and then withdrew. He showed a few of his engravings at Durand-Ruel's gallery in 1891, at the Libre Esthétique in Brussels in 1895, and at Vollard's gallery in 1896.

All the impressionists, even Manet and Degas, insisted on the democratic nature of engraving, stressing its power to give wide circulation at low prices to works which, despite their multiplicity, were none

the less originals of a distinctive cast. Yet they regarded engraving principally as a private area for experiment, almost as a secret preserve quite removed from the concern for prestige or commercial success. They were reluctant to show their proofs in public and kept them for a few friends – Manet for Guérard, Degas for Rouart – or guarded them jealously for themselves. If exhibitions were infrequent, so was publication in albums or reviews (which we will discuss more fully as we look at each artist in turn). And yet it was the impressionists, in association with the poets and writers of the time, who invented the formula of the modern book illustrated by a painter. In particular Manet's brief but decisive ventures in this field should be noted, as he was the precursor both of poster art and colour lithography.

Renoir was encouraged by Vollard to try his hand at commercial lithography and his editions, though few, were of a fair size. But with this exception, the work of the impressionist engravers enjoyed no more than a limited circulation during their lifetimes and went unremarked even by the informed public. In much the same way the contemporary critics adopted a non-committal attitude or even maintained total silence on the subject. When Manet's engravings appeared in 1862, Baudelaire pointed out their merit, but had neither occasion nor time to comment further. Zola passed over them altogether in his spirited and courageous defence of the artist, in 1866. Théodore Duret and Gustave Geffroy, the first historians who can be regarded as convinced supporters of the impressionist movement, referred to engraving only in passing; they can hardly have suspected how widely it was practised and in all events had more than enough battles to fight to win acceptance for the paintings. The remarkable connoisseur Philippe Burty, who showed considerable foresight in his zealous crusade on behalf of the print, was certainly interested in the impressionists' engravings and even collected them himself, but in his extensive writings they receive scarcely a single mention. Renoir, Degas and Pissarro were still engraving by the time Burty was succeeded by the younger generation of specialist critics, such as Roger-Marx or Mellerio, but they were no longer the centre of topical interest. In a rapidly improving climate of opinion another generation of painters had boldly made the print its own. Naturally it was to them that attention turned.

Duranty, former champion of realism and regular patron of the Café Guerbois, is something of an exception. In his manifesto of 1876 *La Nouvelle Peinture*, in which he referred only to Legros and Bracquemond by name although his real hero was Degas, he noted the parallel changes occurring in engraving:

Take note. Nearly everything about this movement is new or represents an attempt to be free. Engraving too is struggling to evolve new processes. Dry-point is again being used, but this time like a pencil straight on to the plate so that the work is inscribed in a single operation. The burin is employed to produce unexpected nuances in etchings. Etching lends variety to each plate, makes it lighter or gives an air of mystery, and, by means of a clever manipulation of the ink at the moment of printing, the plate is quite literally painted.

Like Giorgione or Caravaggio, Manet brought about a fundamental change in artistic life, paving the way for the modern vision. As Matisse stated, 'he was the first to follow his reflexes and thus simplify the task of the painter . . . giving expression only to what touched his senses directly.' Between eye and hand, perception and its recording, no heaviness creeps in, there is no transitional stage or time-lag. Manet was the founder of the impressionist movement, although he only partially identified himself with it, and it took from him its emancipation of technique and the principles to which its members subscribed: a love of what was natural and free, modernity of subject matter, clarity of light, and fidelity to the first fleeting impression. His beliefs can be summed up: 'There is only one truth. Put down immediately what you see. When it is right, it is right. When it is not, start again.' Like his idol, Velazquez, whose mastery and objectivity he shares if you look beyond his surface sensitivity, he had painting in his

blood. With vigorous brushstrokes that needed no preliminary sketch he gave himself utterly to the canvas and palette on hand. Although his graphic work is not as brilliant as his painting, it is still important and fully deserves the interest it is now beginning to arouse.

Edouard Manet was born in Paris, rue des Petits Augustins (now rue Bonaparte), on 23 January 1832, the son of an old-established, well-to-do bourgeois family. His father was a senior magistrate, an austere and strict man. His mother, the daughter of a Swedish diplomat, was a more romantic figure, an amateur musician and singer. At school Manet's favourite subjects were gymnastics and drawing. It is of interest to recall that one of his schoolfellows at the Collège Rollin was the future Minister of the Arts, Antonin Proust, who was to prove a faithful friend and who has left for posterity some lively and evocative memories of him. Manet's talent showed itself from an early age but the father saw his son's future only in terms of a choice between the navy and the law.

Manet failed the competitive examination for the École Navale and spent a few months sailing the southern seas as a naval cadet. Then, in January 1850, he was accepted as a pupil of Couture, an academic painter of historical set-pieces but a competent handler of smaller works, portraits, heads and nudes. Manet remained in Couture's studio for six years, supplementing his artistic education with visits to copy pictures in the Louvre, study trips to Italy and a tour of the museums in Germany, Austria, Belgium and the Netherlands. He also paid frequent visits to the print collection in the Bibliothèque Nationale where, according to the register, he enrolled as a reader on 26 November 1858.

In 1860, at the time when he was beginning to evolve his personal style of painting which was soon to have such widespread repercussions, Manet also started to experiment with engraving, inspired by the movement for the revival of etching which was gathering strength all about him. Etching, the technique of free drawing with the needle directly on the prepared surface of the metal plate, which is then bitten with acid, was then the ultimate modern tool for creating light effects. Its variations and possibilities had attracted such master painters as Rembrandt and Goya. Although very much in tune with the stirrings of romanticism in France, it was more or less ignored by publishers and collectors whose judgment was clouded by the dominant influence of the burin. Frédéric Villot, the knowledgeable and discriminating curator of paintings in the Musée du Louvre, was himself sufficiently interested to experiment with etching and to pass on what he learned to his friend Delacroix. In 1834, in the review *L'Artiste*, he deplored the disrepute into which the practice had fallen, 'this vivid and brilliant form of engraving, so witty and expressive, knowing no rules but those the artist chooses to invent, no principles but his genius.' Meanwhile some excellent painters, notably Huet, Chassériau, Corot and Daubigny, continued to practise the art, unhappily only at infrequent intervals and without arousing much response.

From about 1850 onwards there were signs of change in France and simultaneously in England. Meryon, the son of a British doctor and a French dancer, creator of fantastic visions of Paris, belonged by birth and influence to both countries. As this particular branch of engraving took on a new lease of life the connections between the two countries became stronger, and in May 1862 the co-ordination of effort resulted in the founding of the Société des Aquafortistes. The first president was Seymour Haden, Whistler's brother-in-law, and the three moving spirits behind the enterprise were those men of missionary zeal, Delâtre the printer, Cadart the publisher and Bracquemond the engraver. Auguste Delâtre was himself an engraver, the pupil of Charles Jacque, whose press he purchased. Surrounding himself with the best workmen he developed original methods of printing and impression and won the confidence of the artists. England benefited equally from his experience through his contacts there, and in 1862 he was summoned to London to set up a school of printing and engraving at the South Kensington Museum. In an entry in his diary, dated 17 January 1859, Jules de Goncourt described Delâtre's colourful atelier in the rue de la Huchette, and told of his feelings as he waited for his first etching to be printed.

Alfred Cadart, whose determined features we know from engravings by Desboutin and Ribot, led an energetic crusade as far as the United States of America. Following his arrival in 1865, he founded societies of engraving in New York, Boston and Philadelphia, counterparts to the society in Paris.

The generous and open-hearted Felix Bracquemond, whose own talents earned him speedy recognition, placed all his prodigious craftsmanship at the disposal of his contemporaries, giving help and advice at different times to Corot, Courbet, Rousseau, Millet, Degas and Manet, to mention only the best known. He acted in the firm belief that, even where technical matters were concerned, it was the masters who counted and not the professional engravers.

It is the masters, the painters, who have taught us the true lessons of engraving, and not the engravers in the strict sense. They have never done more than refine or perfect procedures of engraving that the painters have discovered. No portrait engraver has equalled Van Dyck's precision of design; no architectural engraver has surpassed Canaletto or Piranesi; no landscape engraver has shown himself a superior craftsman to Claude or Ruysdael at his best. These very different masters do not practise engraving purely for its own sake, but to draw and model their prints in the way they paint their pictures.

Baudelaire was an outstanding lover and connoisseur of prints. Even as a child he was fascinated by them. In the *Revue Anecdotique* of 2 April 1862 he published anonymously a sort of manifesto, 'l'eau-forte est à la mode', which ends with these words: 'of all the different expressions of the plastic arts, it is etching that comes closest to literary expression and that is best fitted to reveal the essential nature of man. So, long live etching.'

On 4 August he wrote to Théophile Gautier asking for his support in the venture of the Aquafortists (the appeal was answered in an article by Gautier in *Le Moniteur* of 27 August), and on 14 September he set out his ideas at greater length in an important article published in *Le Boulevard*, this time signed 'Painters and Aquafortistes'.

He redefined what seemed to him the characteristics of etching and singled out the distinctive qualities of those he considered the best exponents of the art. Naturally Meryon was included and also Whistler, Jongkind, Bonvin, Legros and Manet, still young artists at the start of their careers. He was on good terms with them all, and also with an astonishing engraver apart from the rest, Bresdin. It was Baudelaire's dream to compose 'poetic meditations in prose' to accompany plates by Meryon. Better than anyone he recognized this artist's magnificence of conception and execution and appreciated the visionary inspiration and solemn precision of his work. He admired the first sets of engravings by Whistler, the *Twelve Etchings from Nature* printed by Delâtre in 1858, and also the sixteen etchings of the famous *Thames Set*, published in London in 1859 and later displayed at Martinet's gallery in 1862: 'marvellous tangles of rigging, masts and cables; chaos of mists, furnaces and spiralling smoke.' Even at this early stage this brilliant cosmopolitan artist amply demonstrated his mastery of a technique that exactly suited his alert temperament and inspired a lifetime's pursuit of perfection. Later he was to explore lithography with the same happy results. His style owes its vivacity to his economy of line, the delicacy of the biting and the airy vibration of the inking. He was one of the first to take the copperplate out into the open air and engrave the motif directly without preliminary drawing, as the sensation of the moment dictated.

By contrast Bonvin and Legros, still under the influence of Courbet, were hard-working and thorough, although their work shows plenty of energy and conviction. At the time of Baudelaire's article, albums of both artists' etchings had recently been published. Legros' album was published by Cadart in 1861 and was dedicated, with some reason, to Baudelaire: 'ecclesiastical ceremonies, sumptuous as dreams or, more precisely, as reality; processions, night offices, priestly pomp, austerities of the cloister.' In February

1862, it was again Cadart who published the first etchings by Jongkind, the six *Views of Holland* (*Vues de Hollande*), 'remarkable miniature versions of his paintings'. Already they show a supreme freedom of execution, an accuracy of vision that is entirely impressionist in its portrayal of reflections, light, movement, even colour. In all, Jongkind's contribution to the graphic arts consists of only twenty-two plates, but they must be classed among the masterpieces of engraving.

The Société des Aquafortistes numbered among its membership of some sixty artists and collectors the king of Sweden, the king of Portugal and the Princess Matilda. Its headquarters were in Cadart's shop at 66, rue de Richelieu, near the Bibliothèque Nationale and the Cabinet des Estampes. Apart from holding meetings, banquets and exhibitions, the society's main function was the regular publication of original modern etchings, by monthly subscription folios of five prints or by annual albums of sixty, each with an engraved frontispiece and an introduction by an art critic. The prefaces were written in turn by Théophile Gautier, J. Janin, W. Bürger, Castagnary and E. de Montrosier. The monthly series made a brilliant start on 1 September 1862 with a folio of Bracquemond, Daubigny, Ribot, Legros and Manet (who had, in addition, been accorded the signal honour of a 'cahier' to himself in the following month). The principal artists included in subsequent issues, together with professional engravers of more or less significance, were Jongkind, Seymour Haden, Appian, Hervier, Huet, Fantin-Latour, Meryon, Guigou and Charles Jacque. Corot was also represented (*Souvenir of Italy*, published in April 1863; *Outskirts of Rome*, in March 1866; *Italian Landscape*, in October 1866), together with Courbet (*The Young Village Girls*, September 1866) and, posthumously, Delacroix (the previously unpublished etchings: *The Jewess of Algiers*, July 1865; *Arabs of Oran*, December 1865; *The Blacksmith*, June 1867). The copperplates by Corot and Courbet were bitten by Bracquemond.

At the end of 1867 financial difficulties and internal squabbles, a break with Delâtre, forced Cadart to disband the Société des Aquafortistes. But he refused to accept defeat, moved to new premises and set up his own printing press. The following year, with the help of Buhot, Desboutin and Rops, he founded as an alternative *L'illustration nouvelle*, which continued production even after his death, until 1880. In 1872 he revived the annual anthologies. In his preface to the 1874 album, 'L'eau-forte en 1874', Burty declares, 'Cadart introduced to etching painters who might otherwise never have thought of it: Corot, Courbet, Puvis, Ribot, Chifflard, Huet, Appian, Vollon, Roybet, Amand-Gautier, Lalanne, Veyrassat.' In the same year Durand-Ruel, the impressionists' dealer, illustrated his catalogues with reproductive etchings that inevitably owed much to the new style, of which he was such a stalwart supporter.

Cadart sold not only the prints themselves, but also the complete kit of engraver's tools and materials. At about this time he also published a number of technical manuals and treatises, the most famous of which is by Lalanne, *Traité de la gravure à l'eau-forte* (1866), which ran to five editions by 1897 and is still in use today. Nothing as clear and methodical had been published on the subject since the celebrated treatise by Abraham Bosse. The work is strongly recommended in the introduction by Charles Blanc, editor of *La Gazette des Beaux-Arts*; this was the journal established in 1859 to replace *L'Artiste*, which devoted considerable attention to engraving, publishing notably prints by members of the Barbizon school, Rousseau and Millet. The *Nouveau traité de la gravure à l'eau-forte* by Martial, announced in 1867 but not in fact published until 1873, is a much shorter piece. The author was a prolific engraver specializing, like Lalanne, in urban scenes – one shows Cadart's shop in the rue de Richelieu. But by far the strangest manual to emerge from Cadart's presses and, because of its letter preface by the Vicomte Lepic the one most symptomatic of the impressionist approach, was *La gravure à l'eau-forte* (1876) by Raoul de Saint Arroman. Lepic was a fellow pupil of Monet and Bazille in Gleyre's studio, exhibited with the impressionists between 1874 and 1876, and was a friend of Degas, who gave him much encouragement and produced a monotype in collaboration with him. He made out an exaggerated case for his invention

of the 'mobile' etching, claiming that it is quite literally the 'impression' that is all-important: by dint of varying each time the procedures of inking and 'retroussage' (wiping the plate with muslin) perfected by Delâtre, he himself succeeded in pulling from one plate, *The Banks of the River Scheldt*, eighty-five different proofs that reflected changes in the light and atmospheric conditions (sunrise, night, back-lighting, rain, snow, fog etc.).

This brief summary serves to recall that Manet's involvement with graphics was related to a whole set of historical circumstances. In 1864 Fantin-Latour painted his *Homage to Delacroix*; Manet is depicted as one of the writers and artists grouped about the portrait of the departed master. With him are many of his best friends of the time (Baudelaire, Bracquemond, Legros, Whistler and Fantin-Latour himself) precisely the people who were most intimately involved in the movement for the revival of engraving. Whistler was a foreign member of the Société des Aquafortistes; in fact he acted as his own publisher, otherwise Cadart would no doubt have fulfilled that function for him as well.

Focillon invites us to admire in Manet's neglected prints 'some of the most subtle and telling delights his genius has to offer.' He picks out two essential characteristics of his engraving style: 'it is not sub-ordinated to achieving an effect, it does not dwell on the finicking details of craftsmanship.' Manet rejected out of hand virtuoso decorative displays and romantic alchemy. On engravings and paintings alike he imposed the total honesty and authoritative simplicity that characterizes his vision. For the most part his plates derived from his pictures, being usually reworkings of entire compositions, but occasion-ally of fragments. The transposition was effected, not directly from the canvas, but via the intermediary stage of a watercolour, drawing or tracing, or better still a photograph in which the necessary reduction in scale was made automatically. In its own distinctive fashion, the engraving condenses and reinforces the message of the painting; appearing before or after the picture was exhibited, it acted as an announce-ment or reminder to the public.

The body of Manet's graphic work comprises sixty-five etchings, nineteen lithographs or autographs, five lesser wood engravings and three series of illustrations for poems by Cros, Poe and Mallarmé.

Nearly half the etchings were produced between 1860 and 1862, in the climate of enthusiasm and friendly competition that developed around Cadart. Impatience to create made Manet race through his apprenticeship; it is possible to trace over a period of months his rapid progress and instinctive mastery in the art. If he did occasionally ask for help from his friends Bracquemond and Legros, it was only where techniques were concerned and not on matters of style, where his originality is never for a moment in question. Certainly he assimilated the work of the best of his contemporaries, Meryon, Daubigny, Whistler and Jongkind (whom he rated above Corot), and went back to Chassériau and Delacroix, but the major influences on him were Rembrandt and, above all, Goya. At that time the various series of prints by Goya, who saw engraving as a 'universal language' and a 'testimony to truth', were beginning to circulate fairly freely in France and their importance was quickly grasped by a number of critics, Baudelaire among them. Manet had far less in common with the dominant Northern tradition of etch-ing with its cross-hatching and ingenious tricks of lighting, than with the Southern tradition to which Goya too belongs, the tradition of the Venetian masters of the eighteenth century, Canaletto and Tiepolo, who used single parallel lines and floods of pale brilliant light.

The uncertainty and clumsiness still evident in a plate dating from early in 1860, *The Travellers* (M 3) – which was never produced as an edition and was abandoned at the first state (only one trial proof is extant) – have quite disappeared in *The Little Cavaliers* (M 4), an ambitious composition in four states that successfully situates in space, in full outdoor light, a lively and picturesque group of thirteen charac-ters. Already it shows Manet in full command of his elliptical calligraphy, ranging easily from a close to an airy texture and bringing the full register of tonal variations into play.

The ground is a dark, ridged area of complex irregularity, while the transparent, insubstantial sky shimmers and shines brightly. The characters are scattered in groups, dispersed at intervals in the air that envelops and penetrates their forms. To the left are costumes of a dense, velvety black and, in the centre and to the right, silhouettes barely sketched in and dissolving in the light, notably the figure in profile who is raising his hat.

At the Salon of 1861, Manet won a medal for his painting of *The Spanish Singer* now in the Metropolitan Museum of Art, New York. Théophile Gautier dubbed the picture *Guitarrero* and, in the July issue of the *Moniteur Universel,* praised its picturesque savour and superlative workmanship. Its remarkable stylistic innovation, decisive in the development of modern art, is the elimination of half-tones and chiaroscuro in favour of bold and direct contrasts. The contrasts are accentuated in the corresponding etching in five states (M 12), which perfectly expresses the artist's maturity and confidence in the medium and illustrates a rare ability, particularly in engraving, to create an entire figure 'at a stroke'. The main iconographic sources for this motif, used also by Courbet, Leleux and Legros, are the paintings in the Spanish tradition of the Golden Age; there are clear parallels in the setting of the model against an expanse of light-coloured wall (in the engraving the tone values are reversed) and the inclusion, in the left foreground, of a rural still-life – the smoking cigarette butt adds a contemporary touch. In addition precedents are to be found in the work of Goya, Greuze, Teniers and the Italian engraver Marc-Antoine Raimondi.

During the year of 1862 Manet concentrated all his efforts on two very different but complementary approaches: the use of a network of internal lines to give animation and character to the surface; and precise line-drawing to produce an accurate reduction of the image. A striking and major work of this period is *The Gipsies* (M 16), published in September of that year together with plates by Bracquemond, Daubigny, Legros and Ribot in the first of the monthly folios from the Société des Aquafortistes. It derives from a painting later reduced to three fragments. (The less satisfactory etching *The Little Gipsies* (M 15), which never progressed beyond the proof stage, is either a hasty copy or a preparatory state.) The elements of the composition are set against the landscape with a stark and monumental severity quite unlike the subtly diffuse effects of *The Little Cavaliers*, so that each figure displays its characteristic vitality to the full. The scene of popular life in the harsh Spanish manner conceals within it echoes of traditional religious subjects such as *The Virgin with Child, The Flight into Egypt* and *The Adoration of the Shepherds*; the names that spring to mind in this context are Velazquez and Ribera, himself an engraver. Manet combined a profound admiration for Spanish painting with the 'taste for things Spanish' of the Second Empire, a fashion to which he was quite content to conform.

The album of etchings published by Cadart in October of that year serves as a point of chronological reference and an index of quality. Of the fourteen plates originally promised, nine were ultimately included, these being some of Manet's best work to date: *The Spanish Singer* (M 12); *The Little Cavaliers* (M 4); *Philip IV* (M 8); *L'Espada* (M 29); *The Absinthe Drinker* (M 14); *Woman Dressing* (M 18); *The Boy and the Dog* (M 11); and, together on one sheet, *The Street Boy* (M 26) and *The Young Girl* (M 17). The most notable omission is *Lola de Valence* (M 27) which was included, in October 1863, in the regular series published by the Société des Aquafortistes. Manet relied heavily on this selection to establish his reputation as a serious engraver and to publicize his one-man exhibition, due to be held in a few months' time at the Martinet Gallery. In spite of the modest charge, twelve francs for the full set and two francs for an individual print, the enterprise was a total failure. In the words of Moreau-Nélaton: 'The precise and clear statements of a man speaking the language of genius were taken for the stammerings of a freak.'

Lacking the necessary material support and encouragement, Manet spent less and less time on his graphic work, although he never abandoned it entirely. At the famous Salon des Refusés of May 1863,

which made him the star and rallying point for the independent-minded younger generation, his three etchings (M 4, M 8, M 27) went unnoticed in the uproar surrounding *The Picnic* (Louvre). Barred from the Salon of 1867, he followed Courbet's example and organized his own exhibition, at the avenue Montaigne, again showing three etchings (M 4, M 8, M 16). When two recent major paintings, *Luncheon in the Studio* (Munich) and *The Balcony* (Louvre), were accepted for the Salon of 1869, he also submitted an assorted collection of five etchings (M 4, M 37, M 41, M 49, M 51) as a reminder of his contribution in this field.

In 1874 Cadart published a second album of etchings by Manet. There is no indication of its contents beyond a list compiled by Philippe Burty which is almost certainly incomplete (M4, M 7, M 12, M 16, M 17, M 18, M 26, M 27, M 49). Manet took the opportunity to revive one of the three frontispieces that had been engraved for the 1862 album but never used. A trial version (M 30) shows simply a half-open portfolio of prints on a rack; the portfolio bears the conventional inscription, but a strange touch is added by the inclusion of a cat, which may be taken to represent the artist himself. The second version, more complex both in form and iconography (M 31), unites elements of Manet's artistic vocabulary of the time and, if Theodore Reff's suggestions are correct, also contains allusions to Manet's private life. A Punch's head peers out from the curtains in the manner of the traditional theatre engraving; here the source is Callot. Pinned to the back wall is a picture of a balloon that resembles the contemporary lithograph (M 68), except that the background is of Dutch windmills and not the city of Paris. Suzanne Leenhoff, Manet's close companion, was of Dutch origin. Manet did not marry her until October 1863 but she had already borne him a son, the boy of ten who appears in the four variations of *The Boy with a Sword* (M 21–M 24) carrying the heavy, tempered blade and the bulky shoulder-belt seen hanging on the left of this print. On the ground is a still-life in typical Spanish style, including the sombrero, guitar and basket of costumes that Manet used in a number of pictures. This motif, on its own, was used for the engraving in three states (M 32), of which the second state, without the inscription, ultimately served as frontispiece to the 1874 album.

The brief trip to Spain, in August 1865, confirmed on the spot Manet's view of Velazquez as the 'painter of painters' and also marks a turning-point in his development. His drawing has less of the subtlety that previously characterized it and achieves a greater harmony of composition, a greater luminosity in its bold contrasts. A new co-ordination is established between figure and background, between the unmodelled silhouette and the quivering haze against which it is set (M 42, M 43). The decorative verve of the Japanese influence is more in evidence (M 52, M 53). In such felicitous examples as a print of 1865 (M 40) and one of 1869 (M 57), Manet successfully reconciled his two extremes of linear stylization and atmospheric vibration, conveying both the autonomy of the flat image and the imprint of the surrounding air, in which it bathes without at all being softened or dissolved. After the 1870 war, under the influence of impressionism, he concentrated more and more on outdoor effects which, Léon Rosenthal has shown, are more in evidence in the engravings than in the paintings, and at an earlier date.

Manet's etchings reflect the extent and variety of his range. There are compositions of groups and single figures, interiors and exteriors; there are examples of all styles, whether portraiture, genre painting, religious or theatrical subjects, nudes, still-lifes, landscapes, animal subjects or scenes of contemporary life. Four are copies of works by painters of an earlier age, copying being a discipline Manet observed strictly during the formative years of his apprenticeship. In the course of his visits to Florence he executed many drawings, notably those based on the monumental paintings of the Renaissance, and also one of his first engravings, *Silentium* (M 2), which is a fairly free copy of Fra Angelico's fresco of St Peter the Martyr in the convent of San Marco. The engraved title of the print and the gesture of the finger held

to the lips recall the Dominican rule of silence. Manet loses nothing of the calm dignity of his model in making the transition, omitting as he does the saint's traditional symbols and the signs of his martyrdom.

Three of the etchings derive from three paintings in the Louvre, then attributed to Velazquez and for that reason objects of veneration to Manet, who longed to achieve in his own times the technical virtuosity and social acclaim of the Spanish master. He attached such importance to his engraving of *The Little Cavaliers* that it was included in both his albums, in 1862 and 1874, and in all the exhibitions at which he showed his engravings, in 1863, 1867 and 1869. The figure on the extreme left of this much-praised picture, which Manet first copied in oils and watercolour, was taken to represent Velazquez himself. Manet included himself in much the same position in his *Music in the Tuileries Gardens* (National Gallery, London). This is the first canvas truly representative of his modern vision and it is significant that the rhythm of its composition owes much to *The Little Cavaliers*. The engraving figured in a still-life of 1871 by Renoir (Museum of Fine Arts, Houston). Renoir too had an overwhelming admiration for Velazquez and regarded the little Infanta in the Louvre as one of the miracles of painting – it is in fact the only one of the three pictures referred to that is still generally attributed to Velazquez. Manet must have met Degas for the first time at the Louvre when he was copying the figure of the Infanta directly onto copperplate; later Manet too based on it a rather rough and hasty etching (M 7). In contrast, he took great pains with his engraved portrait of *Philip IV* (M 8) dressed for the hunt, which is based on the picture acquired by the Louvre in 1862 (now in the Musée de Castres). Only later, when he saw Velazquez' original in the Prado, did Manet realize that this was just a replica. The eight states of the etching show the successive stages of the work, correction of details, such as the drawing of the dog's left paw, the flexible and imaginative exploration of the relationship between light and dark tones, between figure and landscape. Goya's first attempts at engraving were his copies of portraits by Velazquez. Manet adopted the essential characteristics of Goya's technique: the clearly delineated frame, the broken contours of the forms, expressed in short parallel hatching strokes, the contrast between the dense, regular grain of the blacks and the transverse zones of light in long, slanting, widely-spaced lines.

With Manet, the worship of Velazquez and the cult for things Spanish go deeper than the mere prevailing fashion fostered by the Empress Eugénie, herself of Spanish origin, who summoned to Paris the best performers her country had to offer in the way of musicians, dancers, singers and bull-fighters. The dance company of the Teatro Real of Madrid played with great success at the Hippodrome from 12 August to 2 November. Full of admiration for their performance, Manet asked the whole cast to pose for him in the large studio of his friend and neighbour, Stevens, and painted *The Spanish Ballet* (*Le ballet espagnol*, The Phillips Collection, Washington), one of his most spirited and brilliantly executed canvases. Later he painted and engraved separate portraits of the two protagonists, *The Spanish Dancer, Mariano Camprubi* (M 28) and *Lola de Valence* (M 27), the *première danseuse*. In the print of *Lola de Valence*, the figure is set against a neutral background, as it was in the Louvre painting before the theatre scenery was added; originally the background was light in tone and in the manner of Tiepolo (the background also of the two splendid watercolour drawings in the Louvre and the Fogg Museum, Cambridge, Mass.), but was later reworked and blackened with aquatint in the manner of Goya, to give emphasis to the texture of the materials and the grain of the skin. A number of other changes were made following the version in oils: changes in the pose, attitude and gestures, in costume details and, especially, in the expression of the face, turned more to the front and serious rather than smiling. In his frantic search for Spanish motifs, Manet asked Victorine Meurend, the exceptional model he had recently discovered and whom he used over a period of ten years, to adopt the pose and costume of *L'Espada*, the matador preparing for the kill. The result was the painting in the Metropolitan Museum of Art, New York, also the watercolour in the Rhode Island School of Design, Providence, in which the image is reversed and

the size reduced to that of the copperplate, and, based on the watercolour, the etching itself which is possibly the most ambitious and confident of the 1862 series of etchings. Like *The Spanish Dancer*, it is encased in a broad black frame. Paradoxically Manet communicated this new and direct feeling for life by drawing on artistic sources: Velazquez and Utamaro for the poise of the prominent and eye-catching central figure; Goya for elements of the background, borrowed directly from plates 5, 16, 19 and 28 of *The Tauromachia*. The rhythmic gradation of black, white and grey creates the forms and reorganizes space into a number of sharp-angled planes, abandoning traditional perspective. Early in 1863, Manet again availed himself of Stevens' studio (the setting for *The Spanish Ballet* of the previous year), transformed it into a Spanish inn, *La Posada* (M 33), and filled it with bullfighters who happened to be visiting Paris at the time. The figure in the foreground, seated on a bench in the manner of *The Spanish Singer*, is picked out in black against a frieze of light-toned figures reminiscent of *The Little Cavaliers*. Once again Manet draws freely on Goya and Velazquez, but the plate was never more than an experiment. The same is true of a number of other plates that were never printed in an edition and of which only one proof is known to have survived: *The Travellers* (M 3), *Man in a Straw Hat* (M 6), *The Little Gipsies* (M 15) and *The Street Singer* (M 20).

Quite apart from the copy of *The Infanta*, several of the other etchings depict children, a popular motif in Spanish painting and also in the work of the Le Nain brothers which at the time was enjoying a revival. In 1859, in his biography of Velazquez, Louis Viardot pointed out that the artist kept in his studio a young apprentice who served him both as assistant and as a model capable of assuming a variety of expressions. Manet made similar use of the boy Alexandre, who is shown full face and laughing, wearing a red hat, in a painting of 1859, *The Boy with the Cherries* (Gulbenkian Foundation, Lisbon), and then later in profile and with an anxious expression, still wearing the same red cap, in a vividly drawn etching of 1861, *The Boy and the Dog* (M 11), based on a drawing to which there is no corresponding painting. Alexandre committed suicide in 1861 at the age of fifteen, and his tragic end inspired Baudelaire to write his short story *La corde*. The succession fell on Manet's own son, Léon Koëlla-Leenhoff, known euphemistically as the painter's brother-in-law. He was aged ten in 1862 when he posed, bare-headed and shorn and dressed as a page boy, for the four versions of *The Boy with a Sword* (M 21–24) and for *Boy Carrying a Tray* (M 25), tremulous silhouettes set against their different backgrounds. He appears again in *The Street Boy* (M 26), an admirable print of telling accuracy and calm harmony, which overlays the palpable reality of the live model with a source drawn from painting, Murillo's *Boy with Dog*, which was reproduced in a popular publication of the period. He is also the model for *Child Blowing Bubbles* (M 57), in which Manet achieved a characteristically perfect synthesis between the dominant image and its surrounding luminosity. Like *Boy Carrying a Tray*, taken from a picture in the Musée de Lyon, both *The Young Girl* (M 17) and *Man Drinking Water* (M 40) were based on fragments of earlier paintings, although in the transition they acquired the unity of an entirely new technique and new vision.

Degas, Bracquemond and Legros made extensive use of the engraved portrait, and so indeed did Manet, although he concentrated chiefly on faces and selected his subjects only from family or friends. He began by portraying his father and, unusually for him, dated both engraved copperplates. The earlier, executed in 1860 (M 5), has a forceful and immediate impact in spite of a certain clumsiness, the other, which dates from 1861 (M 9), is a reversal of the image and demonstrates his increasing skill. *Man Reading* (M 13), *The Absinthe Drinker* (M 14), *The Philosopher* (M 42), *The Tragic Actor* (M 43) and *Man Smoking* (M 46 and M 47) are at once genre studies in the prevailing fashion and also true portraits based on real subjects. In 1865, Manet engraved a portrait of *Bracquemond* (M 39), who frequently helped him with his work. For it he employed one of the many processes invented by this consummate exponent of the art: drawing with a pen on dry copperplate, varnishing it and plunging it in water to soften the ink and wash

away the covering varnish, so that finally only the pristine power and harmony of the original line-drawing remains.

In spite of the inevitable paucity of written documents, much has been bandied about concerning the relationship between Baudelaire and Manet and about the elder man's evasive attitude towards the younger in artistic matters. The five portraits of the poet engraved at different times by the painter of 'modernity' (whom Baudelaire longed to find yet, when he did, was barely able to recognize for what he was) constitute a revealing commentary on their friendship, which N.-G. Sandblad has shrewdly analysed in his essays on Manet. *Charles Baudelaire in profile wearing a hat* (M 19) epitomizes the dashing and forthright image of the dandy seen among the strollers in *Music in the Tuileries Gardens. Charles Baudelaire, full face* (M 41), in fact almost in three-quarter profile, emerges with a high forehead and flowing hair, staring into space, set against the sober background like a distant vision. The plate was based on a photograph by Nadar and executed in 1865, when the poet was in Brussels and Manet begged for his support in the scandal aroused by the *Olympia*: 'I wish you were here, abuse is raining down on me like hail.'

Baudelaire replied with the 'terrible and kind letter' that exhorted him to endure his tribulations in stoical silence, and ended with the stony declaration: 'you are merely the first in the decrepitude of your art.' The following summer he was rushed back to Paris, seriously ill. Manet visited him regularly in the Chaillot Clinic and attended his funeral on 3 September 1867. It may have been at this juncture that Manet engraved for himself a second full-face portrait, in only one state, full of pathos, with a black frame and a muted aquatint ground (M 55). Asselineau's book on Baudelaire, published in 1869, is illustrated with five engraved portraits, three by Bracquemond based on other sources, and two by Manet. Distance must have somewhat idealized his memories and Manet reworked his two earlier portrait versions, producing an elegant, flowing profile under a top hat, pared down to bare line and stripped of incidental details (M 54), and an imposing and ravaged full face, swathed in shadows, light emanating from the eyes (M 56).

Two very different women painters of great talent and charm joined Manet's circle at about the same time. With stylization of line and Japanese-inspired foreshortening, Manet captured, in two engravings of 1870, the majestic profile and abundant hair of Eva Gonzalès (M 58 and M 59). In complete contrast is his etching of Berthe Morisot in a black bodice and hat (M 61), her tremulous features framed in smudgy shadow, as she appears in one of the portraits of 1872 that Valéry thought his finest. In 1874 Manet wrote the following letter to Théodore de Banville: 'Dear Sir, I have an idea for the book of the *Ballades*: Banville, the collector of rhymes, sitting writing at his table and smoking a cigarette. In the spirals of smoke I shall sketch in little figures to represent the principal elements in the book. If the idea appeals to you, I will come to your house and make a sketch at whatever time and date is convenient to you.' There are two drawings in existence, the original study (in the Rouart collection) and the alleg-orical composition (in the Louvre), to which correspond the two trial etchings (M 63 and M 64) that Manet judged in the end inadequate for the projected frontispiece. It was in 1882 that Manet finally wrested success from the Salon, when he exhibited as a symbol of *Spring* the radiant portrait of the actress Jeanne de Marsy (private collection, New York), whose pose and costume he chose himself. On a photograph of this painting he based the drawing published in *La Gazette des Beaux-Arts* in June, which in turn served as the model for his last, superb etching (M 66), bitten in the first state with a fine grain of aquatint by Guérard.

Although Manet frequently transferred to copperplate motifs from his paintings, seascapes (M 34), figures (M 40), still-lifes (M 48) or religious compositions (M 36), there are none the less a few little genre subjects or scenes of contemporary life that have no counterpart in painting and belong in character

16

and scale entirely to the domain of graphic art. *The Candle-Seller* (M 10), whose pious theme and even workmanship recall Legros, and the later *Woman Convalescing* (M 65) with its delicate and harmonious accents, betray a domestic and sentimental streak unusual for Manet, but which he handles with restraint. Pitched in the same intimate key is *Woman Dressing* (M 18), a motif used in a number of red chalk drawings with no counterparts in painting, whose superb texture and vibrant luminosity invite comparisons with Rembrandt and Chassériau. *The Odalisque* (M 50) has an unexpectedly exotic flavour, continuing as it does the orientalist tradition of Ingres and Delacroix, and contrasts strongly with the impassivity of the *Olympia* (M 44 and M 45). *The Bear Trainer* (M 35) is a lightning-sketch of a circus; the two slightly different plates entitled *At the Prado* (M 37 and M 38) capture a moment in the life of the famous Madrid avenue, thronged in the evening with pretty women in mantillas, here concisely suggested by notations in aquatint in the manner of Goya. A pure etching that remains no more than a sketch, *The Queue at the Butcher's Shop* (M 60), attains a supreme economy of draughtsmanship, the figures being built up of horizontal and vertical strokes without contours. Only the tip of the bayonet, at an angle against the uprights of the door, betrays that this is a scene of the siege of Paris.

After a brilliant flowering, lithography was, in spite of Daumier's heroic efforts, in decline, not least because of lack of interest on the part of the artists. Yet it was precisely the technical innovation of the century that best answered the demand for speed and spontaneity. Cadart sought to relaunch it, along with etching, and in 1862, planning a publication that never materialized, sent lithographic stones to Bracquemond, Legros, Fantin-Latour and Manet. The rejection of their first efforts by the printer Lemercier disheartened the editor and set back by ten years the movement's rebirth.

Manet produced *The Balloon* (M 68) which was, like *Music in the Tuileries Gardens*, an outdoor urban scene. Yet it was not only the graphic equivalent to that painting, it was also its popular counterpart: not the fashionable public assembled for a concert in a palace garden, but the motley crowd of the streets attending a travelling fair with its theatre booths, puppet shows, greasy poles, streaming banners and the central attraction, the huge air-borne sphere moored to the ground by a cord. The sensitive and assured calligraphy lays bare every detail in the heart of the protean mob, interacting with the harmonious distribution of light and shade in regular masses. Manet's terse style breaks right away from the prettiness of romantic lithography. *The Races* (M 72) at Longchamps, a motif common in his paintings for which he made frequent sketches from life, is a split-second effect of consummate skill. The whole plate is flooded with luminous space and the headlong sensation of the gallop. The horses bear down on the dynamic emptiness of the track that slices across the serried ranks of breathless spectators. And standing out in marked contrast against the general giddy swirl are the sharp notations of the two impassive coachmen and the bored society woman.

The execution of the Emperor Maximilian, in Mexico on 19 June 1867, brought scandals and recriminations in its wake. Manet used the event as the subject for a sequence of four pictures that were censored, and for a lithograph that was also banned (M 73), which, stripped of all superfluous detail, conveys the message of the painting in strengthened and concentrated form. Set against a background of high walls, onlookers sketched peering over the top, the head of the platoon raising his sabre as the signal to fire, it is a scene of Goyaesque inspiration, held in close-up with an implacable objectivity that renders it all the more terrible. The composition is organized around the clear delineation of the central figures and the contrasting streaks of black and white echoed on the ground and walls. On related subjects though quite differently handled, broken lines and hazy atmospheric values, are two episodes of repression under the Commune actually witnessed by Manet, which have all the laconic power and condemnatory force of an authentic record. As was his habit, Manet adapted earlier compositional schemes to the immediate needs of depicting scenes based on reality. Thus, in *The Barricade* (M 77), the historical firing squad of

17

Mexico (shown here in 'vertical format') is directed against anonymous victims in a typical urban setting. The corpse in *Civil War* (M 78), lying under an overcast sky behind a pile of paving stones by the columns of the Madeleine, recalls, both by the attitude and the opaque solidity of the figure, *The Dead Torero* (M 49). The signature and date, 1871, are inscribed bottom left, while in the right-hand bottom corner two legs in striped trousers project into the picture. The two lithographed portraits of *Berthe Morisot* of the following year show how the lithographic stone combines economy of resources with maximum flexibility: both do justice to the woman's bewitching charm, but in one this is achieved through a smudgy surface animation (M 79), and in the other through the vibrant line of the contour (M 80).

An autograph is made by drawing on transfer paper with lithographic crayon or wash and using a press to fix the drawing on the stone, so that, in the final impression, the image is not reversed. Manet used this technique with a liquid ink wash for his flowing scenes of café life (M 75 and M 76), theatre (M 85) and cabaret (M 86). Nina de Callias was a talented musician and a brilliant and generous hostess. She received in her salon at the 'Batignolles' anyone of any fame or eccentric reputation in artistic, literary or bohemian circles. In 1874, Manet drew three evocative portraits of her, that were transferred onto boxwood blocks and engraved by Prunaire. Wearing a black hat and a coat with a ruffled collar, she appears half-length in the wood engraving in vertical format (M 91), and leaning on an oriental divan in the two wood engravings in horizontal format called *The Parisienne* (M 89 and M 90).

In contact with the best writers and poets of his age, men such as Gautier, Banville and Zola, an intimate friend of Baudelaire from his early days and of Mallarmé in his last ten years, Manet played an important pioneer role in the development of the modern illustrated book, the product of close collaboration between artists and poets. Several isolated etchings, whether or not they were adopted, were composed specifically to be used in a book: The first portrait, of *Poe* (M 1); the portraits already referred to of Baudelaire and Banville; the version of *Olympia* (M 45), printed with Bracquemond's assistance for Zola's booklet (1867); *Exotic Flower* (M 51), included in the collection *Sonnets et eaux-fortes* (1869) and directly based on the fifteenth of Goya's *Caprichos*; *Cat and Flowers* (M 53), a deceptively simple composition of frankly oriental tenor, which was intended for the second edition of Champfleury's *Les chats* (1870).

In fact it was not until 1874, with the vignettes for Charles Cros' *Le Fleuve*, that Manet finally produced a book, or more accurately an illustrated pamphlet, which was printed in an edition of one hundred by the Librairie de l'Eau-forte. He published two further illustrated books: Edgar Allan Poe's *The Raven*, translated by Mallarmé under the title *Le Corbeau*, and *L'Après-midi d'un faune* by Mallarmé himself. These are no occasional pieces nor are they mere commissioned works; one should not be misled if they sometimes seem hastily put together. On the contrary, these three books reveal a great deal about Manet's literary tastes – Cros actually dedicated the poem to him and was, like Mallarmé, a friend – and also about his views of the function of the illustrator. The illustrations are by no means literal transpositions of the poems into images. The vignettes for *Le Fleuve* and *L'Apès-midi d'un faune* evoke rather than describe, they make allusions to the subject matter rather than being its equivalent in pictures. The unpublished variation of *By the window* for *The Raven* may seem impulsive, in fact it is carefully studied and its simplicity entirely deliberate. Possibly it betrays the lack of imagination for which Manet is so often taken to task – certainly it would be hard to think of a more poverty-stricken notion than *The Chair* to illustrate a poem as rich in imagery as *The Raven*, especially as this 'chair' can be placed in practically any order within the series. The second problem posed by the illustrations is the extent to which they can be regarded as originals. The autographs for *The Raven* are traditionally held to be lithographs although in fact a mechanical process is employed to fix the drawing on the stone. The wood engravings

are even more problematic, being barely distinguishable from photogravures. It may be logical to include in this catalogue blocks drawn by Manet but engraved by a technician (Prunaire or Moller), but there is no technical criterion against which their degree of originality can be measured. It is preferable, therefore, to consider the artist's intentions, whether or not he made his drawing with reproduction by a process of engraving expressly in mind. In the case of Manet this is very difficult to establish and can be the cause of endless controversy, which is why his illustrations have been included both in catalogues of his engravings and of his drawings. Ultimately the question is not of too much importance for the illustrations are neither in terms of quality nor quantity an essential part of his graphic output. As an engraver Manet is first and foremost the dominant etcher of the 1860s and the unfortunate lithographer of *The Balloon* and *The Races*; in the great tradition of Tiepolo and Goya, he is the rediscoverer of the free and sensitive line of airy and dramatic effect, and he uses it in the service of that cause of 'modernity', for which he is the inspirational focus.

If Manet with his etchings in a modern idiom had rekindled the vitality of the old masters, with Pissarro we enter on a new phase of even greater spontaneity, that of 'pure impressionism'. Pissarro's exemplary character can be summed up in a few words: he was sincere, intelligent and good. He strove after what he believed to be truth, nature and authenticity, simple and direct – reality as it is seen, not the reality of intellectual perception. He tried to translate this experience into engraving as an end in itself, almost dreading the need to sell his work to feed his large family. Judging engraving to be a medium precisely fitted to his purposes, he was never, or hardly ever, satisfied with his results. He attempted, for instance, to make the ink evoke the insubstantial sky; or aquatint reproduce the solidity of a cloud (P 18) or the lightening after a storm (P 26); to exploit the sharp contrasts of etching to make objects stand out against the light (P 82) or foliage shimmer in full sunlight while casting heavy shadow on a sloping hill path (P 3); to create the illusion of rain by scratching the copperplate with sandpaper (P 23 and P 64). In his very beautiful print of hayricks (P 22) he used ochre-coloured ink to obtain the golden light of the setting sun; he gouged the plate repeatedly with the needle to convey the impression of a ploughed field of heavy earth (P 25). And in lithography he was skilled at reproducing mist – not that imitation mist used by the romantics as a sort of fireworks display – but a real and unpleasant mist that blots out the landscape (P 100). He tried to make his *Women Bathing* (P 144–P 149) truly consist of flesh and light as they jostle, according to his title, 'in the shade of wooded banks'. These many and radical experiments met with varying degrees of success. Pissarro himself was ready to admit that his engravings were of an uneven quality. There are unqualified triumphs, eminently impressionist in kind, and there are other attempts of doubtful outcome, especially as regards composition and depiction of moving figures. Of this he was well aware and he used to work directly 'on the motif' from his hotel window, or carry his prepared zinc litho plate with him in Rouen; but always he worked alone and followed his own instincts.

Independent by nature, Pissarro was a self-taught man. When he arrived in Paris in 1855 he described himself as a pupil of Corot, although this was hardly the literal truth. In point of fact he has much in common with the realist landscape painters of the 1830s. Their influence is apparent in his engravings. There are affinities with Corot in the first plate (P 1 and P 2) and in particular with Millet (in P 150, for example) in his many figures of peasants. He felt akin to these painter-engravers of the Barbizon school. A character of almost biblical simplicity, he appreciated their rustic side, allied to their sense of modernity. Paul Huet must have appealed to him; he produced an album of etchings in 1836, completely un-remarked at the time, and, in his lithographs, was one of the first to represent a factory (see P 10). It was certainly Daumier, another 'wretched' etcher of the pre-impressionist period, who gave Pissarro the idea of the ploughed field (P 25), which he had already made the subject of an etching. Yet a whole generation separated them from Pissarro; while they still bore the stamp of romanticism and sought for

'telling effects', Pissarro was trying to destroy such notions, like modern artists rejecting attempts at 'significance'. They were ardent republicans, Pissarro a sincere anarchist.

In his experiments with graphics, Pissarro gave this sincerity the force of a law. He never sought to evade a problem. While the printers of his time were wont to use liberal quantities of ink to produce showy effects, so to say 'painting' the plate, Pissarro would have none of this. With infinite care he pulled his own proofs, his 'grey skies', which it was so important not to clog up, his shadows, which depended on meticulous inking. At the price of unimaginable sacrifices, he even bought his own second-hand press. And all this in order to produce a few proofs, sometimes only one, which he gave to his sons or occasionally to friends and, in later life, to the Luxembourg Museum. Like Degas he tackled the whole question of colour, the big disadvantage of engraving for painters who were essentially colourists. He never reached any satisfactory solution with the inks available to him and preferred to colour the proofs by hand, until he discovered wood engraving, a process that combines all the operations in one and can cope with the demands of a pointillist technique. The wood engravings of his later period are marvels of perfection. By the fine detail of his design and the tricky superimposition of impressions he achieves at last the famous 'optical mixture' which, in painting, was never more than an attractive theory. A blob of blue and a blob of yellow in a canvas by Signac, have never in fact amounted to green in the eye of the beholder. But if you look closely at Pissarro's wood engravings (P 203, for example) you can verify that the violets are indeed produced by a multiplicity of blue dots superimposed on a multiplicity of red dots, engraved on separate blocks and brought into juxtaposition at the moment of printing, precisely in register. Even in the dresses of the reapers one can discern the mauve glow of the setting sun and the scarcely perceptible shadows of the green grass on which they are standing; it is a strict and successful application of the theory that an object casts a shadow tinged with its complementary colour.

So Pissarro was, together with Degas, the truest engraver of the impressionists, and the truest impressionist of the engravers. It was no accident that he and Degas remained the most loyal and devoted members of the Société des Peintres-Graveurs. Their stubborn creative independence, their love of experiment and their shared passion for engraving, frequently enabled them to forget divergences of opinion or personality. Thus their work runs in parallel, although with two important differences. Pissarro was the landscape engraver of impressionist graphics, as Degas was not. But, unlike Degas, he was not the great draughtsman he would have wished to be. This raises a question of fundamental importance for engraving. To understand it in its context it will be necessary to trace Pissarro's career through from its beginnings.

Pissarro started drawing very early, even before he had learned to handle a paint-brush. And he continued to draw in his old age after he was forced to lay his brushes aside. For him drawing was not merely one means of penetrating the secrets of the visible world, it was also a method of refining his art and realizing it to the full. He therefore refused to limit himself solely to drawing and wanted to explore all the techniques to which a sheet of paper can be adapted. He used crayons, charcoal, pastels, watercolour and gouache, as well as all the printing processes: dry-point, etching, aquatint, monotype, lithography and even wood engraving.

So, right from one of the rare early drawings that has survived (*Palm Tree*, executed in Venezuela in 1853) up to the last wood engravings that he left to be completed by his son Lucien, his graphic work shows a clear continuity of development, the sources of inspiration constantly renewed, capable of reflecting the prevailing artistic currents and influences and yet of a profound unity. With Pissarro the line remains simple, the forms vigorous yet subtle; always in evidence are this gentleness and humility and taste for the play of light and shade that at times make him the equal of those he himself most admired: Rembrandt, Goya, Manet and Corot.

In his *Letters to his son Lucien* (which, like Delacroix's diary or Van Gogh's letters, could provide ample justification for believing that it is the painters themselves who are the great art historians) he returned continually to the importance of drawing:

You must draw and draw a lot. . . .
While you have the time, draw a lot, waste no time, it will be of more use to you than you realize. If all you can do is copy, with scrupulous care, Egyptian bas-reliefs or statues, that will help you a great deal. For preference choose simple objects, sphinxes, oxen etc., figures seated or standing etc. . . .
Everything is a fit subject for drawing, everything. . . .
Lots of drawing, lots and lots, remember Degas.

And indeed it is true that Pissarro's total output of drawings must have equalled Degas' – and Degas was the most prolific draughtsman of all the impressionists.

Judging by the hostility the impressionists' paintings attracted, it is not unreasonable to suppose that the engravings were even less well received. For a long period they were known only to a small circle of friends. It was certainly Pissarro who contributed most to this secret activity: we possess 190 engraved and lithographed plates by him, as opposed to 67 by Degas, 59 by Renoir and 9 by Cézanne. He took part in most of the exhibitions of engravings – that these passed off in an atmosphere of general indifference barely needs to be said. Self-taught as he was, Pissarro learned engraving on his own and managed to preserve his individuality, even though, as we have already mentioned, he was influenced by Corot, Daubigny and, most consistently, Millet. He engraved for pleasure and not to make money; he never sought to make his engravings virtuoso feats of skill. It is entirely consistent with his general attitude that they were really no more than artist's sketches printed on old sheets of paper and produced in editions of twenty at the most.

It was in 1862 that he started engraving, but produced comparatively little in the years up to 1874. One of his earliest known plates is *Field near Asnières*, 1864 (P 3). *A Street in Montmartre* (P 4) and *La Roche-Guyon* (P 5) followed in 1865 and 1866 respectively; the lines are cleaner and the interplay of light and shade better orchestrated than in the earlier etchings. With *The Negress*, 1867 (P 6), he shows a preoccupation with spatial organization that is characteristic of him at this period.

When Pissarro left Louveciennes and went to live in Pontoise in 1872, his new neighbour was Doctor Gachet, also an engraver under the pseudonym Van Ryssel. It may have been under his influence that Pissarro took up engraving again. It is to this burst of renewed activity that we owe his portrait of Cézanne, 1874 (P 13), one of his finest prints. The purity of line, the flowing sweep of the coat that envelops the model, endow him with a prophetic dignity that also characterizes Pissarro's self-portraits.

The black year, 1878, saw the start of his friendship with Degas. Henceforth the work became a steady stream. The artist mixed the different processes with assurance: dry-point, pure engraving and aquatint, in which he later became an expert. During this period colour exploded on his canvases and in his engravings, he mastered the various techniques for manipulating space and producing a play of light on objects. For some time Pissarro did not own a printing press and had a few proofs pulled by Degas or Jacque or a professional printer. It was not until 1890 that he bought a press. But even before that he respected the engraver's tradition of allowing no latitude to the printer. Everything was expressed in the line and the grain, the subtlety of his effects being the result of ferociously hard work. At times he would even use a burnisher to scrape a plate and start entirely afresh. He worked his plates over several times and was even then frequently dissatisfied with the results and would destroy a plate after making several states. This was the case with *Woman Emptying a Wheelbarrow*, 1880 (P 31), of which he engraved

twelve states. *Woman at the Gate*, 1889 (P 83), reached nine states and still he was not satisfied with the result. *Women Tossing the Hay*, 1890 (P 94), passed through eleven states. But with most of the best plates he achieved the effect he wanted after only a few attempts.

Pissarro has sometimes been accused of being a careless draughtsman, and it is true that in the engravings executed before 1890 the figures are often loosely drawn and the outlines blurred. In fact the line is always subordinate to the general tone and the forms are loose, not from any lack of technique, but from a lack of interest in this type of problem. In *Landscape at the Hermitage* (P 28) which dates from 1880, the trees seem mannered, barely constructed at all. And certainly in a number of other engravings of this period there is a kind of ingenuousness, a decorative haze that creeps in to conceal a lack of decision in the line-drawing. Even so, the overall harmony more than compensates for these defects. Pissarro himself said to Lucien in 1891 : 'I think you will have some difficulty in making people understand that I am not an engraver, and that these are simply engraved impressions.'

It is apparent from *Path at Pontoise*, 1880 (P 32), that Pissarro had not fully mastered aquatint either and was still using old-fashioned techniques, such as employing paint-brush or pen to make irregular smudges. He also used to scratch the resin with sandpaper to produce a network of close lines, and even used emery paper in dry-point work, calling this his 'grey manner' – see *Saint Martin's Day Fair at Pontoise* (P 21) and *Woman Selling Chestnuts* (P 15).

The Rondest House at the Hermitage, 1883 (P 35), provides the best example of the harmony to which Pissarro could henceforth lay claim. Aquatint has been used in the treatment of shadow, while the transparent tones and the restrained delicacy of line owe something to Japanese art. The same unerring skill at lightly suggesting shadows is apparent in *Landscape with Shepherds and Sheep*, 1883 (P 40). There too aquatint has been used in a typically impressionistic way to conjure up the dazzle and transparency of a day of rain and sunlight.

Let us look finally at the landscapes he engraved at the height of his maturity. *Field and Mill at Osny*, 1885 (P 58), which earned him Degas' congratulations, is distinguished by the purity of the cutting line. Pointillist effects were achieved by a black on white network of slanting shadows that give the illusion of painting. He was similarly successful with *Landscape at Osny*, 1887 (P 69), where the delicate restraint of the cutting line equals that of *The Rondest House*, or *Fields at Bazincourt*, 1888 (P 78), in which the line is so muted as to create the effect of a dream, truly an 'engraved impression'.

Although Pissarro concentrated chiefly on scenes of rustic life, he certainly did not neglect the town where he felt as much at home as in the country. *A Street in Montmartre* (P 4) dating from 1865, gives little hint of the descriptions of cities the artist was later to produce. The engravings of Rouen streets (in particular P 41, P 43, P 45, P 50, P 52, P 53, P 63) cover a period from 1883 to 1886 and, like the landscapes, are simple impressions and atmospheric effects. Pissarro used aquatint to convey the haziness of rain, wet pavements and long expanses of wall. Only *Rue des Arpents*, 1883 (P 44), is an architectural drawing. Of all the views, *Rue Malpalue* (P 41) is the most powerful and clear in execution, and *Rue de l'Épicerie*, 1886 (P 63), has an arrestingly individual flavour, a kind of tension between the baroque subject and the classical execution of the drawing. For this engraving Pissarro used a special process, scoring the multitude of little lines with sandpaper. All these are views of a medieval town, only very rarely did Pissarro find inspiration in the bustle and crowds of big cities (see P 188, P 189 and P 197). The lithograph of *Boulevard Montmartre* (P 197) dates from 1899 and is related to a series of twelve paintings of 1897 on the same theme. Clearly discernible is the influence of photography, then very much in the ascendant.

Pissarro's preference was always for country life because of the wide range of subjects it offered. It was not until fairly late, about 1880, that he used human figures at all prominently in his work : peasants,

women bathing, workmen. These figures rarely appear apart from a landscape and never without some sort of setting. They may be academic but are never conventional. Pissarro took up a less personal position than Millet, who brought out the individuality and power of his creations. He has more in common with a certain romantic tradition, emphasizing the monumental quality of a particular attitude and selecting a few characteristic strokes to suggest the silhouette of a really rather vague 'type' of peasant. By comparison, Millet's figures have a positive virility of bearing and expression.

The *Market* series (P 21, P 73, P 75, P 96, P 97, P 112, P 128, P 135, P 157, P 177) signals the emergence of a certain ingenuousness that is in fact characteristic of the whole impressionist school, in both their drawing and their way of representing life. Arthur Hind found it a regrettable trait, although it was more a sign of youthful vigour than of decadence. In *Vegetable Market at Pontoise*, 1891 (P 96), and *Poultry Market at Gisors* (P 97) the movement of the bodies is more expressive than the faces themselves. Yet Pissarro did not limit himself to creating abstract patterns. His *Children Talking*, 1889 (P 88), shows acuteness of observation and formal grace, a sense of humour that appears elsewhere as irony. Pissarro certainly had a streak of the grotesque which frequently showed in his drawings. Possibly this relish of caricature came from Daumier, whom he admired. In 1884 he sent some of Daumier's lithographs to Lucien and wrote in a letter: 'It seems to me that it can't have meant much to you as you haven't even mentioned the subject. Yet from every point of view they are "miracles". I cannot look at them without forming a high opinion of this great artist. But, take careful note, if it "comes off" it is only because it is admirably "constructed".'

This same good-natured irony, presumably more or less instinctive, gives a particular edge to *Men Working in the Harbour at Rouen*, 1887 (P 66), *The Maid Shopping*, 1888 (P 73), *Woman Picking Cabbages*, 1888 (P 76), *Peasant Woman in a Field of Beans*, 1891 (P 101), and even *Two Women Bathing*, 1894 (P 107).

The series of haymakers (P 94, P 125, P 140) are some of the most attractive of his pastoral engravings. The influence of Millet is apparent. But from *Peasant Woman at the Well*, 1891 (P 99), to *Women Carrying Hay on a Hurdle*, 1874 (P 138), Pissarro evokes in truly masterful fashion the robust calm and simplicity of an entire race. He has also caught its characteristic grace in his series of women bathing (P 118, P 145, P 147), which show the influence of Goya and Manet, and indeed Velazquez. He wrote to Lucien in June 1894: 'I have just had printed two etchings of *Women Bathing*, magnificent, you will see! Perhaps too true to life, they are well-covered peasant women . . . well-covered with firm flesh! . . . I think they are the best things I have done, that is, unless I deliberately deceive myself.'

Most of the engravings already referred to are etchings, only a few lithographs. Lithography, although a less restricting process than etching, does not lend itself all that well to Pissarro's purposes. There are rare examples of lithographs on transfer paper, the rest are zinc lithographic 'plates'. Only one or two, such as *Saint Martin's Day Fair at Pontoise*, 1874 (P 135), were drawn on stone. Few of the 'plates' made before the 1890s have survived. The street views of Rouen, executed in 1896 (P 162–P 168), are less typical than the etchings of 1883 and 1886 of the same motifs. Also deserving of mention are: *Grandmother; The Artist's Wife*, 1895 (P 153), *Women Gathering Wood*, 1896 (P 179), *Group of Peasant Women*, 1896 (P 180), *Woman Minding Cows*, 1899 (P 196), which has a perfect simplicity of line, and *Woman Bathing: near a Wood*, 1894 (P 146), which resembles Fantin-Latour in style.

At times Pissarro worked with a rag and spirit solution, an unusual technique, otherwise employed only by Whistler, by which he aimed to intensify his tone values and produce an appearance of transparency. *Women Bathing, jostling with each other*, 1894 (P 147), was treated with a 'dry' process: it is sharply lit and the expression of the faces is more emphasized than elsewhere. In *Line of Women Bathing*, 1897 (P 185), he rejected this compromise and relied entirely on light, not even attempting to draw in silhouettes and leaving the faces in heavy shadow.

23

Primarily a colourist, Pissarro also investigated the possibilities of producing engravings in colour. *The Market at Gisors: Rue Capperville*, 1895 (P 112), is distinguished chiefly for its background, a number of imperfect tonal gradations being in evidence in the foreground. At times Lucien mentioned the difficulty of obtaining the exact colour his father stipulated. For its harmonious colours and attitudes and fine precision of line, *Peasant Woman Weeding the Grass*, 1895 (P 113), must rank as a masterpiece. Four plates were used for *Women Bathing while Minding the Geese*, 1895 (P 114). The shades ranging from green to purple and brown, the broken reflections in the water, the mauve and purple nuances of the shadows, the light playing on the bodies, all reveal a typically impressionist feeling for colour. Here Pissarro is closest to Renoir.

Towards the end of his life, Pissarro was persuaded by his son to draw wood blocks for Lucien to engrave and print in the *éditions de luxe* he had established in England. Lucien worked within the impressionist tradition. *Work in the Fields* is a set of six engravings (1894), including two in colour: *Women Weeding* (P 202), of which there are five plates, and *Women Weeding the Grass* (P 203), of which there are six. Camille Pissarro planned a further series of drawings on the same theme and no doubt some of these were actually engraved. *The Ploughman* and *The Sower* (P 205) show an interest in chiaroscuro. Later Lucien added a few touches of colour. And, finally, in *Daphnis and Chloë* (P 206) we have a plate in a more decorative style, although the Pre-Raphaelite manner chosen here does not suit Pissarro particularly well.

There are few portraits in this long series of engravings (P 13, P 89, P 90, P 92, P 132, P 153, P 154, P 155, P 156, P 191). The portrait of Cézanne, the first and one of the best, has since acquired an historical importance. The self-portrait of 1890 (P 89) has about it an intensity and a humility of self-regard that invest it with all the sovereign and harrowing grandeur of the late self-portraits by Rembrandt. If solitude and material difficulties were Pissarro's lot for a large part of his life, he remained no less responsive to his friends (one thinks of Monet, Degas, Seurat, Signac and Cézanne, all at various times close to him) and to changes in the world about him.

The impressionists were, as a general rule, indifferent to social questions. This was not true of Pissarro who inherited from Daumier, Courbet and Millet a tradition of egalitarianism and social conscience. More sincere and profound than the young Claudel, he too inhaled 'the clean air of anarchy that was to be breathed in France in the 1890s.' On 5 May 1891, he wrote to Lucien: 'Luce asked me if you would be interested in collaborating with me on drafting certain anarchist ideas on the role and grouping of artists in an anarchist state; giving a brief indication of how artists might work, given complete freedom from the appalling shackles of their lordships the capitalist patrons, speculators and tradesmen all.' It was in 1890 that Camille Pissarro met Jean Grave, the leader of the French anarchist movement who later became the editor of *Les Temps Nouveaux*, to which Pissarro contributed two lithographs: *Women Carrying Faggots* and *The Vagabonds*. Later still he produced a lithograph in colour, *Ploughing* (P 192), to illustrate Kropotkin's booklet, also called *Les Temps Nouveaux*. He always put himself out to help Jean Grave, even giving him money at a time when he himself was financially embarrassed.

Over Pissarro's graphic work there remains a question mark. The question is that posed by the whole of impressionist engraving: whether, in a movement so overwhelmingly concerned with colour, drawing did not lose the splendid vigour imparted to it by the romantics. By the time Pissarro and Monet went to London in 1870 and discovered the etchings by Turner, who was a first-class draughtsman, impressionism had already begun to experiment with the use of optical techniques to break up forms. Later Degas, a brilliant draughtsman, refused to be classed as an impressionist; and to Arthur Hind, Manet evidenced 'mere affectation masquerading as sound drawing'. Of all the impressionist draughtsmen, Pissarro remains something of a solitary figure: the only genuine landscape artist the movement

produced. If he was not always an engraver of the first rank, it is because he was essentially a colourist and sought the means to reproduce on copperplate or stone those features that distinguished his paintings. For him engraving remained one method, and only one, of conveying an 'impression'.

It was under very different conditions from those experienced by Manet and Pissarro that Renoir began to work as an engraver. They had been the pioneers of engraving, lonely and uncompromising explorers of unknown territory. Manet had practised the art at a time when only he and Degas had any faith in it; Pissarro had kept his two hundred plates hidden away, reluctant to submit them to a wider examination. Renoir, on the other hand, came to engraving at a time when, in Pissarro's words, 'it was the only done thing'; he applied himself to it at the request of societies or dealers and he had his engravings printed and sold – even today some recent restrikes are available at a modest cost.

Renoir's relationship with the impressionist group compared with, say, Pissarro's, was always much more opportunistic. Renoir detested intellectual arguments, aesthetic or political labelling: he refused, for example, to exhibit with Pissarro, who was Jewish, not because he was anti-semitic but because he was afraid of compromising himself, and time and time again he attacked the theoretical research of the neo-impressionists. These are all factors to be taken into account in trying to make an assessment of Renoir's graphic work. Although it reveals the same taste for direct experience, the same technical expertise as the work of his predecessors, it does after all come much later in time, at a period when there already existed an assured public and clientele for original prints. It was a period when the artists, far from working in isolation without the slightest hope of selling an engraving, motivated only by the urge to express themselves in a new way, as had been true of Manet, Pissarro and Degas, were, on the contrary, actually being encouraged to engrave by the big dealers. It was the period when Durand-Ruel housed the exhibitions of the Société des Peintres-Graveurs in his galleries, and not long before Vollard too became interested in engraving.

The year 1889, in which Renoir drew his first etching, marks a decisive stage in the movement for the revival of engraving which was first got under way by Cadart and his group in 1862. After thirty years of struggle and continual setbacks, when the impressionist 'co-operative' had already disbanded, engraving finally won the day. After 1889 it was unusual if a painter did not also engrave or produce lithographs. Victory, or more accurately total rout, was sealed by the foundation of the Société des Peintres-Graveurs, which enlisted many new recruits through its annual exhibitions. Its two leading lights in the early days were Pissarro and Mary Cassatt. They participated in the exhibitions of 1889 and 1890, but in 1891 there was an untoward upsurge of nationalist sentiment that transformed the Société des Peintres-Graveurs into the Société des Peintres-Graveurs français. Pissarro and Mary Cassatt were excluded on grounds of nationality and forced to retreat to a room adjoining Durand-Ruel's gallery. Their places were taken by new converts: Sisley, Berthe Morisot and Gauguin all began to engrave at exactly the same time, as did the already famous Renoir.

It was the Société des Peintres-Graveurs that asked Renoir to contribute to its second group exhibition, in 1890. Renoir's reply to Durand-Ruel has been preserved for posterity: 'I have a single etching which belongs to Mallarmé, ask him for it if you wish, it is a mere trifle.' This comment modifies the chronological order given by Delteil in his catalogue, where he places first in sequence the plates for *The Country Dance*. In fact the etching belonging to Mallarmé can only be the frontispiece for *Pages*, which was not published until 1891, and can therefore be established with certainty as Renoir's first engraving.

It would be difficult to conceive of a personal initiative in the matter on the part of Renoir, who frequently declared that he had no sympathy with the self-indulgence of the poet labouring aloof from the world. No doubt he was approached initially by Deman the editor or by Mallarmé himself. In spite of Renoir's unconcealed dislike of intellectual theories and refinements, the drawing he did for *Pages* is

in complete accord with the spirit of the book and the spirit of the times. This flowing linear motif is in the best traditions of 'aestheticism' and must have delighted Mallarmé with its elegant purity, its sophisticated simplicity, its firm yet mannered line. It is notable that Renoir employs instinctively a style very close to Manet's treatment of the vignettes for *L'après-midi d'un faune* by the same author.

Although it is true that the position of the painter-engraver had changed radically and completely in the years between 1860 and 1890, there is still every justification for talking of an 'impressionist approach' – Renoir in his engraved and lithographic work shows clear affinities with, for example, Pissarro and Degas. The closest bond between all these painters, all innovators at heart, is a shared fascination with the infinitely rich variety of print-making techniques and the unending opportunities for experiment they represent. Degas worked certain plates through twenty states, making modifications at each stage. Pissarro coaxed from aquatint atmospheric effects comparable to those Lepic demanded of his 'mobile' etching. Renoir would return three or four times to the same motif, each time employing a different technique, constantly striving by trial and error to achieve a particular tone value or effect of modelling. Far from becoming a specialist in a technique adapted to his purposes – as do most engravers – Renoir would no sooner embark on one process than he would abandon it for another. Like Degas, who would end up by ruining the plate with his continual experiments, Renoir had a desire for perfection, that expressed itself in plate after plate as he rapidly exhausted the possibilities of one process after the other. It is the beginning of an entirely new conception of engraving, that encourages the artist to express himself as much by his technical freedom as by his style; a tradition that culminates in the current profusion of techniques, reinvented by each artist in turn, and in the many-sided graphic activity of, for example, a Picasso.

This was certainly how Renoir conceived of engraving. Vollard quotes him in his book of reminiscences, describing how he used to visit Cadart in the evenings with Degas, whose contempt he shared for those who sought technical precision in an academic tradition, rather than using the technique as one element in the spontaneous experimentation of creative activity. At the same time he admired Rembrandt 'because he had mastered every last detail [of his craft] and knew the worth of working by hand, so that you do not find, intervening between the artist's idea and its execution, that array of tools that makes the studio of a modern engraver look more like a dentist's surgery.'

Renoir's first etching seems to have been directly inspired by the taste for things Japanese. But one should not over-emphasize the influence of this vogue on Renoir, not at least if one is to believe Vollard's recollections of him. He mentions Renoir's almost total lack of interest when 'during the 1889 exhibition [his] friend Burty took him to see the Japanese prints.' His debut as a 'pure' etcher was no more than a brief experiment, which he did not pursue until much later. He immediately started to explore two other techniques closer to his personal aspirations: soft-ground etching and dry-point. Dry-point was very extensively practised, especially towards the end of the century, not only by Pissarro and Degas, but also by large numbers of mediocre engravers who exploited its quality of charm in order to appeal to the false sophistication of a section of the public. Soft-ground etching is a much rarer and more delicate process, in which Renoir seems to have come closest to a true expression of himself. It was in the eighteenth century, when drawings by the masters began to rival their paintings in the affections of the collectors, that this etching technique, which replicated the 'crayon manner' even down to reproducing the grain of the paper, had been perfected. A liquid ground is applied to the copperplate; a sheet of paper is laid on top of the plate and a drawing made on it. The paper is carefully lifted off, the varnish adhering wherever the pencil has pressed down on it. The plate is then bitten with acid in the usual way, reproducing in the final impression the marks of the greasy crayon against the coarse-grained paper, and even the wire-marks of the laid paper itself.

26

Renoir used this process to render the voluptuous models he favoured in greasy, velvety lines, at times thick and black with ink, at others muted to a soft grey. With soft-ground etching he obtained results equivalent to those he achieved in painting with flat brush-marks and bright colours in harmonious contrast. His second plate, *The Country Dance*, an extremely rare unpublished trial version for the following plate (R 3), shows him struggling to come to terms with this difficult process. He achieved his best results in *Women Bathing, seated* (R 11 and R 12), drawn with a thick textured line that in no way compromises the purity of the curving linear motif; it possesses all the innocent and joyful sensuality of his canvases. Right from the start he sought a similar softly flowing line in his experiments with dry-point, *Berthe Morisot* (R 4) and *On the Beach at Berneval* (R 5), and once again it was in a *Study for Woman Bathing* (R 16) that he perfected the process. He enhanced the willowy curves of the model's very real body, but managed to avoid the excesses of fashionable prettiness characteristic of so many *fin de siècle* dry-points. *Hat secured with a Pin* is a motif that crops up frequently in Renoir's work. In 1894 he adopted it for three engravings (R 6, R 7 and R 8), aiming for velvety shadows, contours without distinct outlines, rich blacks and dazzling light. And, having sought to achieve these effects in dry-point and etching, he turned in 1897 to lithography, varying formats and introducing colour with confident skill. A comparison of the delicate miniature etching of 1894 and the huge colour lithograph of the same subject, reveals that the artist, starting with one and the same motif, has created works that are diametrically opposed in terms of technique and yet achieve similarly harmonious results. The same can be said of the three plates of *Nude Woman Reclining* (R 13, R 14 and R 15), where the luminosity and flowing curve of the body are suggested in the one case by feathery dry-point incisions, in the second by the vibrant purity of the etched line, and in the third by small, separate hatching strokes in the manner of the Venetian etchers or of Manet.

The series of lithographs are of a similar richness. There too Renoir is in pursuit of the voluptuous, a purpose to which the greasy lithographic crayon, smeared thickly on the grain of the stone, lends itself admirably. This is apparent even in a minor print, possibly no more than an occasional piece, *Odalisque* (R 36). Yet still Renoir was not satisfied and once again had recourse to an unusual process, lithographic wash drawing. In this method the greasy lithographic drawing ink is diluted with water as appropriate and applied to the stone with a paint-brush or even a pen. Renoir's lavish washes were executed at a time when he was in complete command of his drawing technique and exhibit the inexhaustible range of tone values of *Study of Nude Woman, seated* (R 42 and the variation R 43) or, most especially, *Woman by the Grape-Vine* (R 44 and the variations R 45 and R 46) which is done with both brush and pen. In his last autographic drawings, the line is so broad that it demands exceptionally large formats and the whole has to be seen from a distance for the motif to reveal itself clearly. The detail is an abstract jumble, rather in the manner of Monet's *Water Lilies*. The concluding studies, *Washerwomen* (R 58) and *Women Bathing* (R 57), are very late in date (1912) and, like the contemporary studies by Monet, push the impressionists' experiments to their ultimate limit.

Colour was a more important element in Renoir's graphic work than it was for his predecessors. However hard they tried, Pissarro and Degas never really mastered the use of colour in engravings; printer's ink was too sticky and opaque to be very suitable, and they never discovered the secret of fine Japanese inks.

At times Mary Cassatt succeeded in trapping the illusory nature of colour, and for that she won general admiration. Renoir attempted, and brought off, one etching in colour (R 10). Attempted, because the colour is very restrained and barely hinted at; brought off, because, at the price of this restraint, he rediscovered the translucent qualities of ink. In lithography the same challenge did not exist. As Renoir knew, lithographic ink can render the whole gamut of muted or intense values, but it has no qualities of

luminosity. In character it is matt as a gouache, an attribute that favoured the Nabis, who made extensive use of white, but was for Renoir a disadvantage which he had to overcome. He found his way round this particular problem by calling on the full register of values and using bright colours, an approach in which his 'piquant' period in painting had made him an expert.

It remains to be said that, as far as can be judged, his colour lithographs are less the product of deeply felt impulses than a concession to the taste of the 1900s. This vogue for colour lithography is relevant not only to Renoir but also to Sisley and even Cézanne, and is a phenomenon worthy of closer examination in its historical context.

After the discovery of photography in 1839, the idea had grown up that lithography was finished; its general function as a reproductive process was confused with its occasional function as an artistic technique. In its more usual role it was indeed superceded by photomechanical reproduction. In 1861 Cadart tried to revive it as an artistic technique. We have seen what happened to Manet's experiment with *The Balloon*. In 1874, Manet tried his hand at printing a colour lithograph from seven different stones; *Punch* (M 83) fared no better and was a venture he did not repeat. Yet in the end it was because of colour that original lithography began to win back its public, from 1890 onwards. The colour lithograph, an original work signed by the artist, but printed in a largish edition of one or two hundred and therefore relatively inexpensive, went from strength to strength, and it has continued to do so up to the present day. The first experiments were made by the Englishman John Lewis Brown, and these, together with the posters by Chéret, greatly influenced Toulouse-Lautrec.

In 1892 the big dealers, Boussod and Valadon, became interested in the process. In 1893, Marty launched his albums of *L'Estampe originale*. He approached Renoir, who gave him *Pierre Renoir, full face* (R 26), his first lithograph. Through Toulouse-Lautrec, Marty also knew Pissarro, and published one of his series of *Women Bathing* (P 144). Other journalists, such as Roger-Marx, de Marthold and Mellerio, quickly followed his example and published other albums and reviews: *L'Estampe nouvelle* (1896), *La Lithographie* (1897), *L'Estampe et l'affiche* (1897), *La Lithographie en couleurs* (1898), all of which bear witness to a widespread enthusiasm. And it was at precisely this period, between 1896 and 1898, that Renoir published his most famous lithographs in colour, *Woman Bathing, standing, Hat secured with a Pin*, etc. (R 27, R 29, R 30 and R 31).

It was a young dealer, Ambroise Vollard, who printed most of the colour lithographs. Seeing the fashion's potential, he hastened to purchase for himself a lithographic press. Vollard knew Renoir well and wrote a book based on his memories of him. He also commissioned a series of lithographs. Renoir produced twelve in black and white, including the portrait of Vollard. Vollard also knew Cézanne, whom he introduced to the public with his daring exhibition of 1895, an event of capital importance for the young painters of the time. The following year he published his first album of lithographs in colour, and produced a second album in 1897. He had asked Cézanne to contribute one plate. It was close enough to being a simple reproduction of his *Bathers* for the printer Auguste Clot to be accused of himself transferring the drawing on to the stone. Apart from the insistent denials of Auguste Clot, the discovery of a first state by Jean Goriany (see bibliography) and of a preparatory drawing coloured by Cézanne (a discovery made and reported by John Rewald) are sufficient proof that this is after all a work executed by the artist in close collaboration with the printer.

In the same album was a colour lithograph by Sisley, to which Vollard refers in his *Souvenirs d'un marchand de tableaux*:

Of all those who have come to be known as the great impressionists, Sisley received the least encouragement, yet today his canvases are much sought after. All of them at some time suffered terrible priva-

tions, but the Master of Moret never knew even the most modest comfort. The first time I met him was when I went to ask him to do me a colour lithograph for the album of painter-engravers I was planning. He accepted with the best of good grace and did me a 'girl minding geese'.

According to Vollard, his albums were commercial failures and twenty years later the stocks were still not exhausted.

Previously, both Cézanne and Sisley had experimented with etching, but only in a sporadic fashion. The five early etchings by Cézanne and the four by Sisley are really no more than 'accidents' and, although they are of undeniable quality, too much importance should not be attached to them, as the artists themselves did not choose to persevere with the technique. Once again it was at the instigation of the Société des Peintres-Graveurs that Sisley tried his hand at etching, in 1890. For the second exhibition of the group he engraved the four plates of *On the Banks of the Loing*; the few proofs were heavily 'sauced' in printing, that is to say, so heavily inked as to give the print a grey background not drawn in the first place by the artist, an effect much prized by the impressionists' printers. As for Cézanne, he decided to wield the needle under the influence of Doctor Gachet, who was passionately interested in engraving and, as has been mentioned, was an engraver himself under the name Van Ryssel and the owner of a press. But it would seem that Cézanne was not convinced by his experiments. It was while Cézanne was living with Pissarro in Pontoise that he was, in the natural course of events, introduced to Gachet, their neighbour from Auvers-sur-Oise. In his short book, Paul Gachet has described how it was little more than chance that led Cézanne to make his rare engravings, some of which are being re-struck in large quantities today. The doctor repeated the experiment with Van Gogh, who mentioned in his letters his intention to pursue his interest in the subject in collaboration with Gauguin.

In respect of the period between Manet's *The Balloon* (1862) and Renoir's *Washerwoman* (1912), one can certainly talk of an impressionist style of print. The variety of the techniques of graphic art, and the wide range of effects that could be obtained within those techniques, accorded well with the self-imposed objectives of the impressionist painters – to destroy contour and relief as conceived of in the classical tradition, and to substitute the play of light on surfaces, the rendering of impermanence. The stable, objective world-order of the Renaissance explodes into a subjective, fragmentary life. Manet's vibrant etching, Pissarro's pointillist wood blocks, Renoir's vast lithographs, were so many weapons in the battle, a despairing struggle at first, but one in which they gained ground inch by inch until the final victory was won. It is true to say that the impressionist cause was served by the freedom the artist gained from the rich variety of graphic techniques. It is perhaps equally true to insist that the impressionists in their turn, however little notice their engravings may have attracted, made a major contribution to the cause of print-making. From 1860 onwards, they refused to make easy concessions to fashion on the one side or tradition on the other. They chose to work with second-hand presses and to install their vats of acid in their own kitchens. They engraved directly from the motif, utterly contemptuous of public recognition. Does this not go a long way towards explaining why, with the dawning of 'modern' art, engraving stands revealed in its full power and splendour?

It is in large measure because of their heroic experiments that engraving is, and will remain, one of the most original means of expression of our time.

THE PLATES

Manet

M. 1

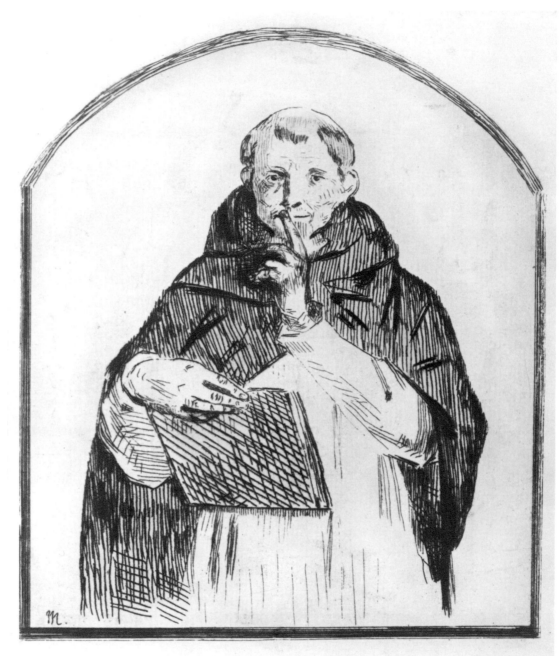

SILENTIUM

M. 2

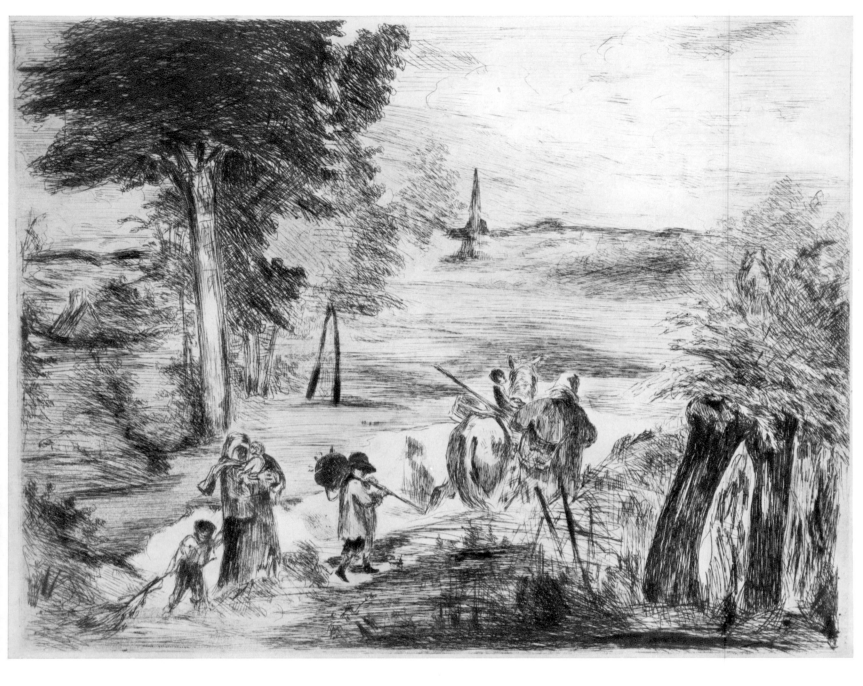

M. 3

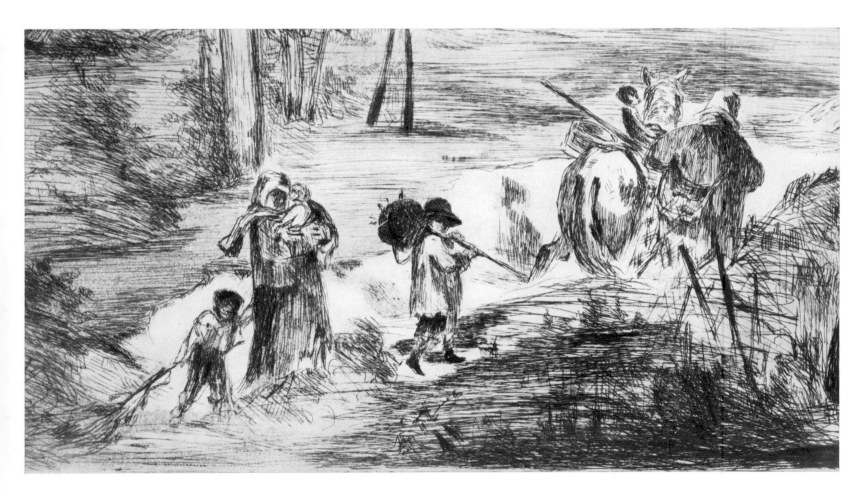

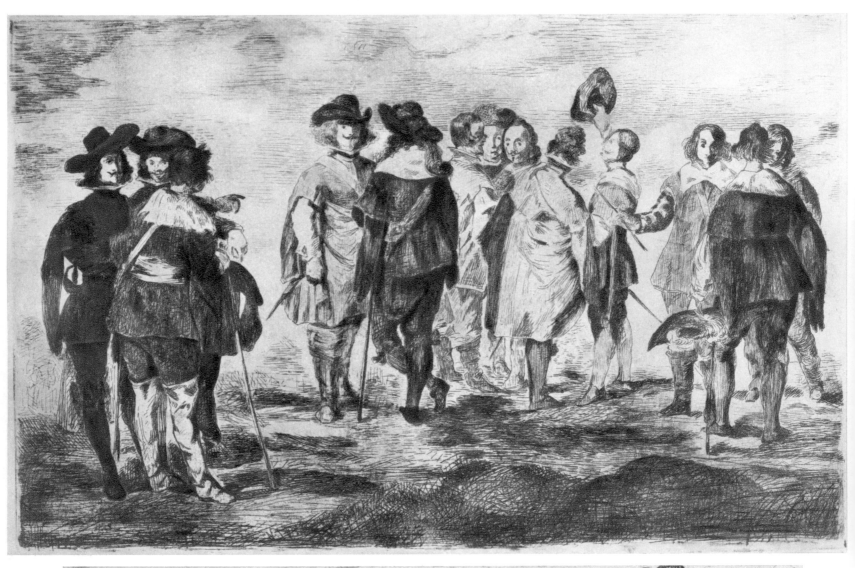

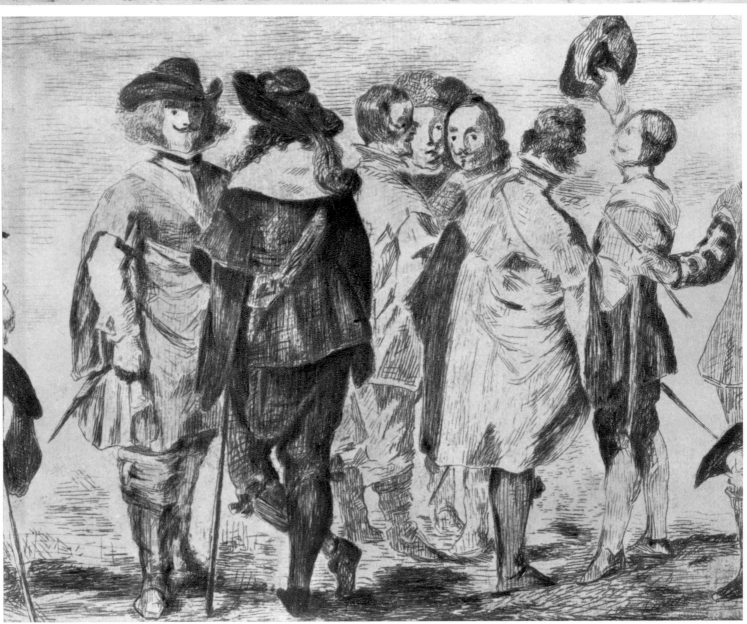

M. 4

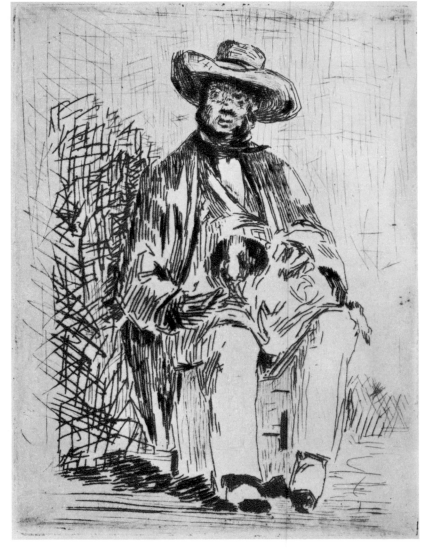

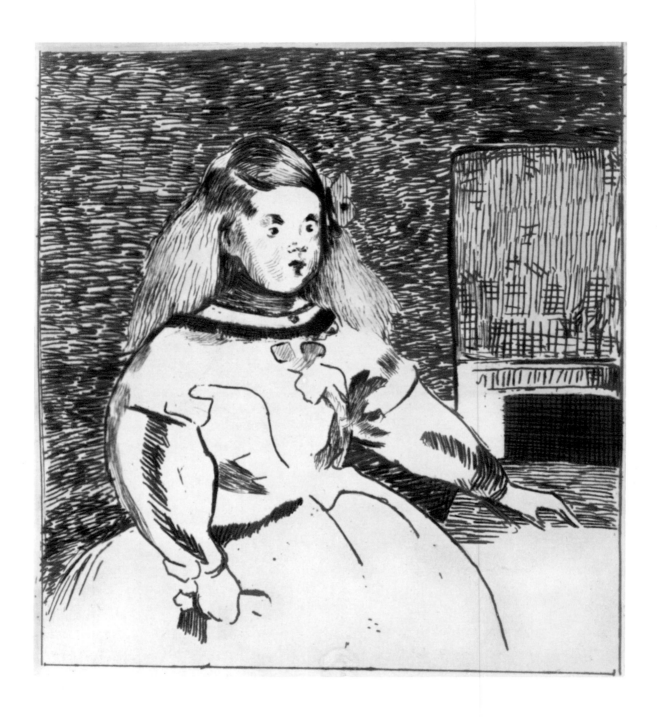

M. 7

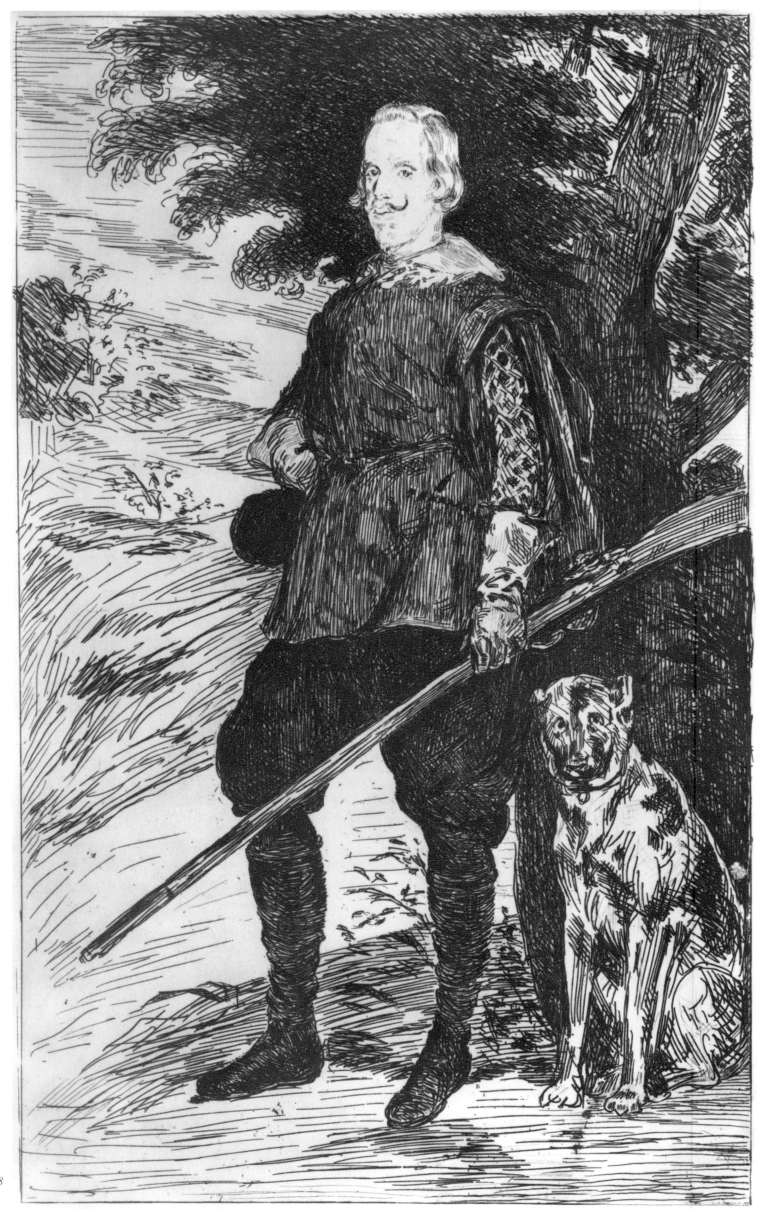

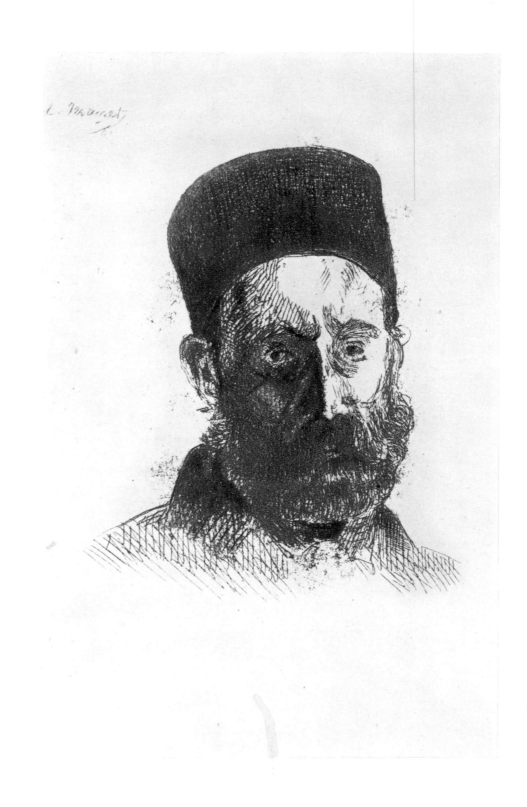

M. 9

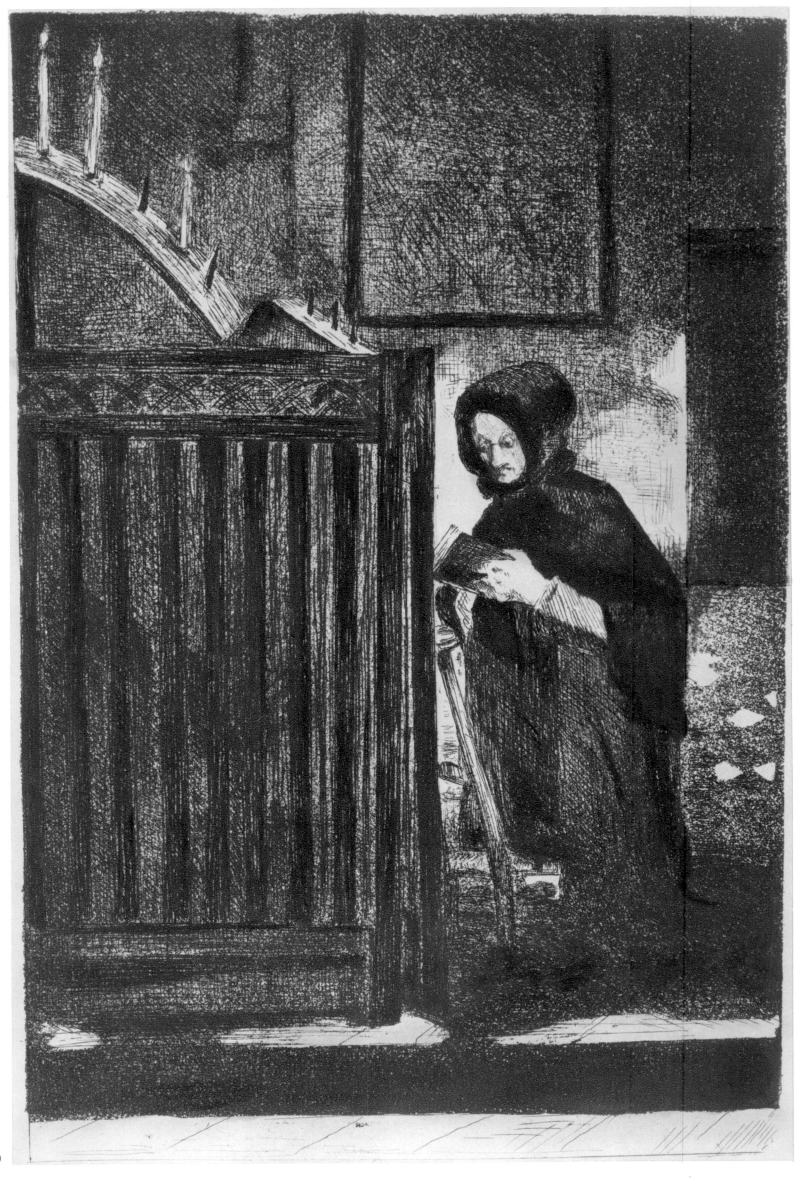

M. 10

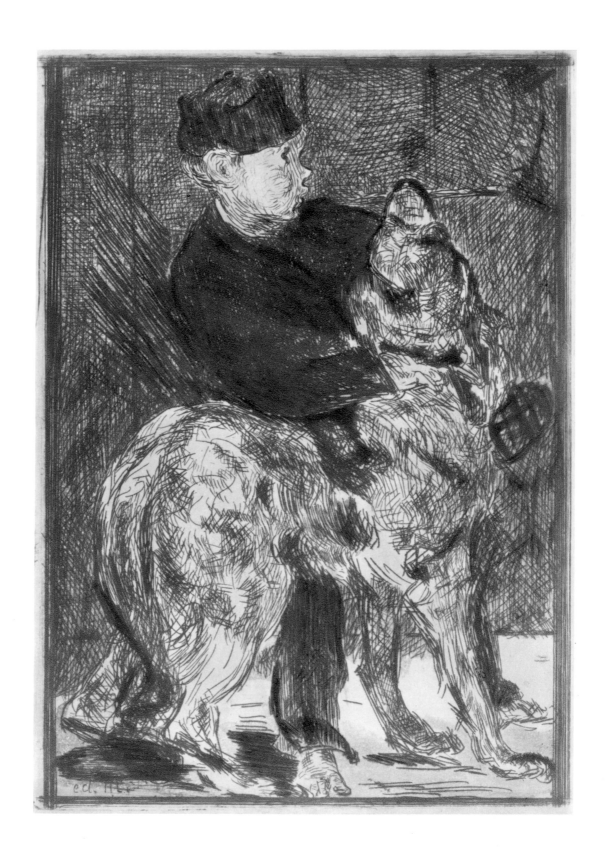

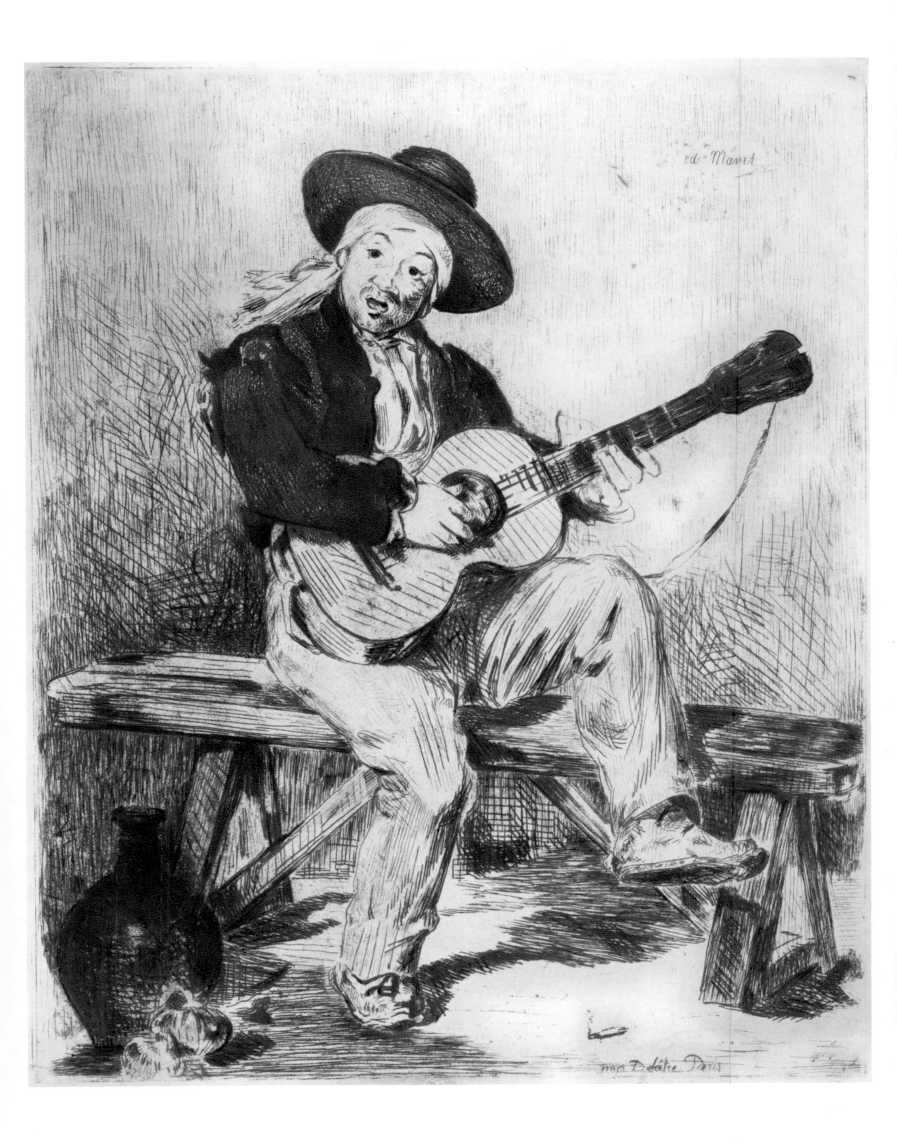

ed Manet

imp Delâtre Paris

M. 12

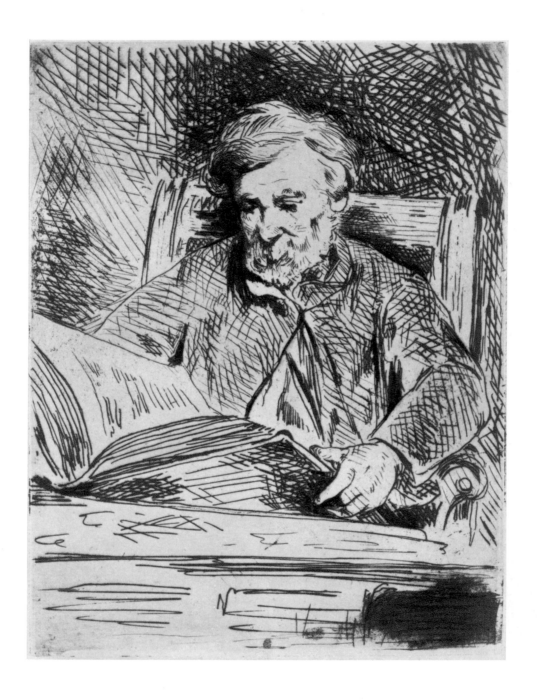

M. 13

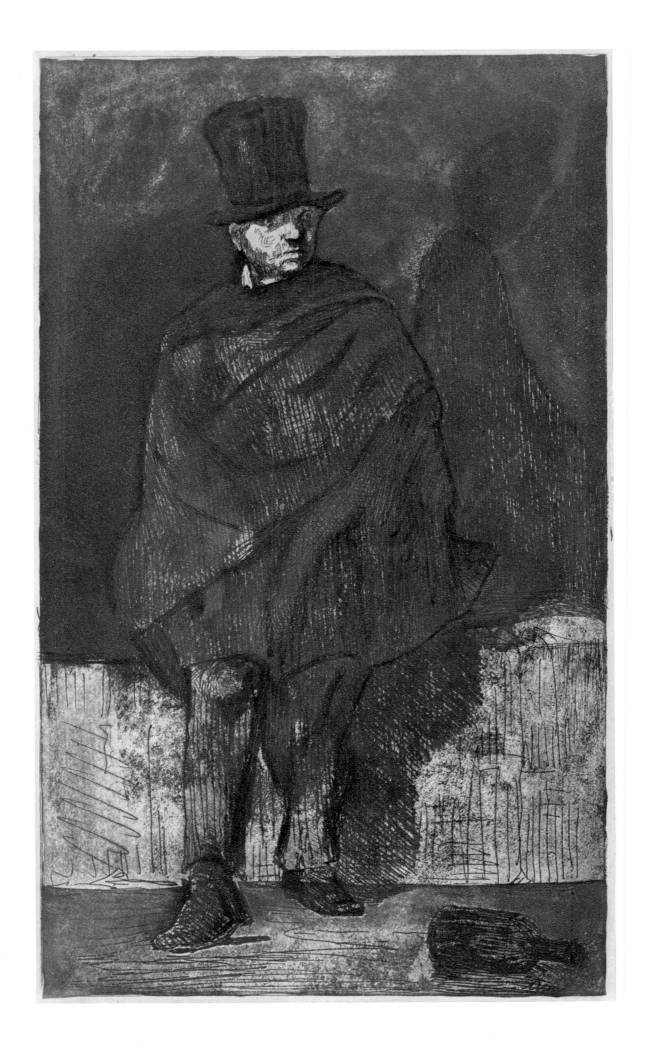

M. 14

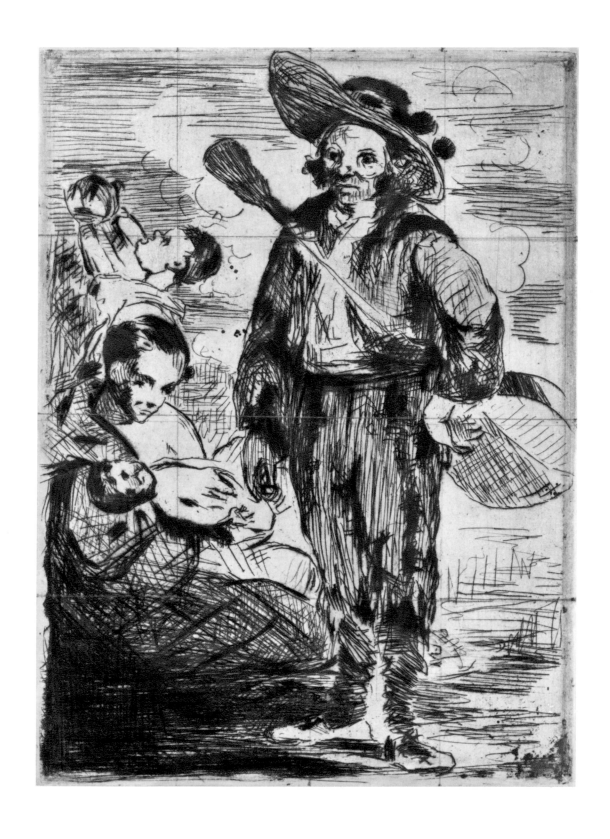

M. 15

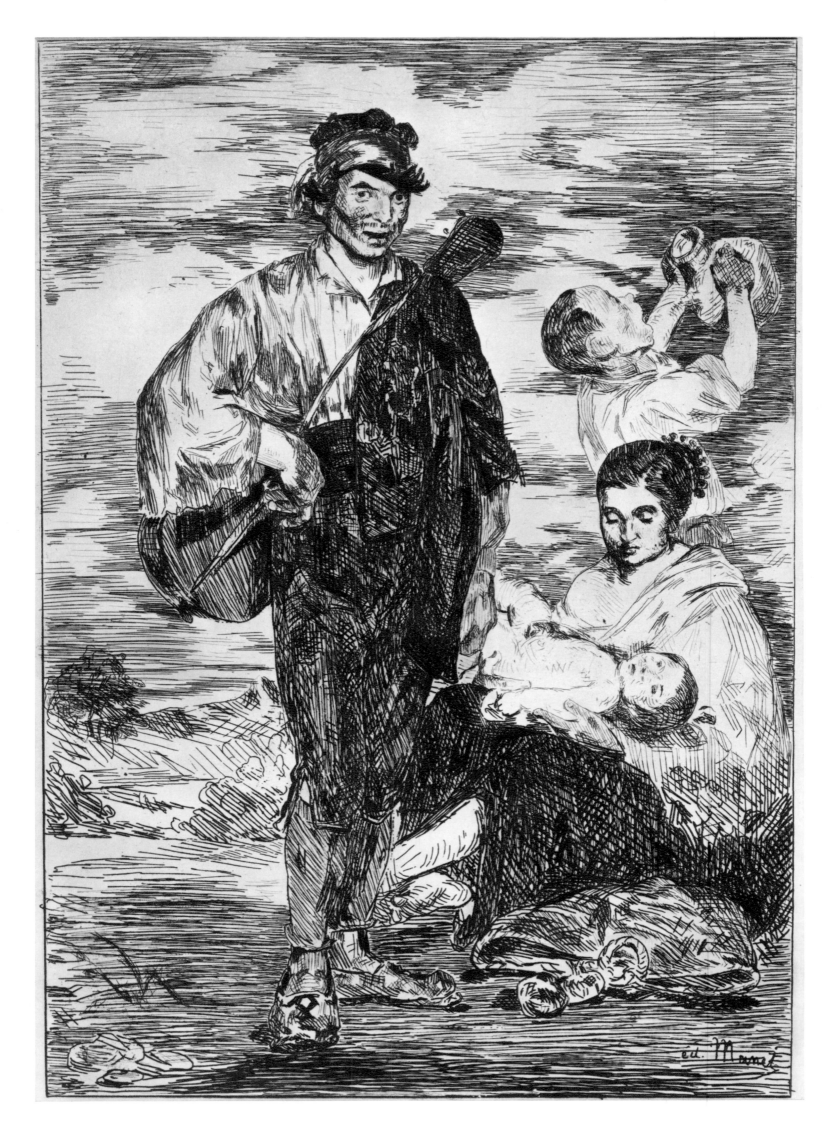

M. 16

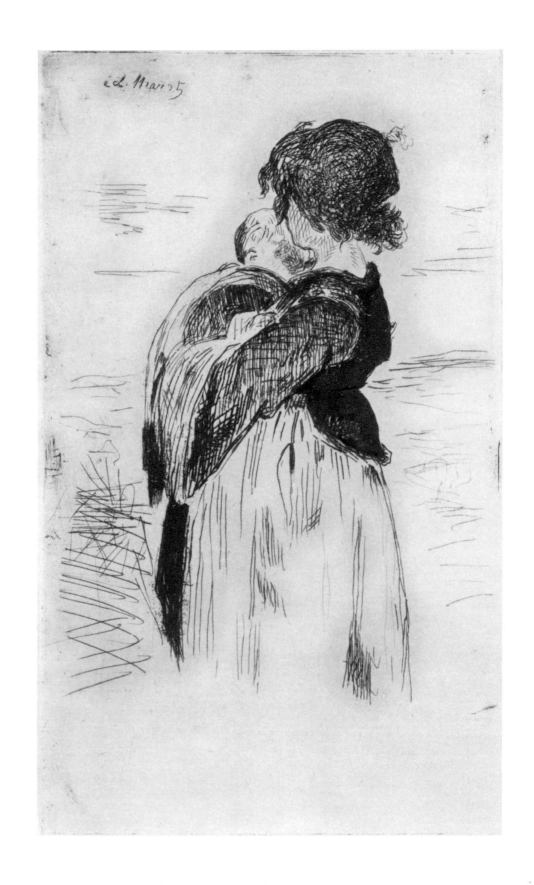

M. 17

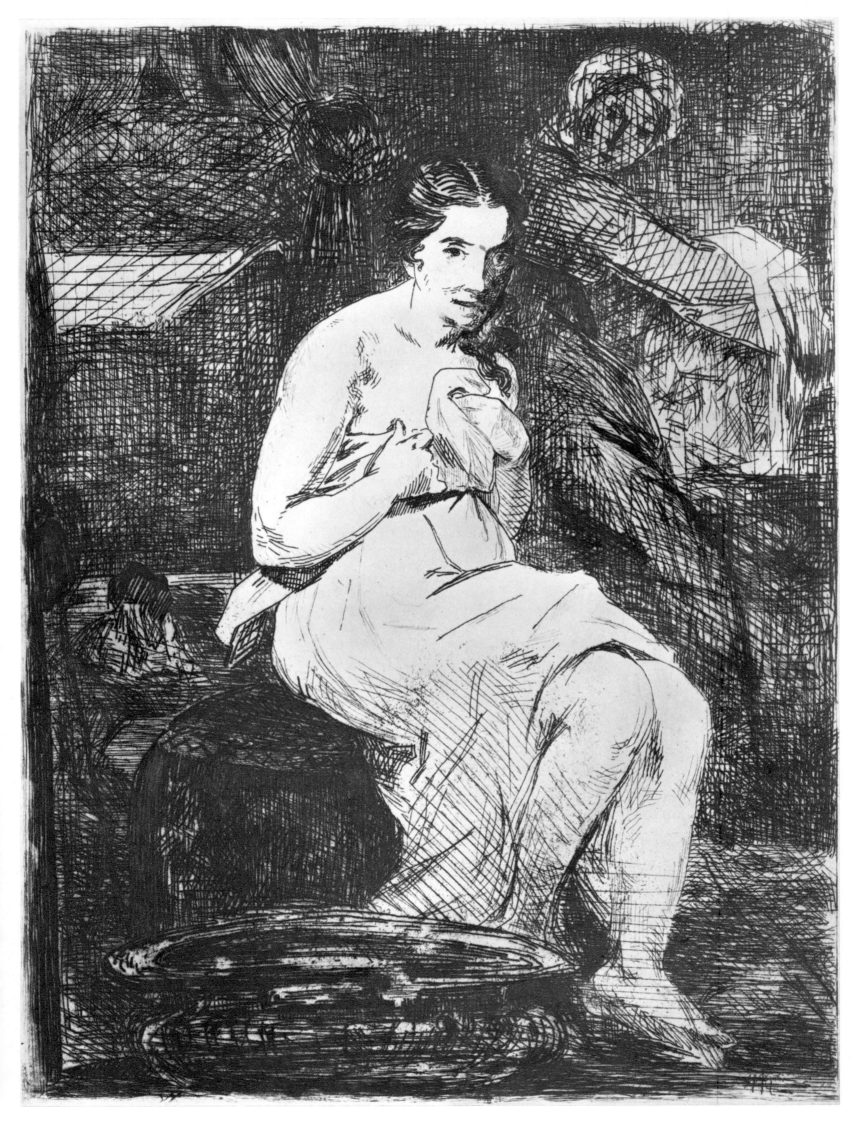

M. 18

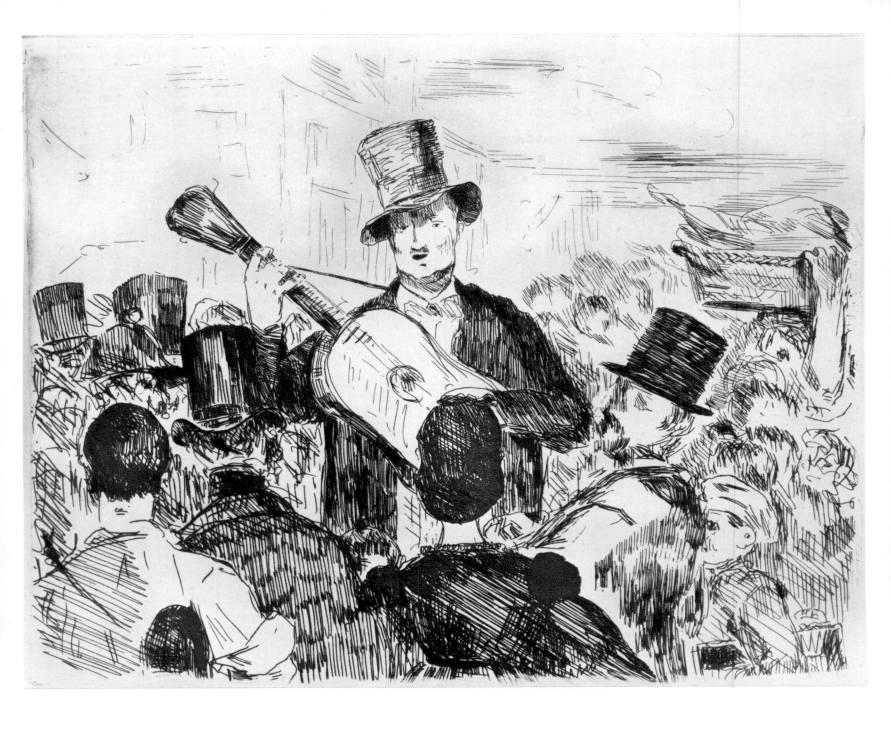

M. 20

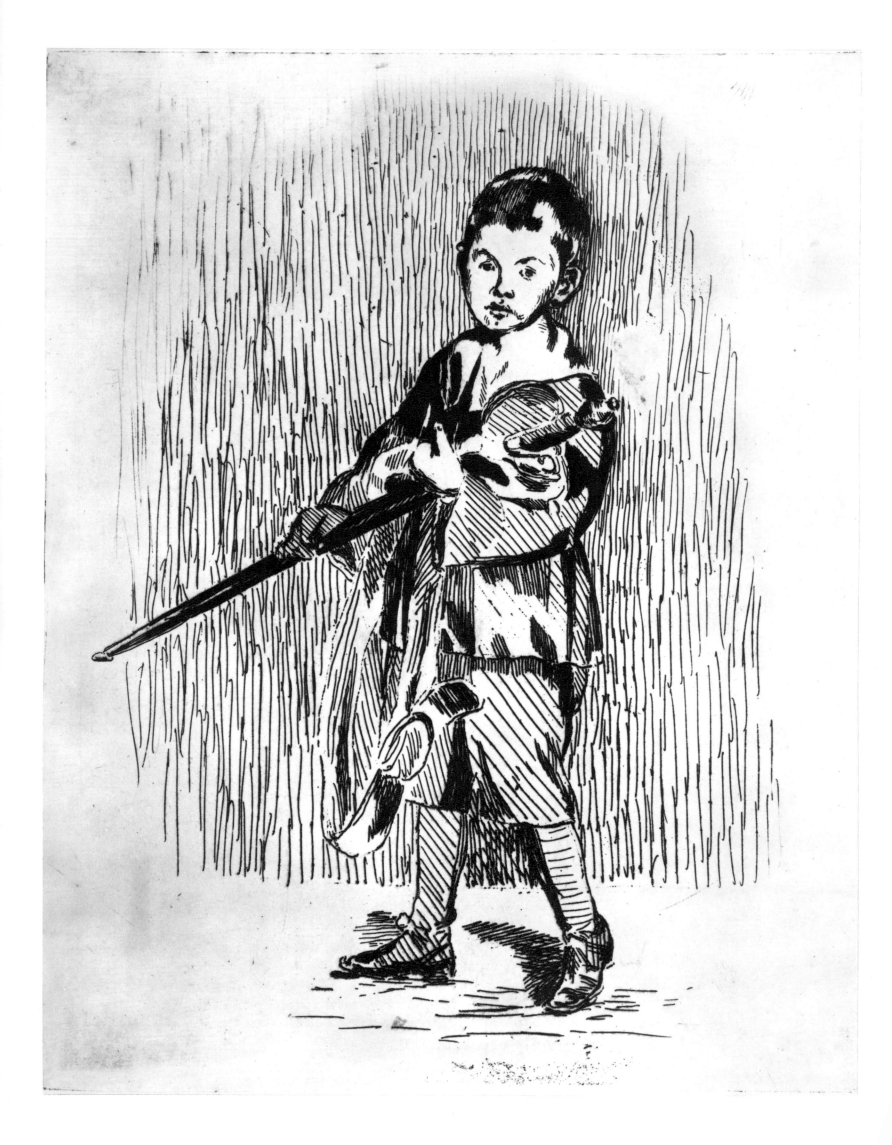

M. 21

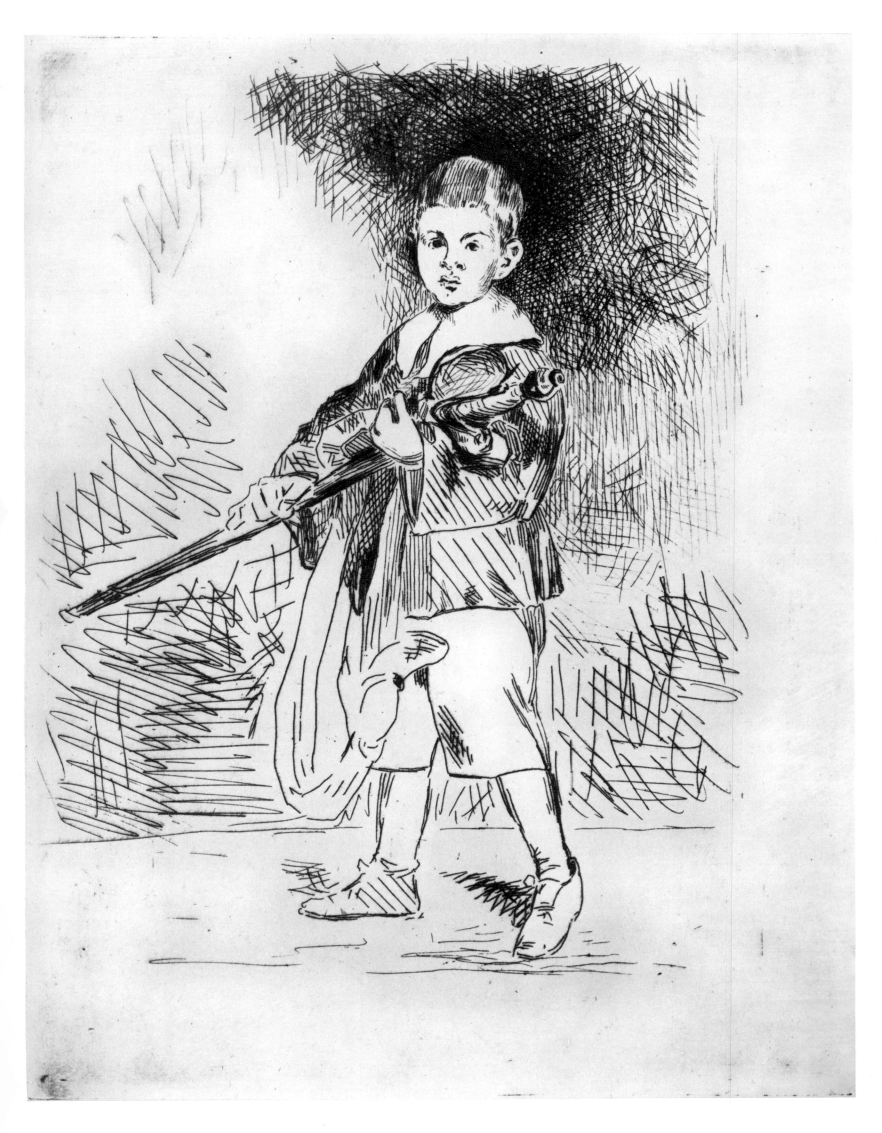

M. 22

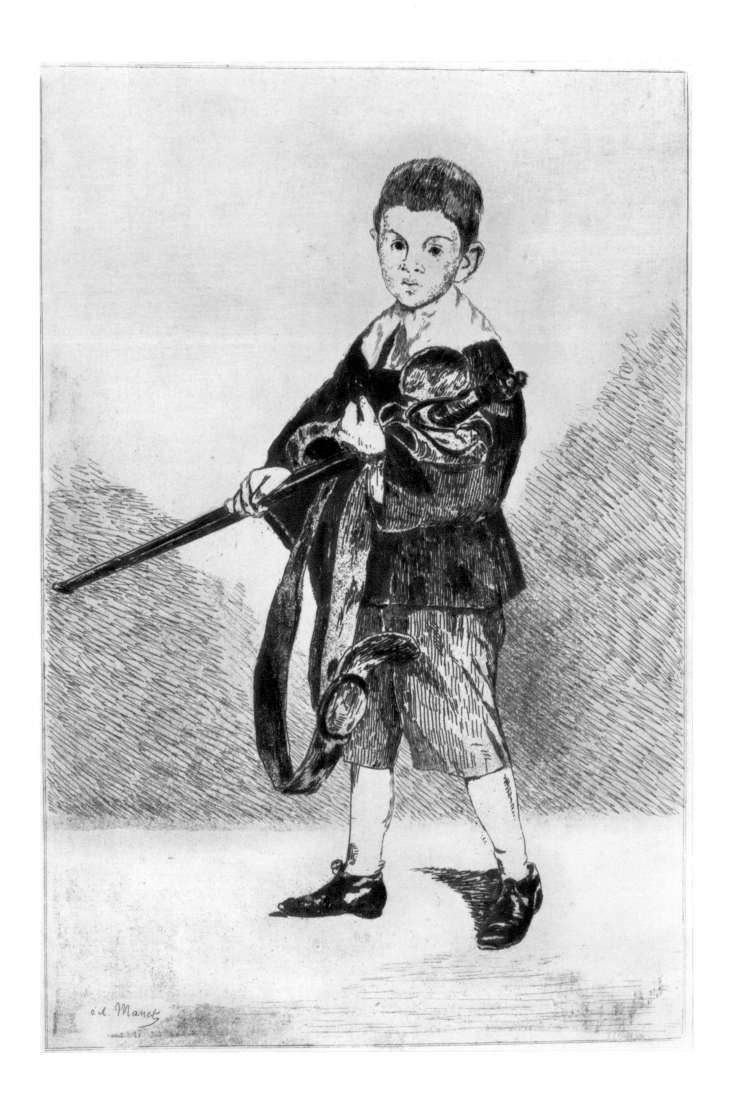

M. 23

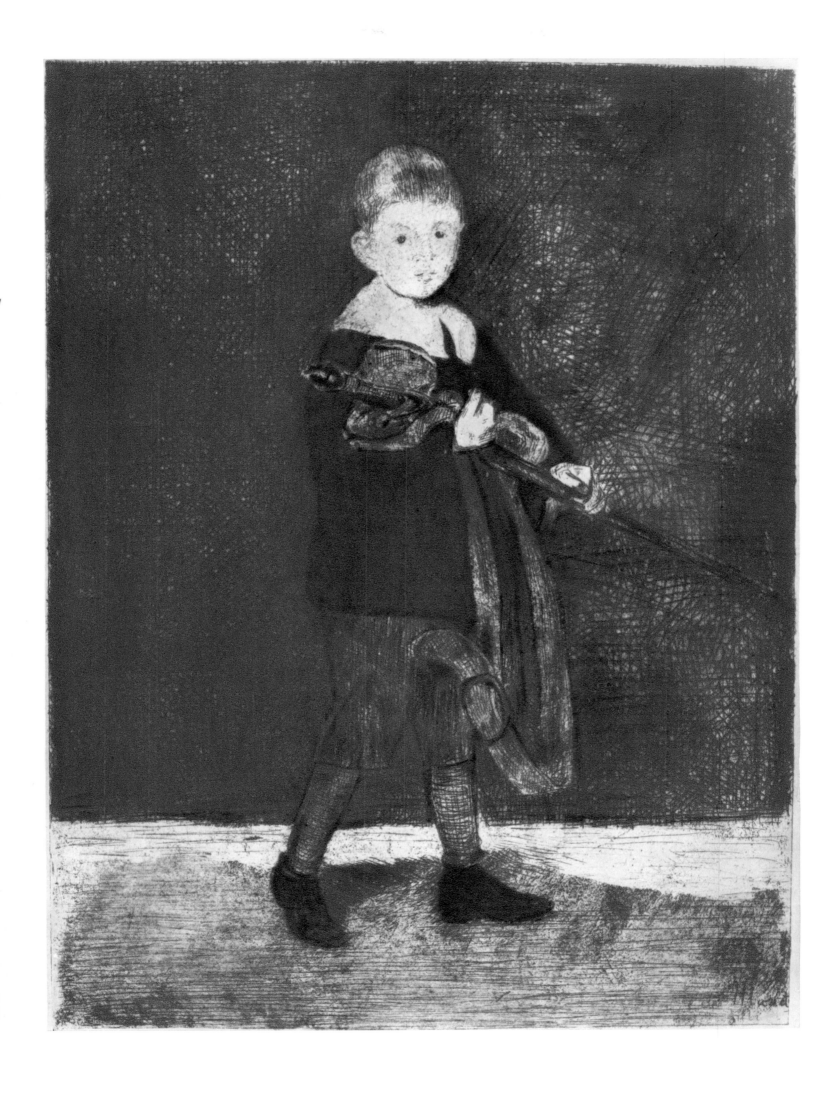

M. 24

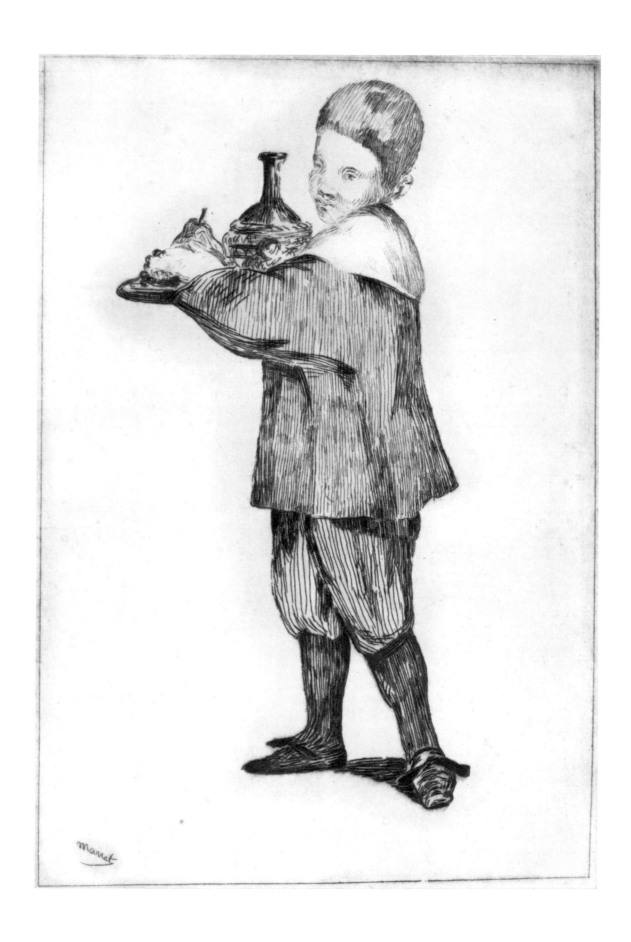

M. 25

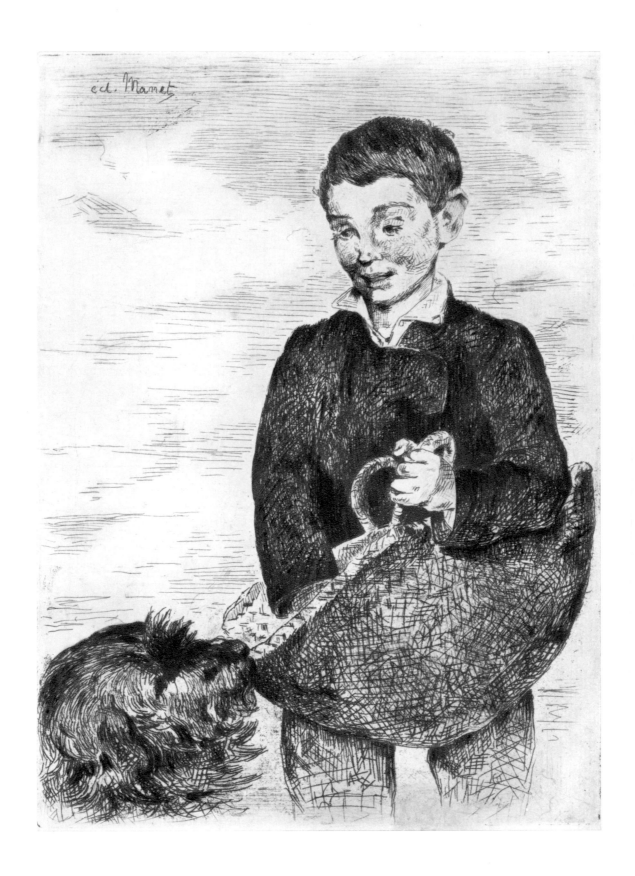

M. 26

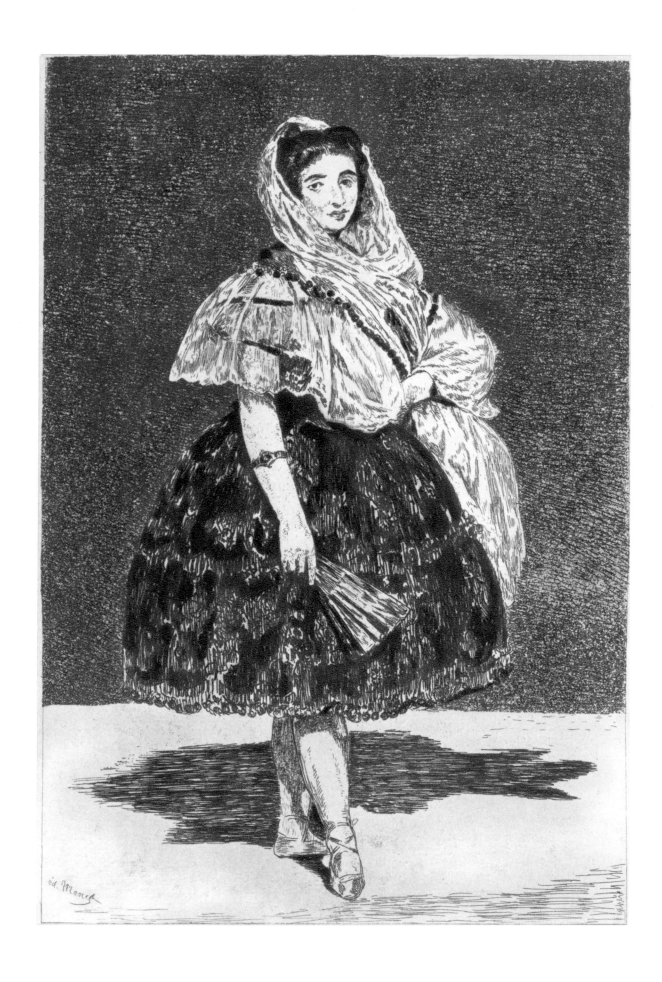

M. 27

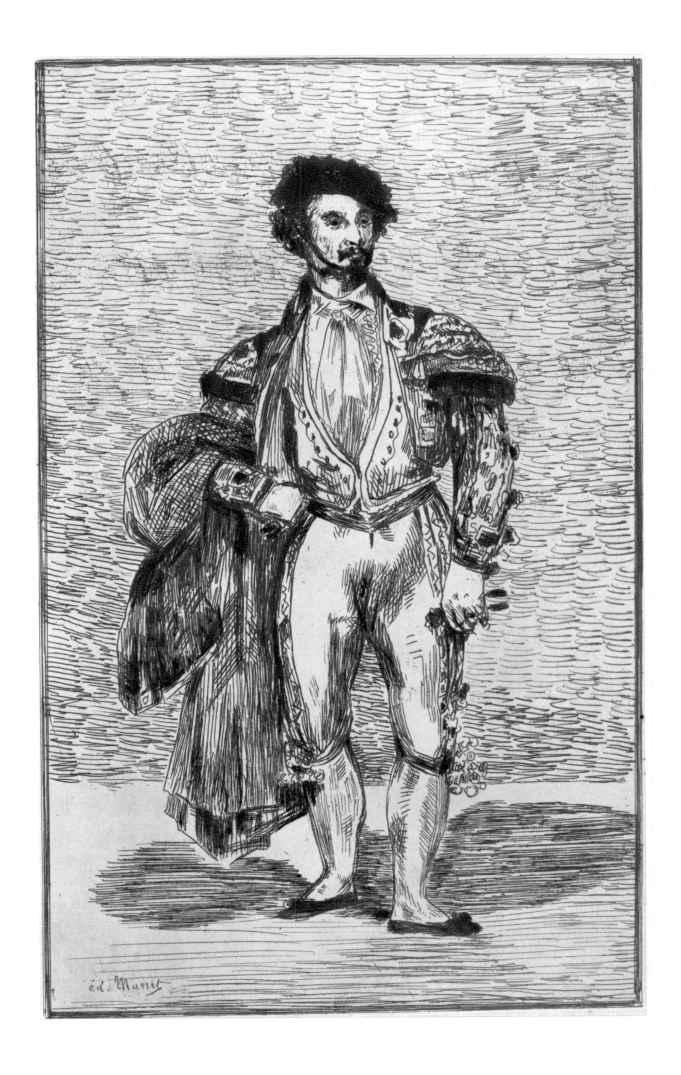

ed. Manet

M. 28

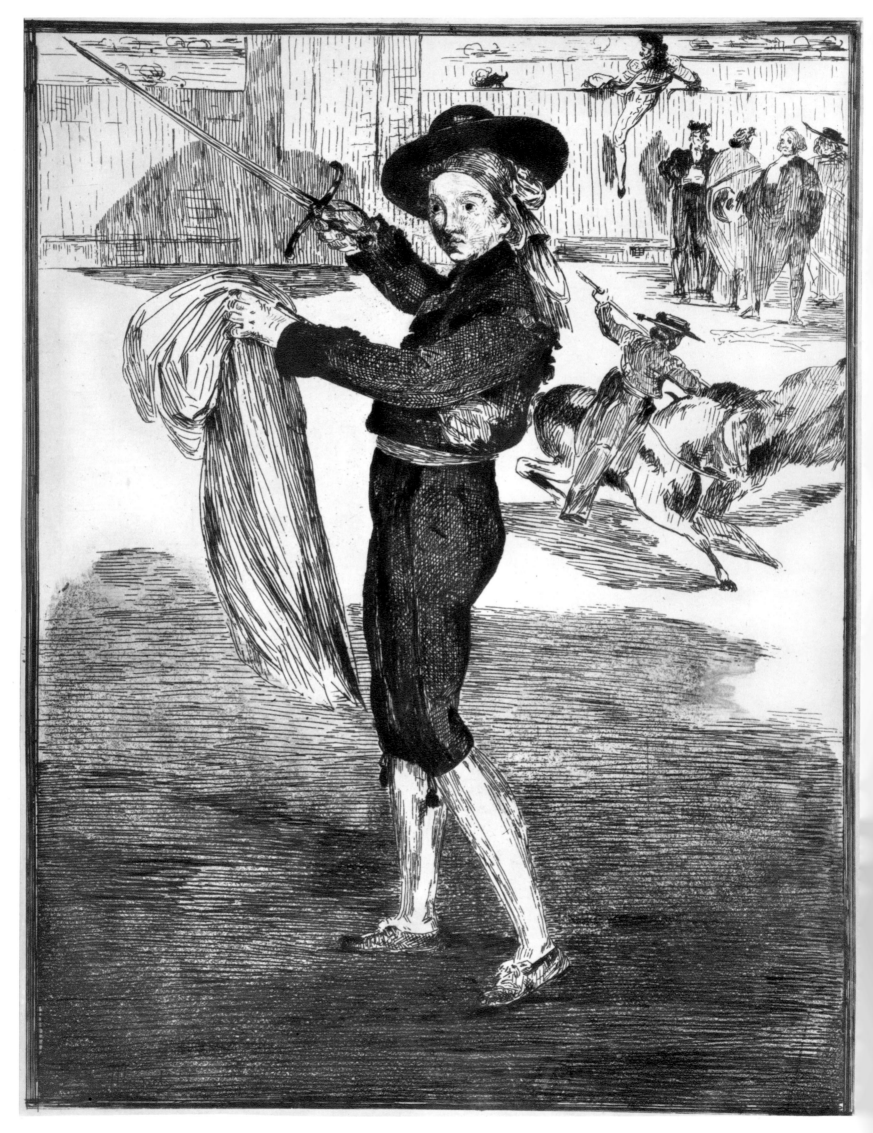

M. 29

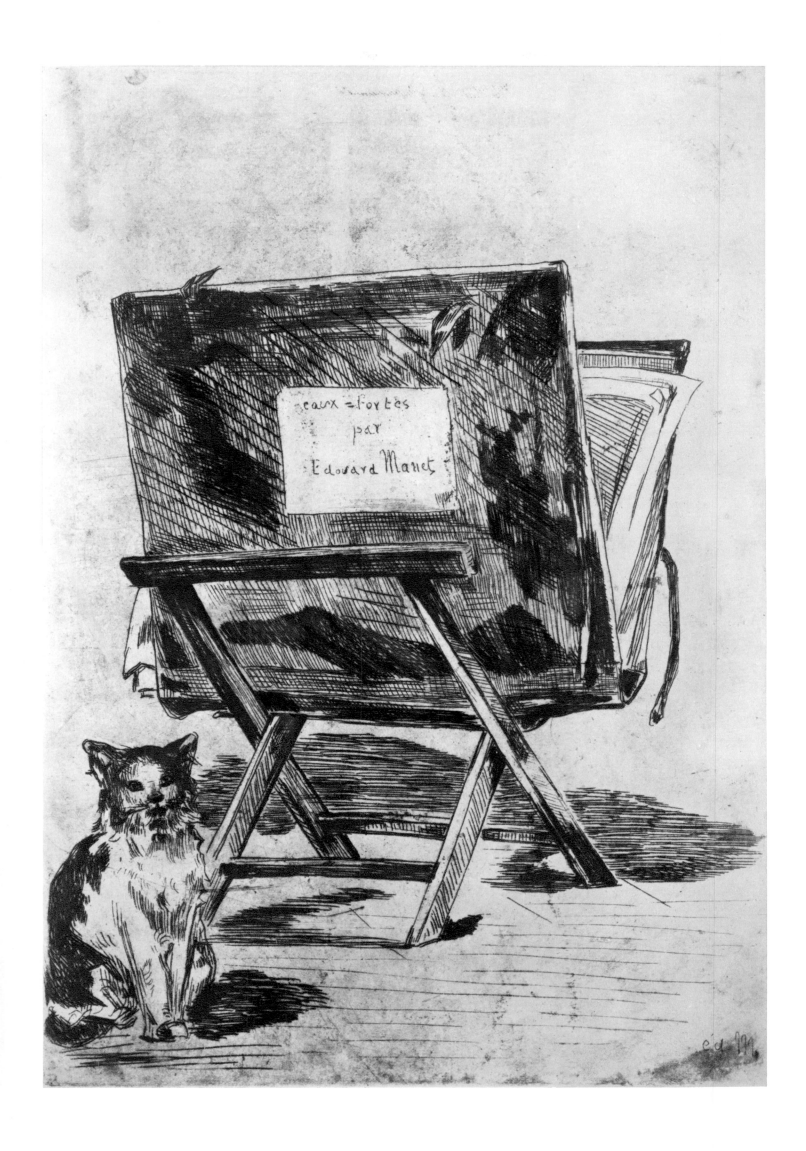

eaux=fortes
par
Edouard Manet

M. 30

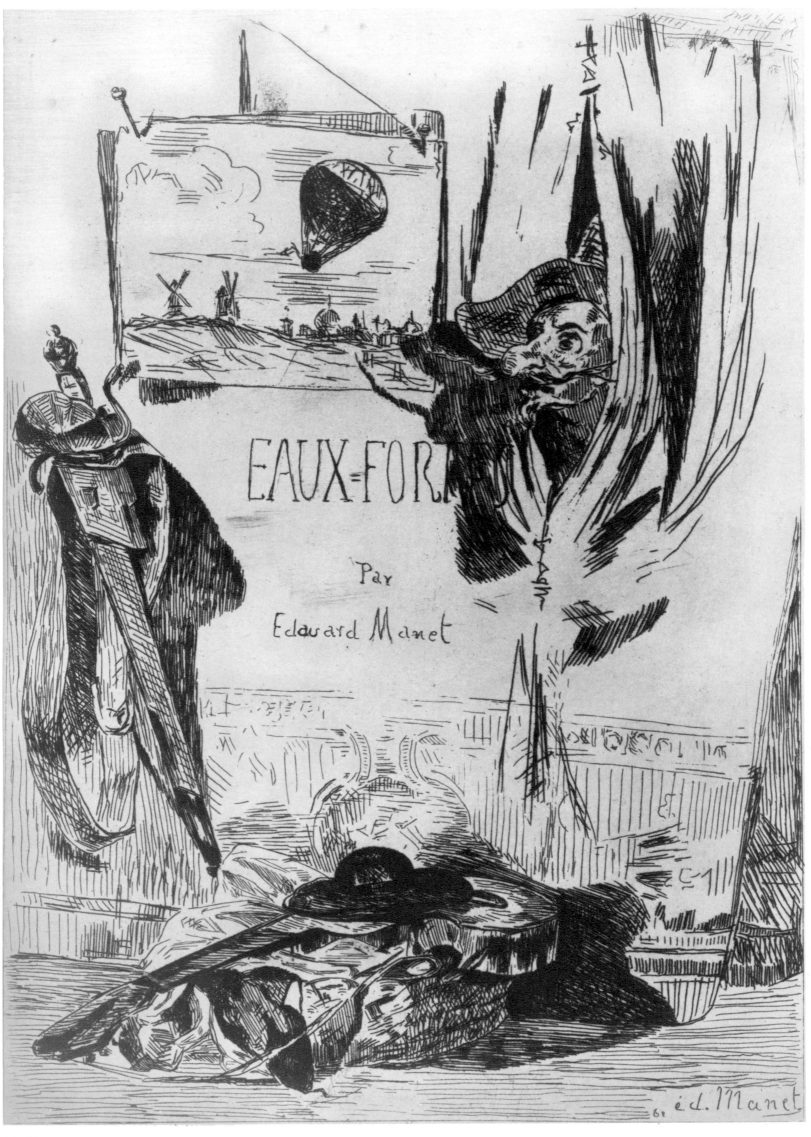

EAUX-FORTES

Par

Edouard Manet

éd. Manet

M. 31

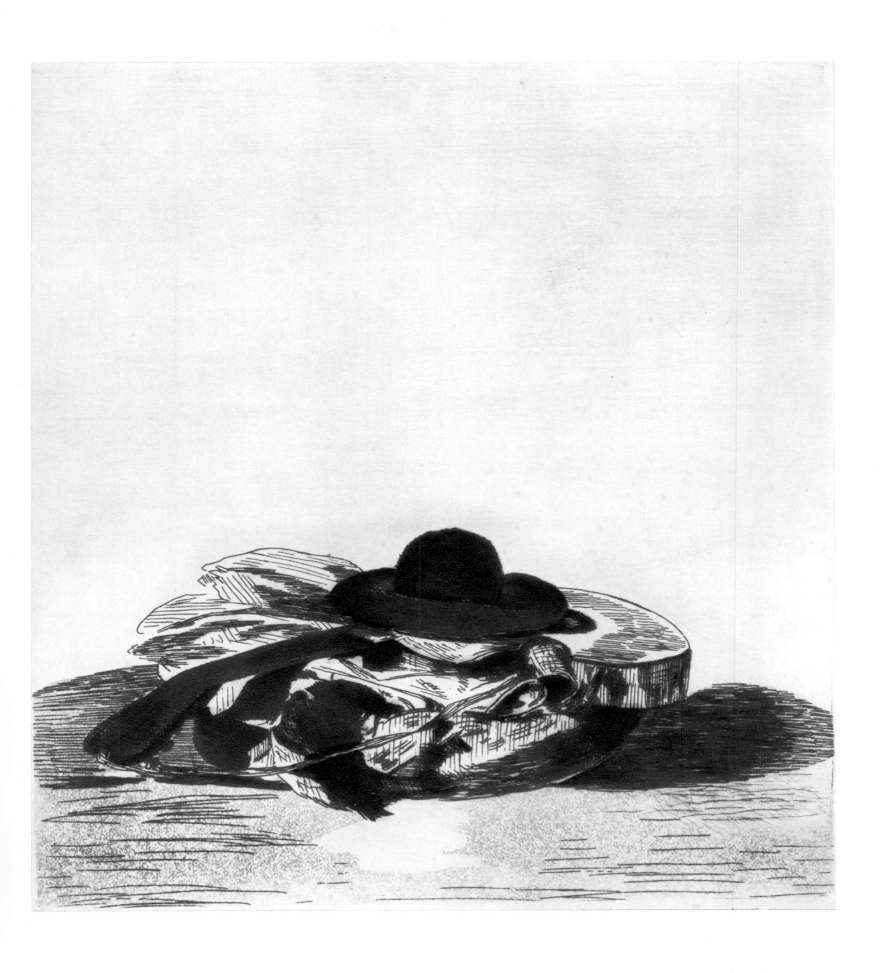

M. 32

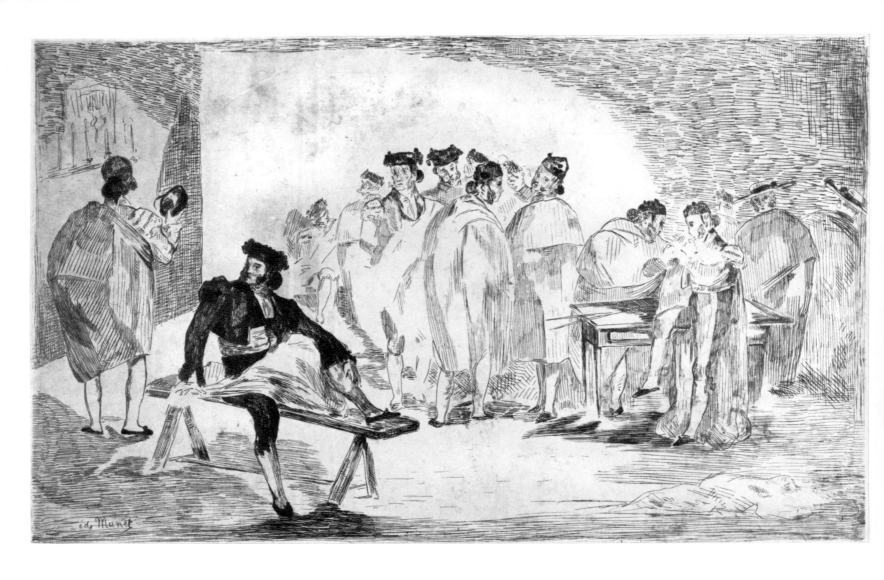

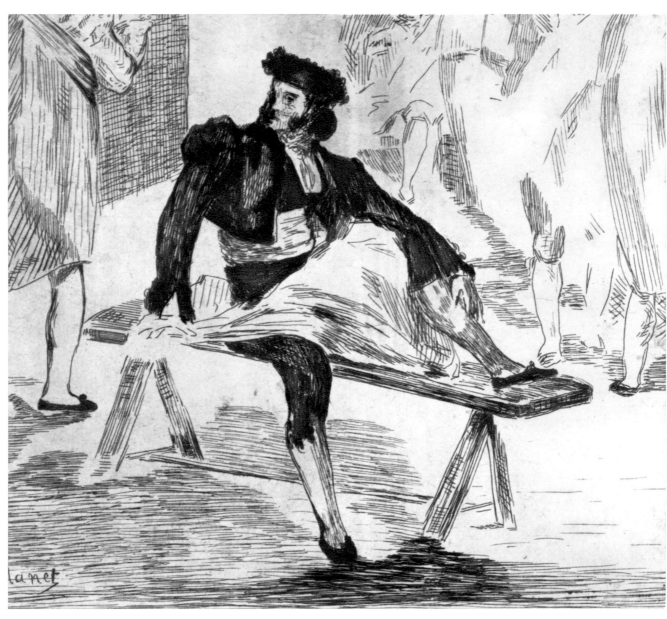

M. 33

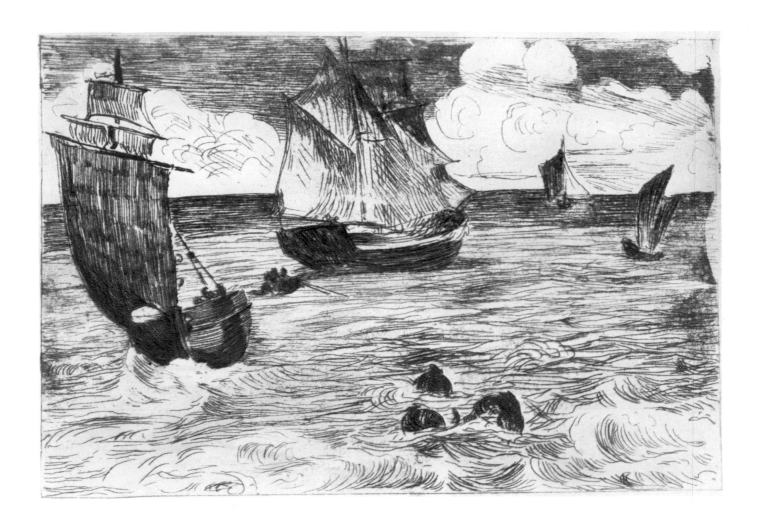

M. 34

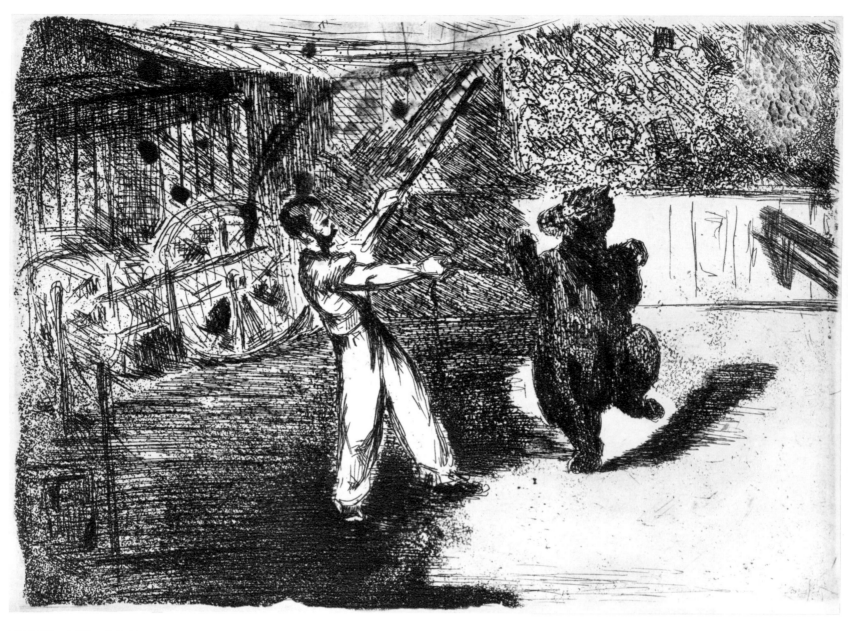

M. 35

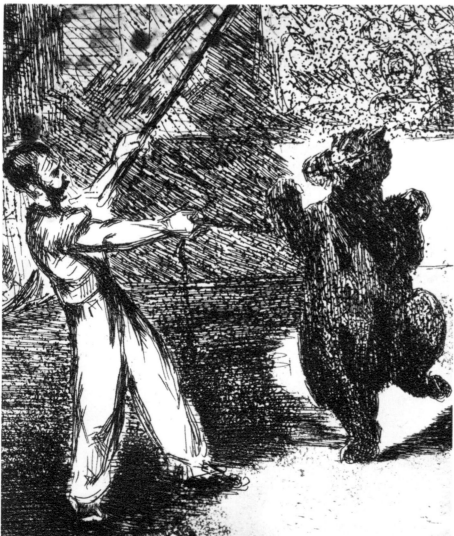

M. 36 detail

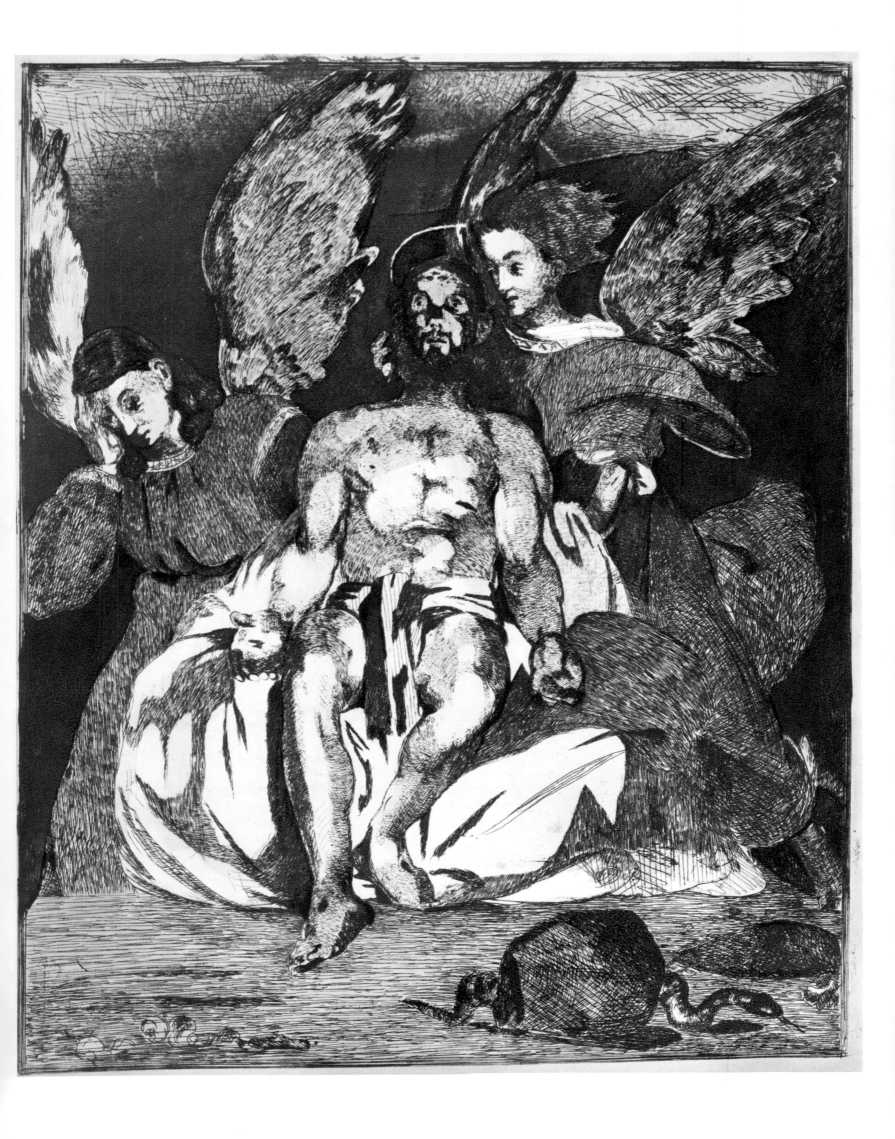

M. 36

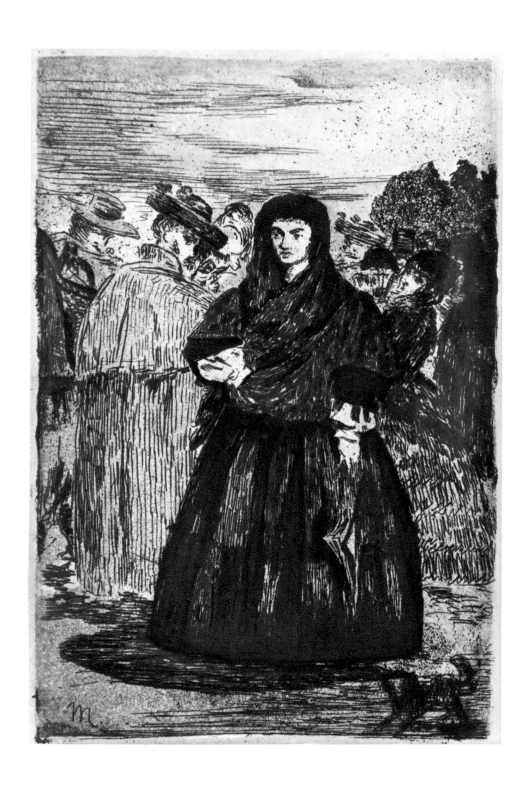

M. 37

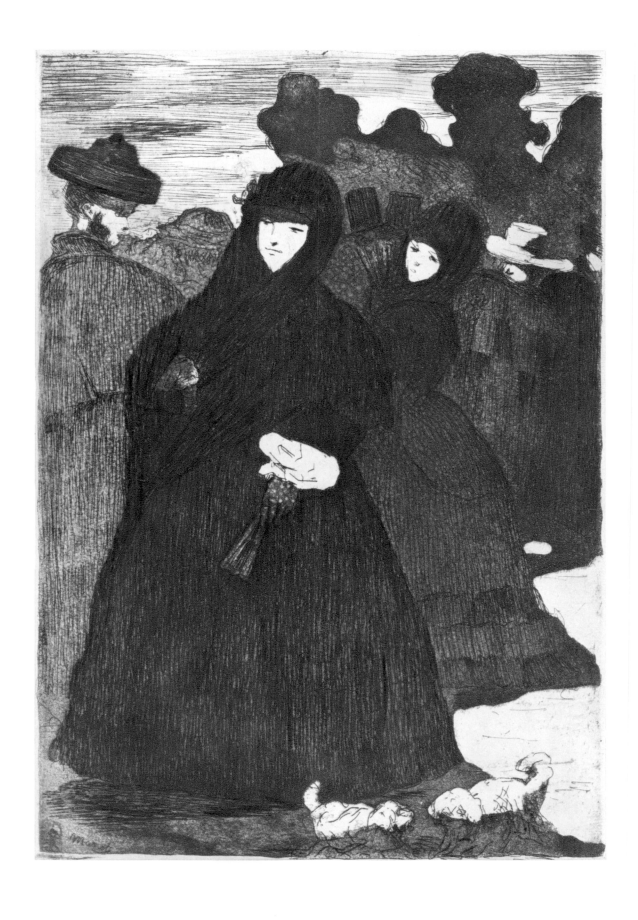

M. 38

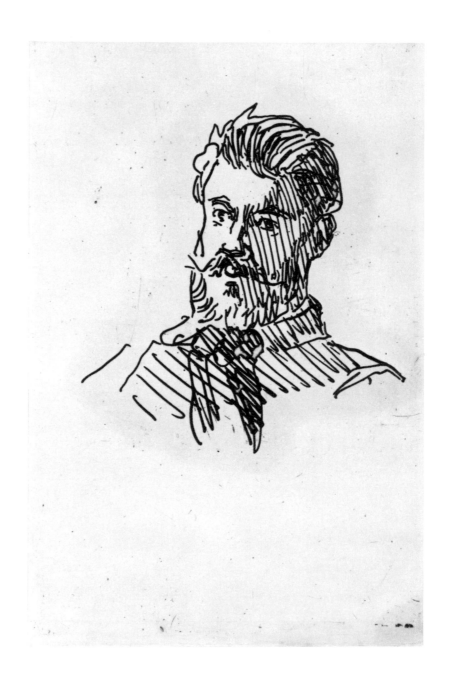

M. 39

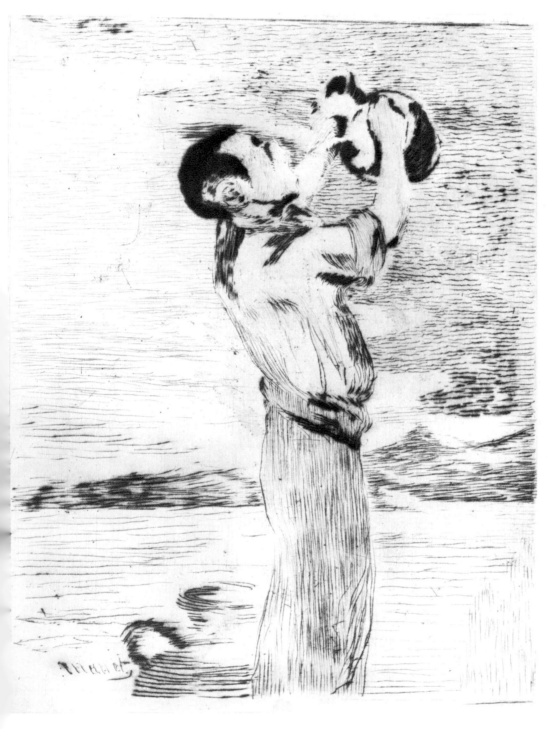

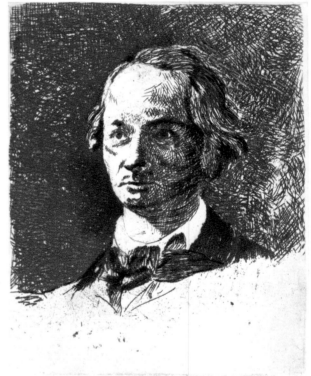

1. 40, 41

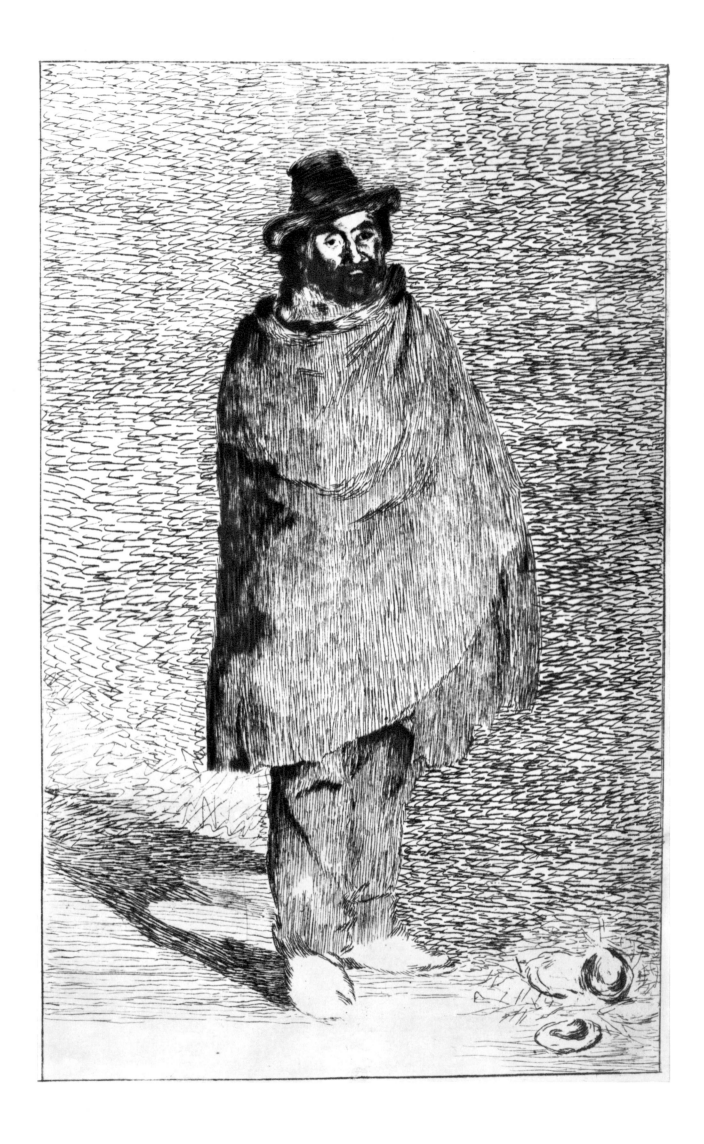

M. 42

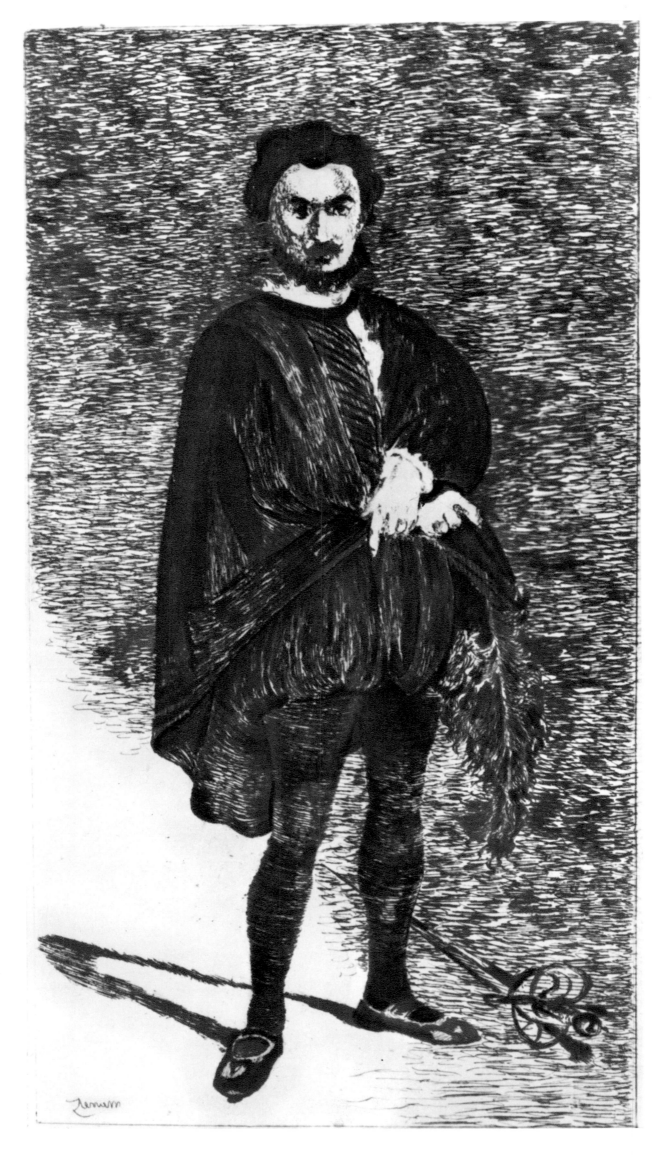

M. 43

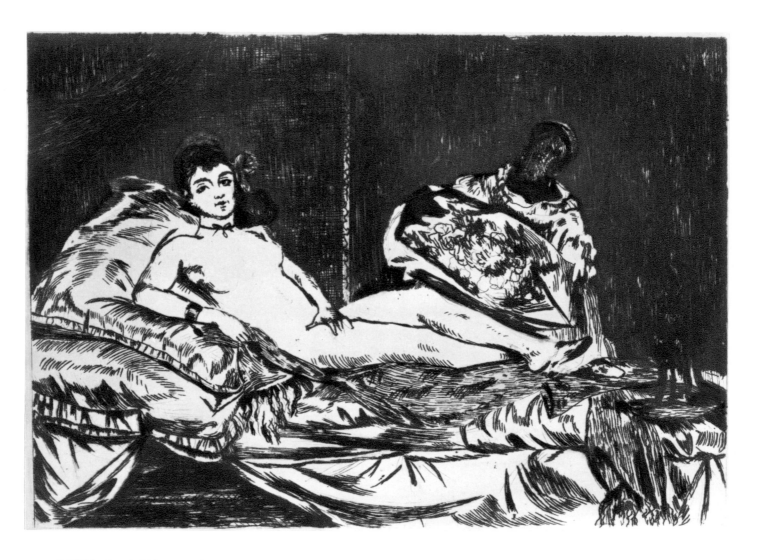

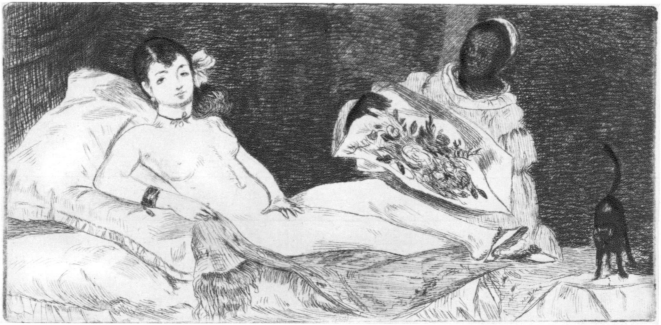

M. 44, 45

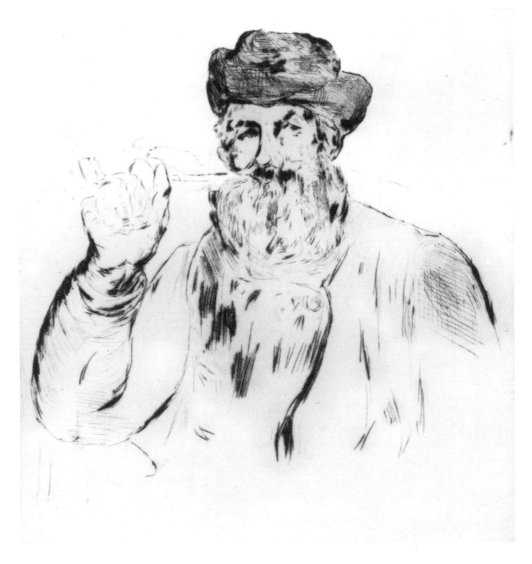

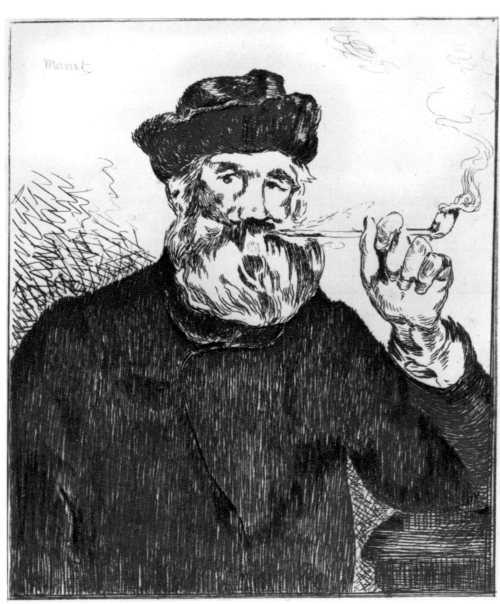

M. 46, 47

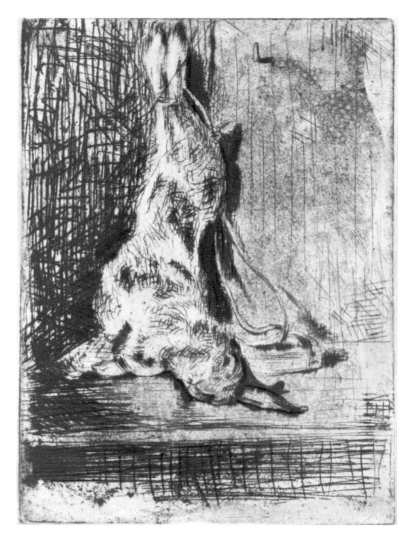

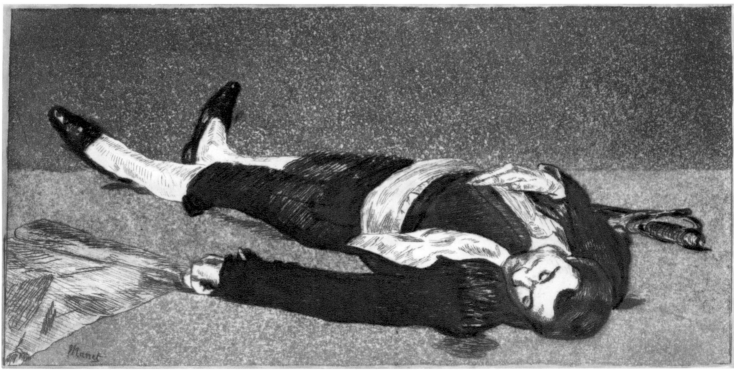

M. 48, 49

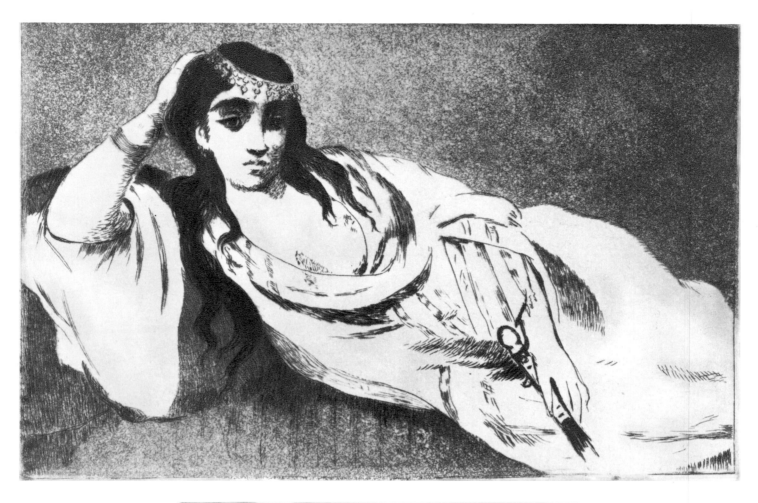

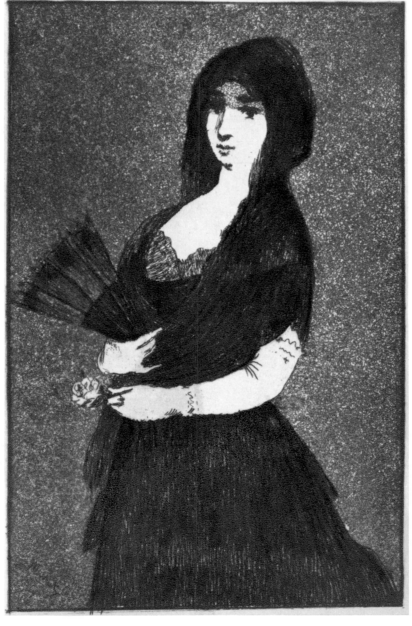

M. 50, 51

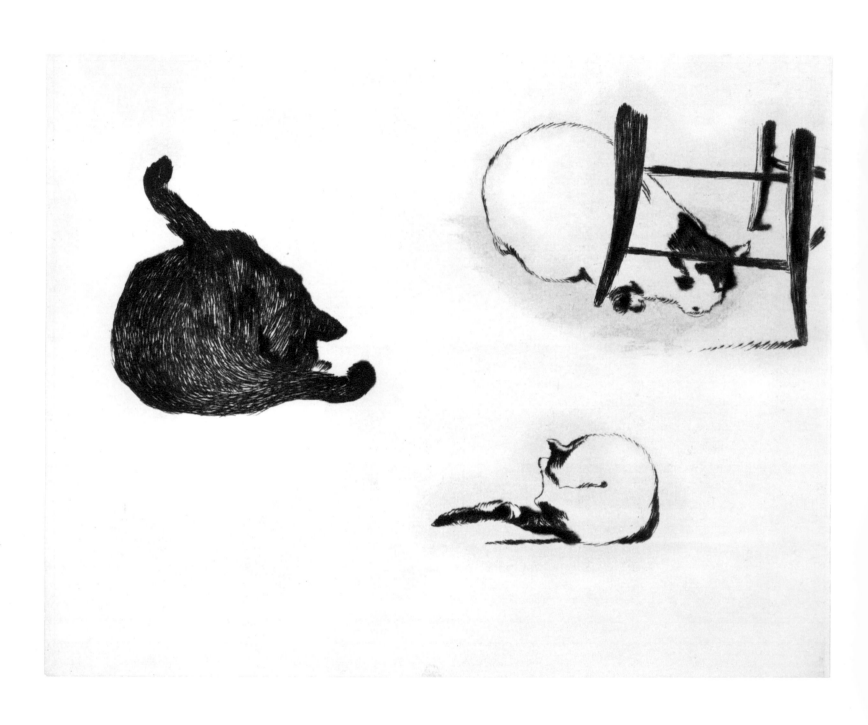

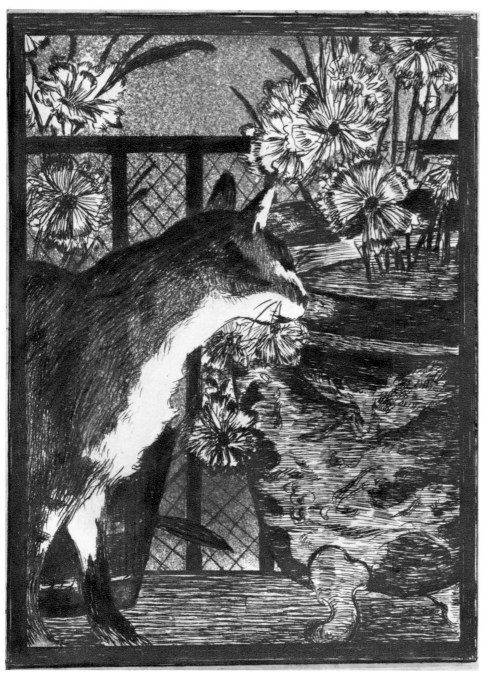

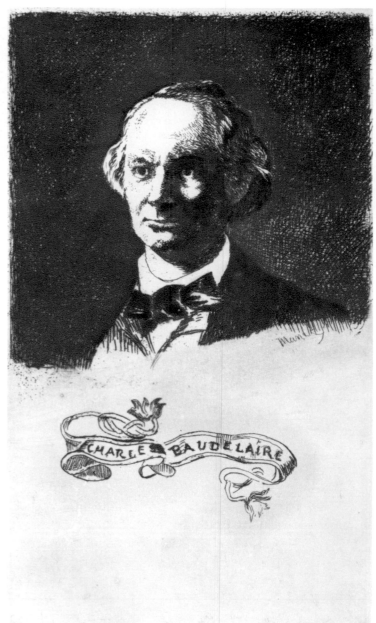

M. 53, 54, 55, 56

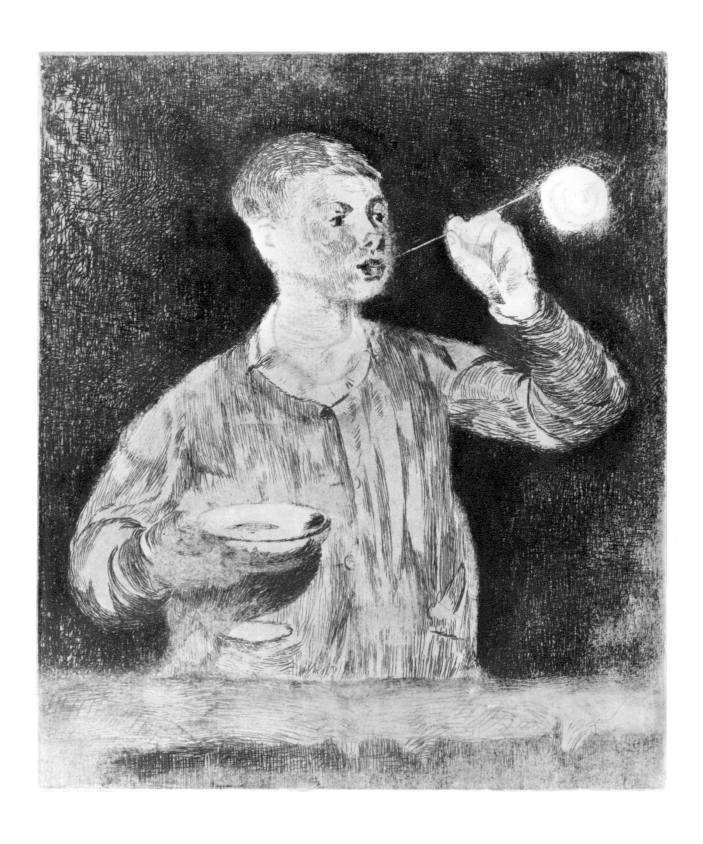

M. 57

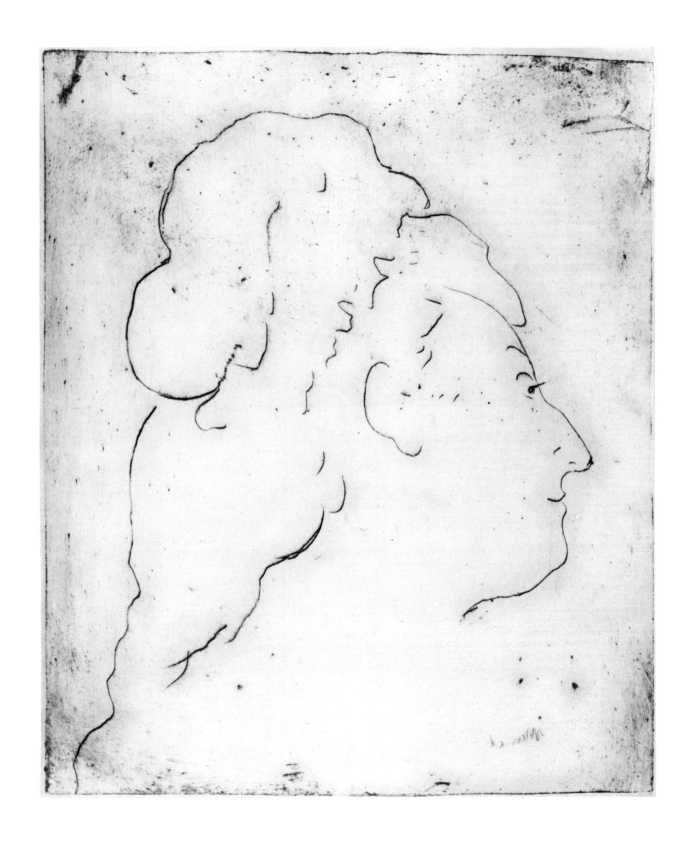

M. 58

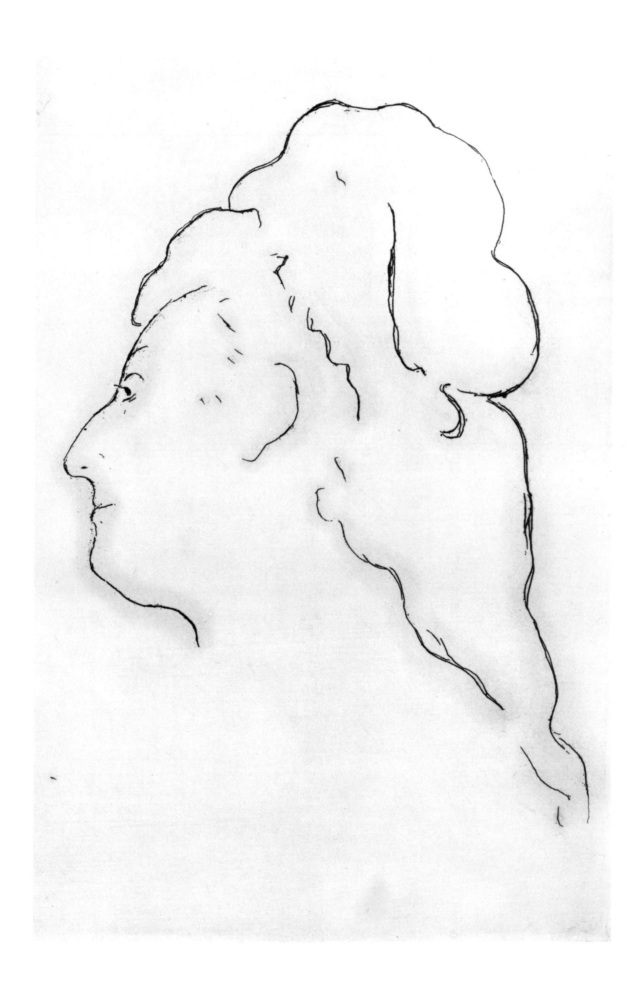

M. 59

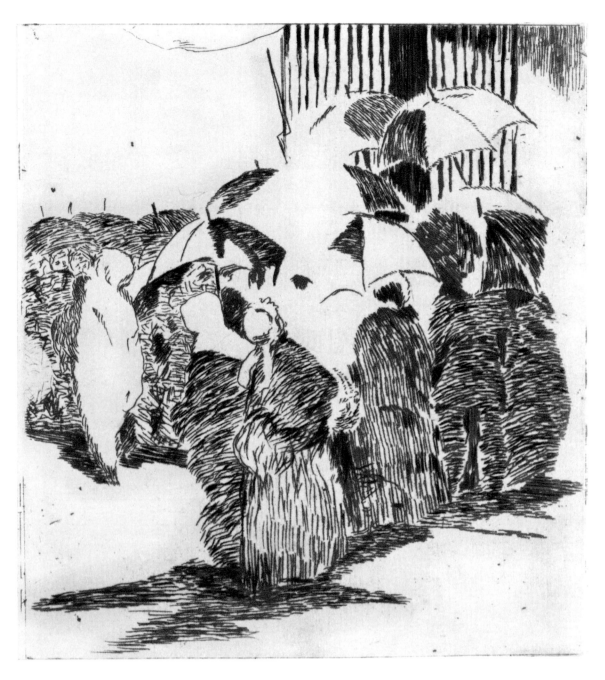

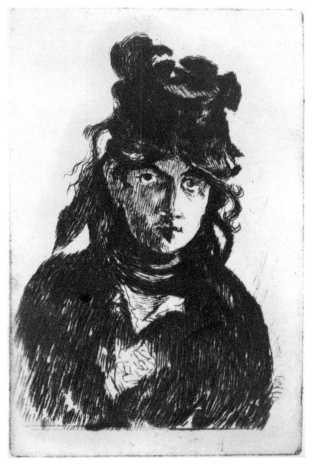

M. 60, 61

M. 62a, b, c, d, e

M. 62f, g, h, i, j, k

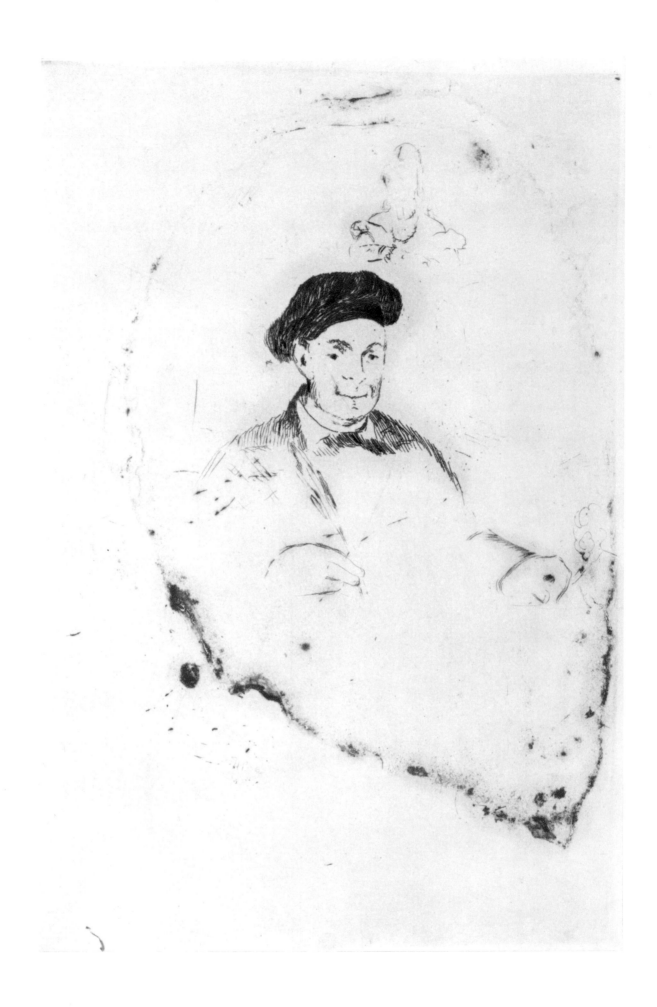

M. 63

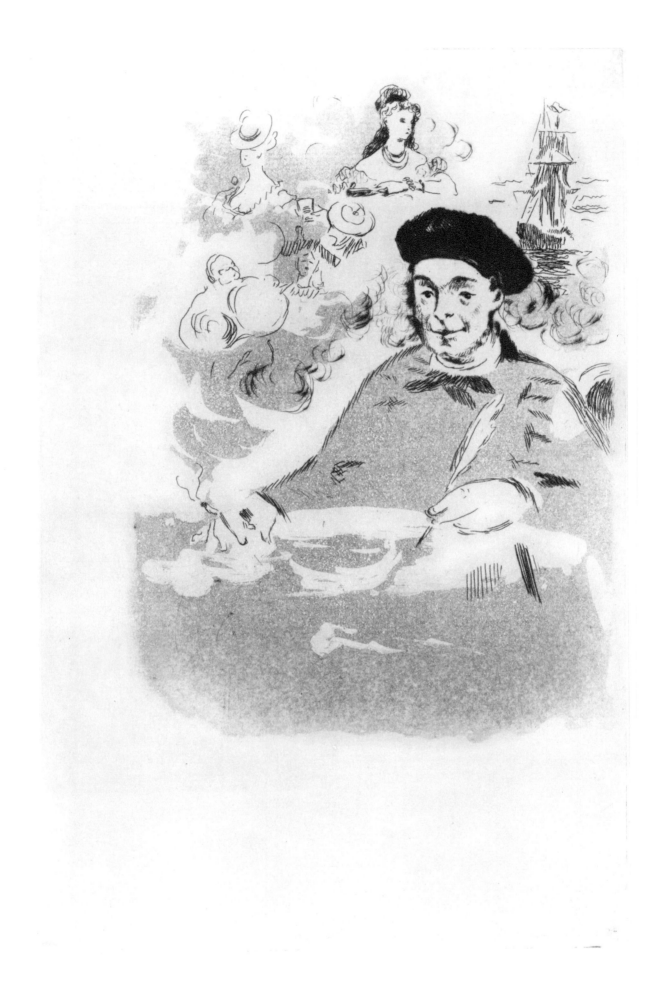

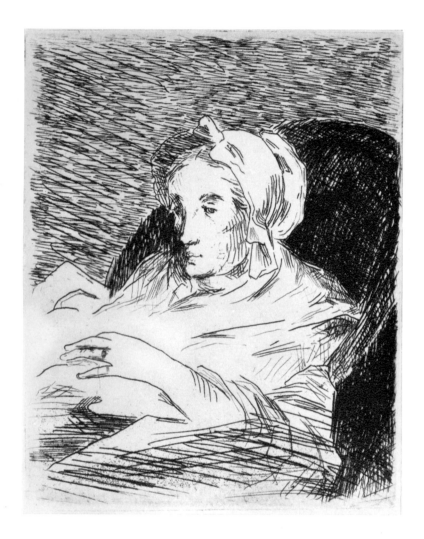 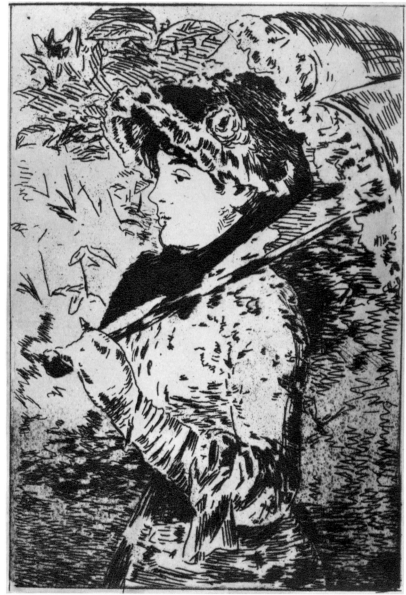

M. 65, 66

DIOGÈNE.

EMILE OLIVIER.

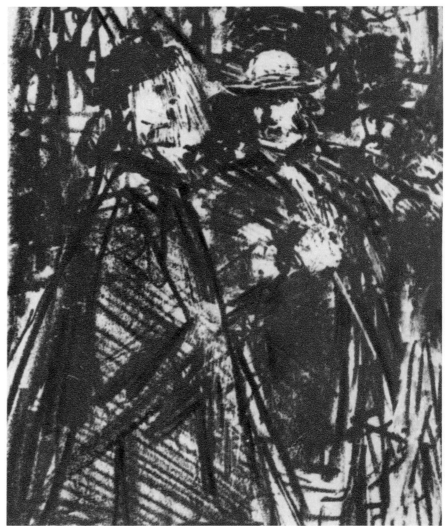

M. 67 detail

M. 68

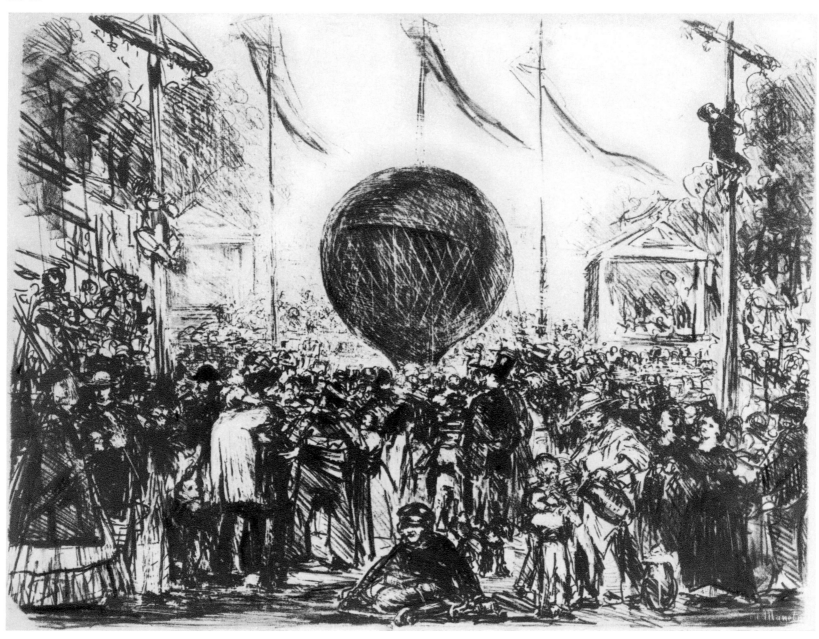

PLAINTE MORESQUE

Op. 85

Pr. 5 Frs.

PAR

J. BOSCH

Propriété pour la France et l'Etranger

M. 70

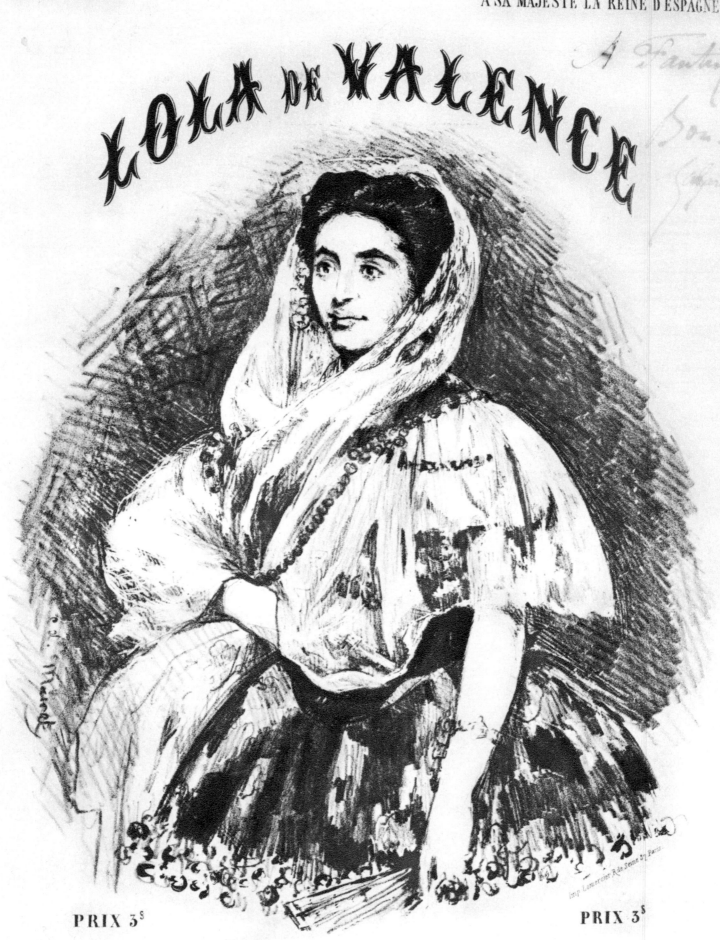

SÉRÉNADE

A SA MAJESTÉ LA REINE D'ESPAGNE

LOLA DE VALENCE

PRIX 3ˢ PRIX 3ˢ

POÉSIE ET MUSIQUE

DE

ZACHARIE ASTRUC

Propriété de l'Auteur et pour tous Pays

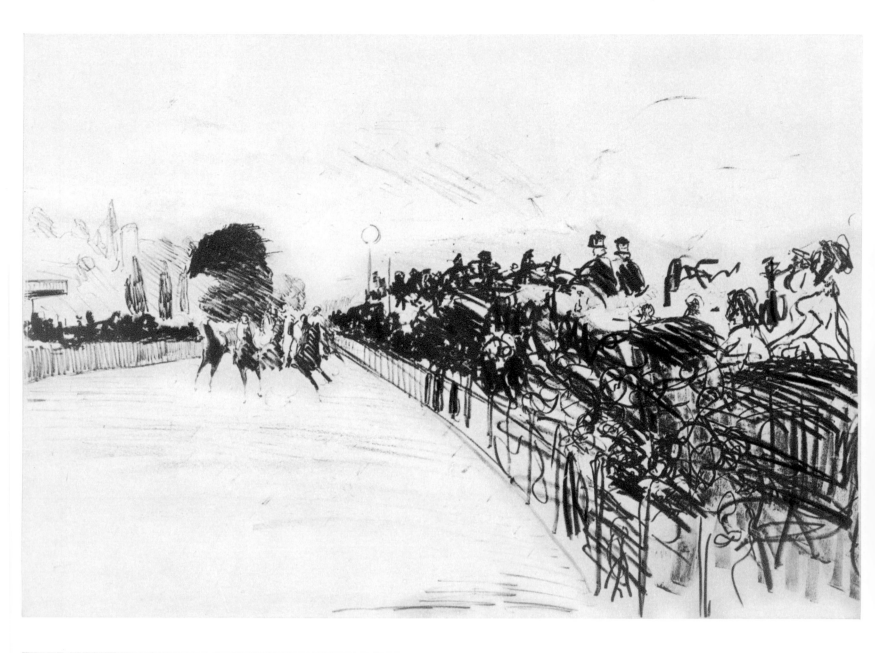

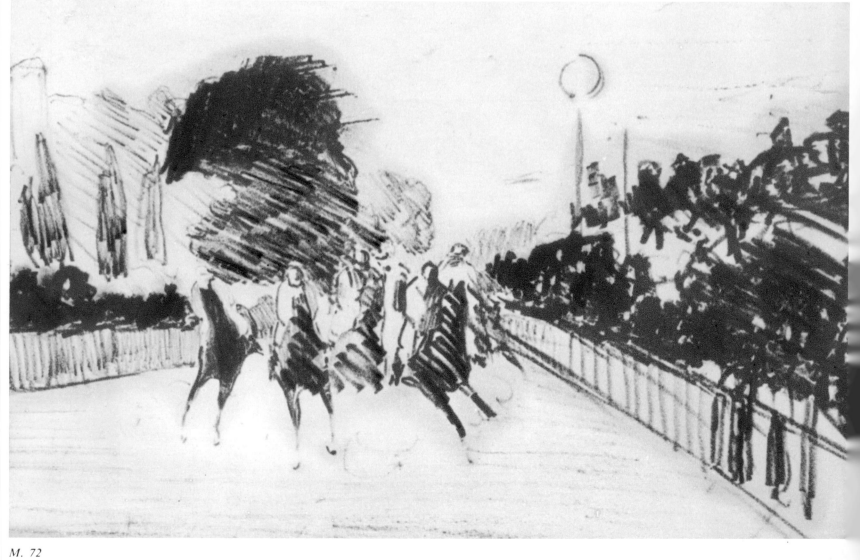

M. 72

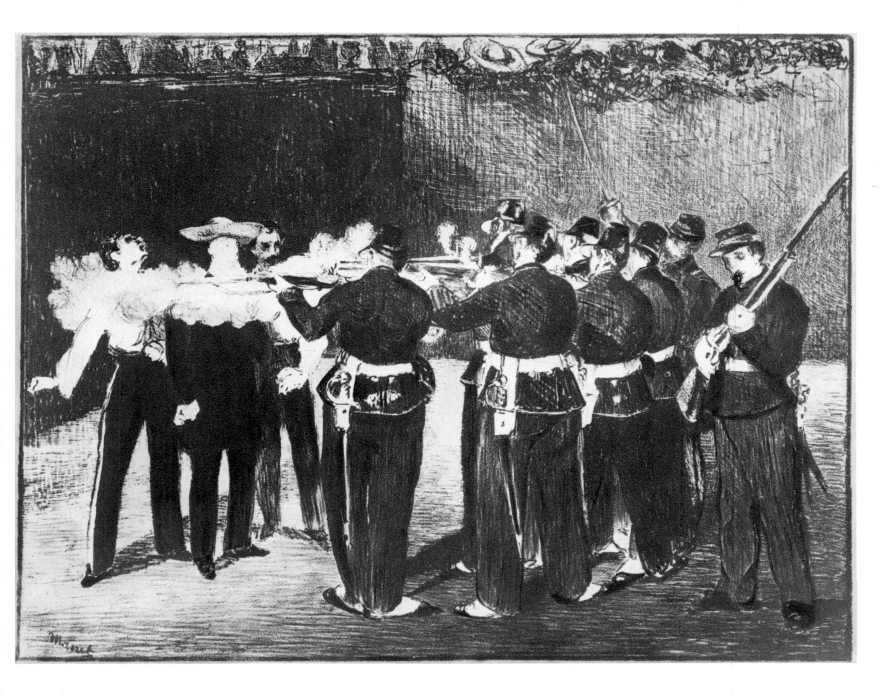

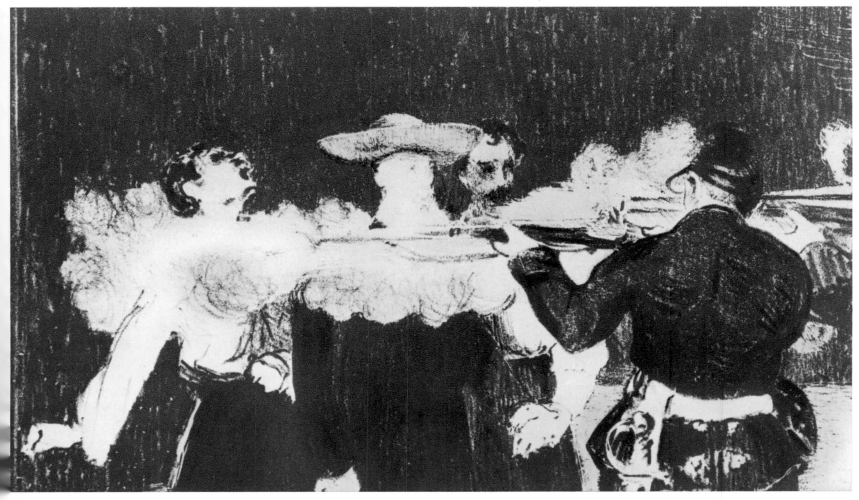

M. 73

CHAMPFLEURY – LES CHATS

Un volume illustré , Prix 5 Francs
En Vente ici.

M. 74

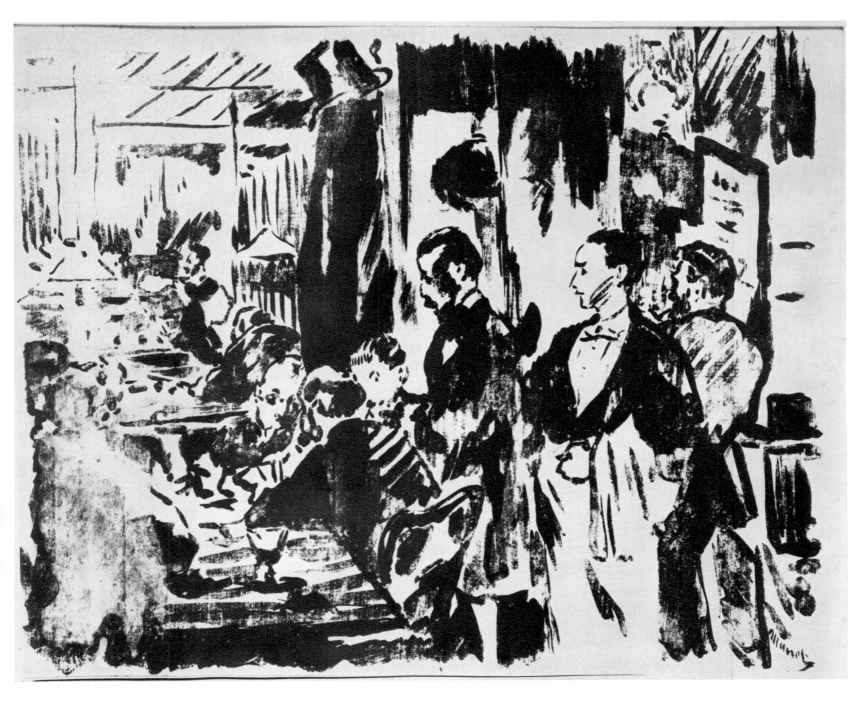

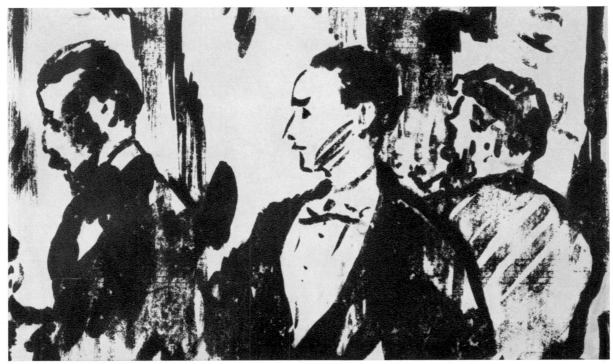

M. 75

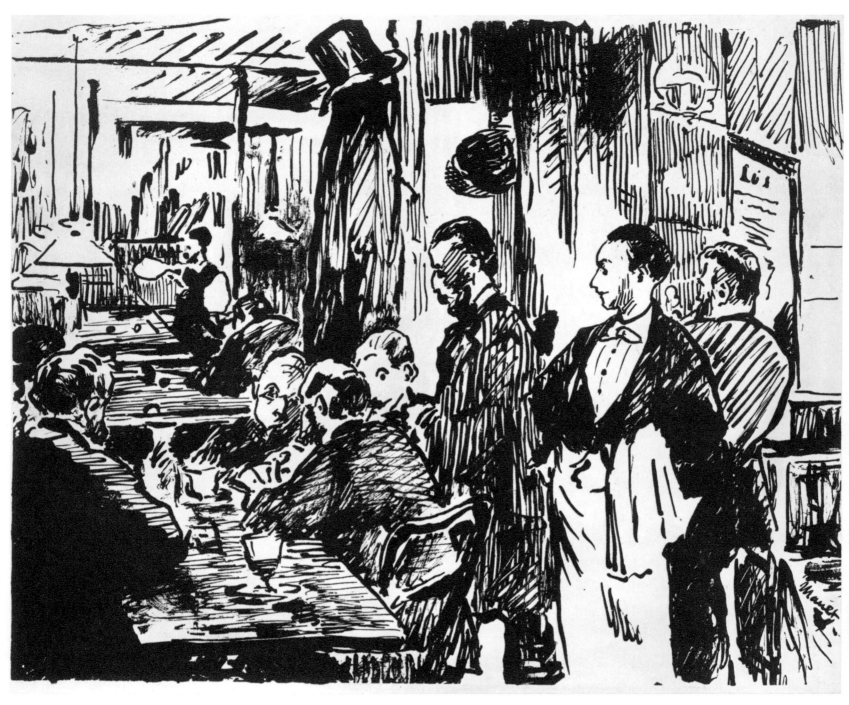

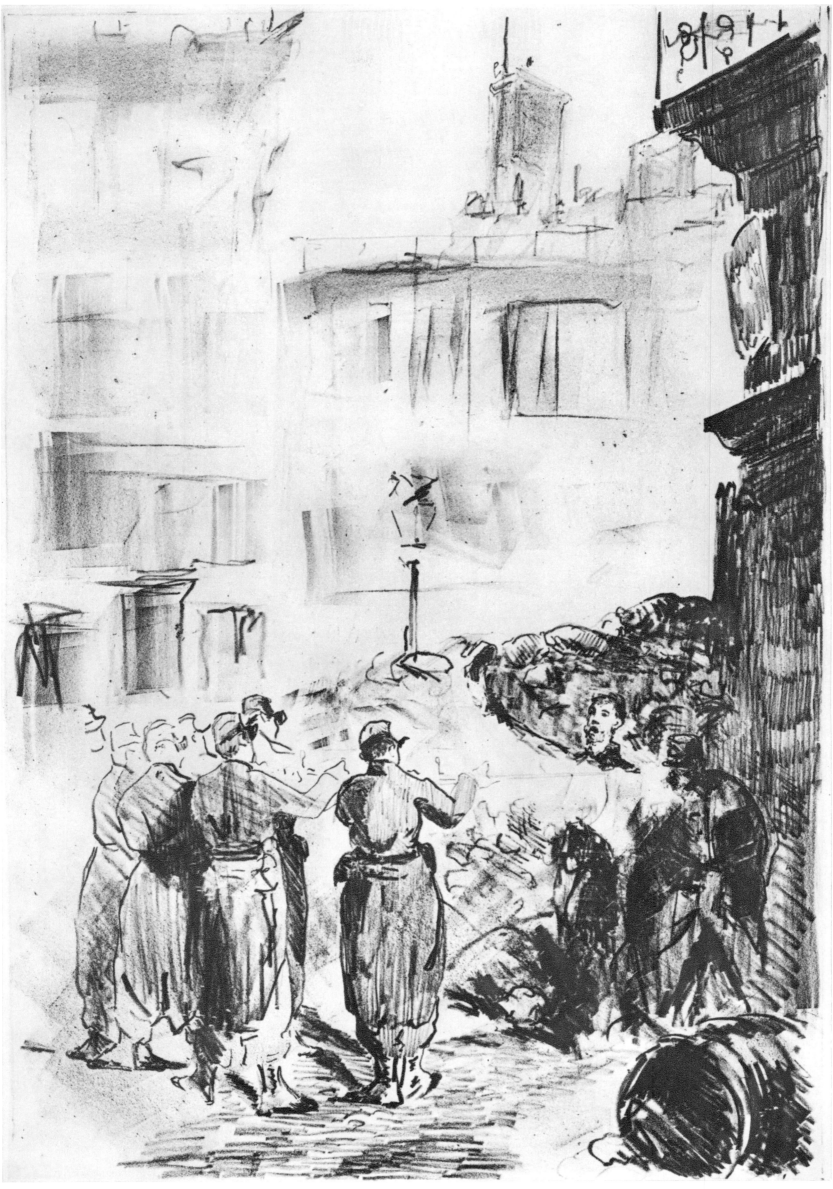

M. 77

M. 77 detail

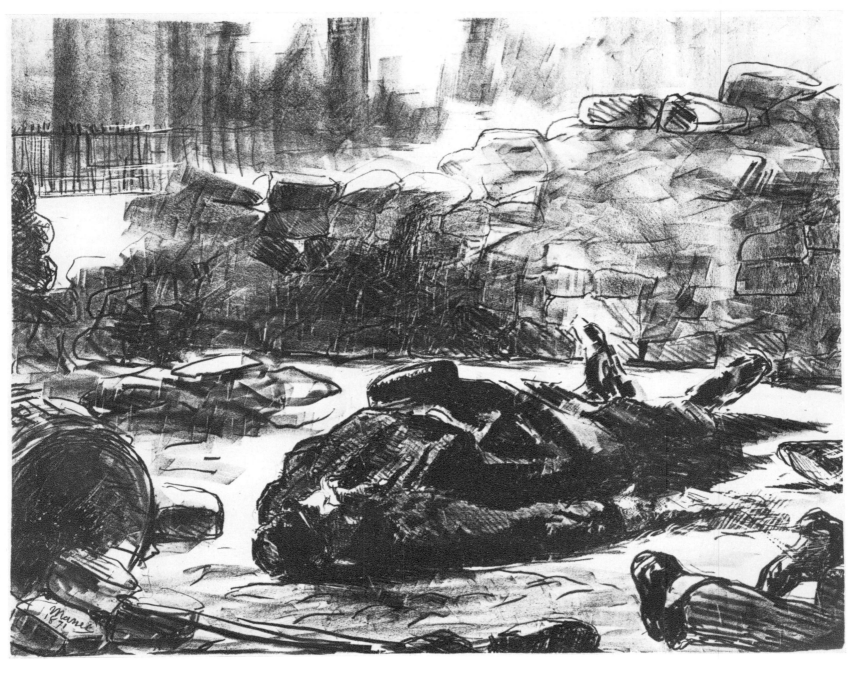

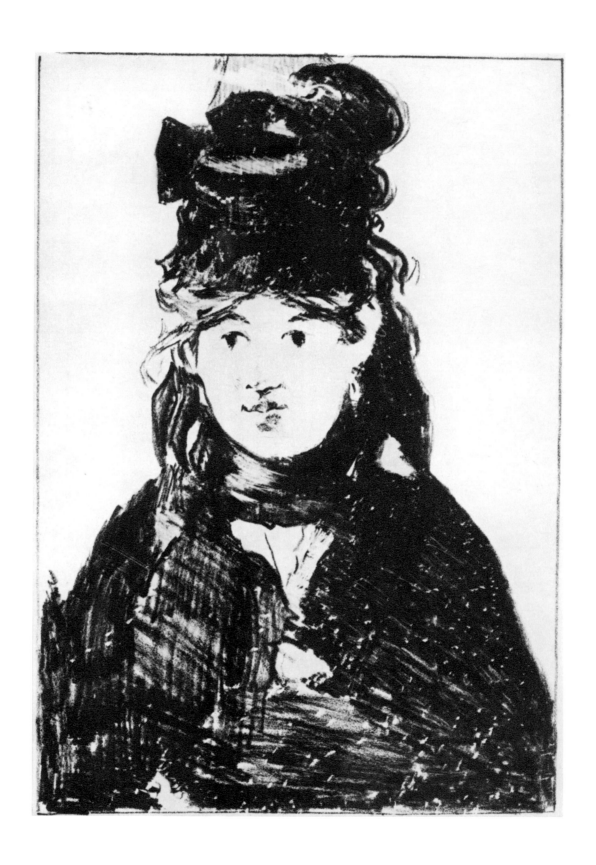

M. 79

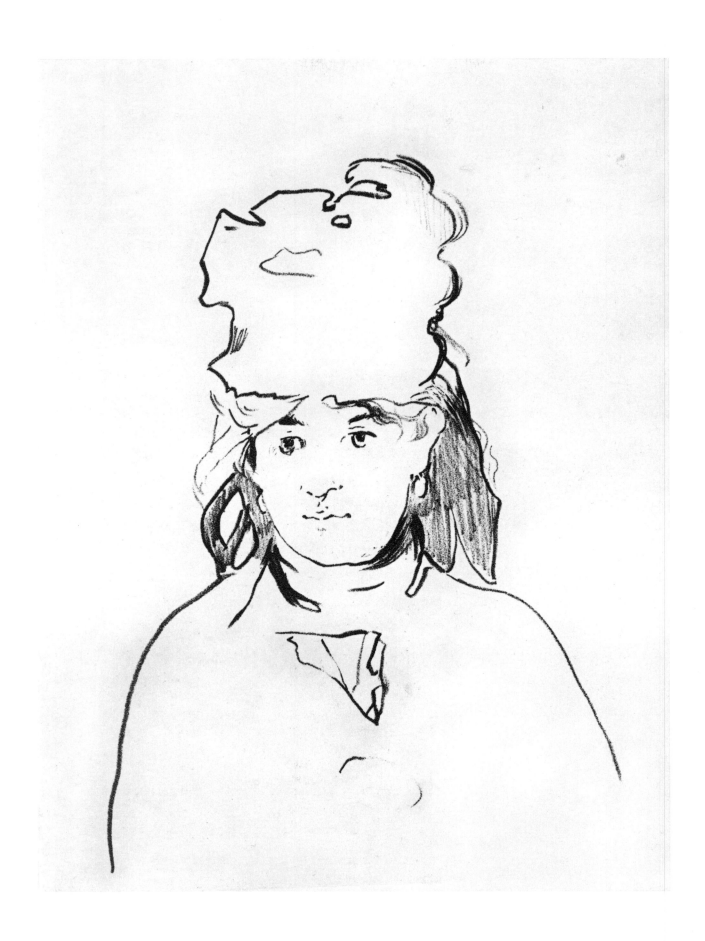

M. 80

M. 81, 82

M. 83

M. 84a

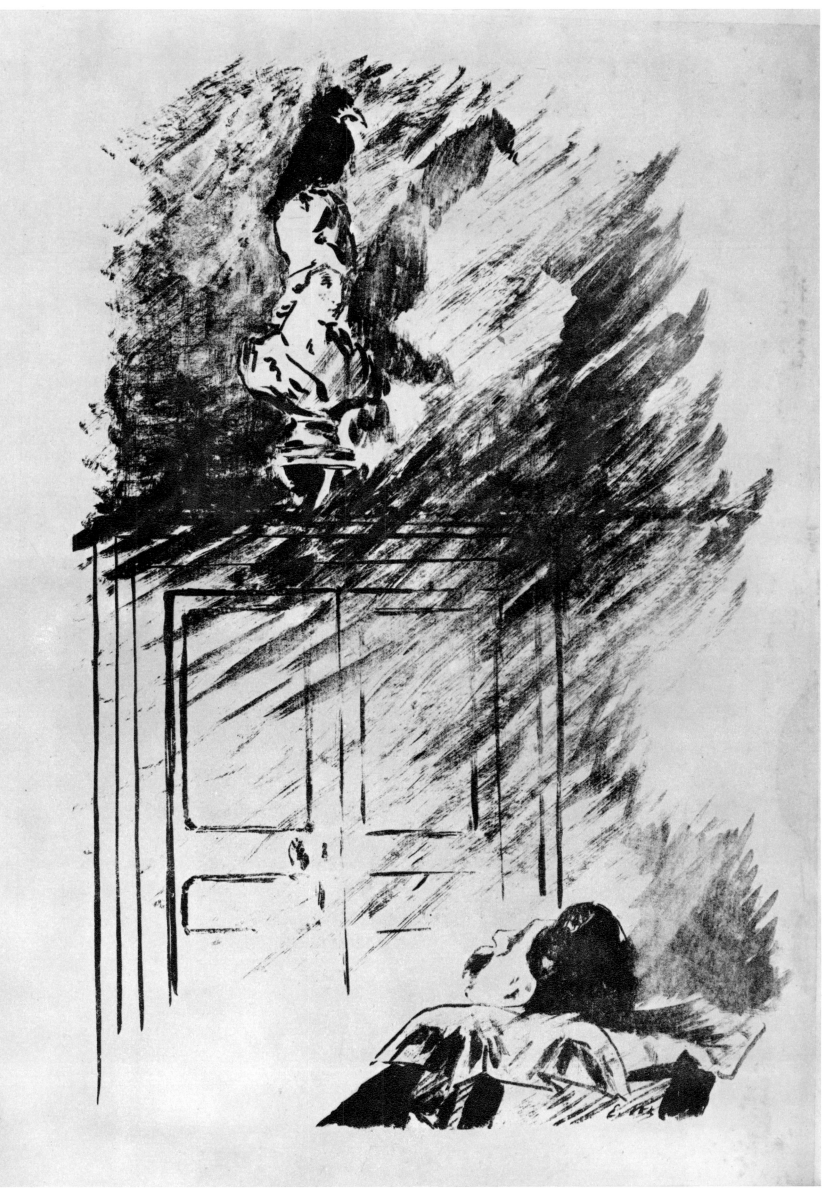

M. 84b

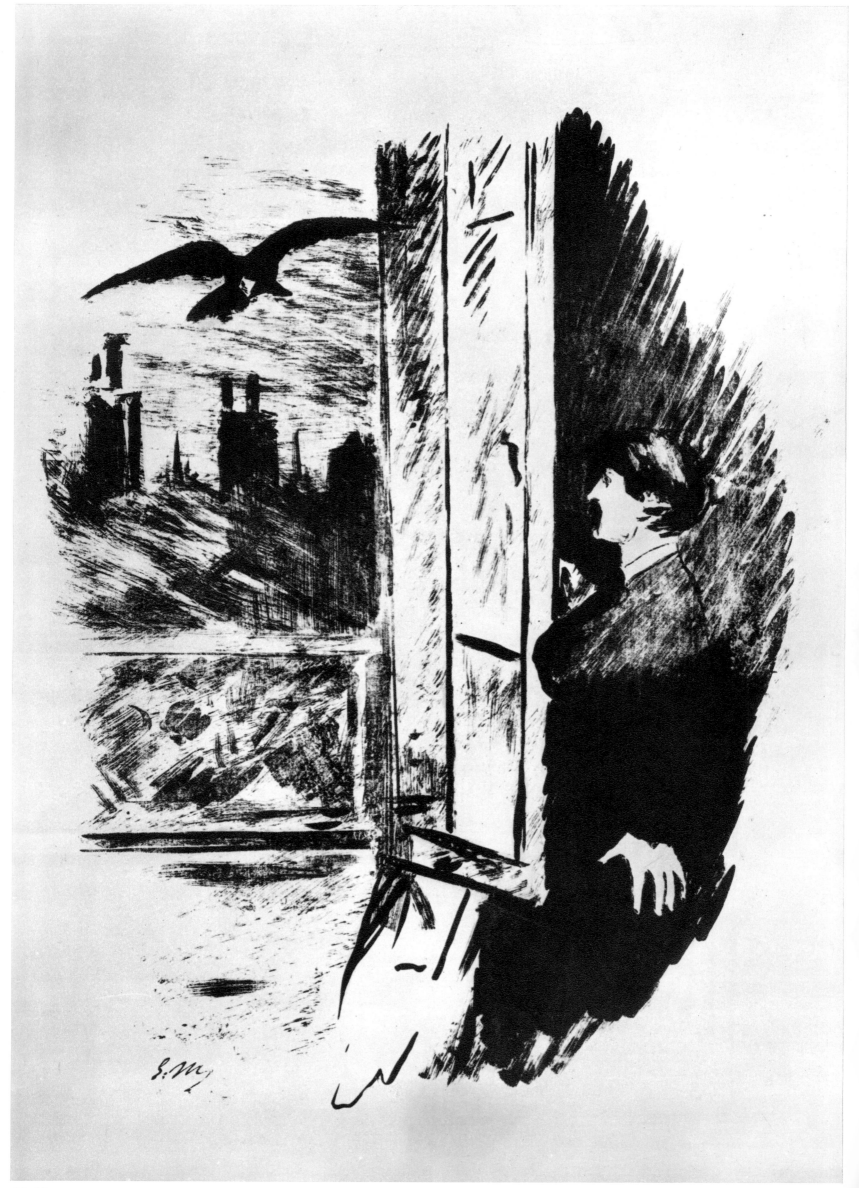

M. 84d

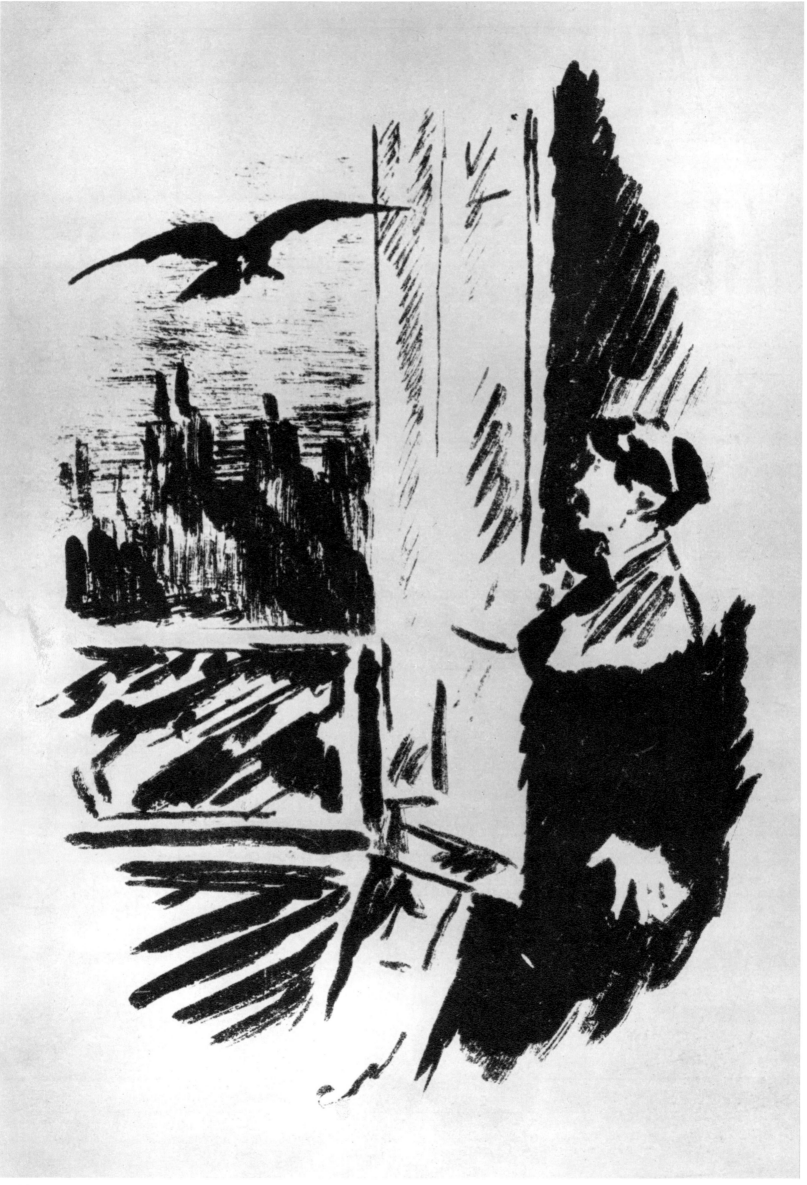

M. 84e

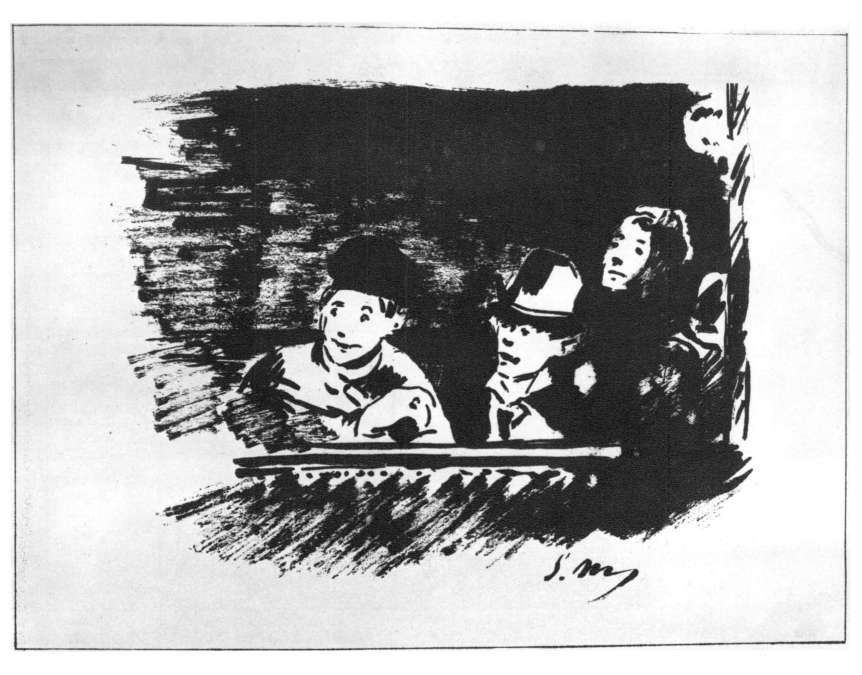

M. 85

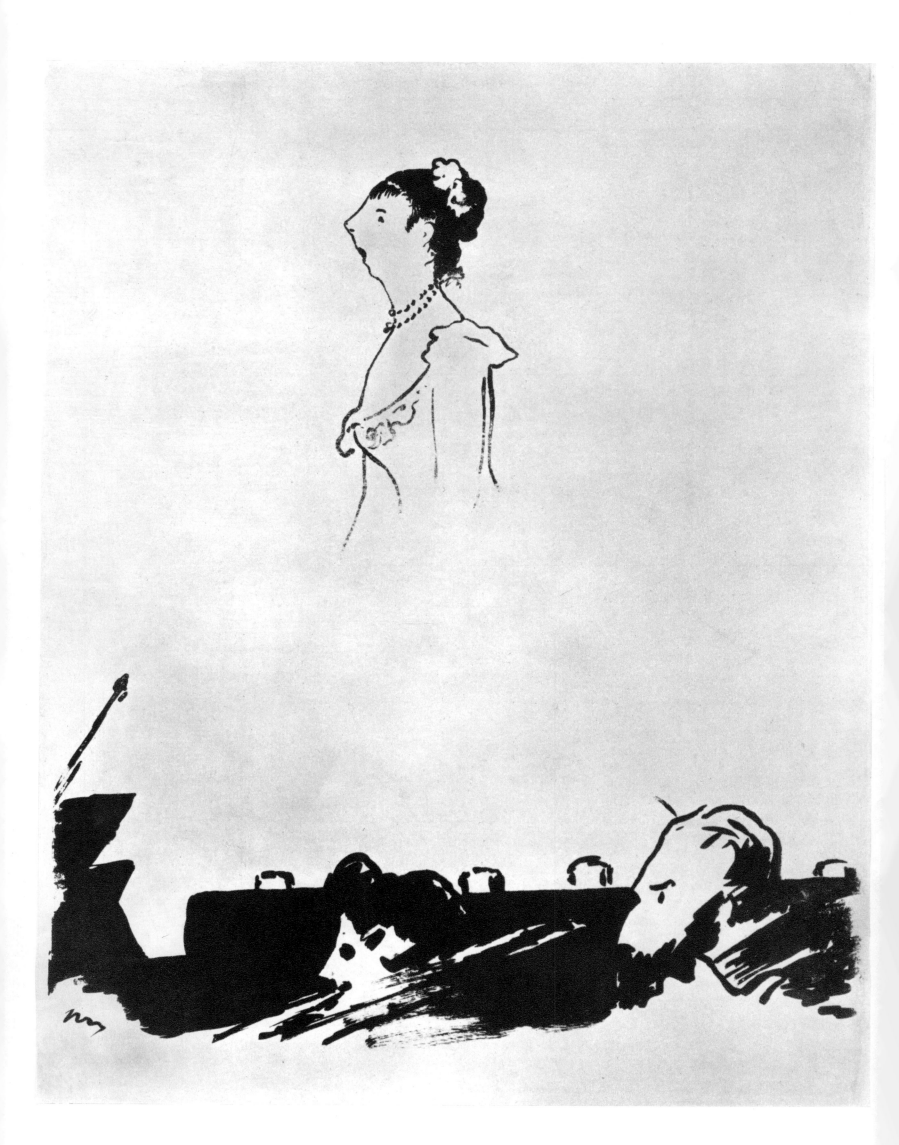

M. 86

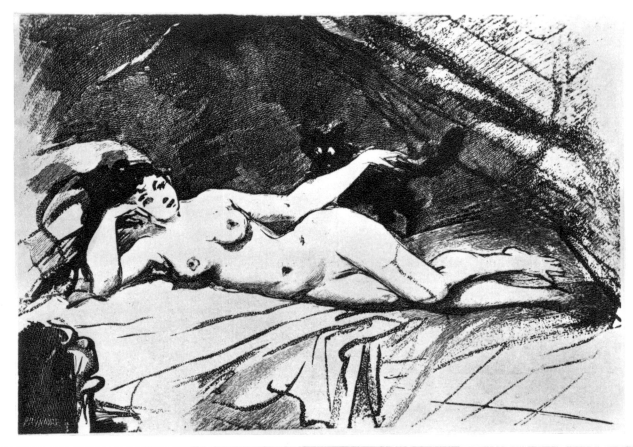

M. 87, 88

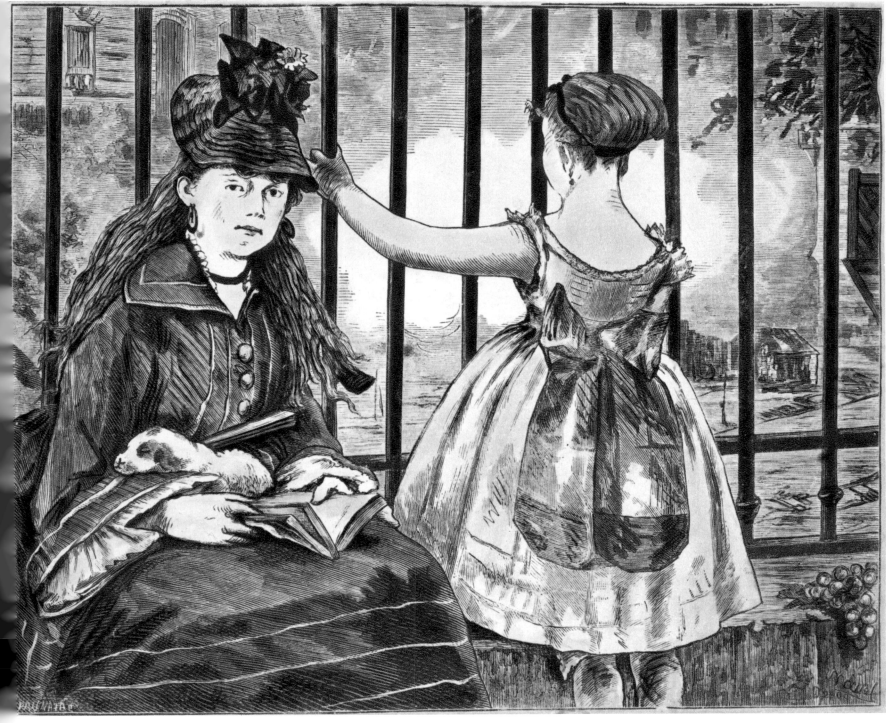

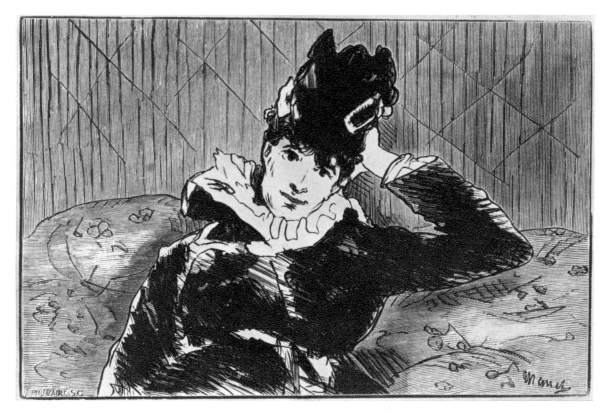

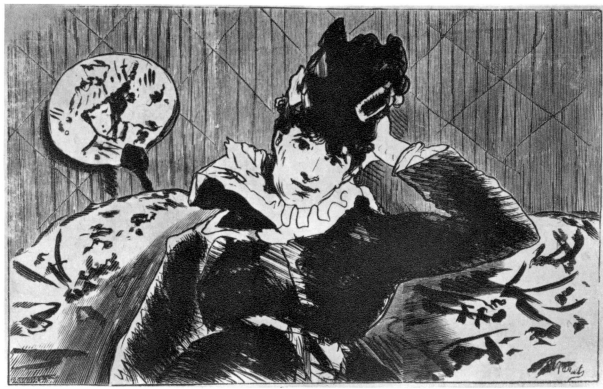

M. 89, 90, 91

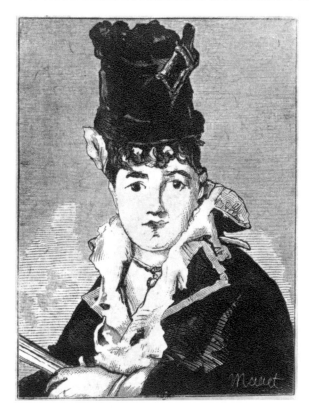

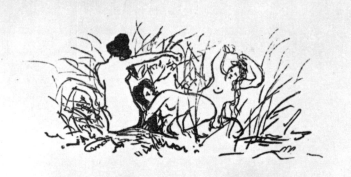

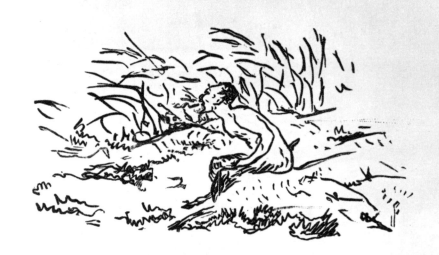

M. 92a, b, c, d

Pissarro

P. 1

P. 2

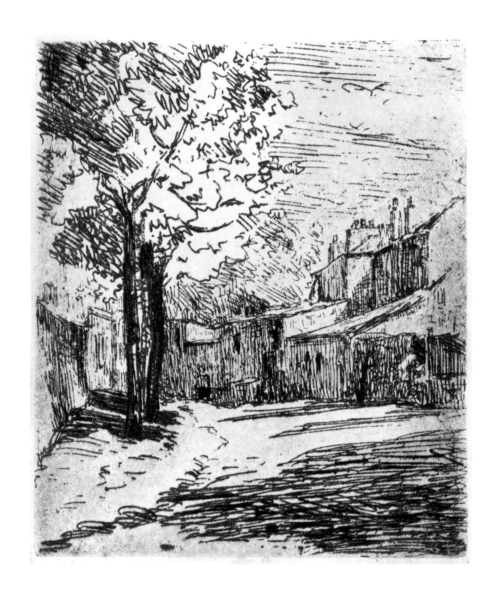

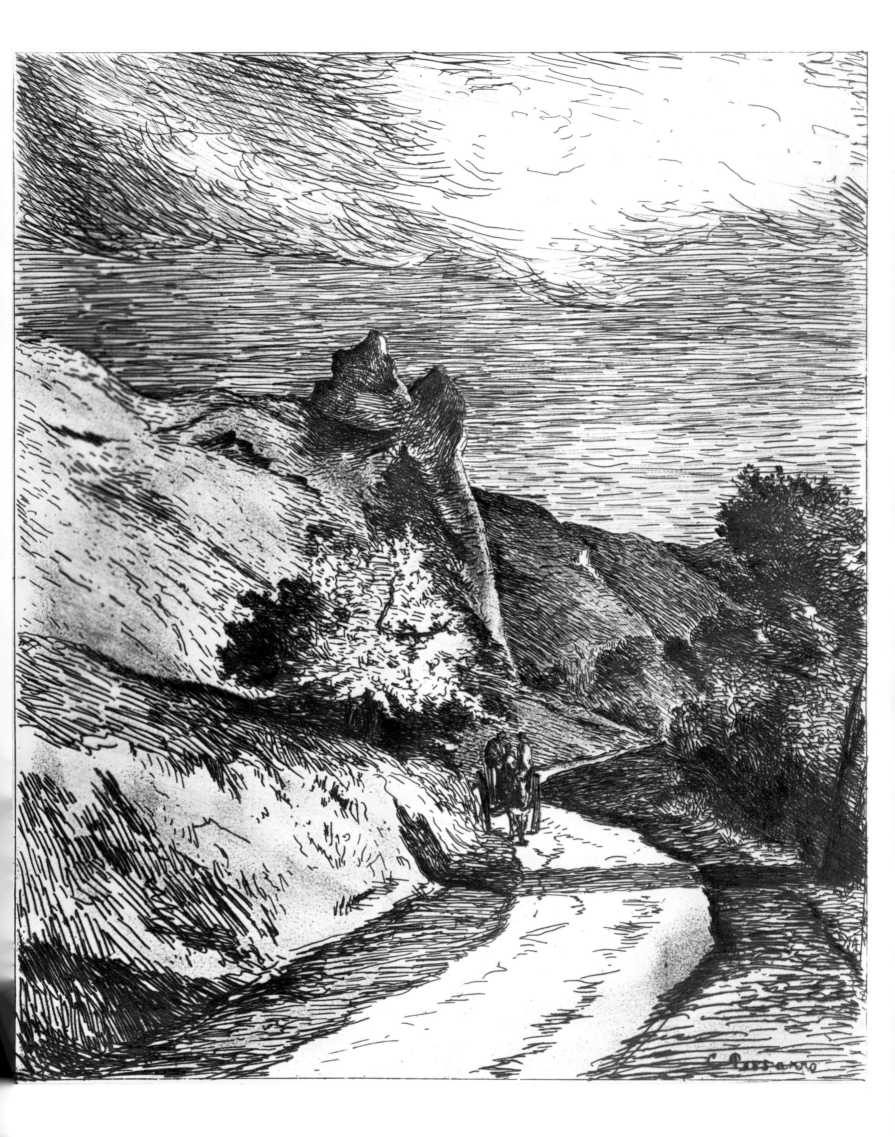

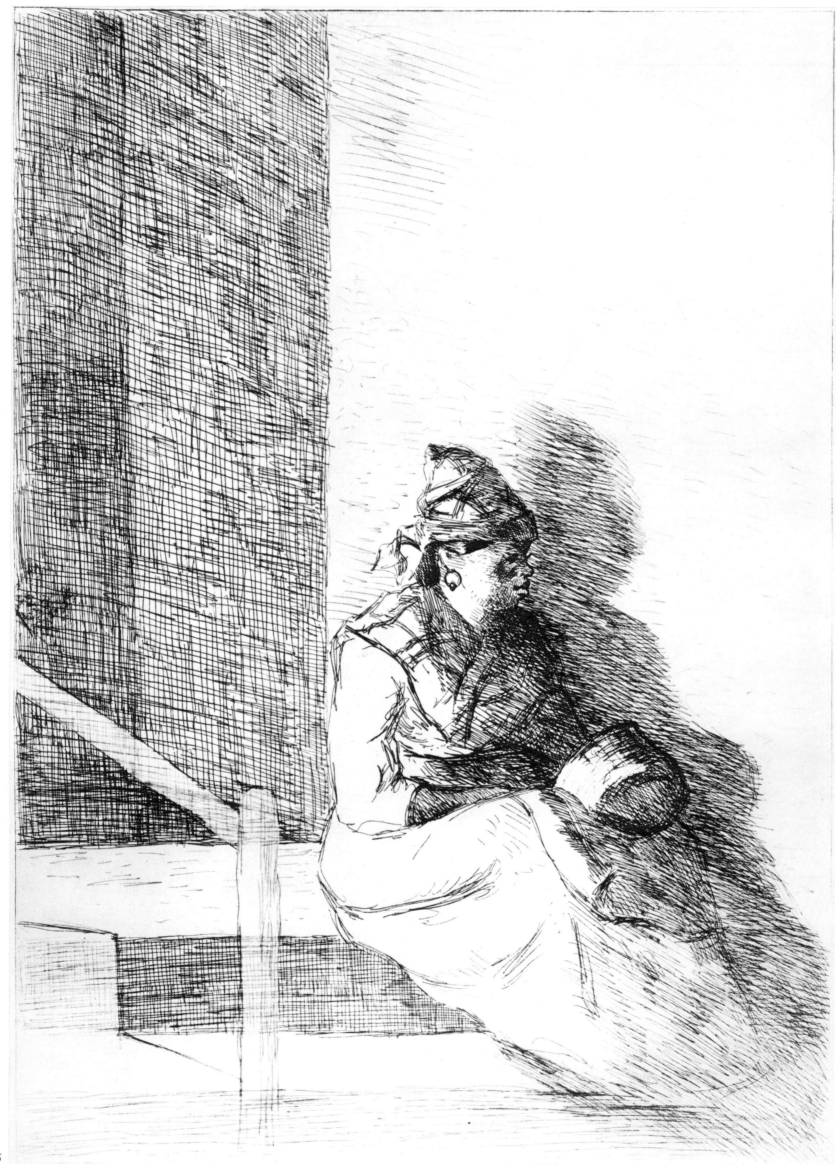

P. 6

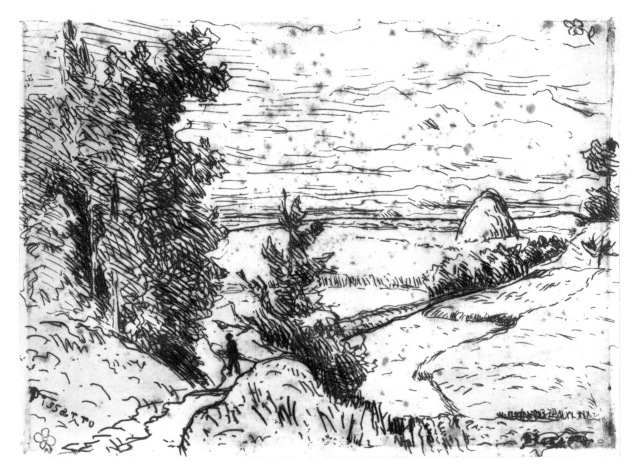

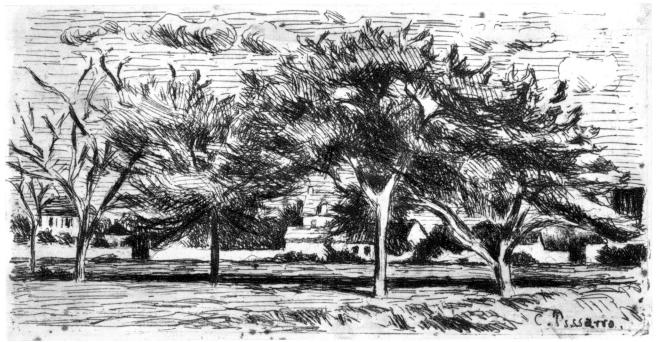

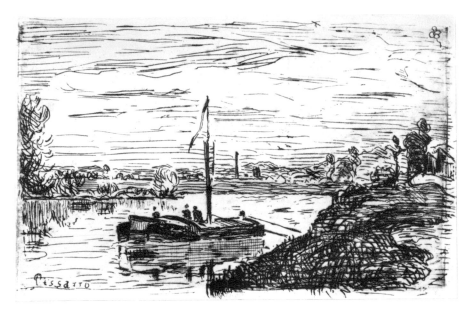

P. 7, 8, 9

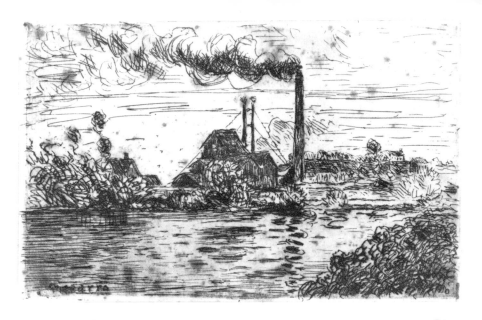

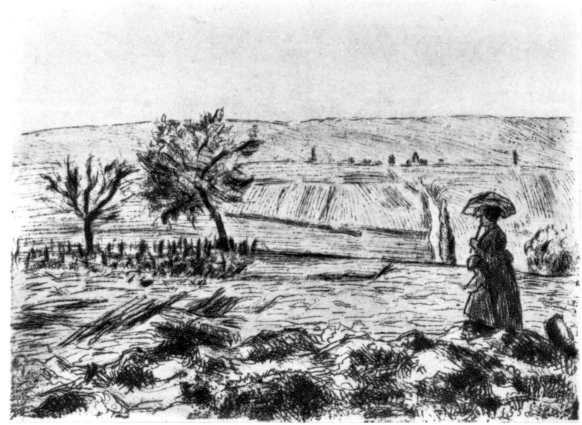

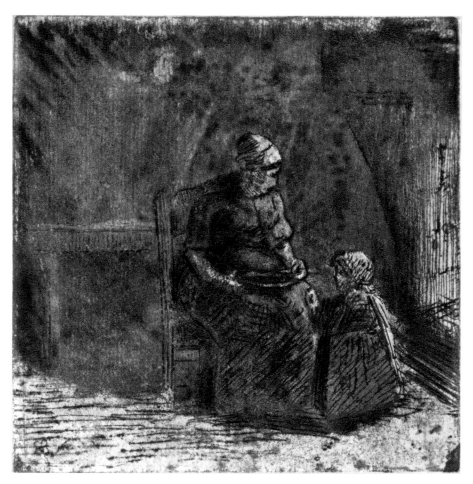

P. 10, 11, 12

.C. Pissarro

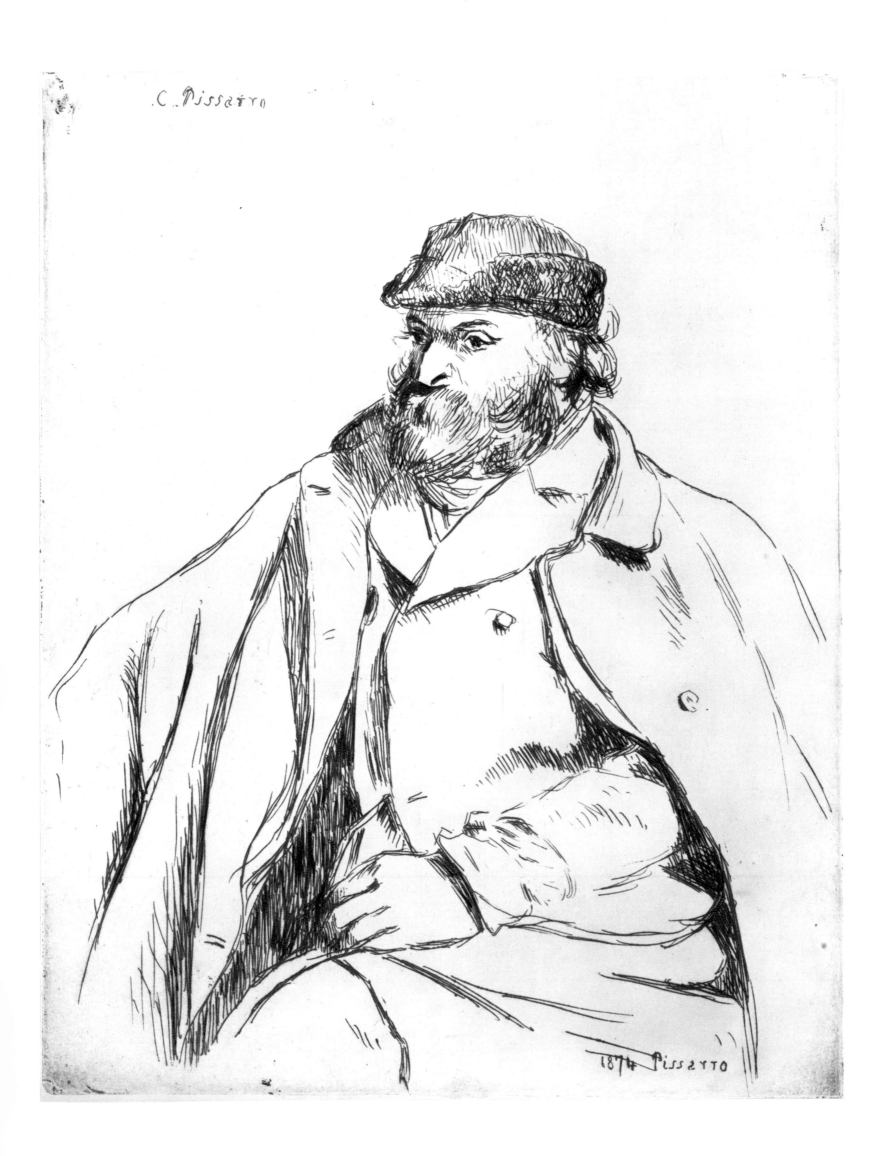

1874 Pissarro

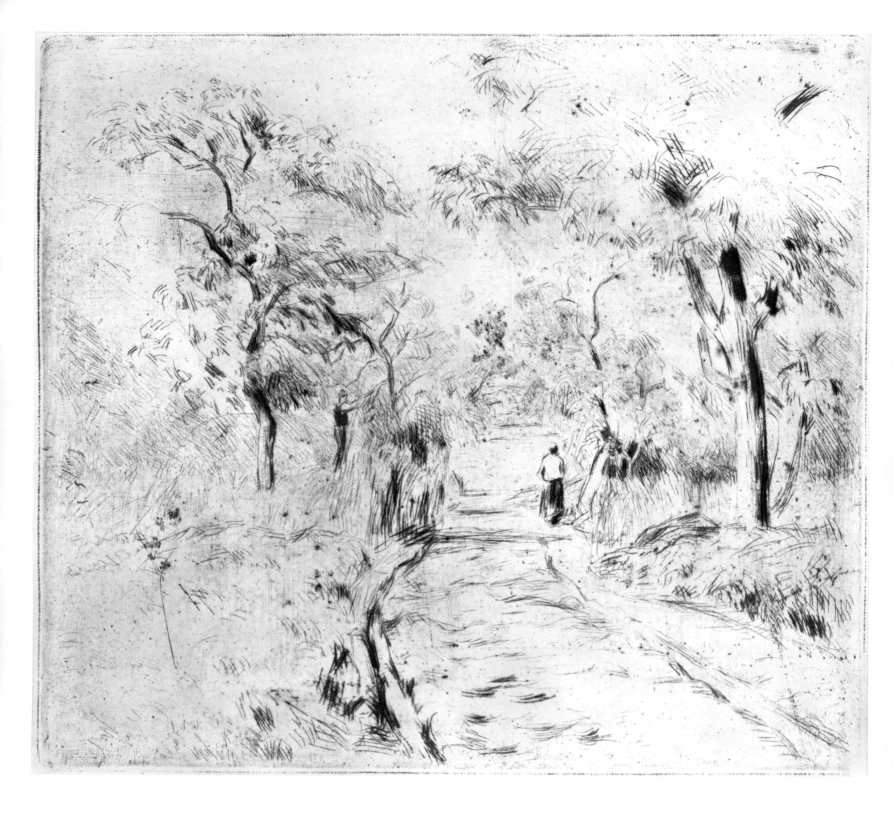

P. 14

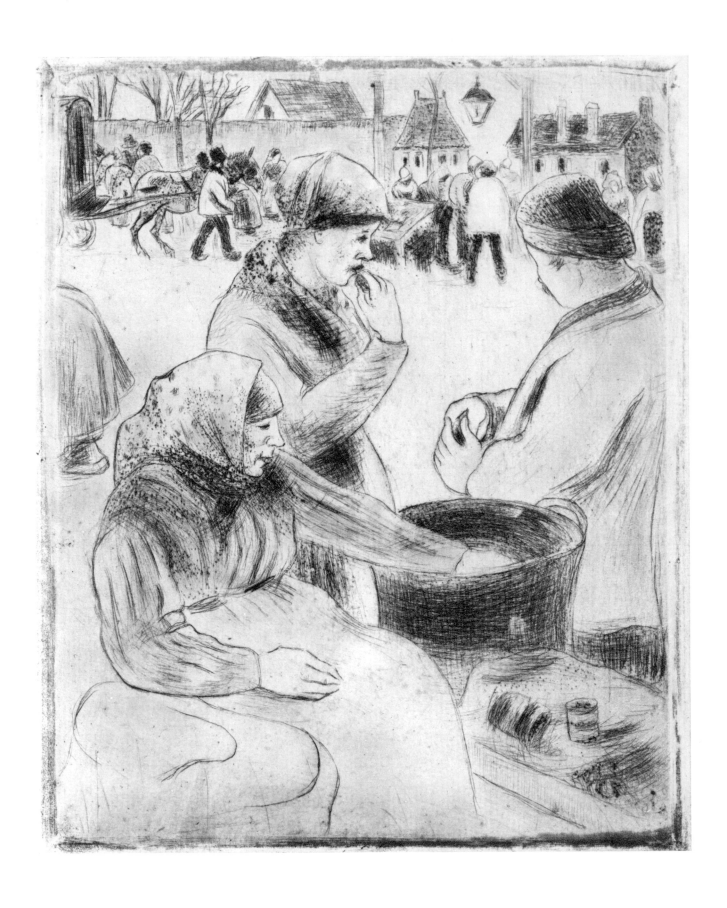

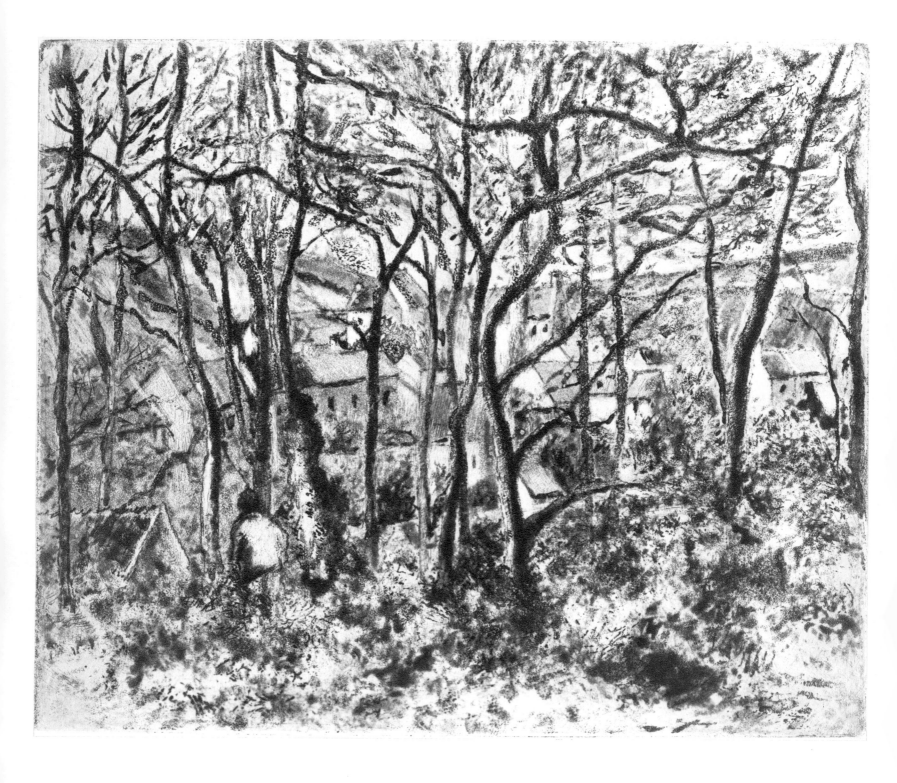

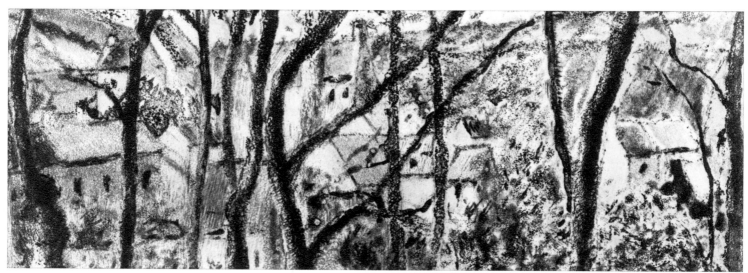

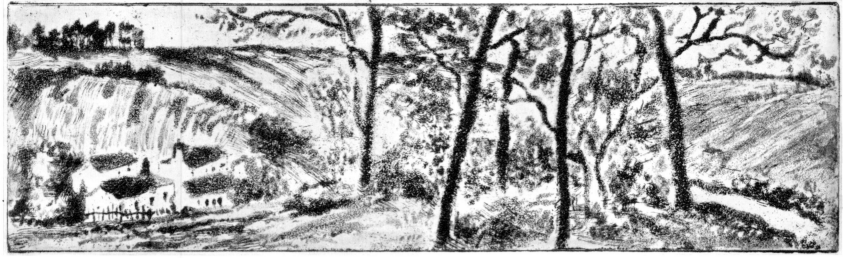

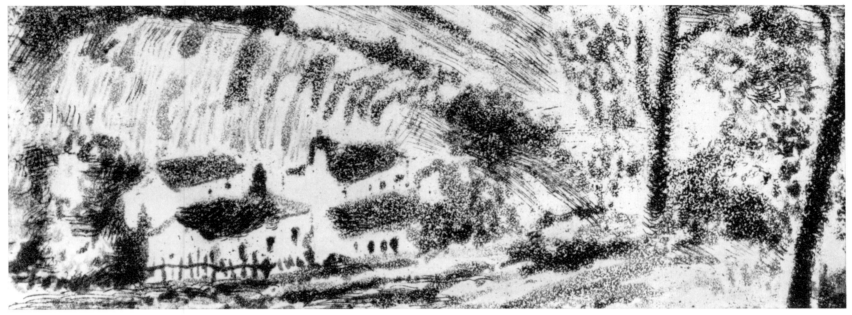

P. 17

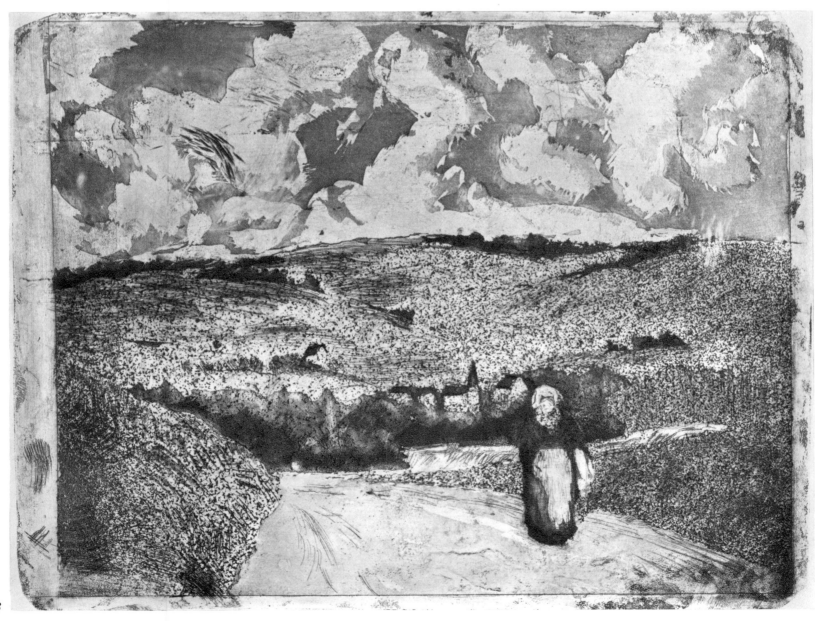

18

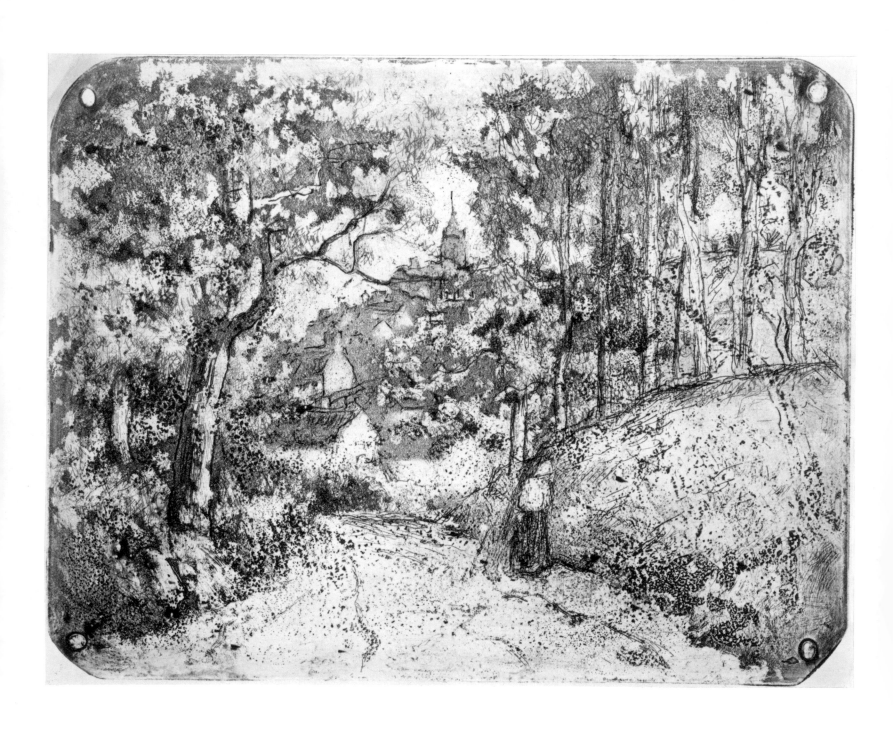

P. 19

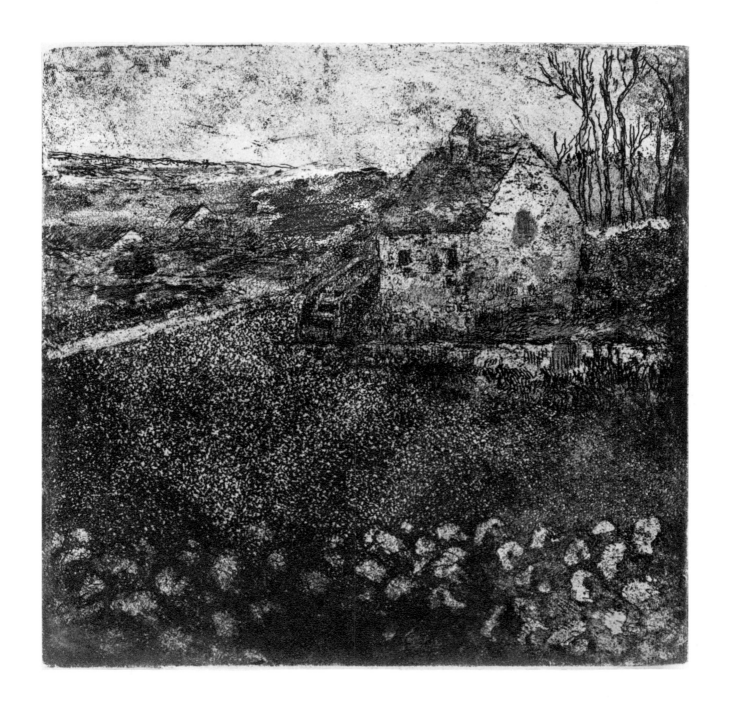

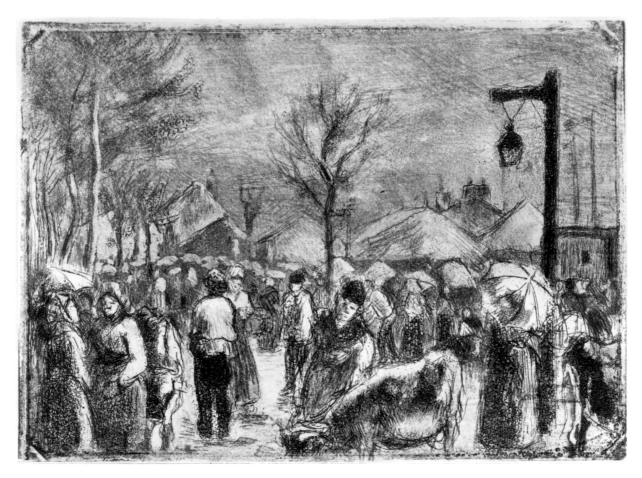

P. 20, 21

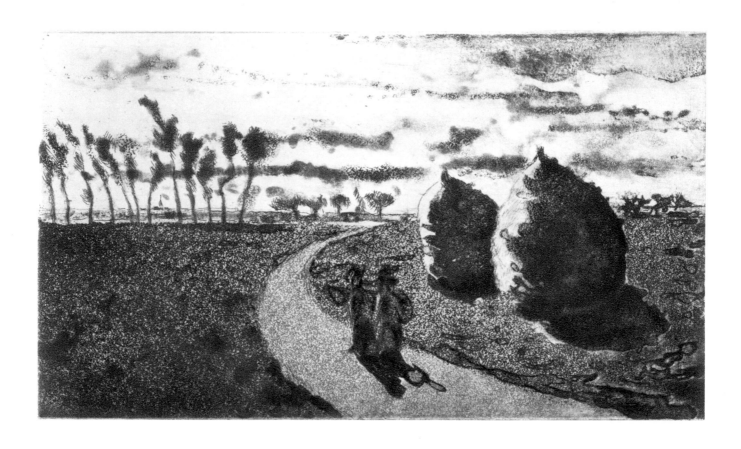

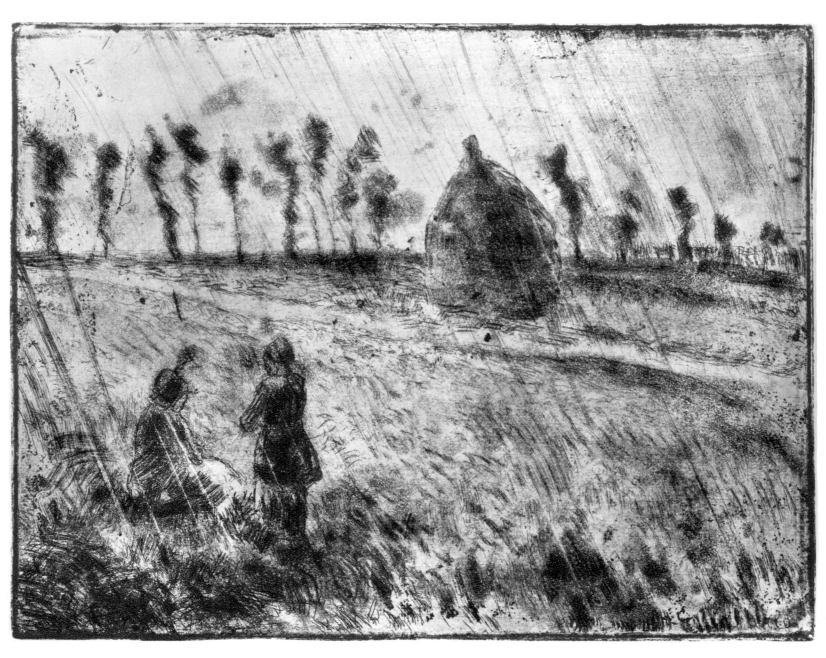

P. 22, 23

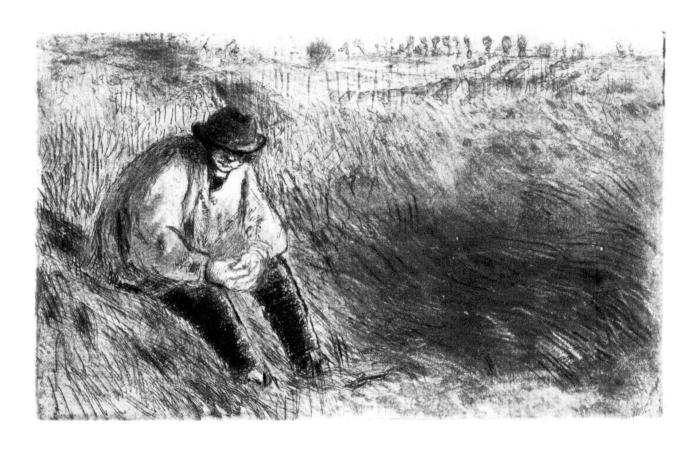

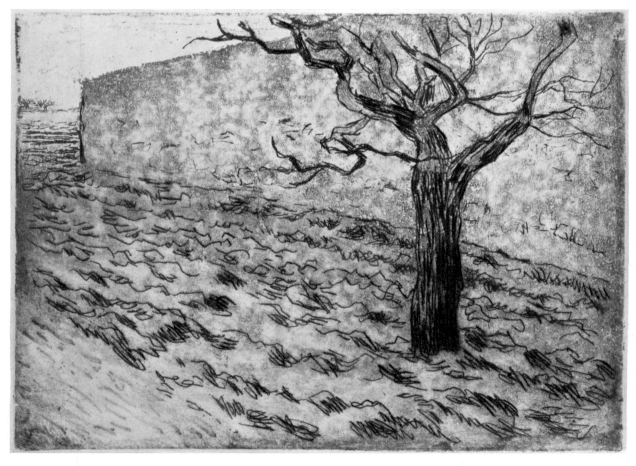

P. 24, 25

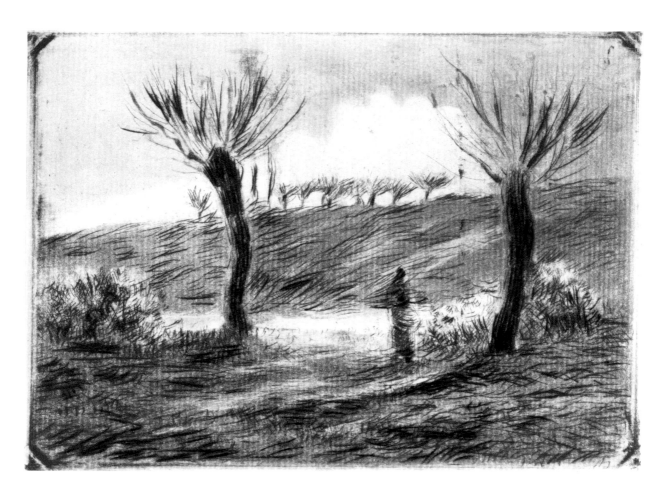

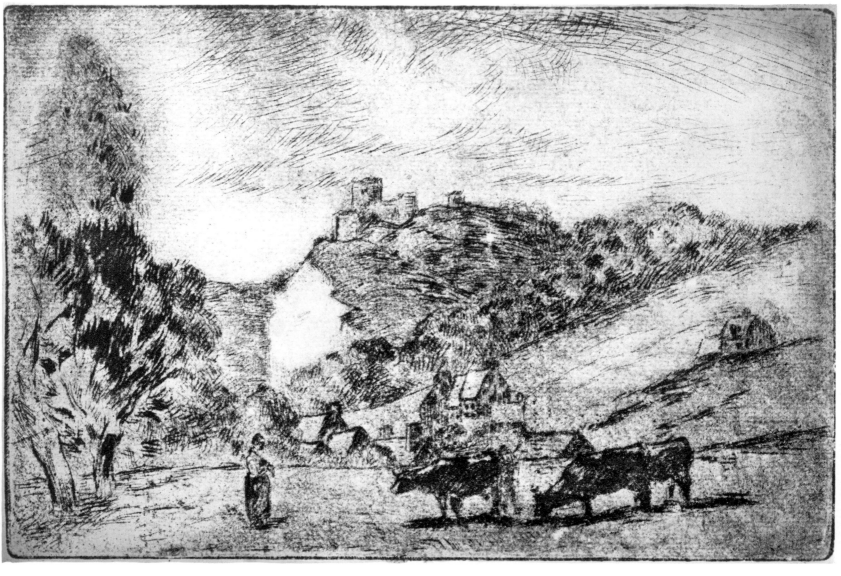

P. 26, 27

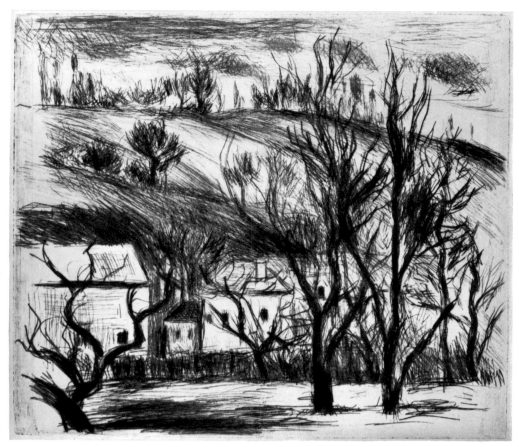

P. 28

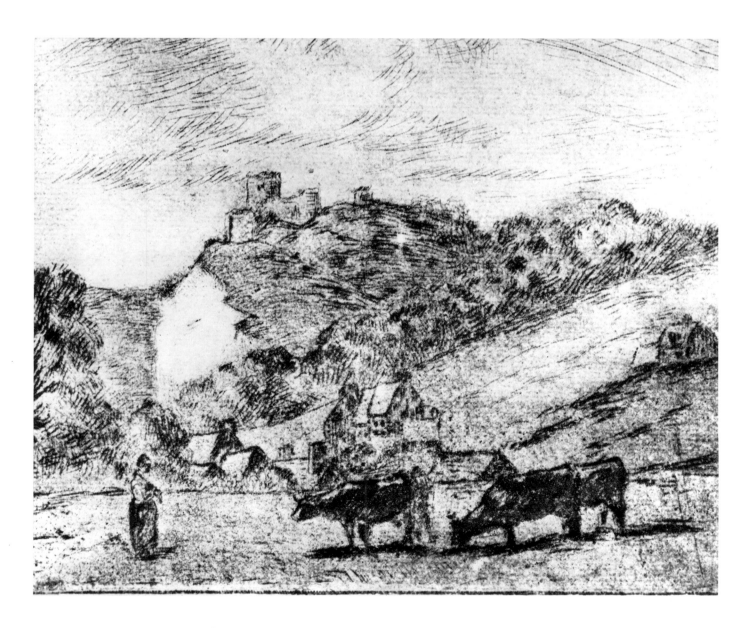

P. 27 detail

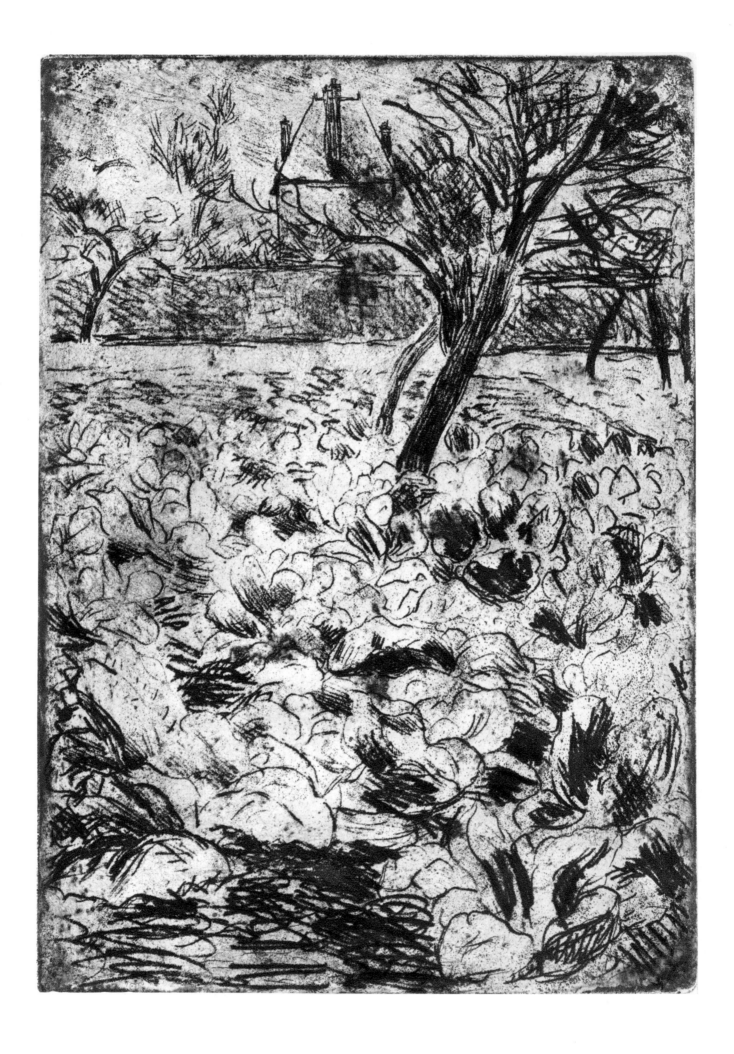

P. 29

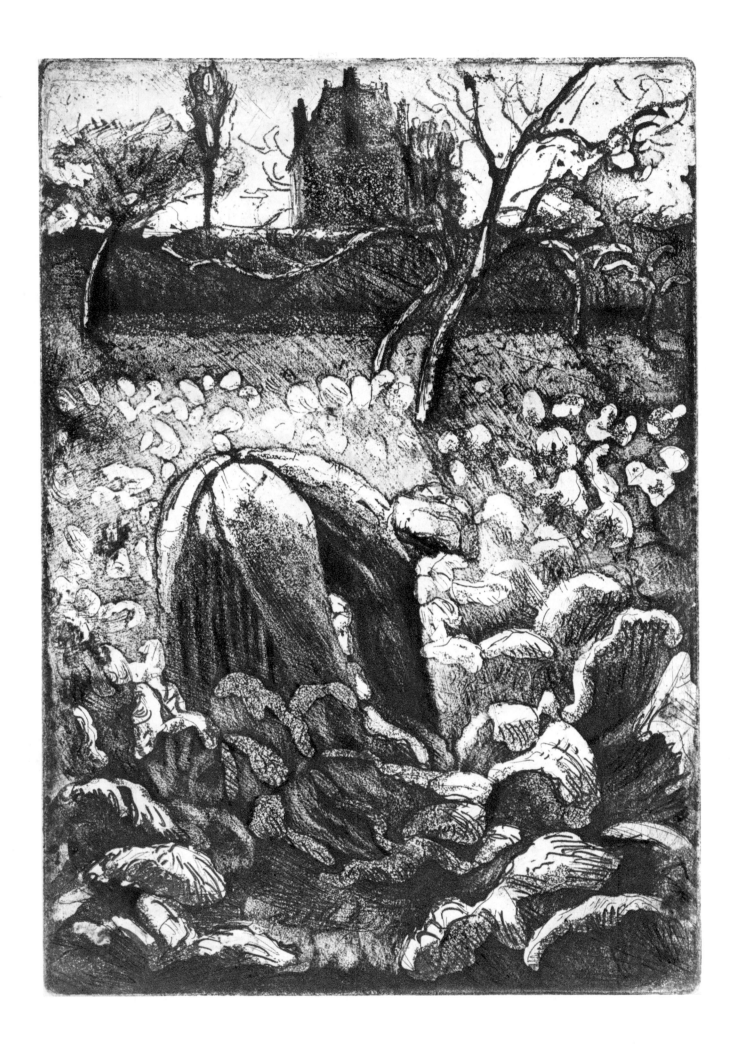

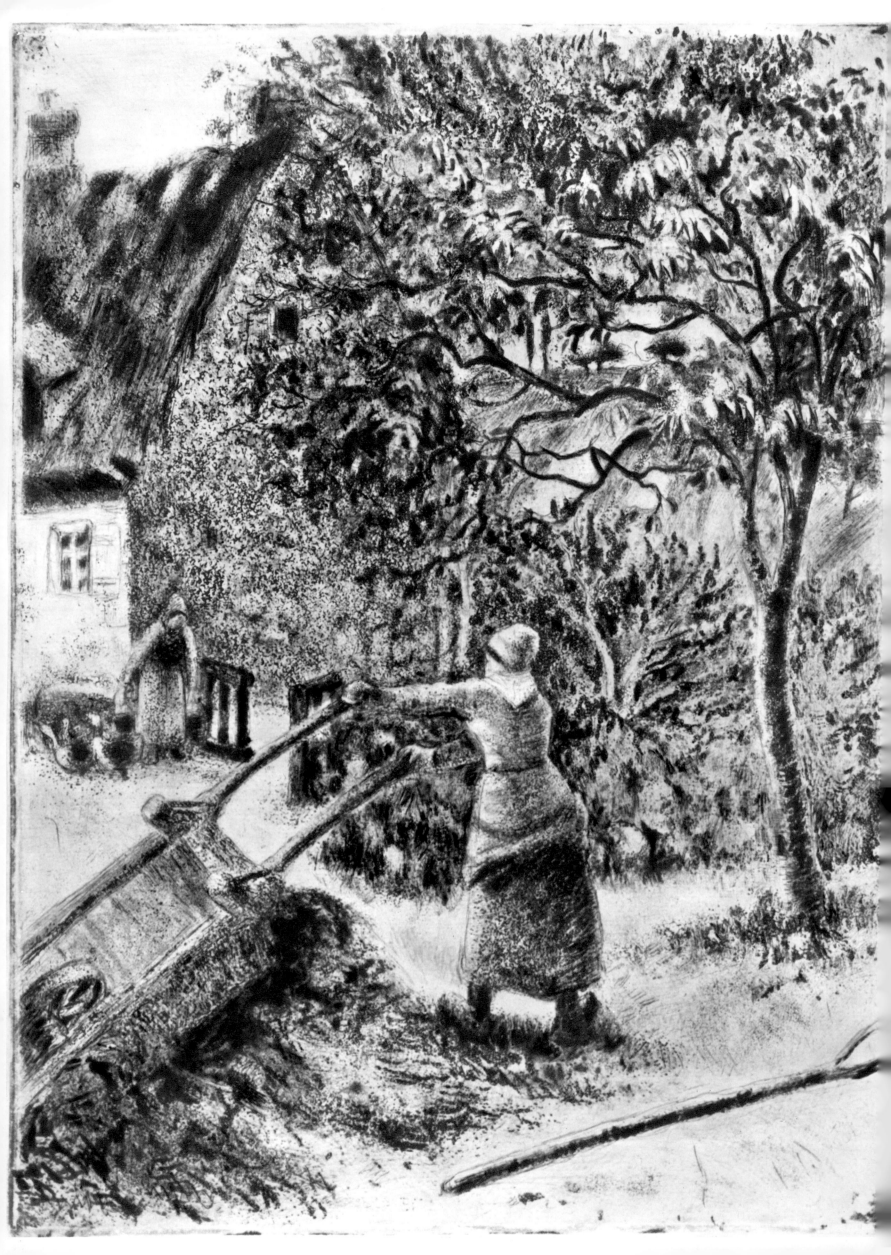

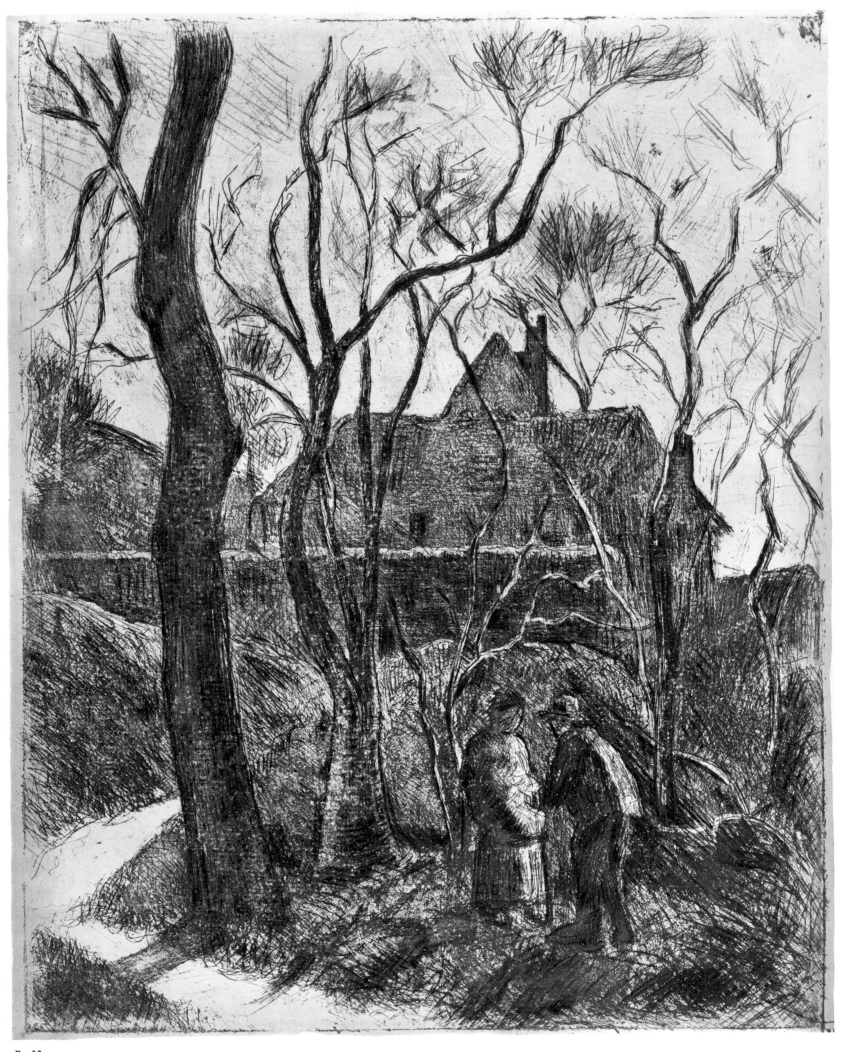

P. 32

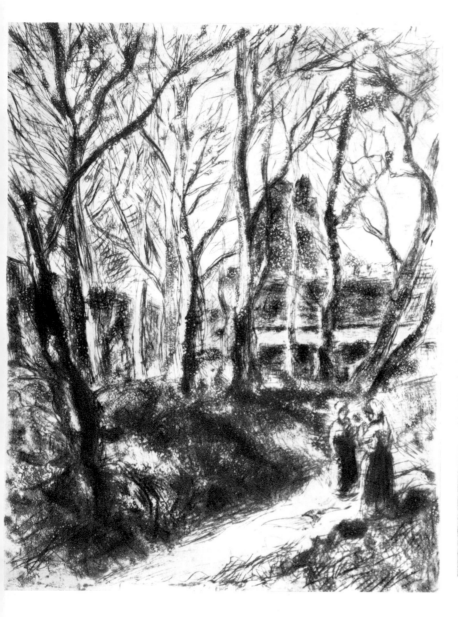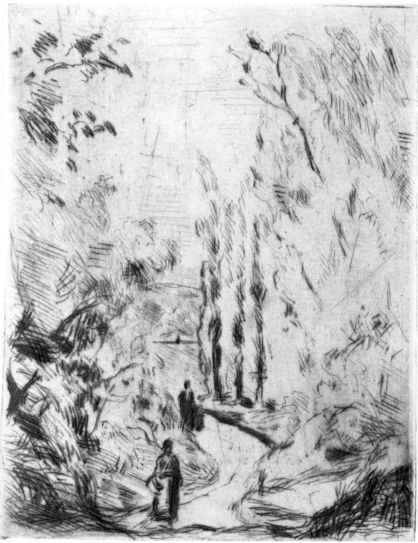

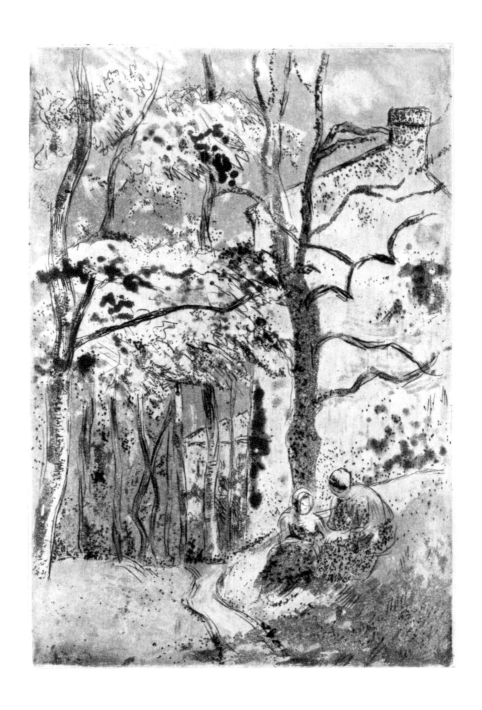

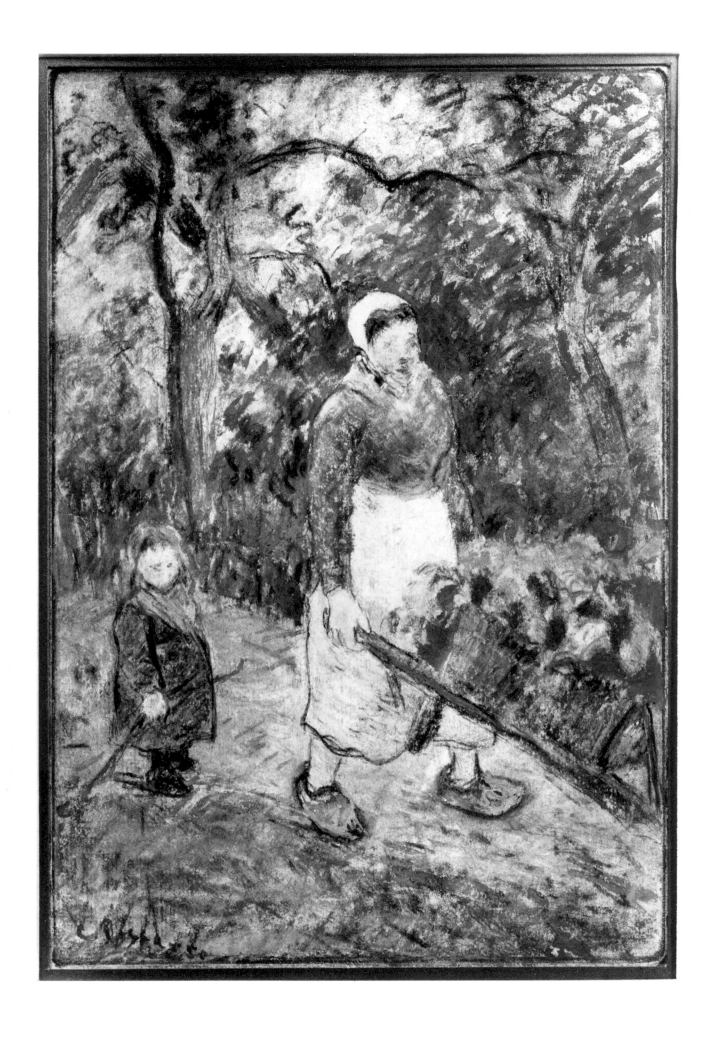

P. 36

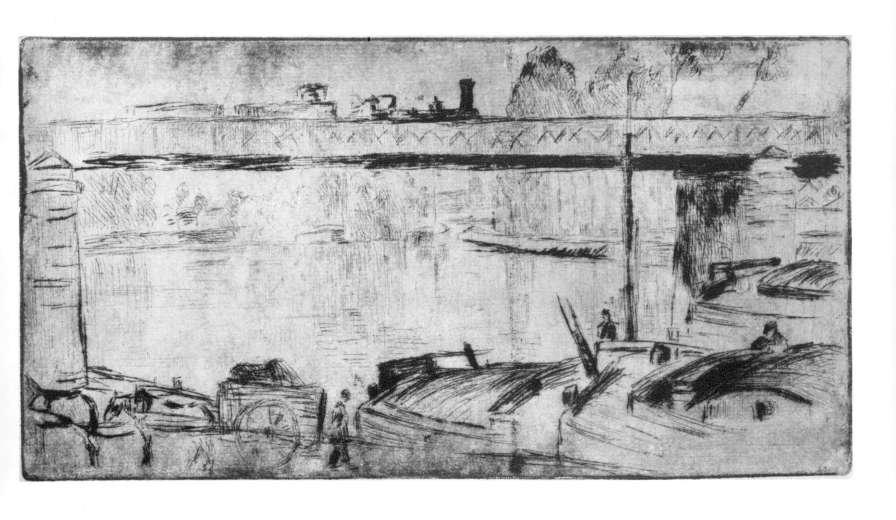

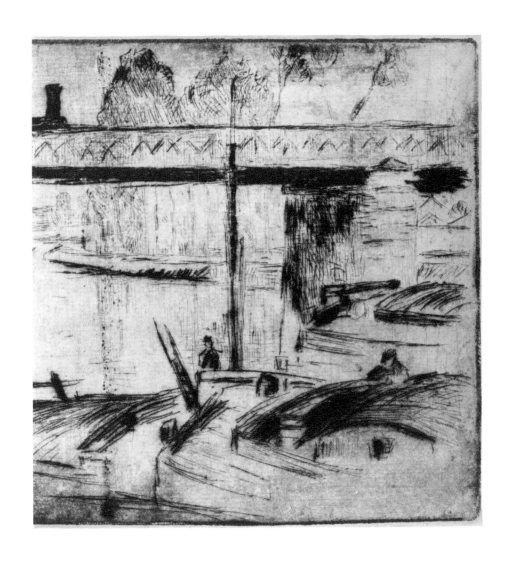

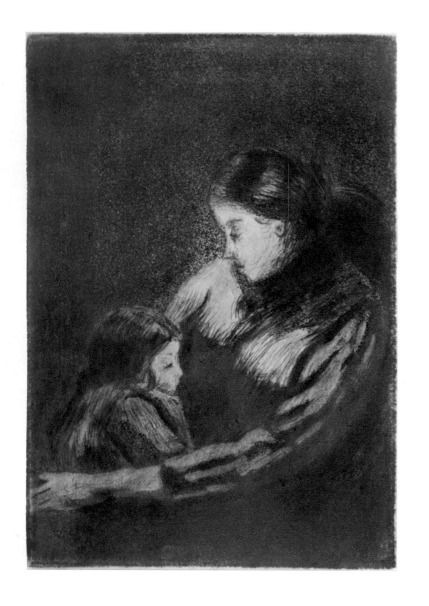

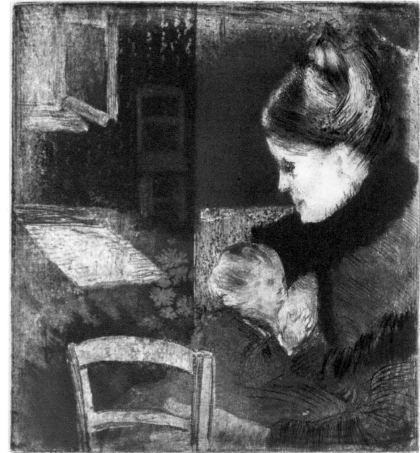

P. 38, 39

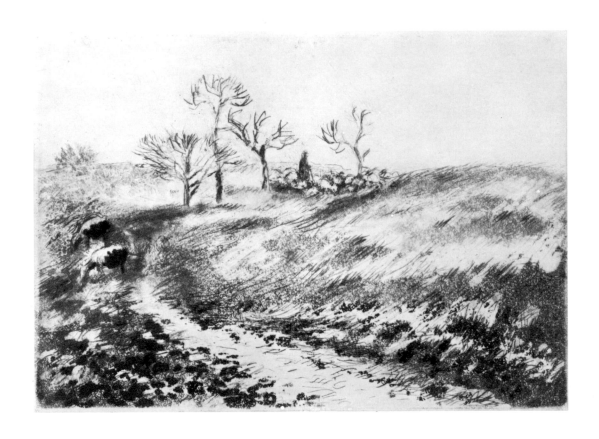

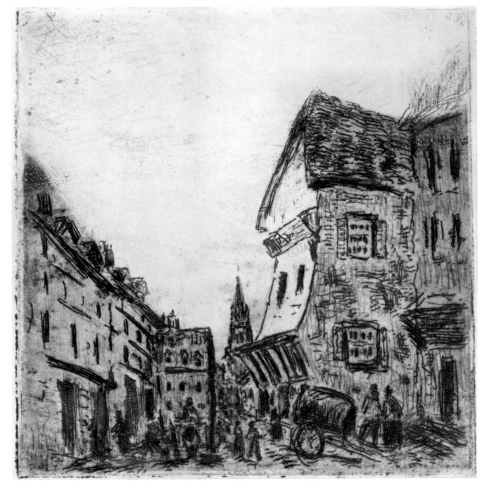

P. 40, 41

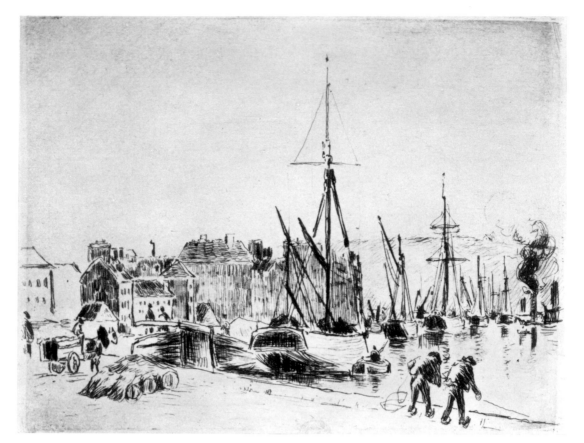

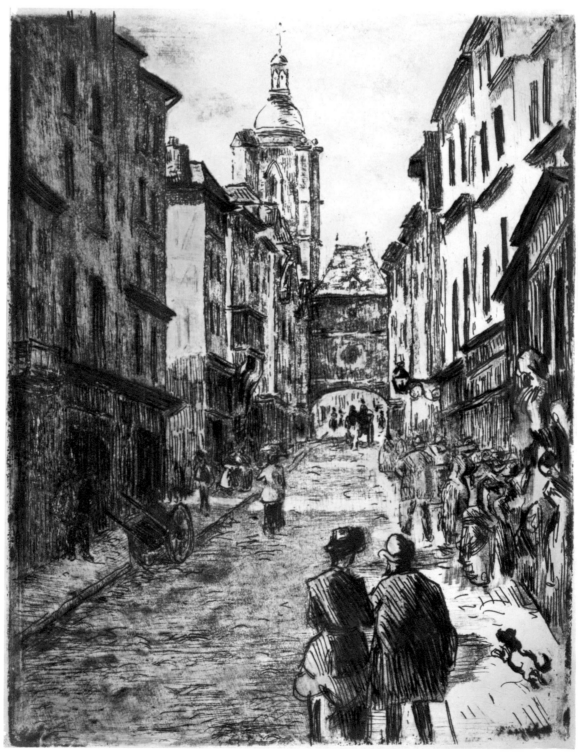

P. 42, 43

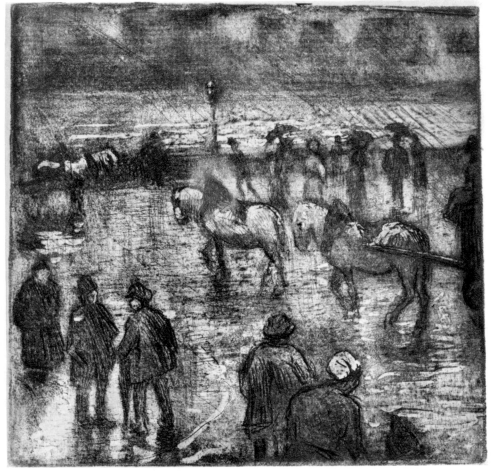

P. 44, 45

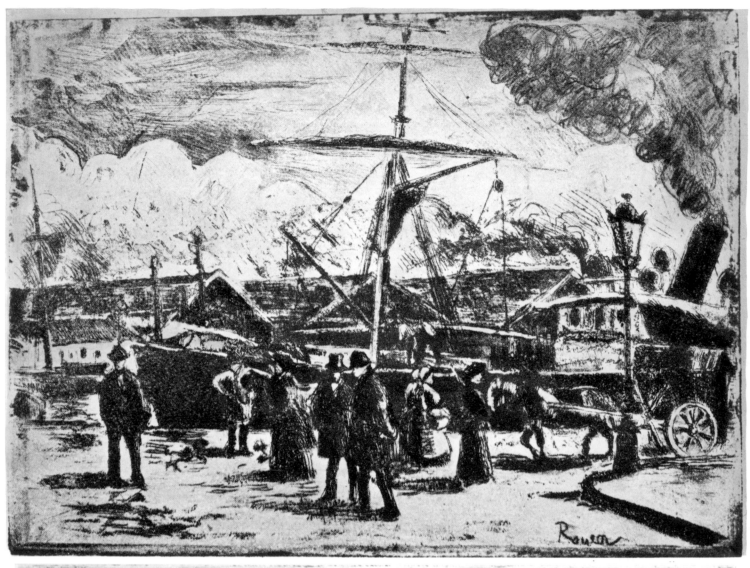

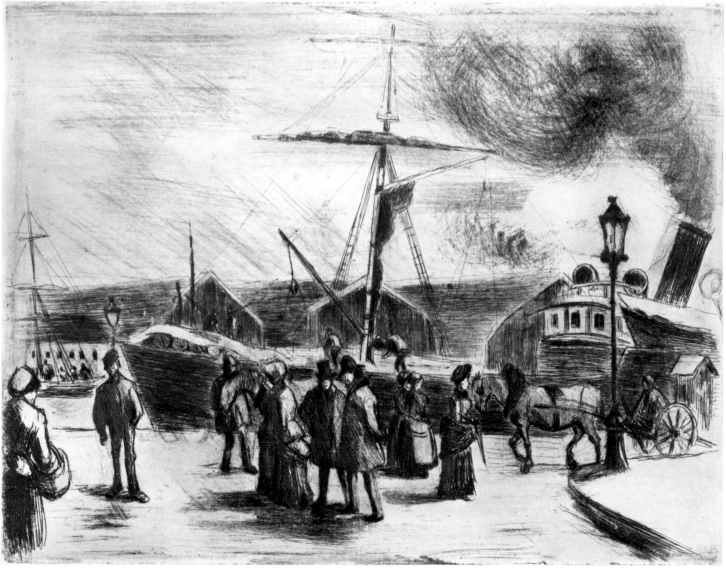

P. 46, 47

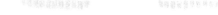

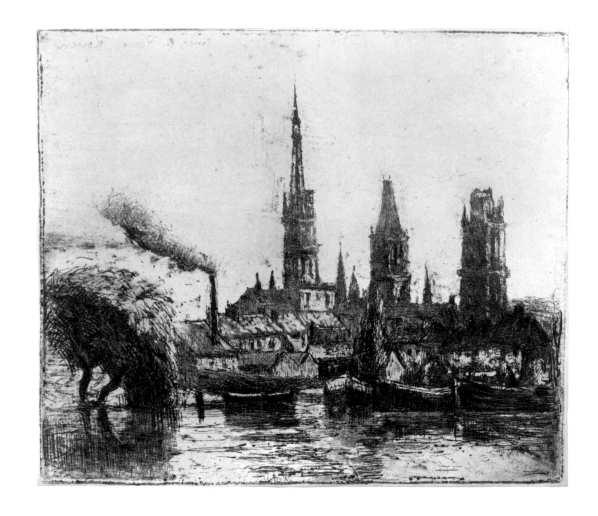

P. 48, 49

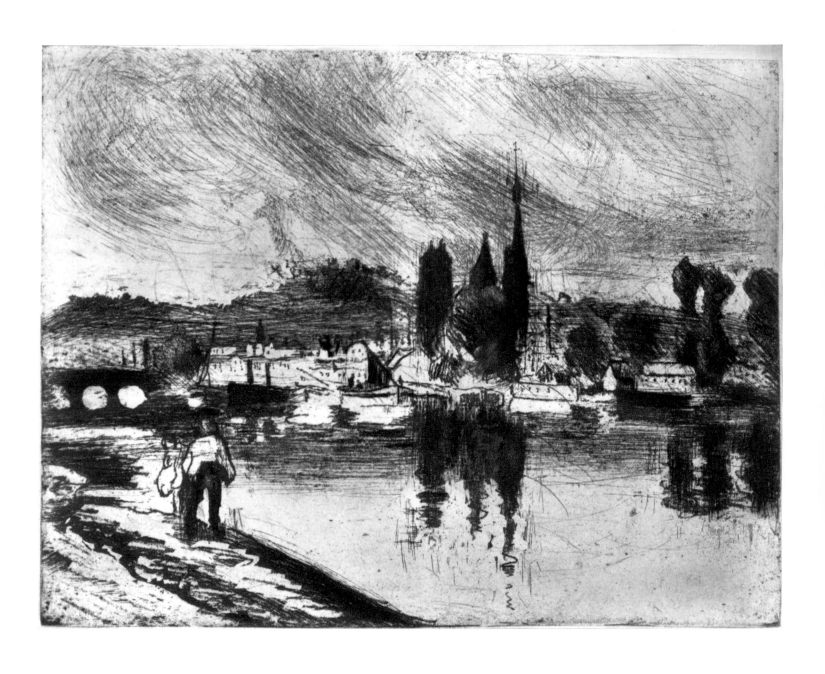

P. 50

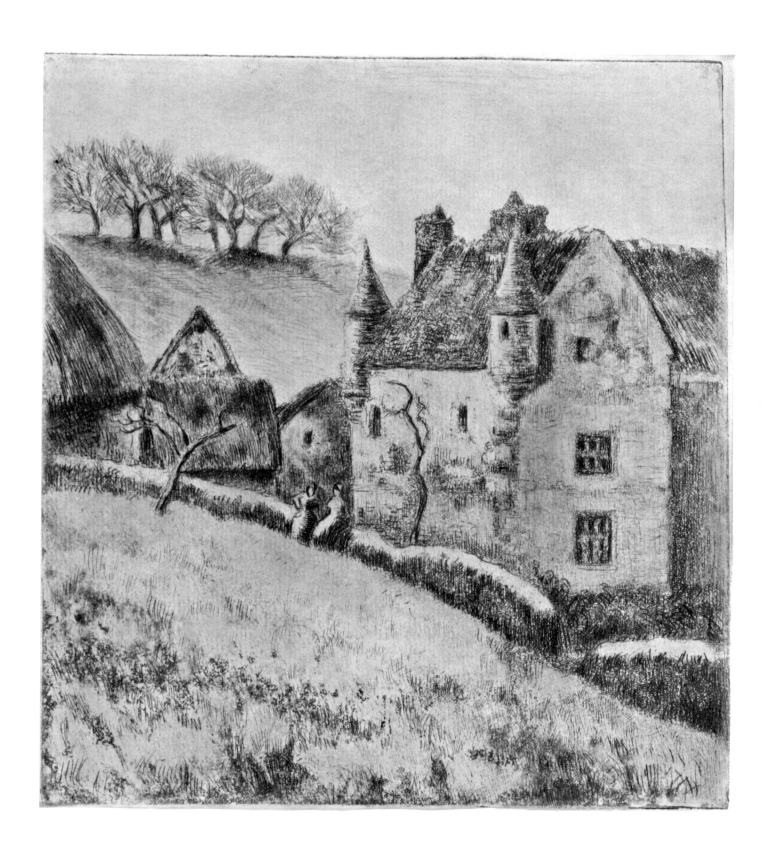

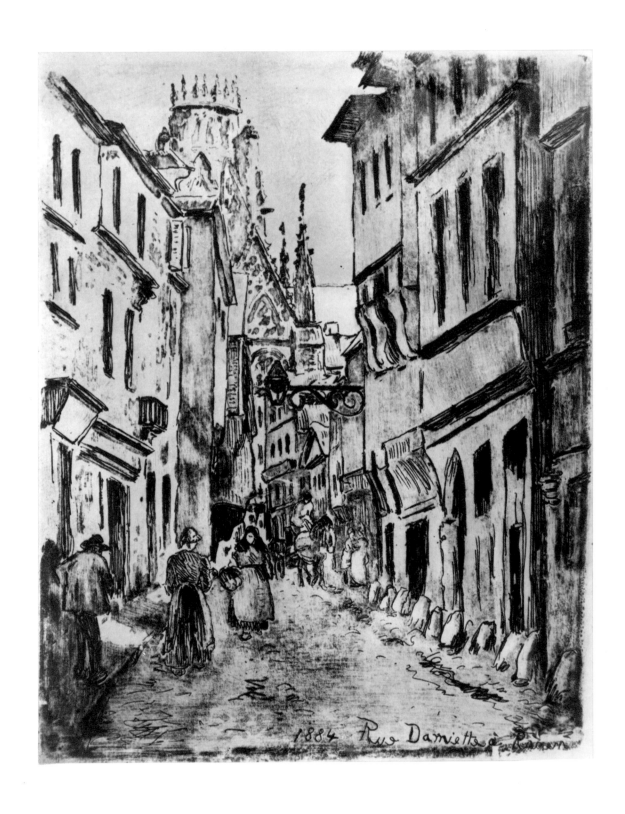

1884 Rue Damietta à Rouen

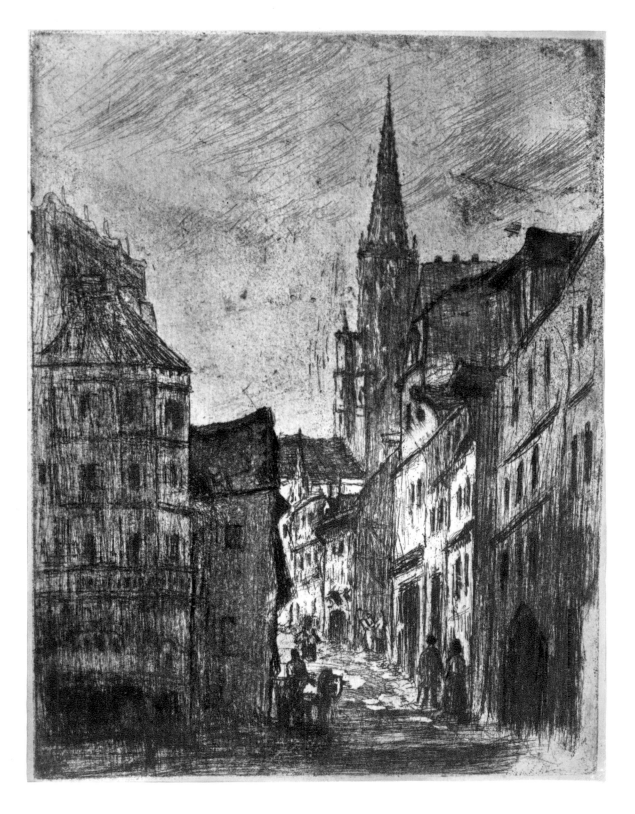

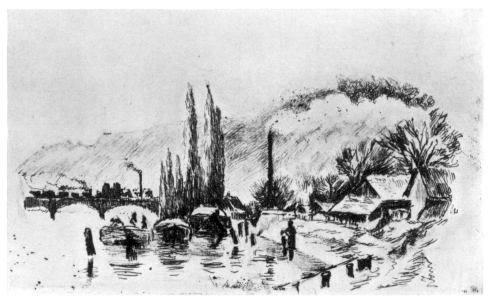

P. 53, 54

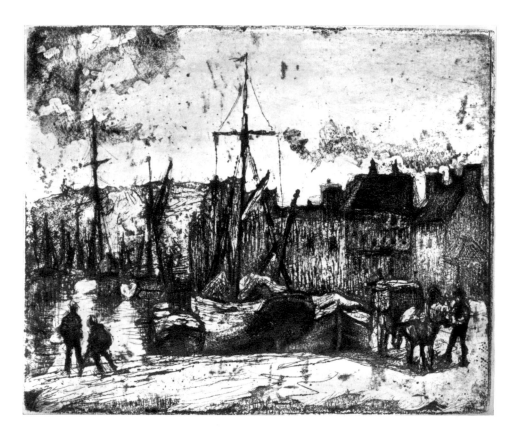

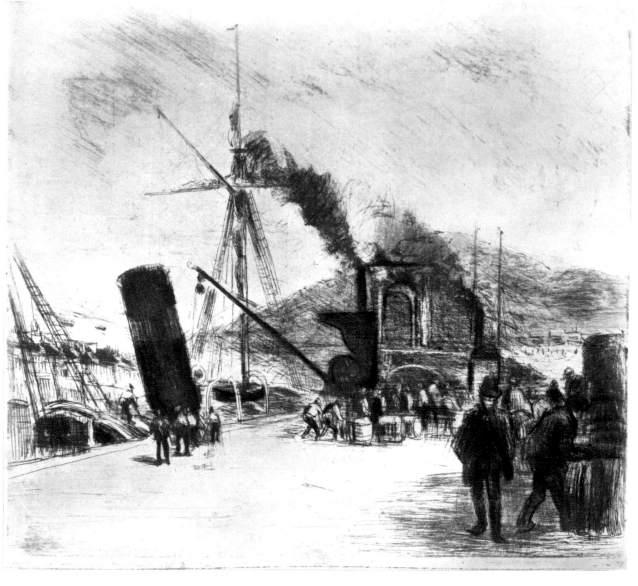

P. 55, 56

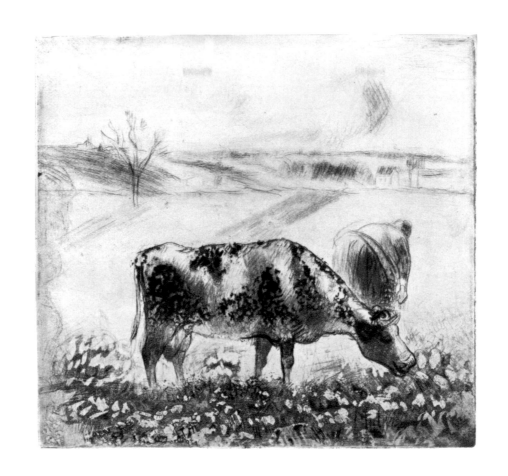

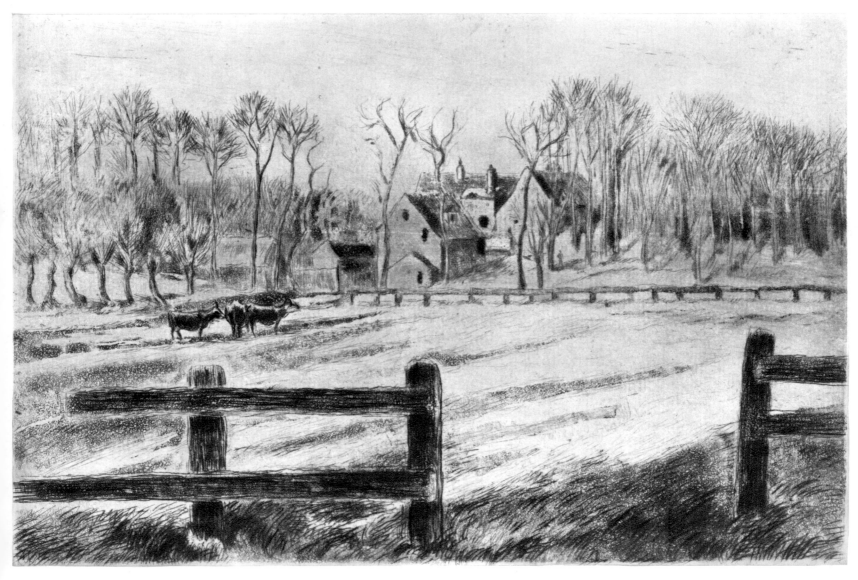

P. 57, 58

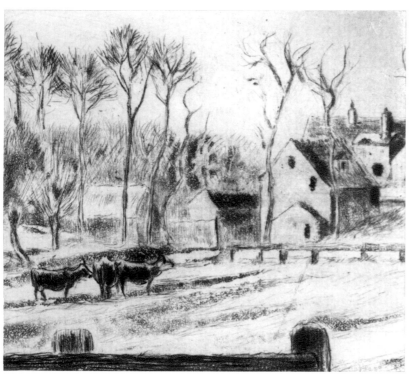

P. 58 detail

P. 59 detail

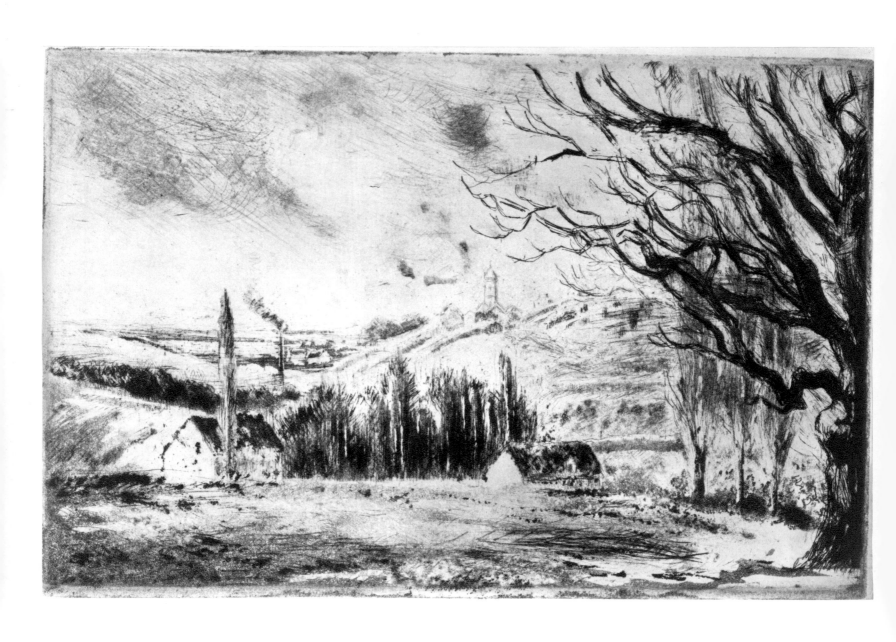

P. 59

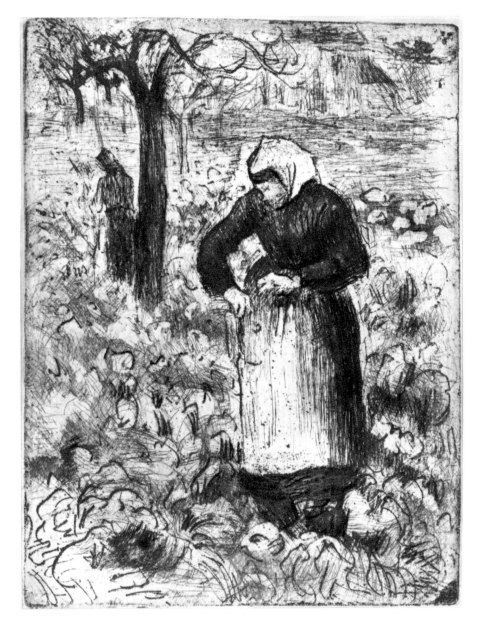

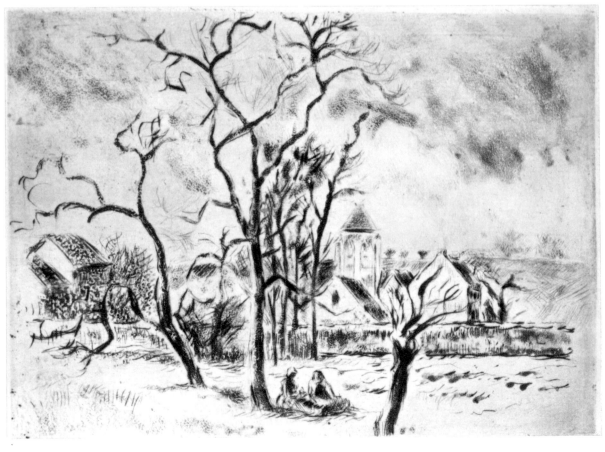

P. 60, 61

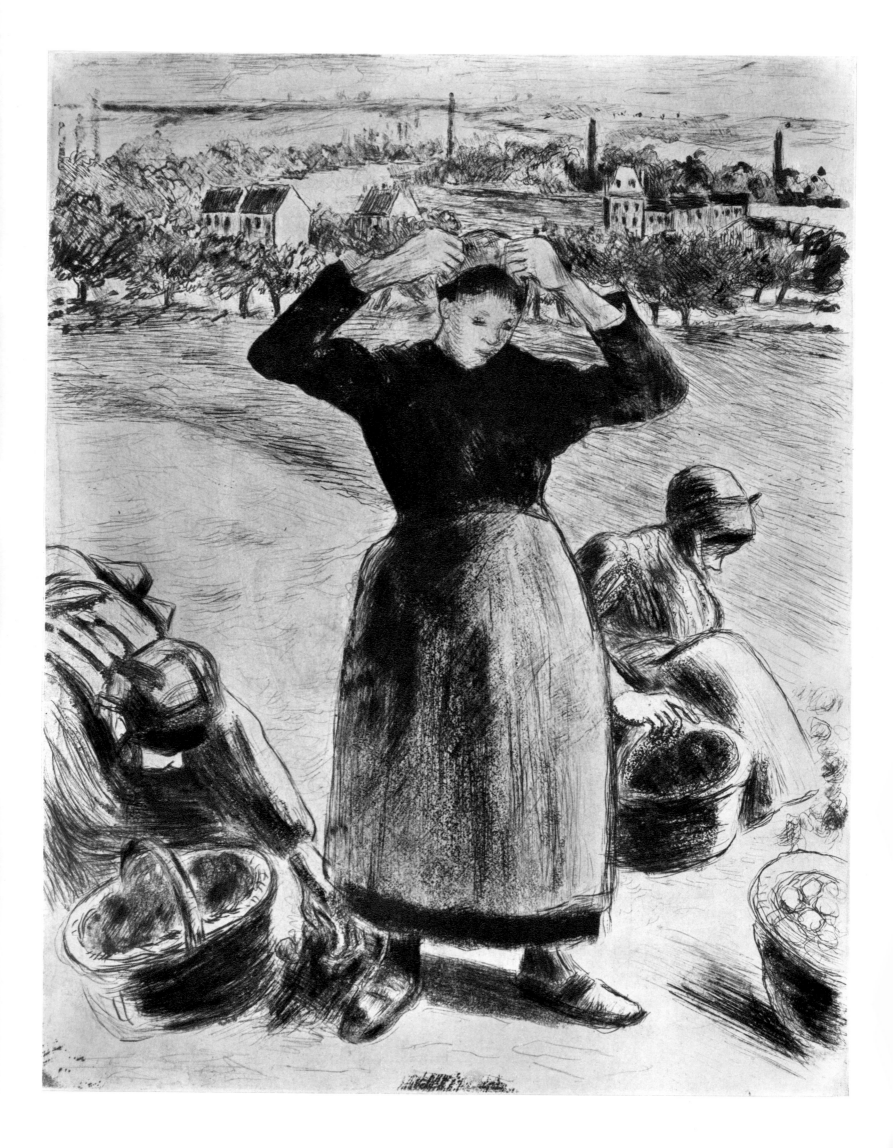

P. 62

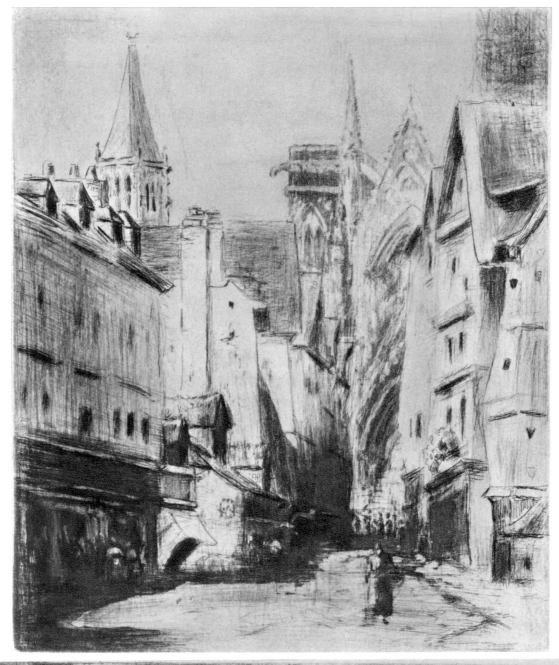

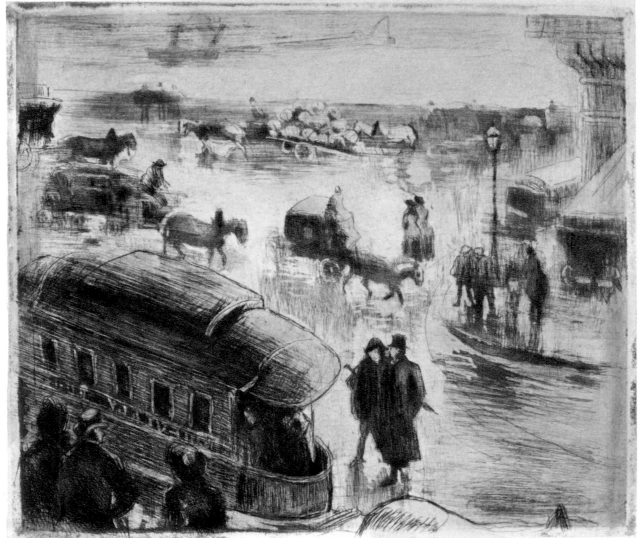

P. 63, 64

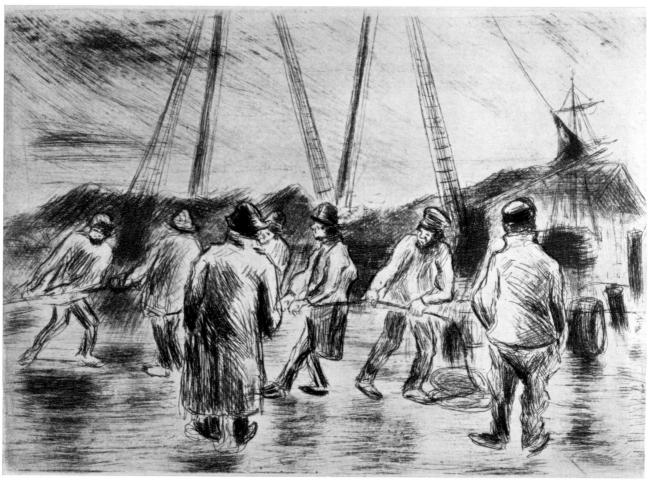

P. 65, 66

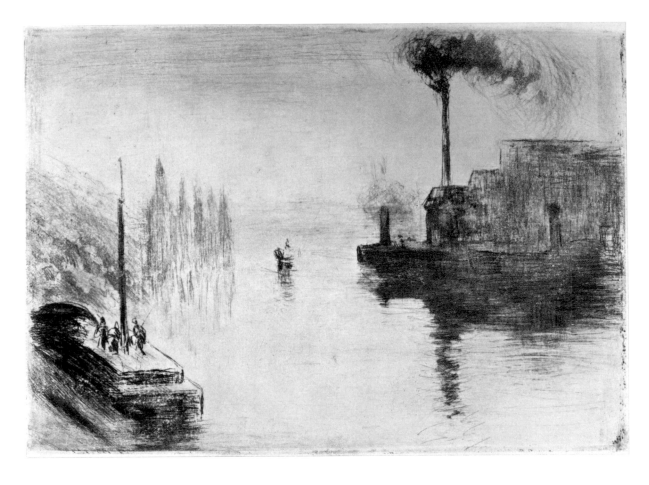

P. 67, 68

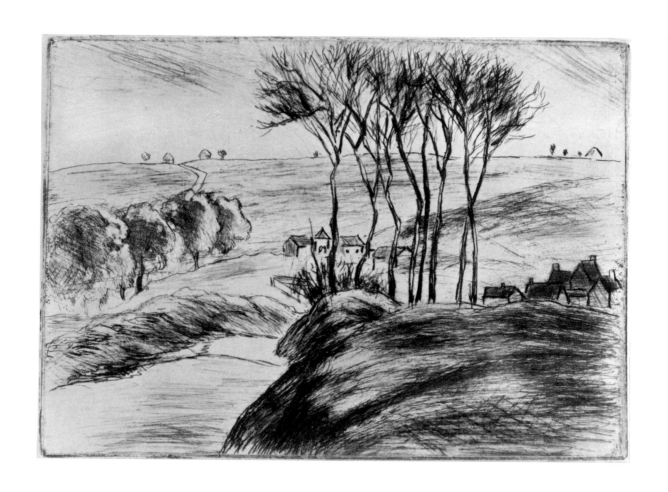

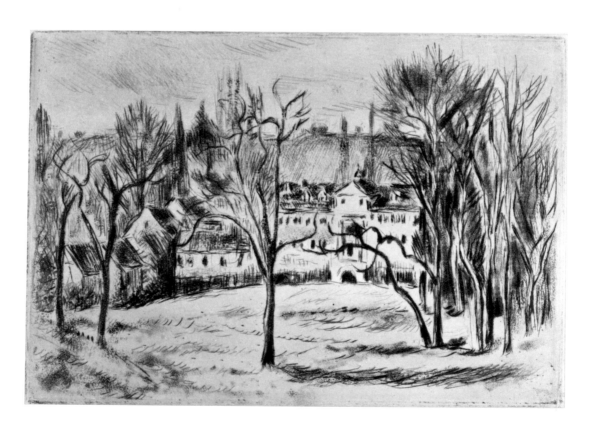

P. 69, 70

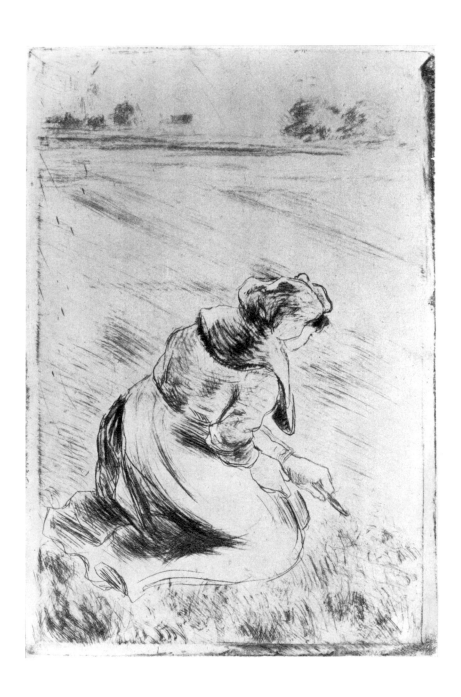

P. 71, 72

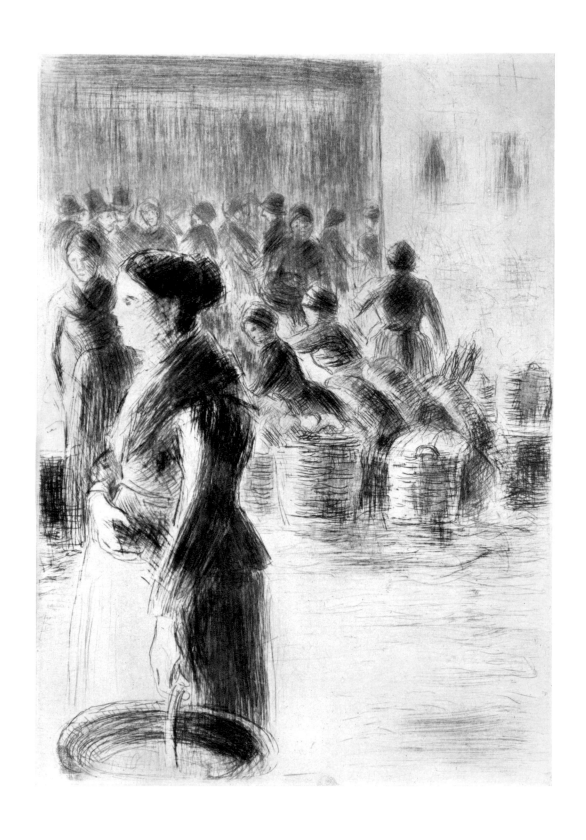

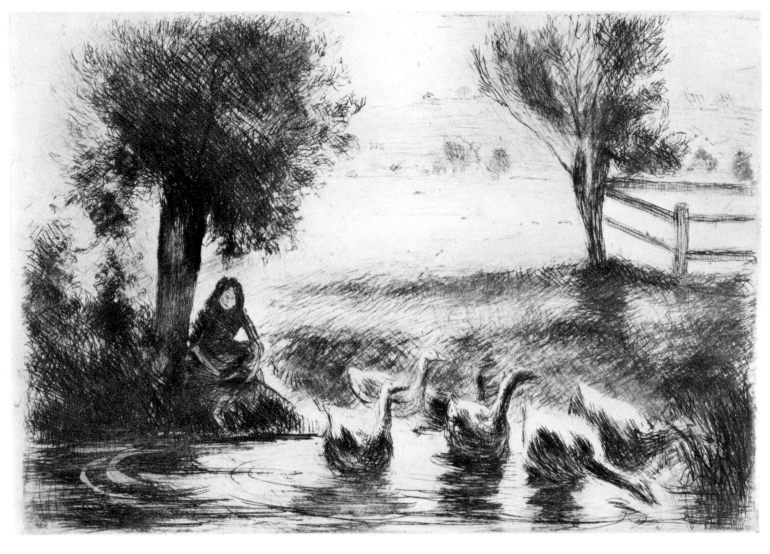

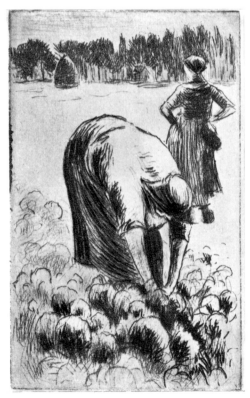

P. 74, 75, 76

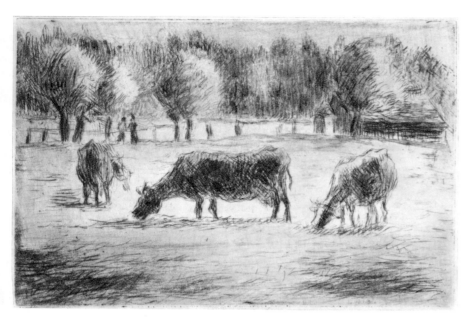

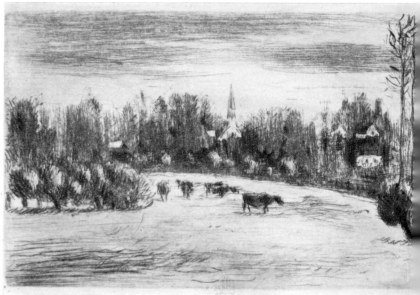

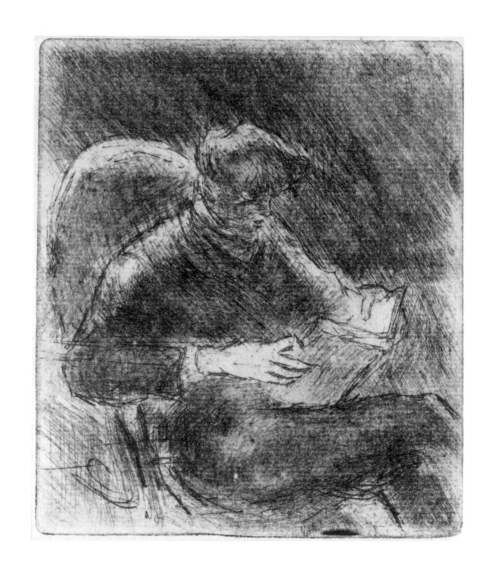

P, 77, 78, 79

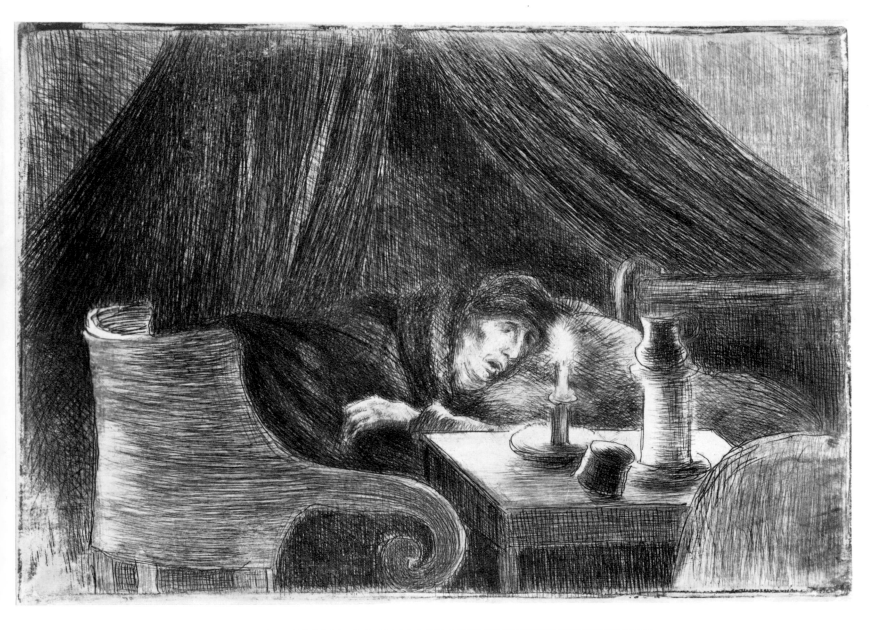

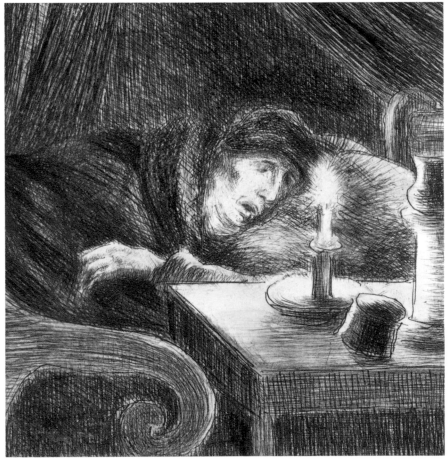

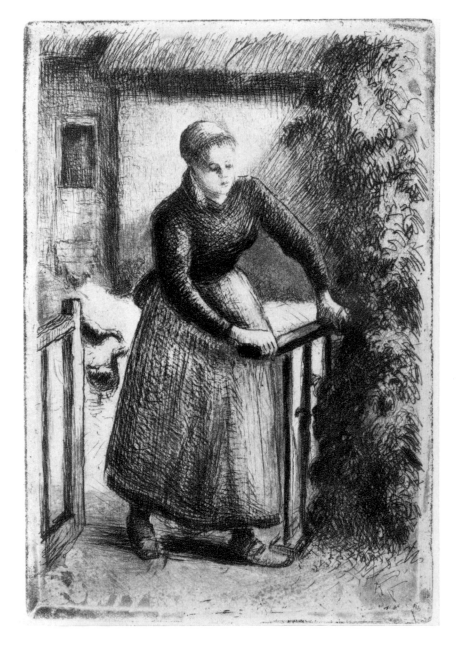

P. 81, 82, 83

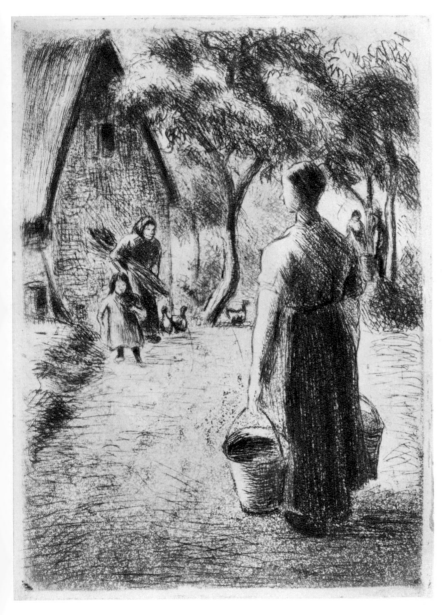

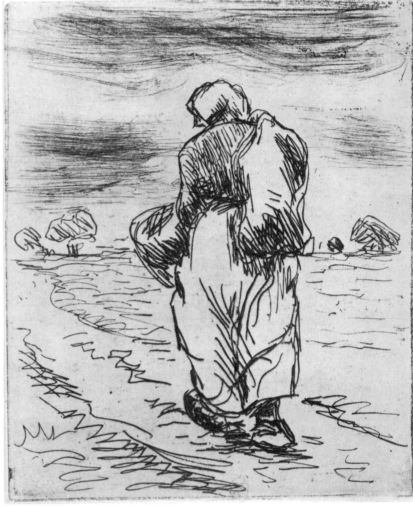

P. 84, 85

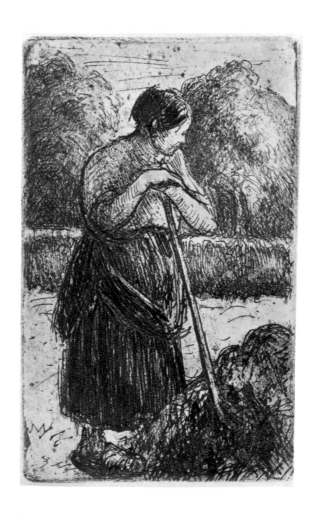

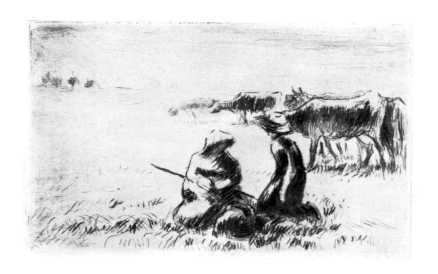

P. 86, 87, 88

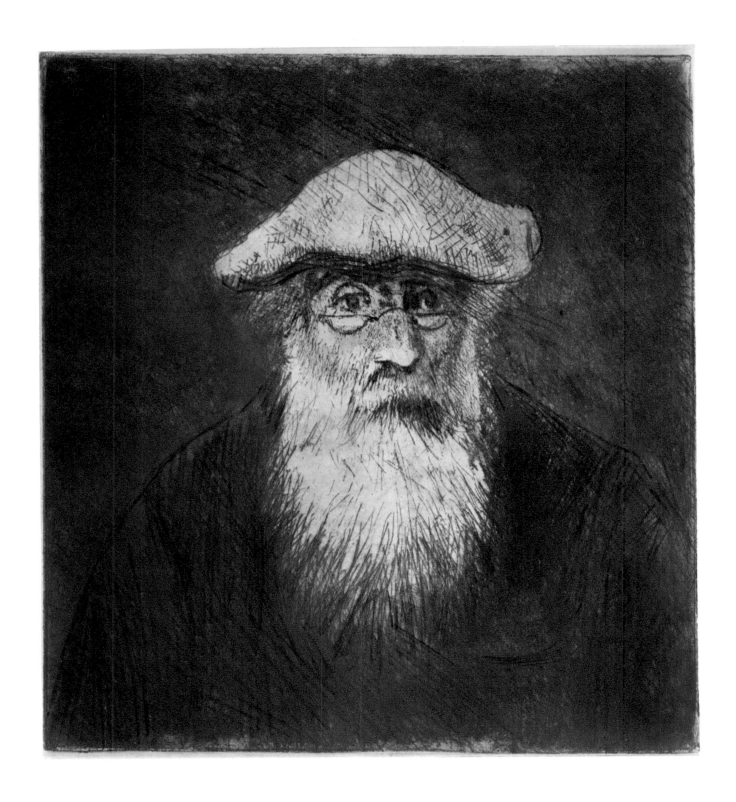

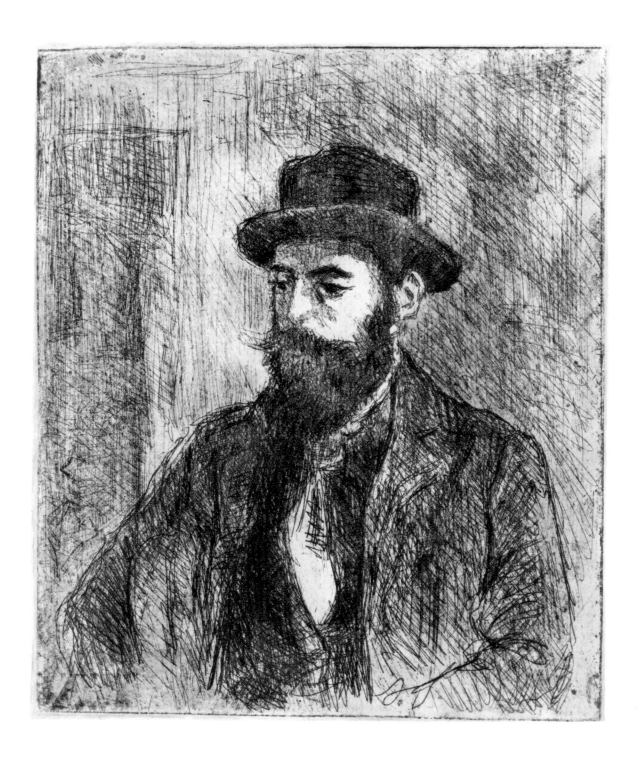

P. 90

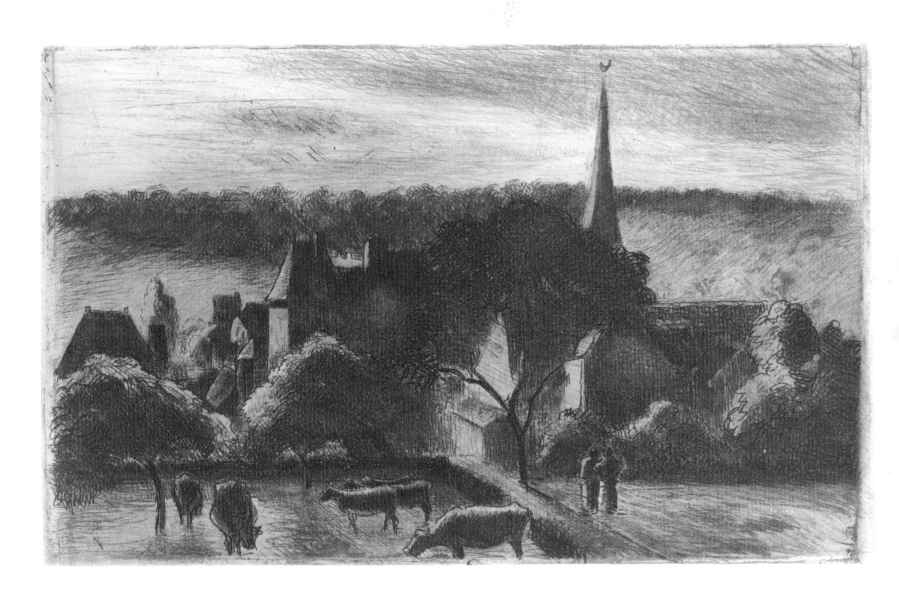

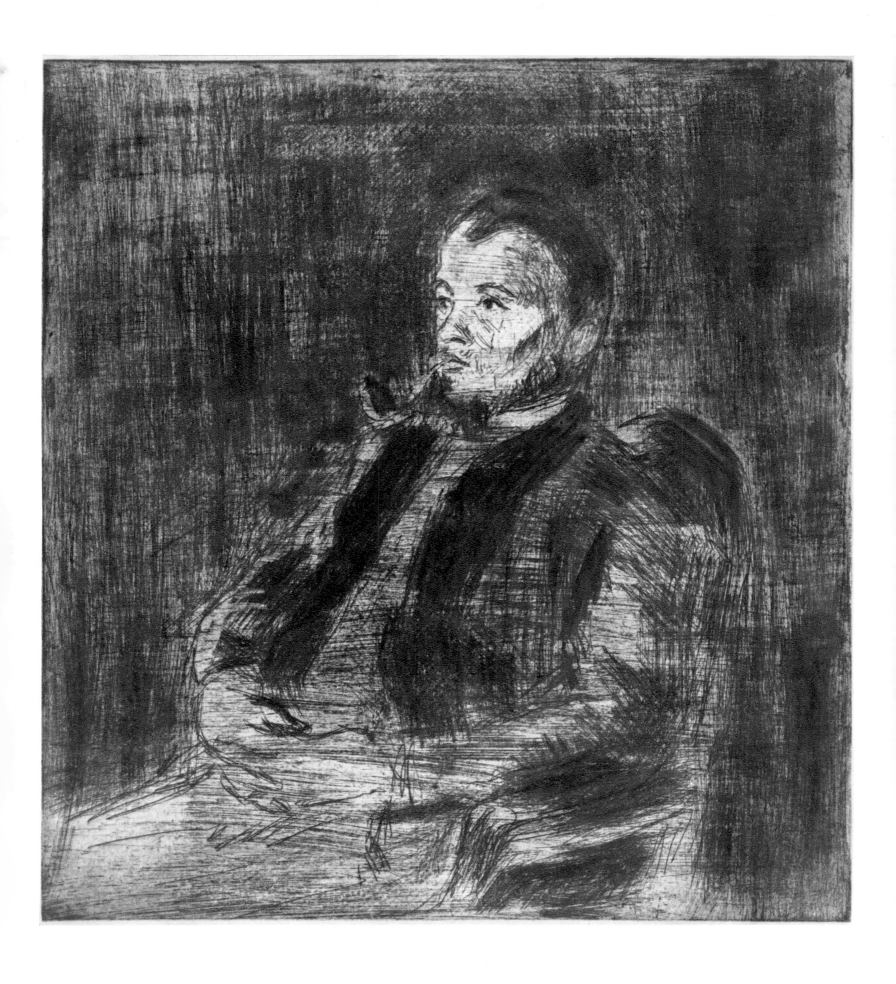

P. 92

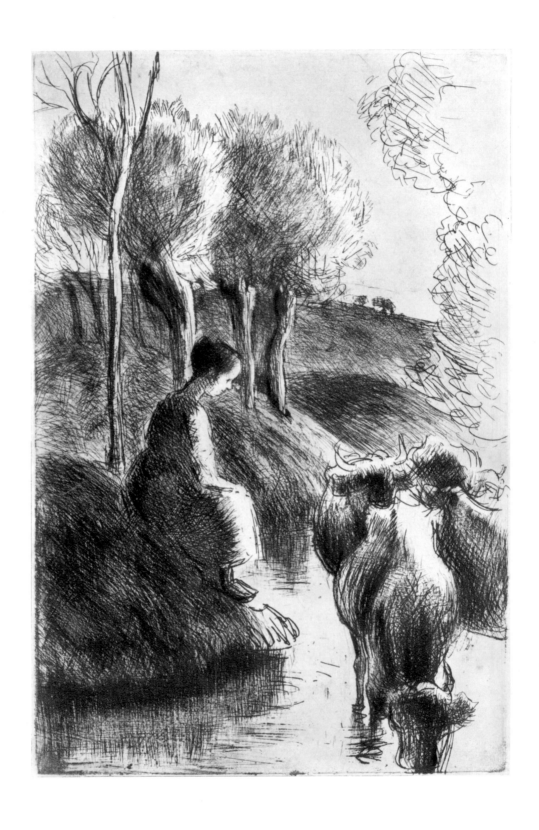

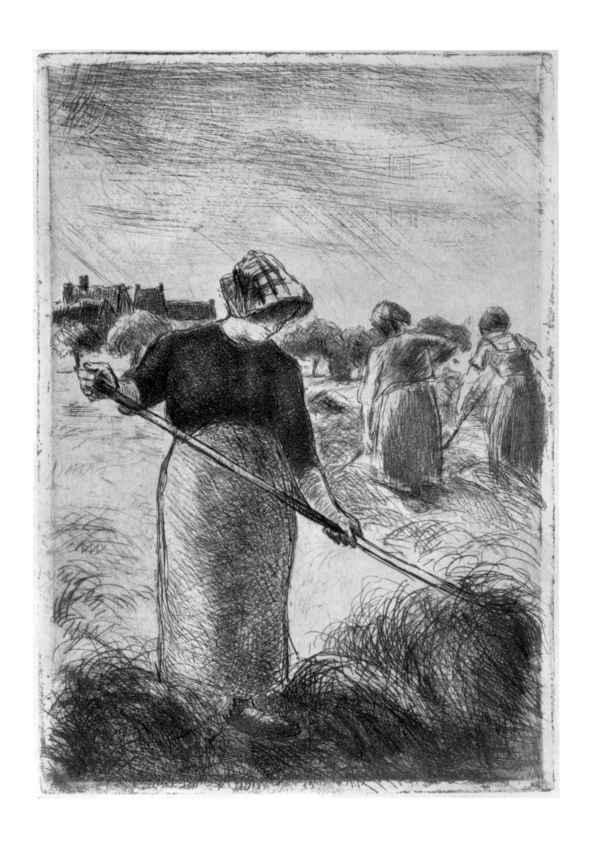

P. 94

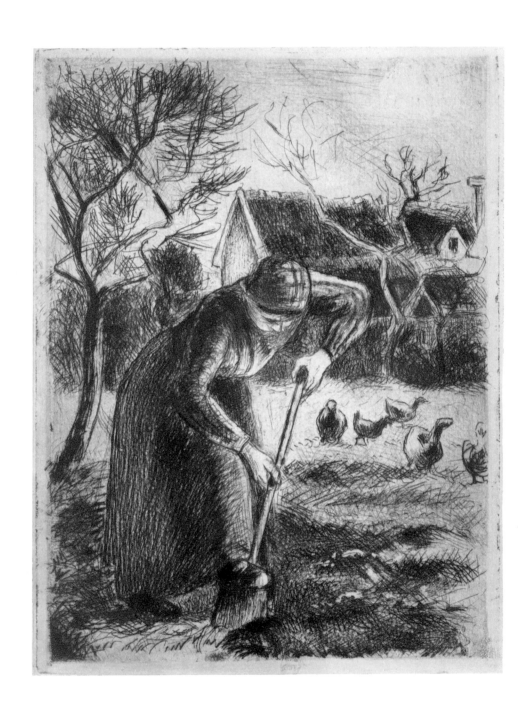

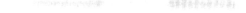

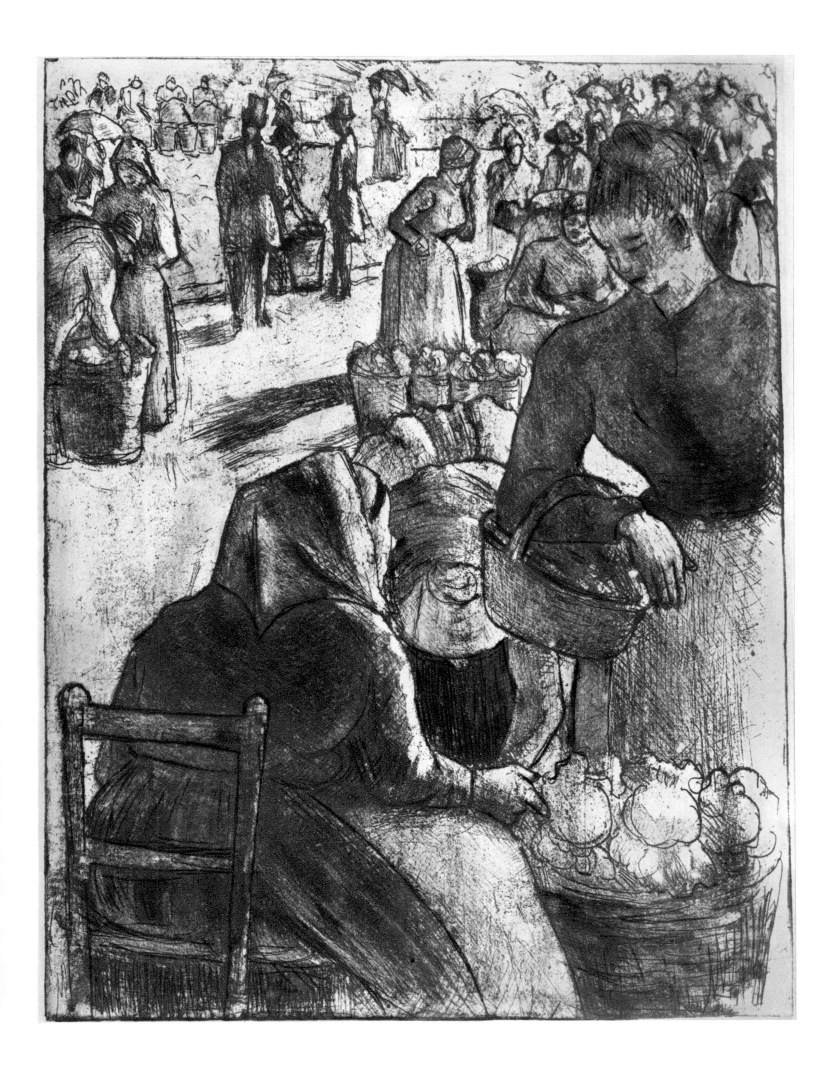

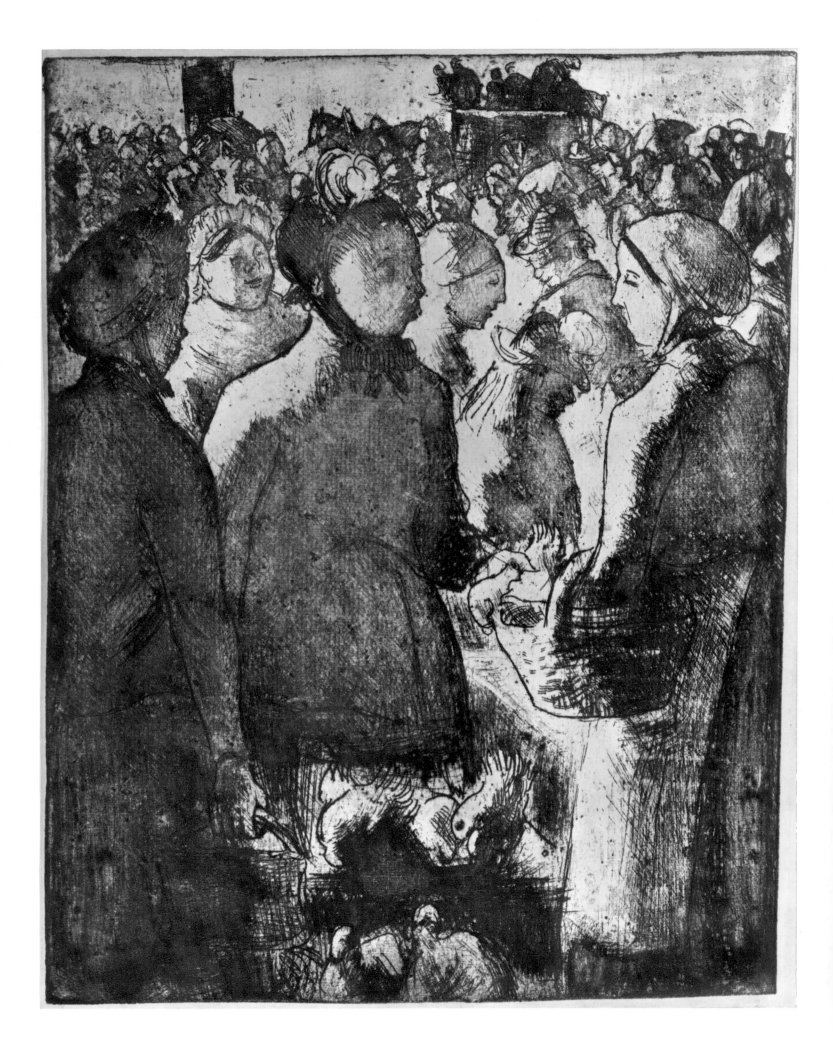

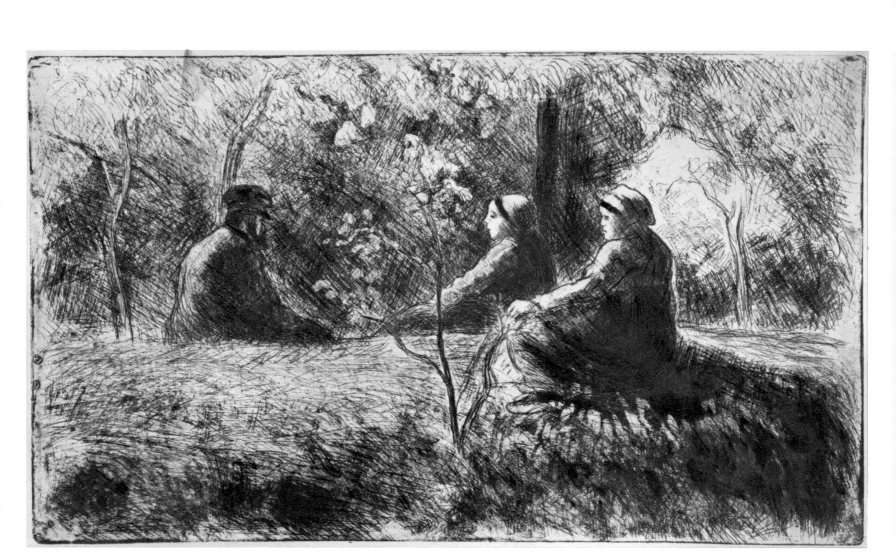

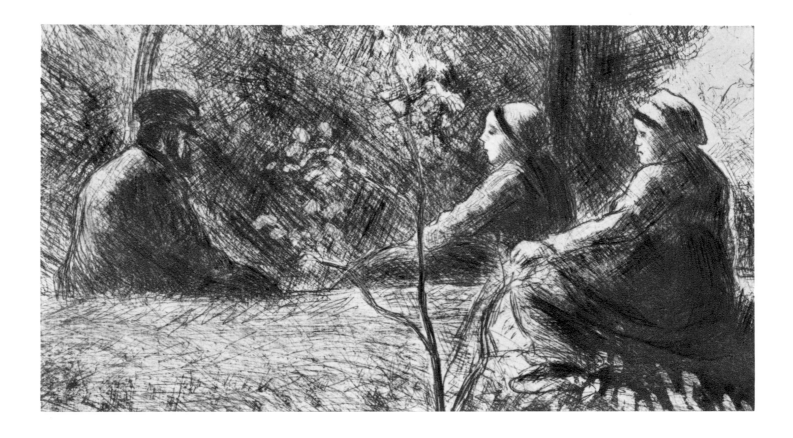

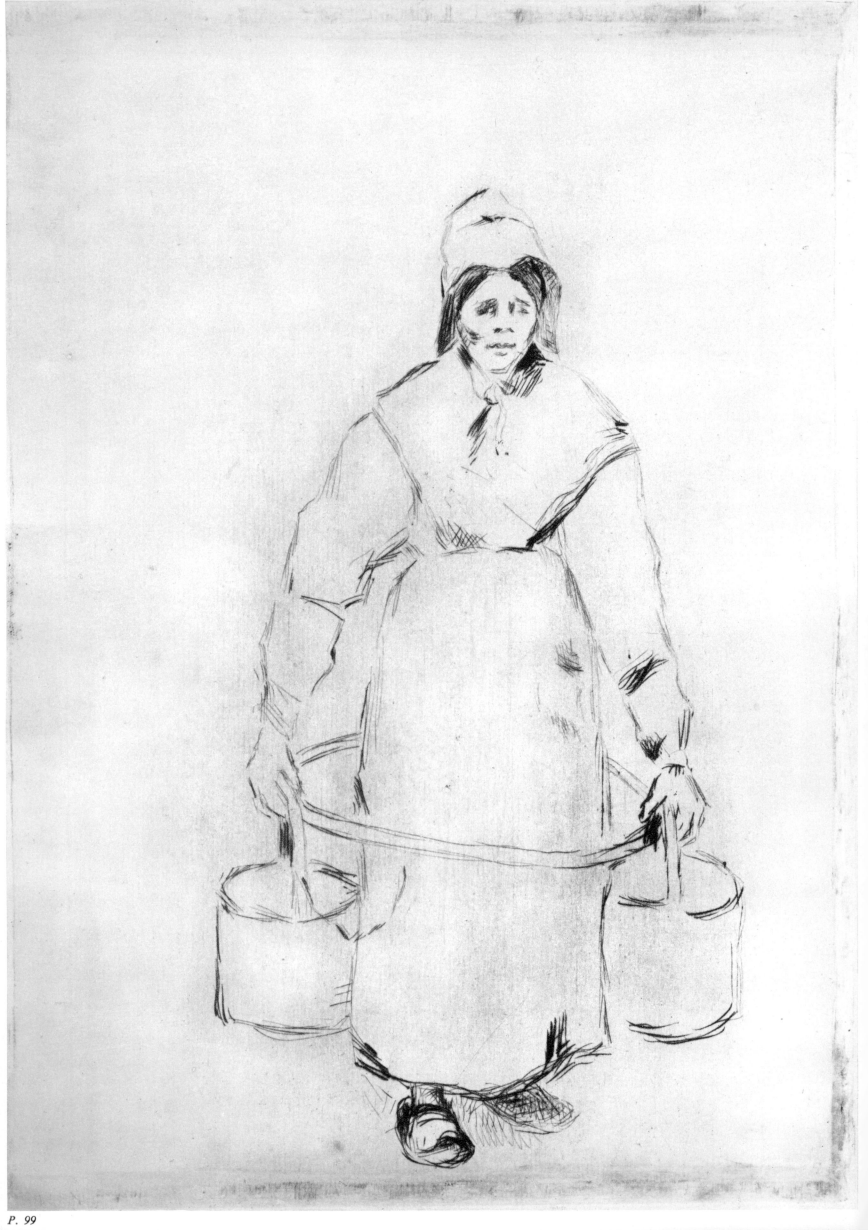

P. 99

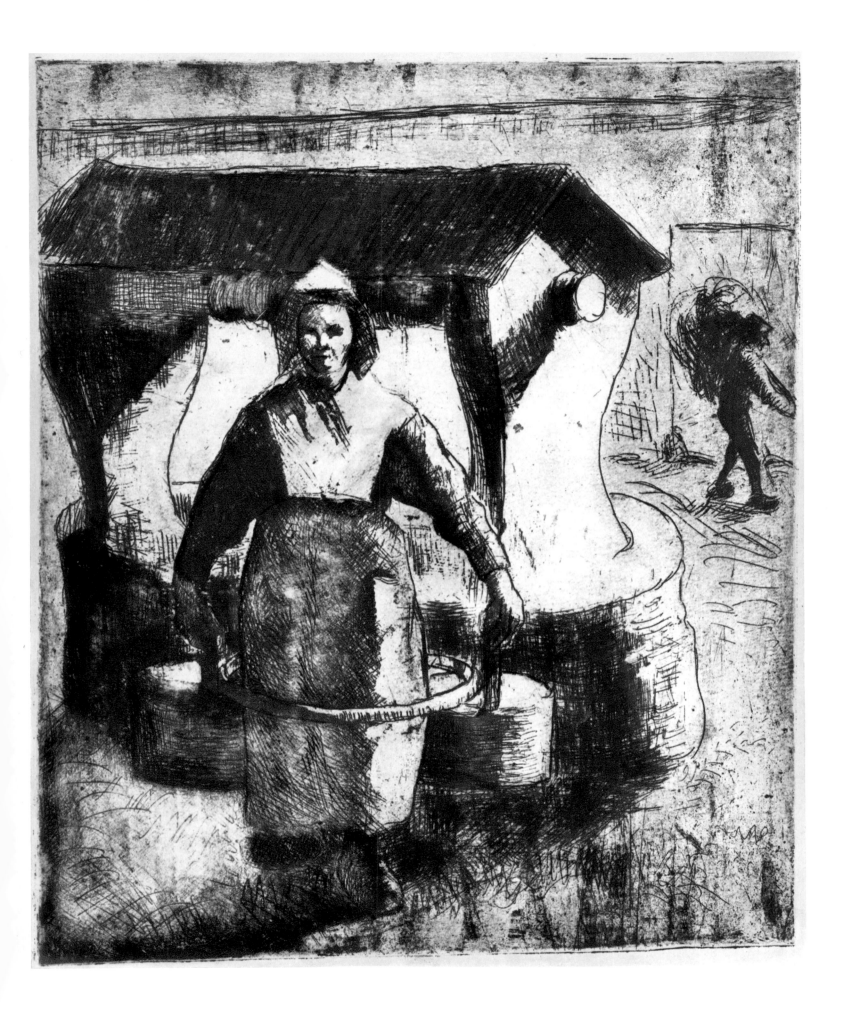

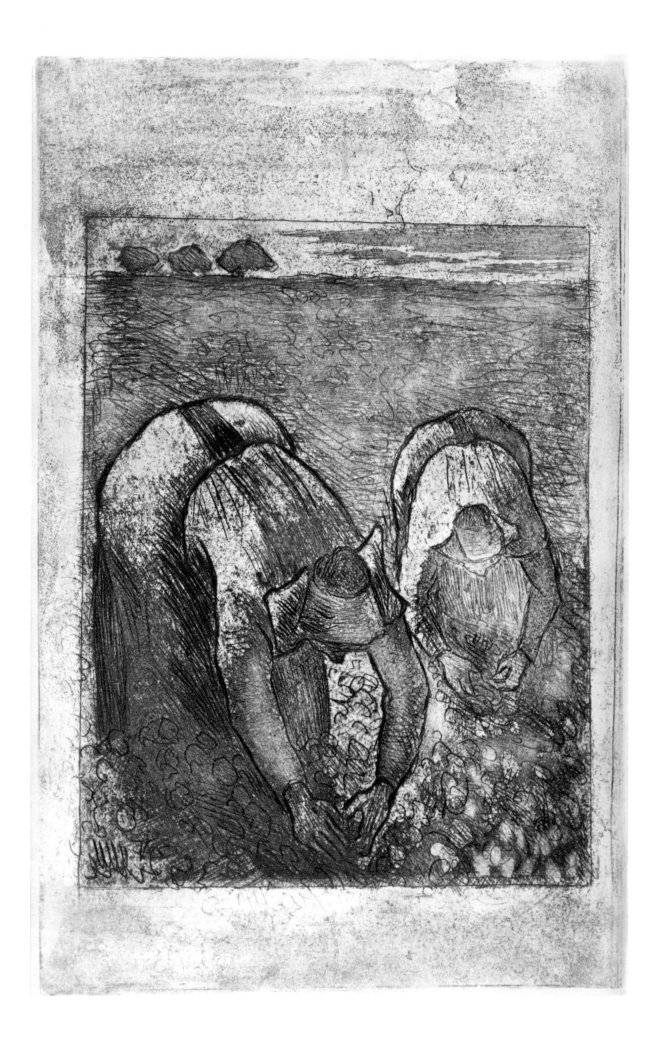

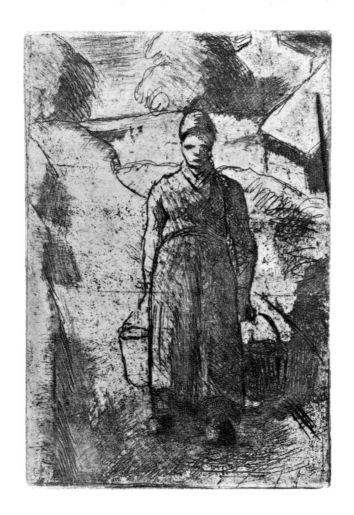

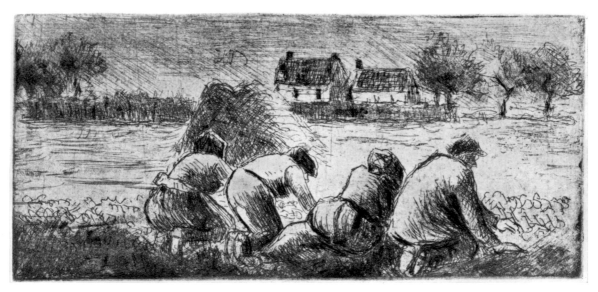

P. 102, 103, 104

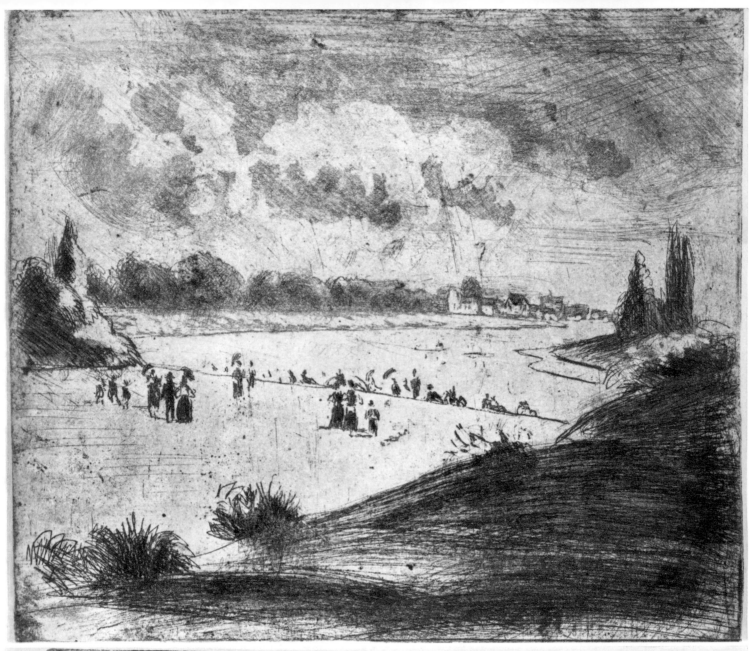

P. 105, 106

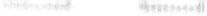
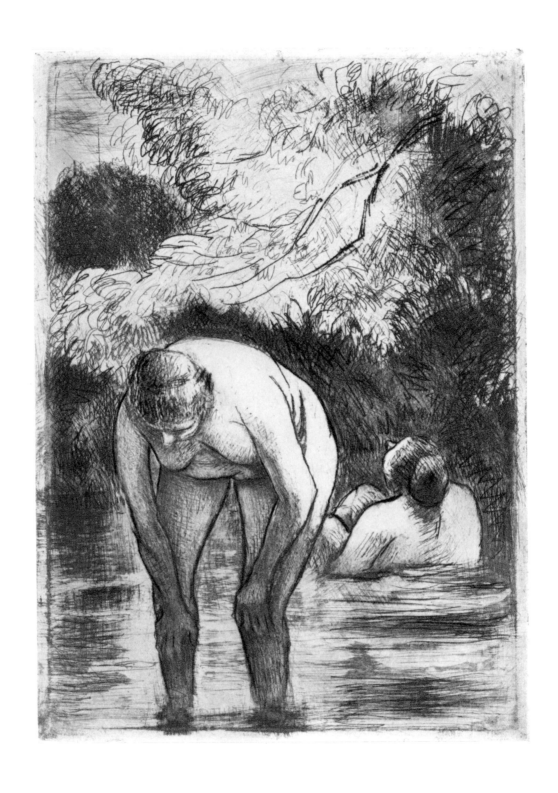

P. 107

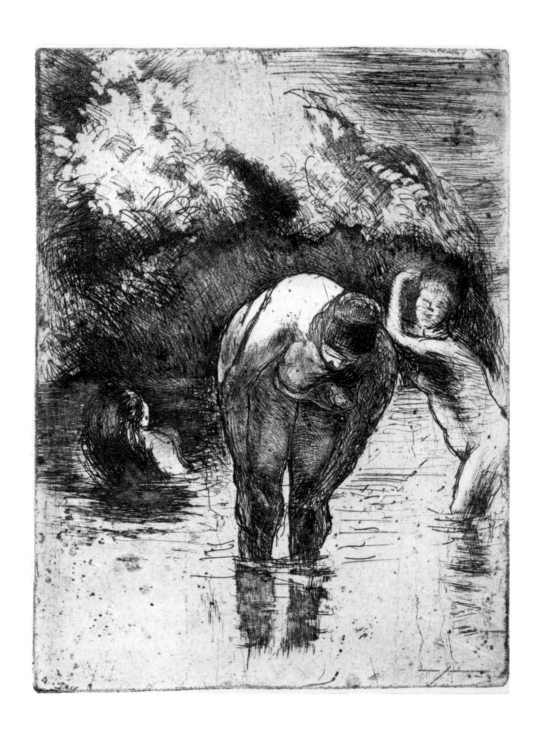

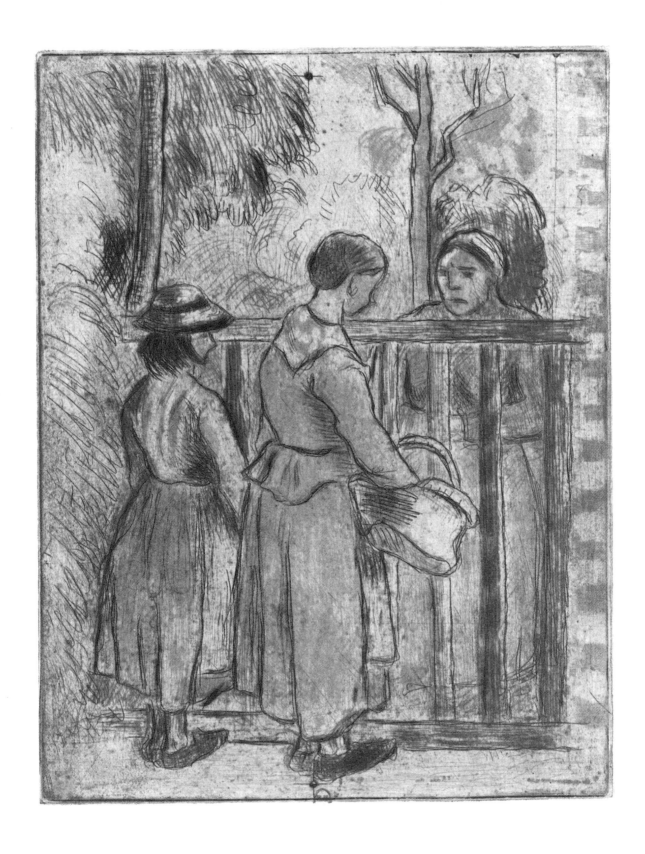

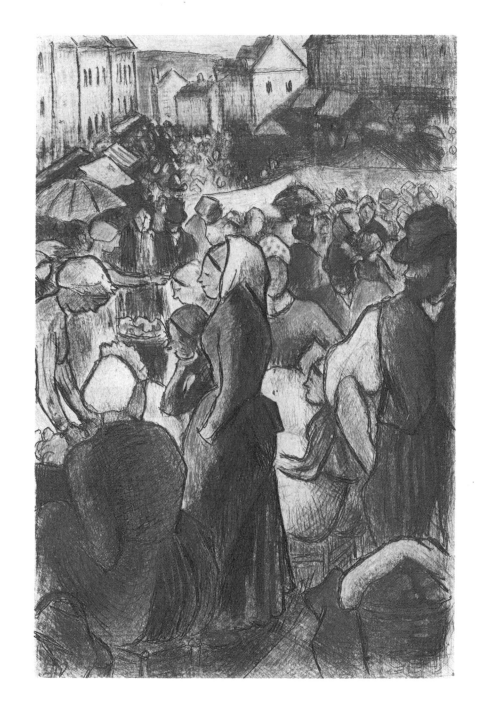

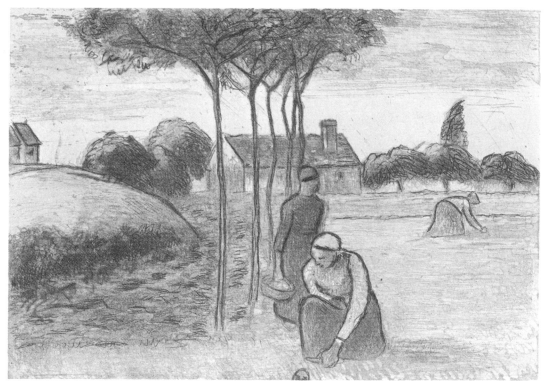

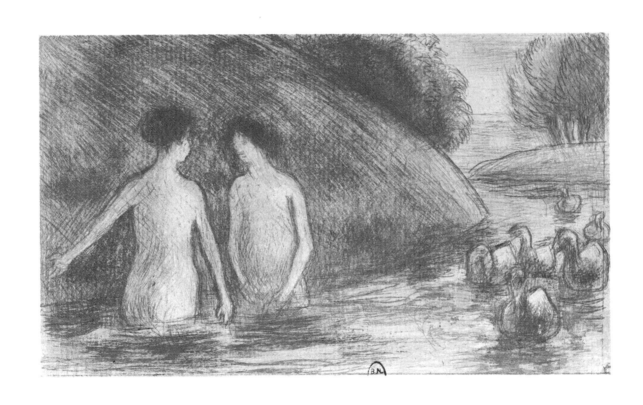

P. 114

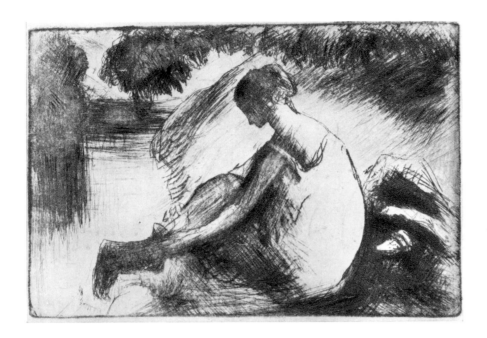

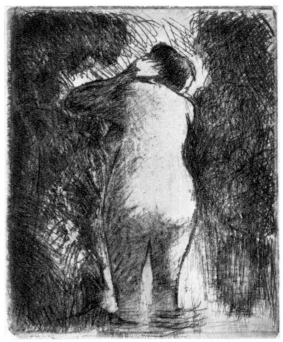

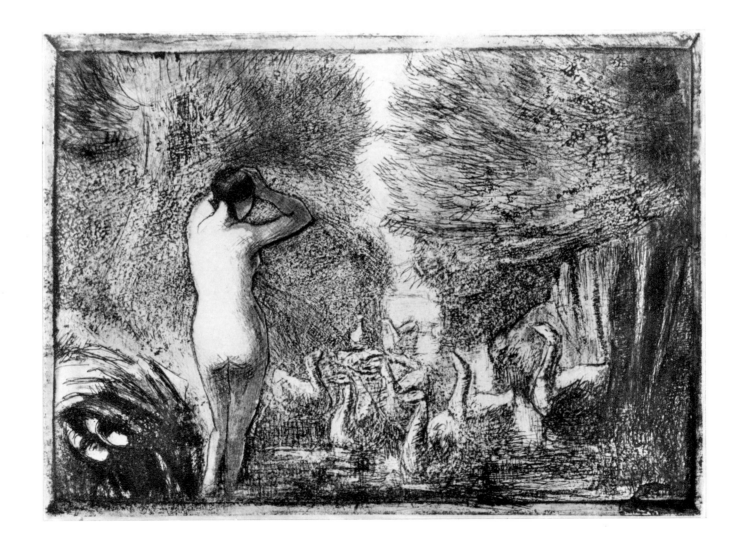

P. 115, 116, 117

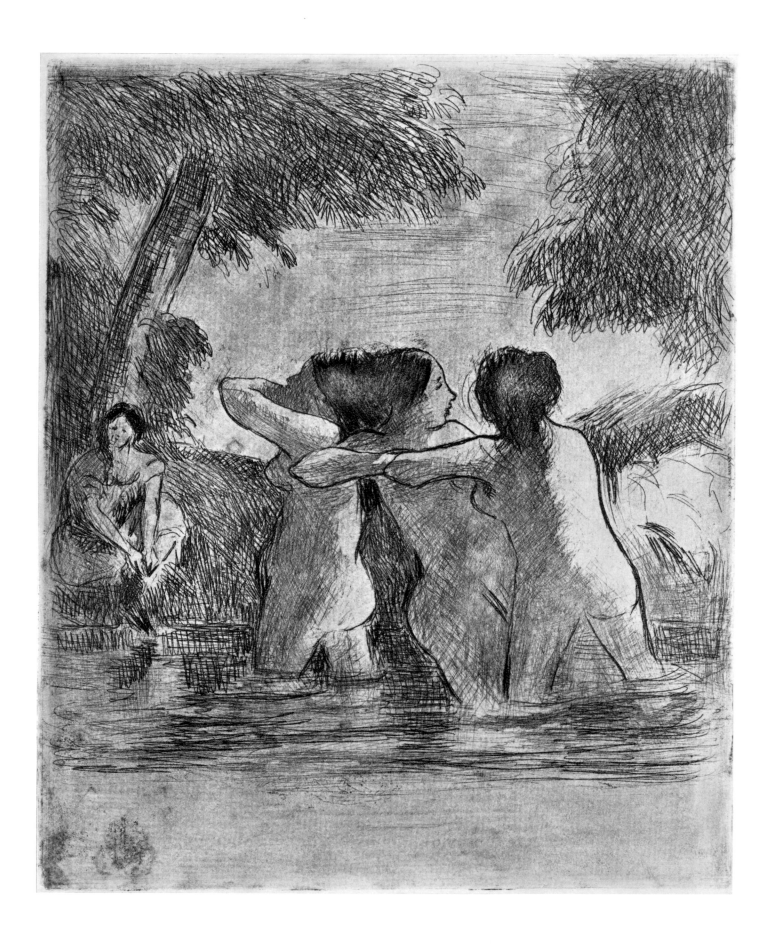

P. 118

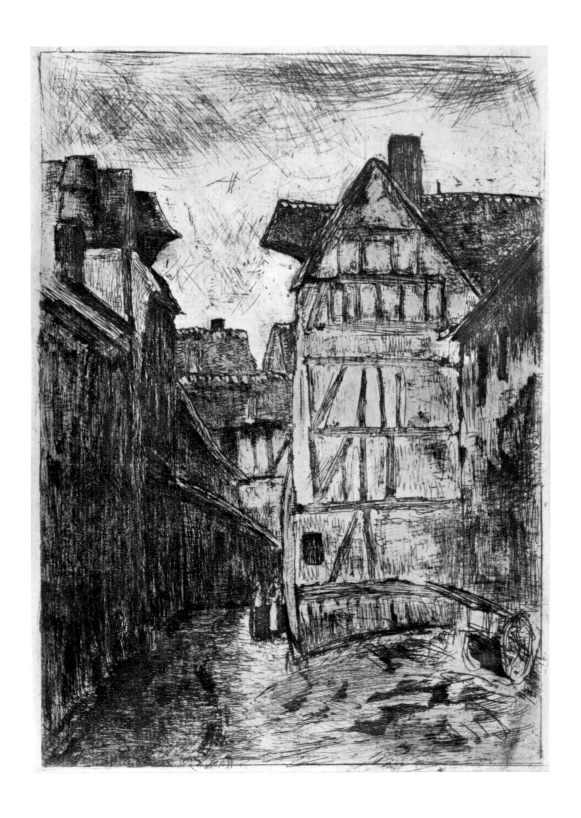

P. 119

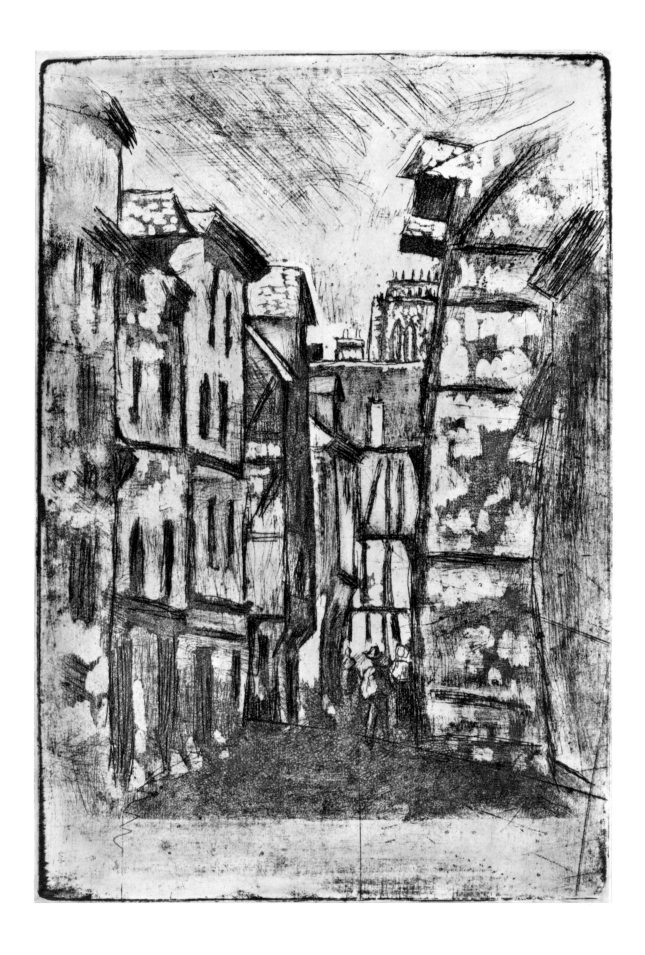

P. 120

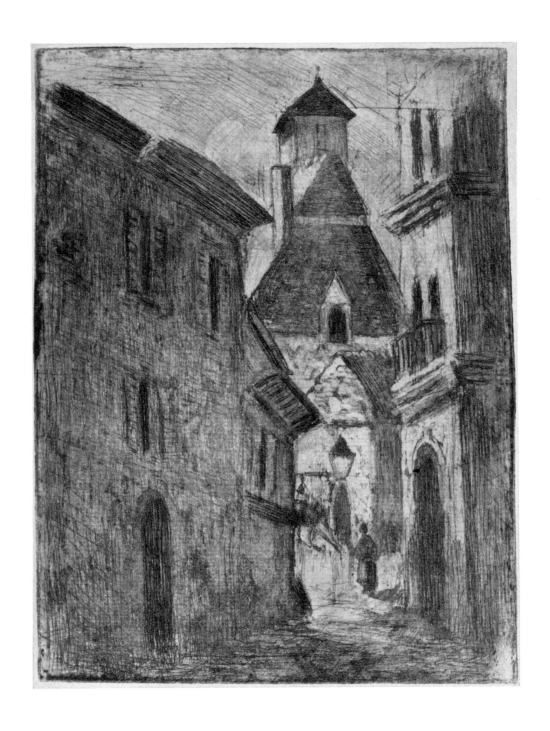

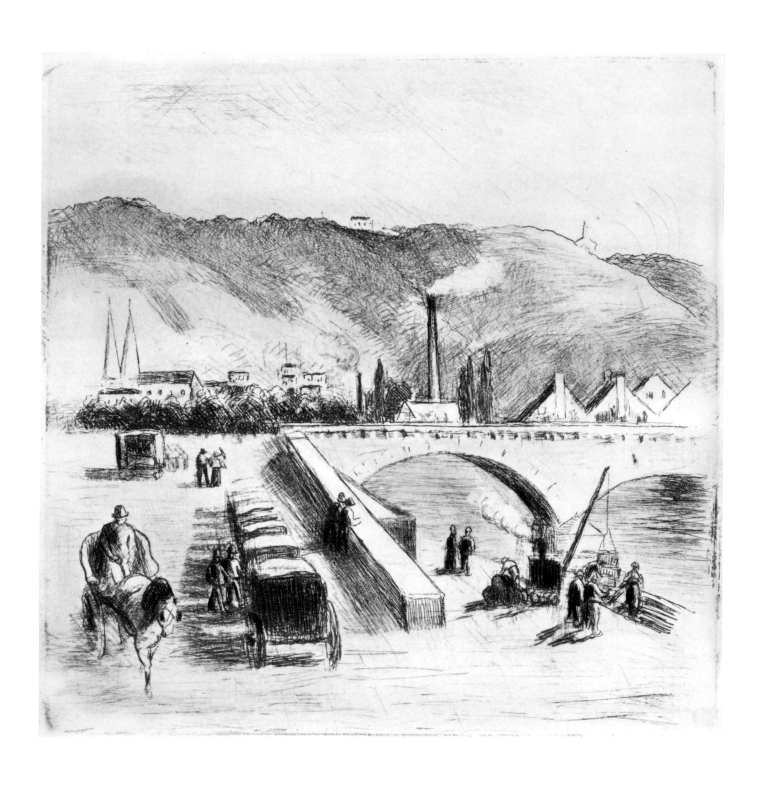

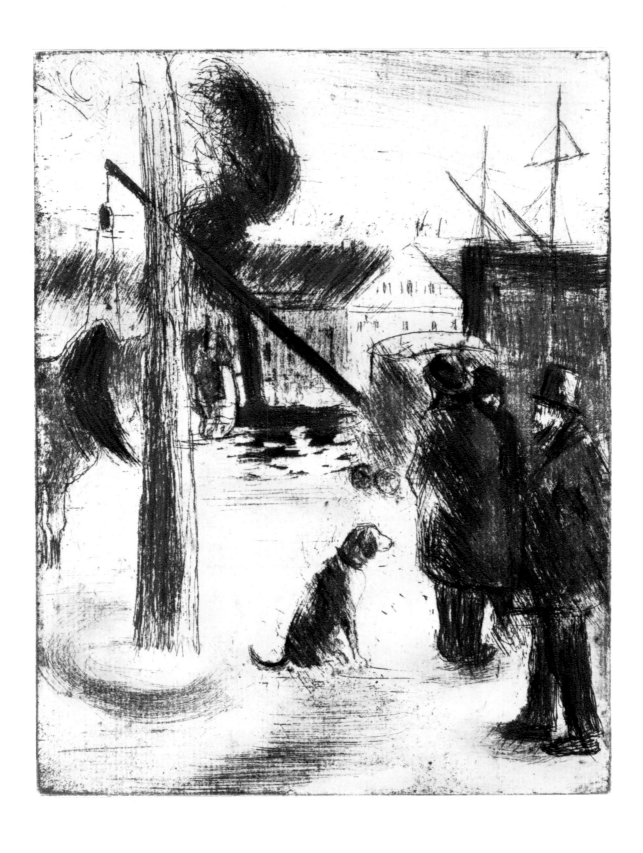

P. 123

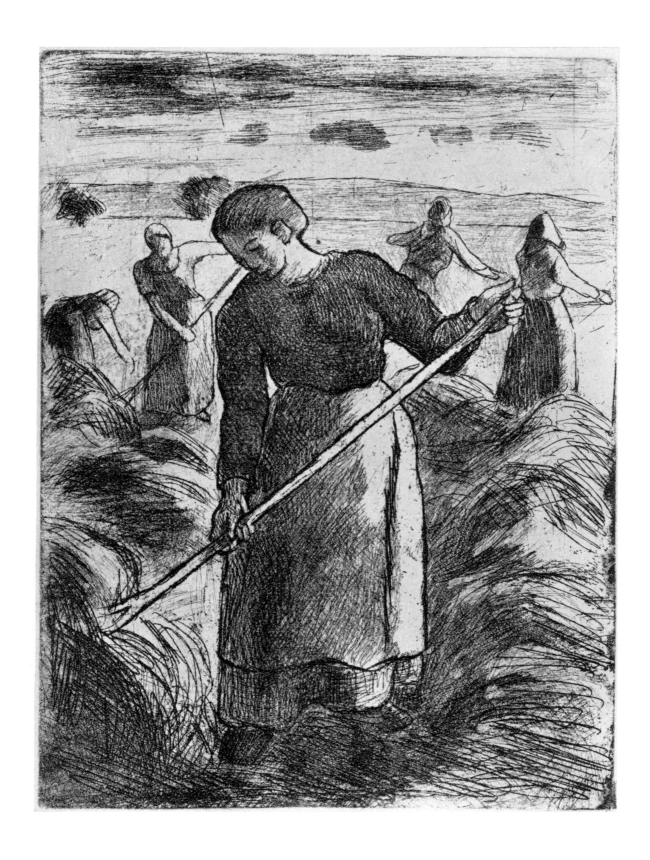

P. 125

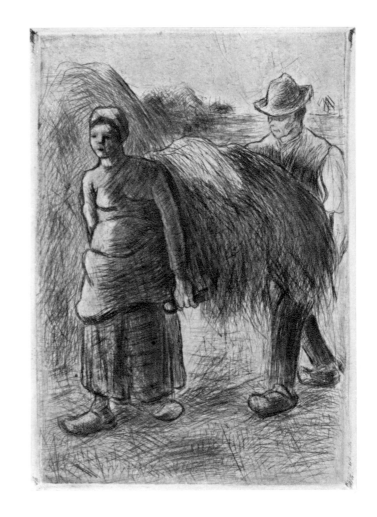

P. 126, 127

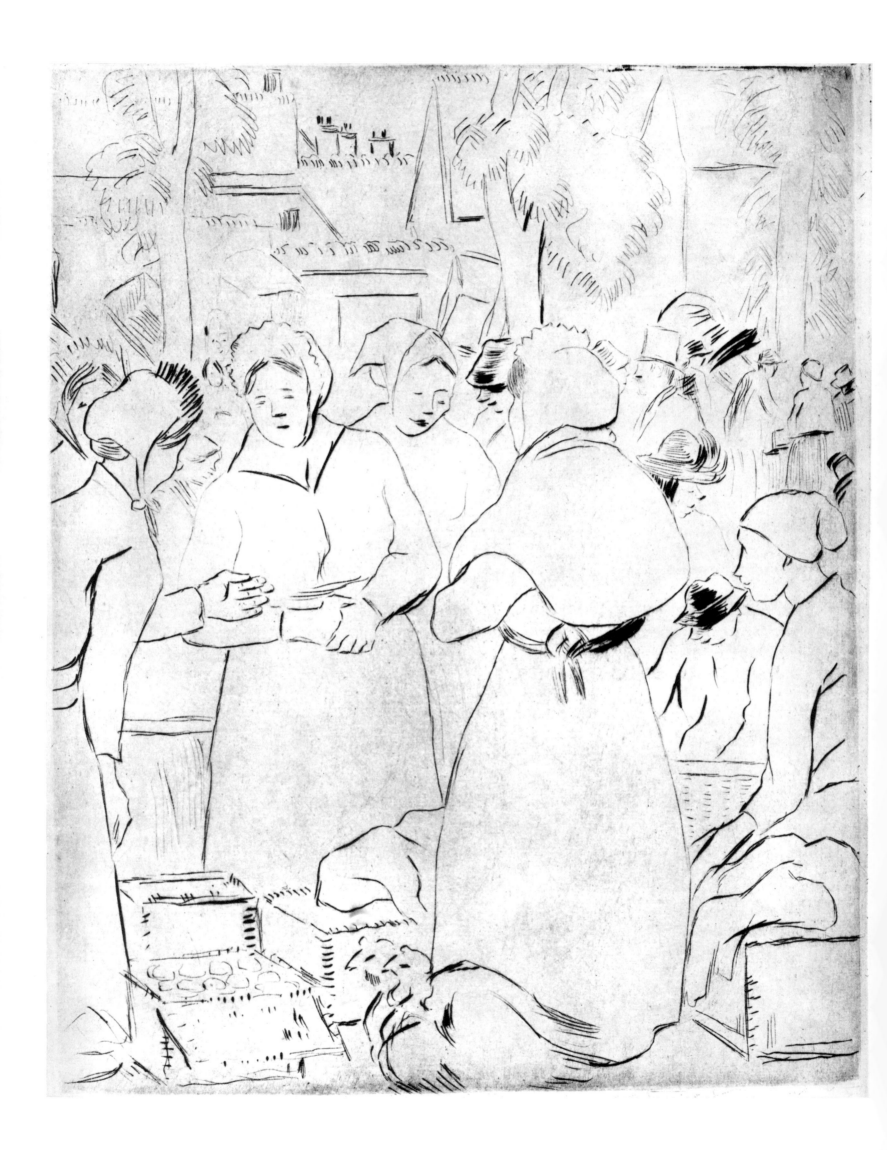

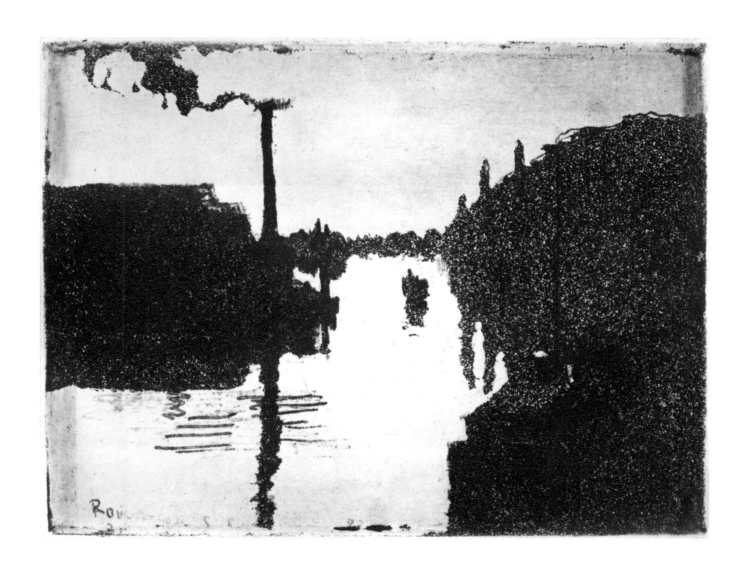

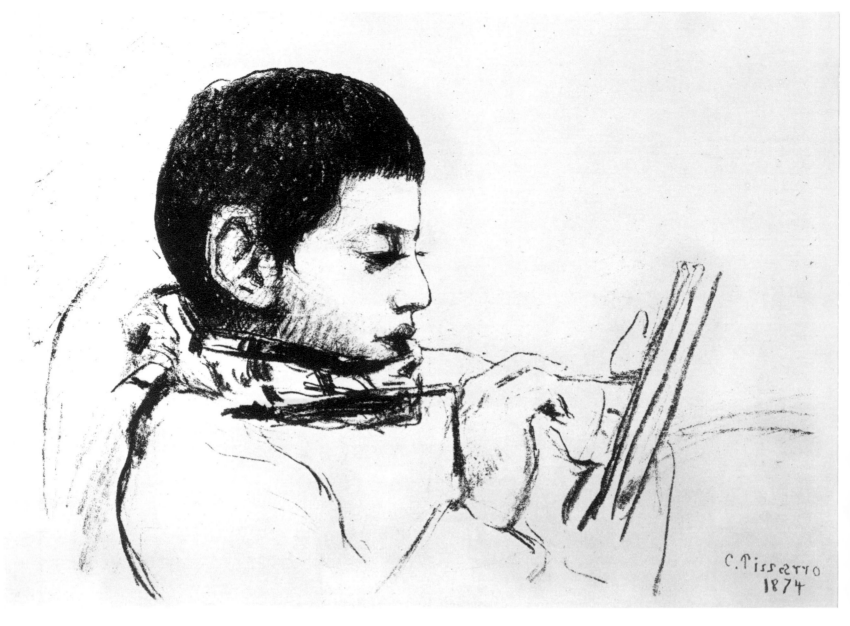

C. Pissarro
1874

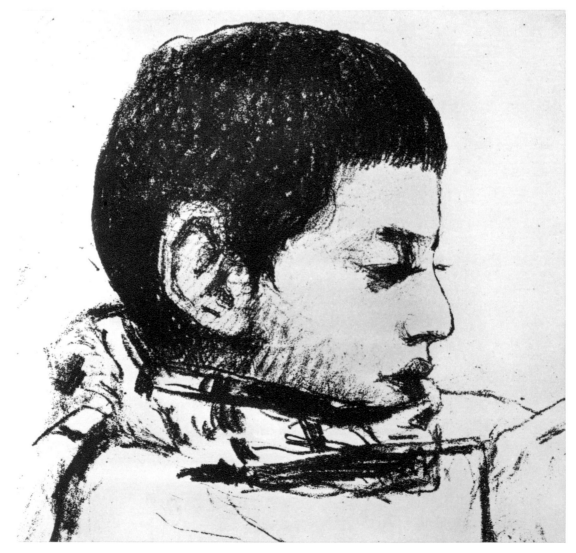

P. 133

3 Fev. 1874
C. Pissarro.

C. Pissarro.

P. 134

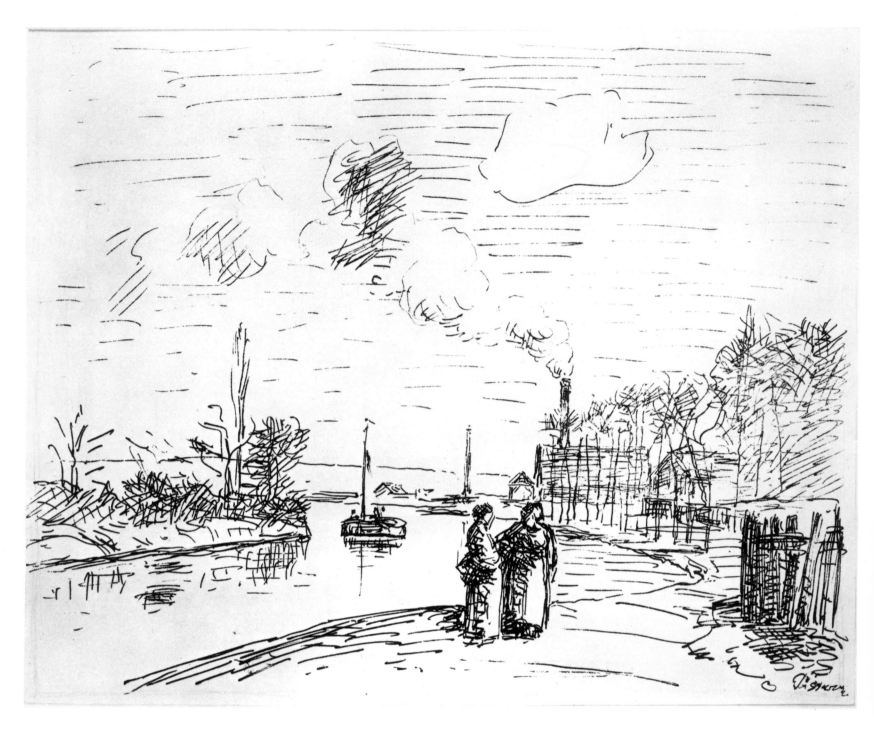

P. 136

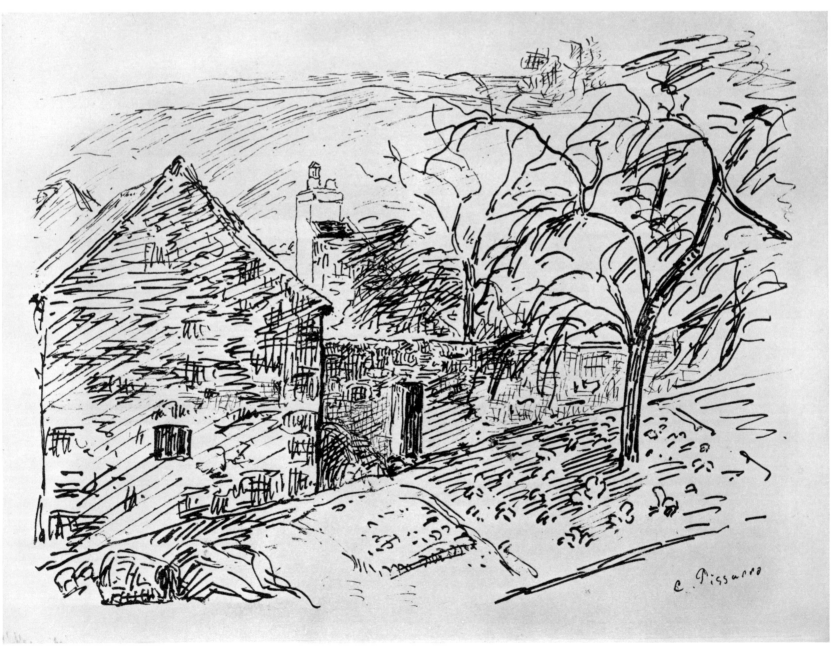

C. Pissarro

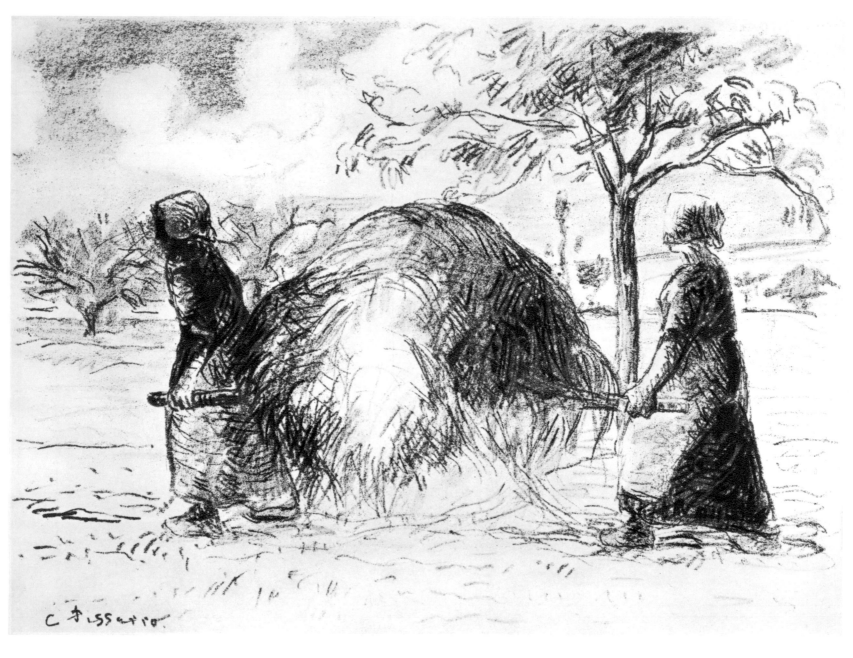

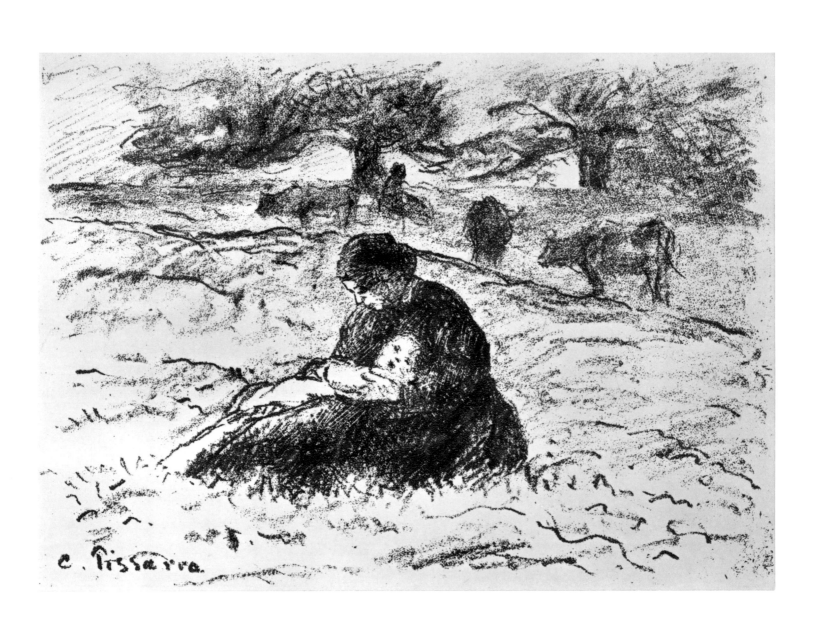

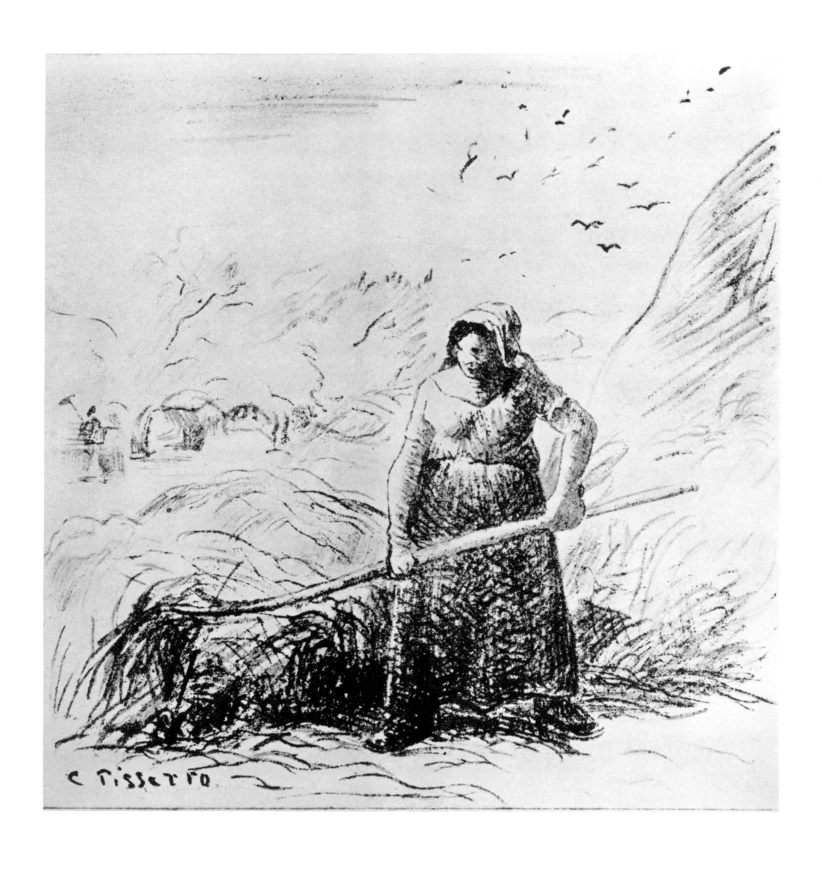

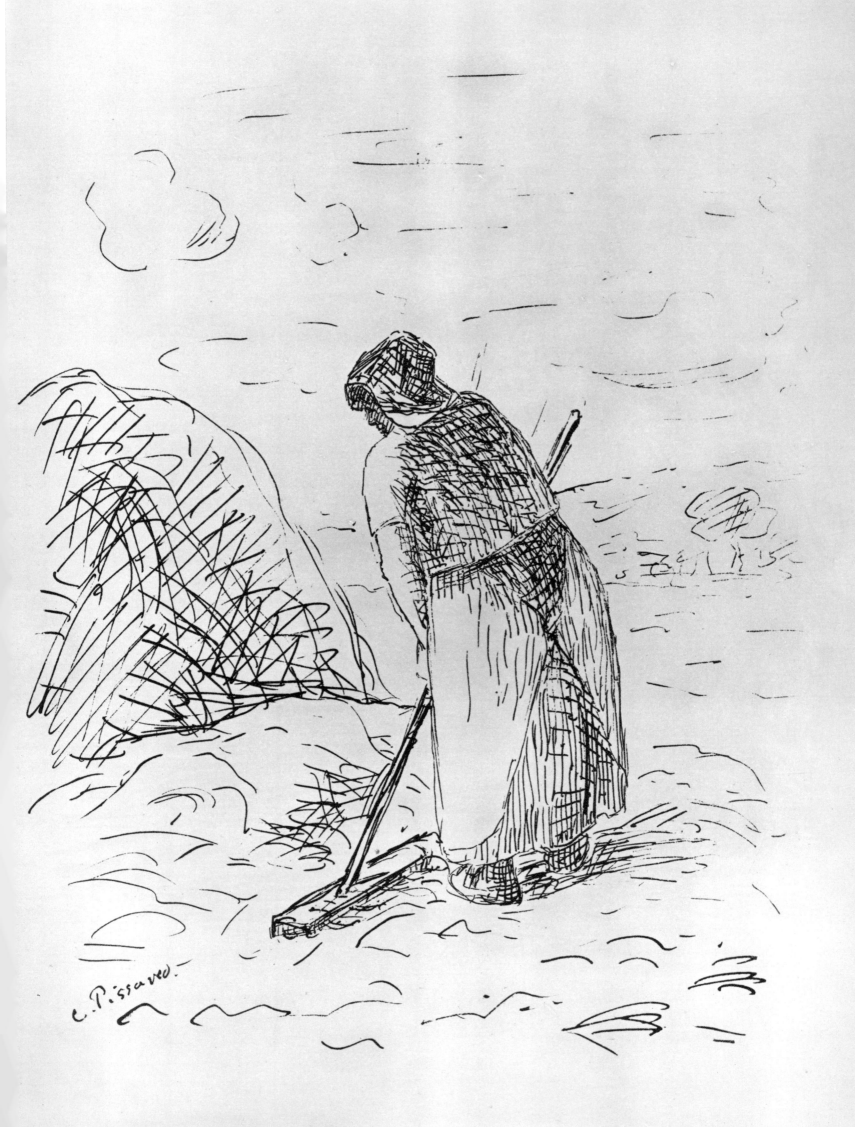

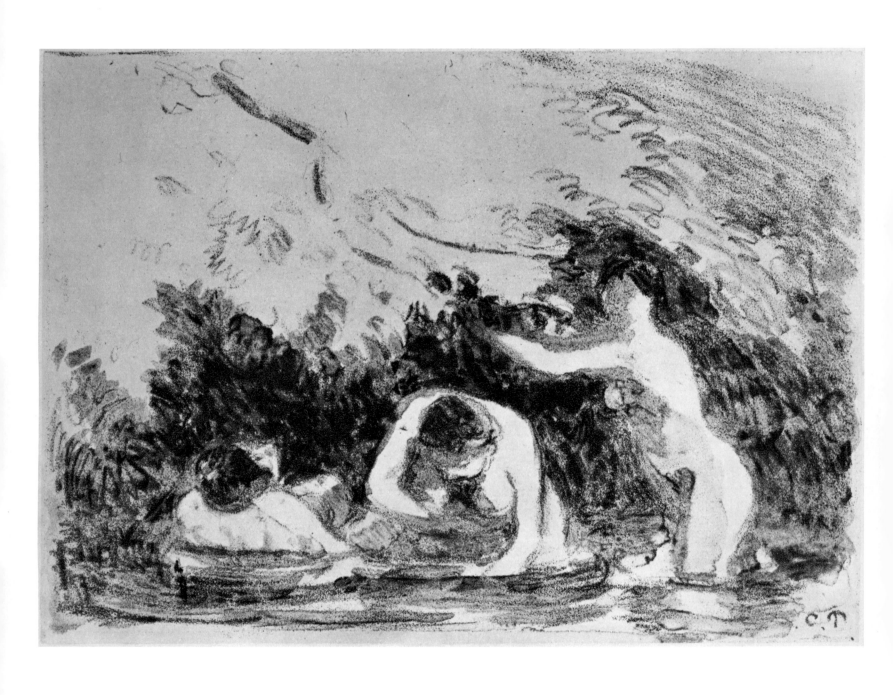

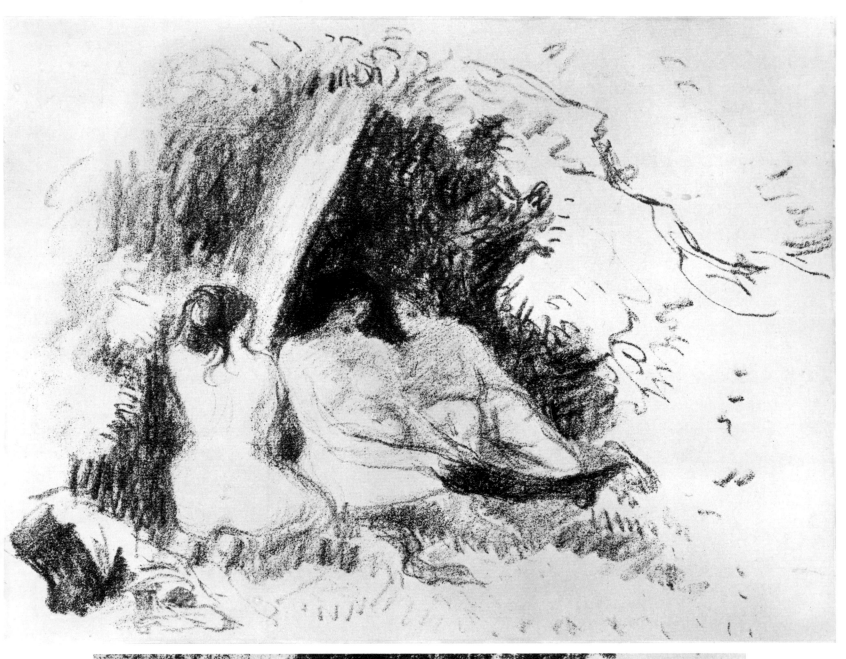

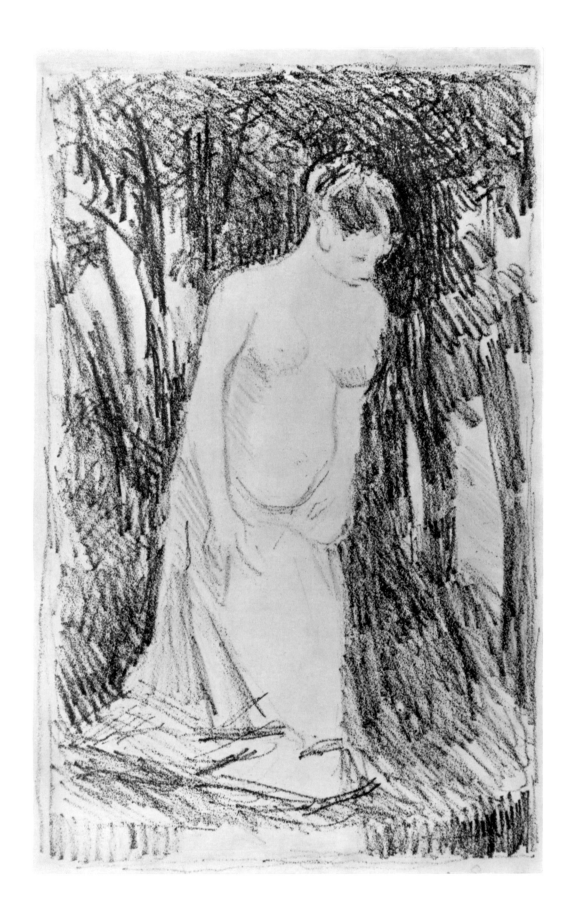

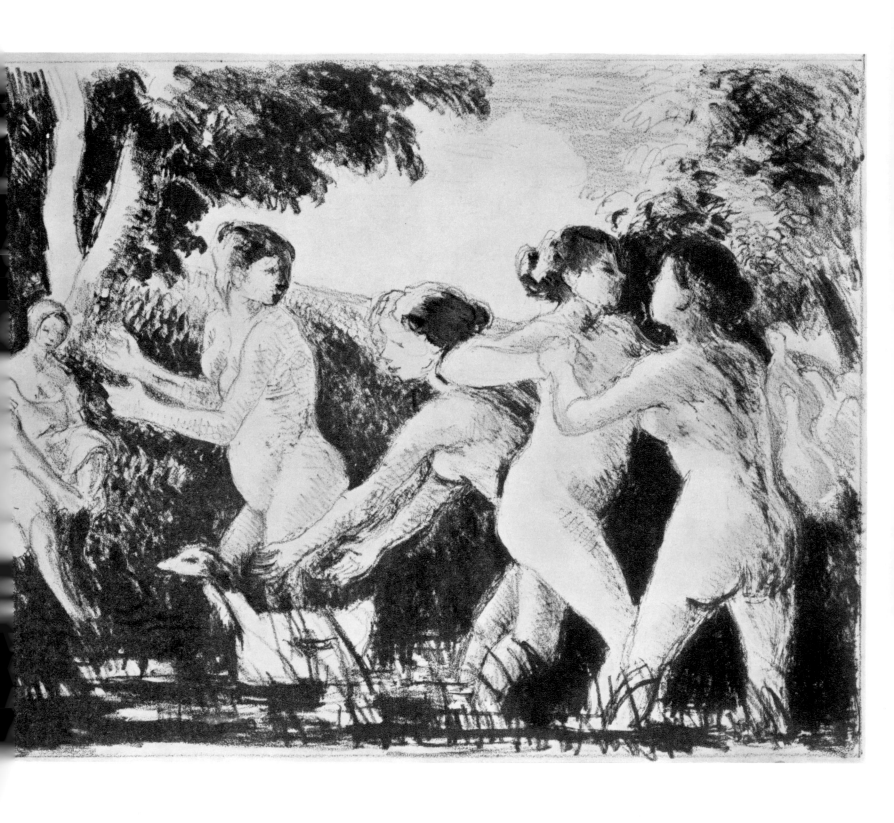

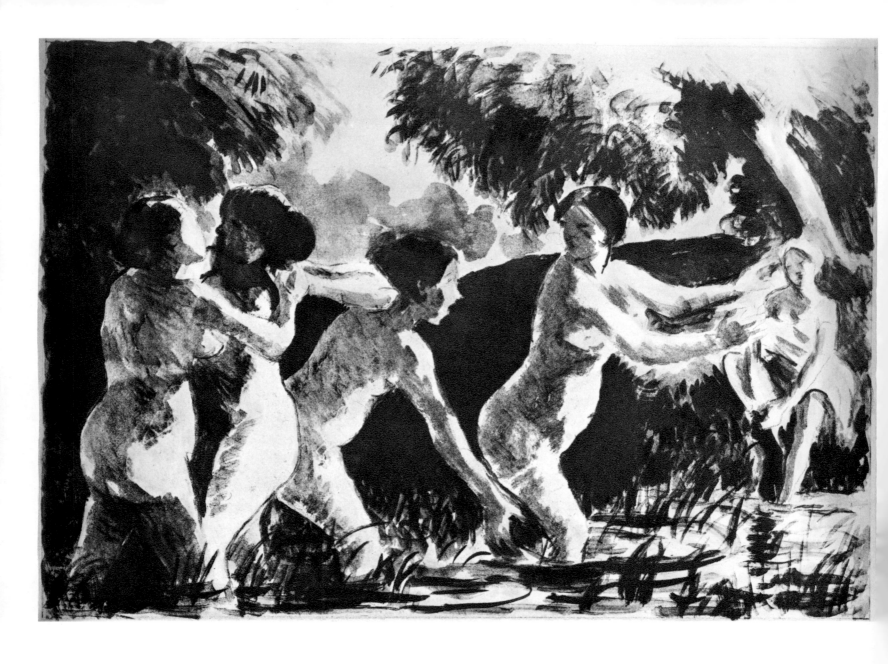

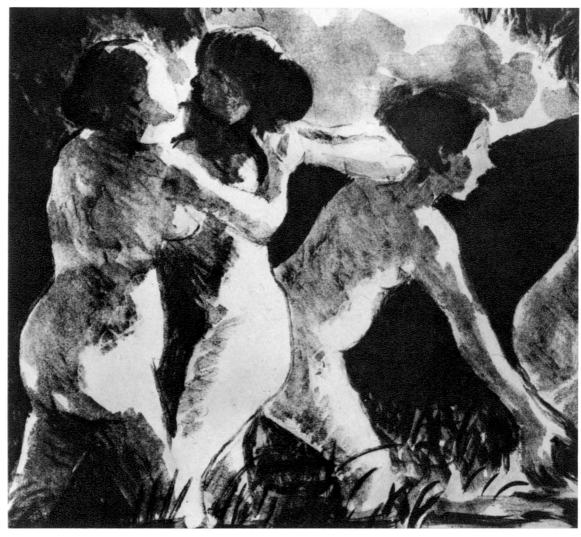

P. 148

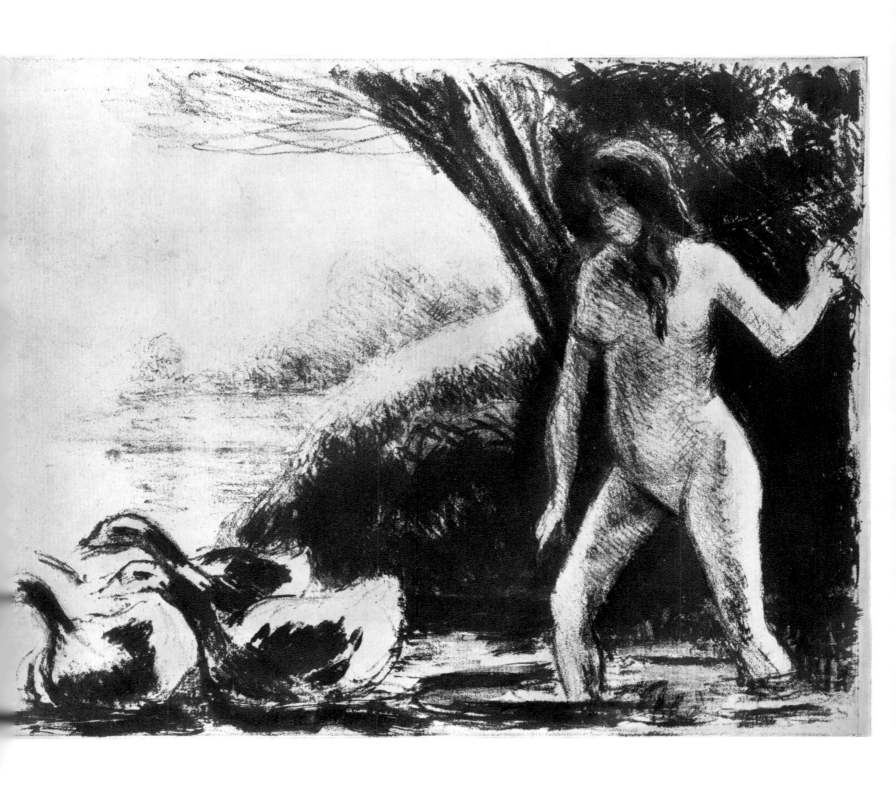

P. 149

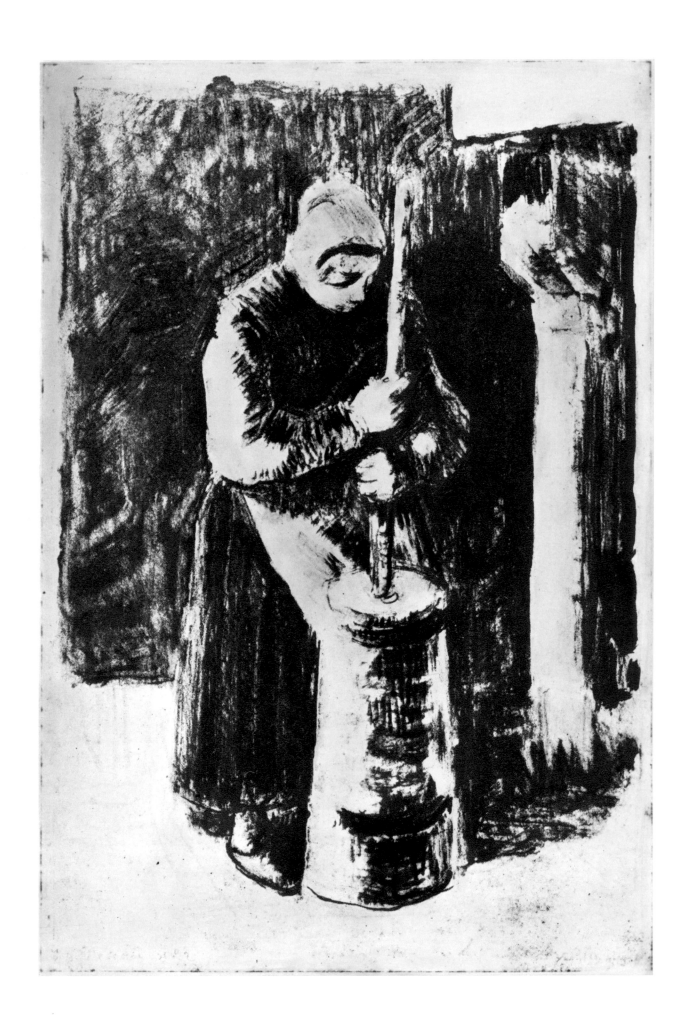

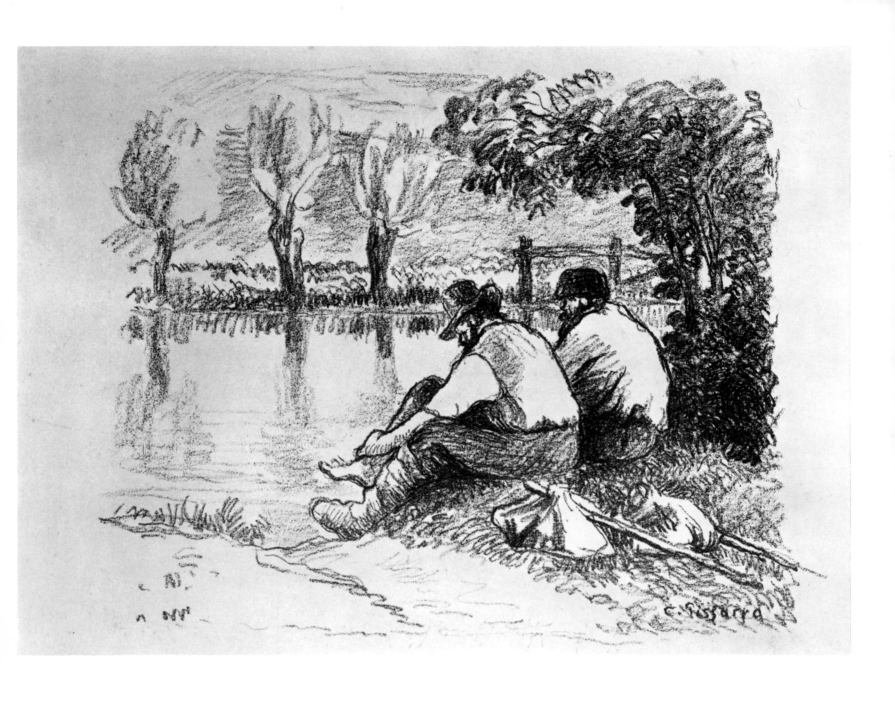

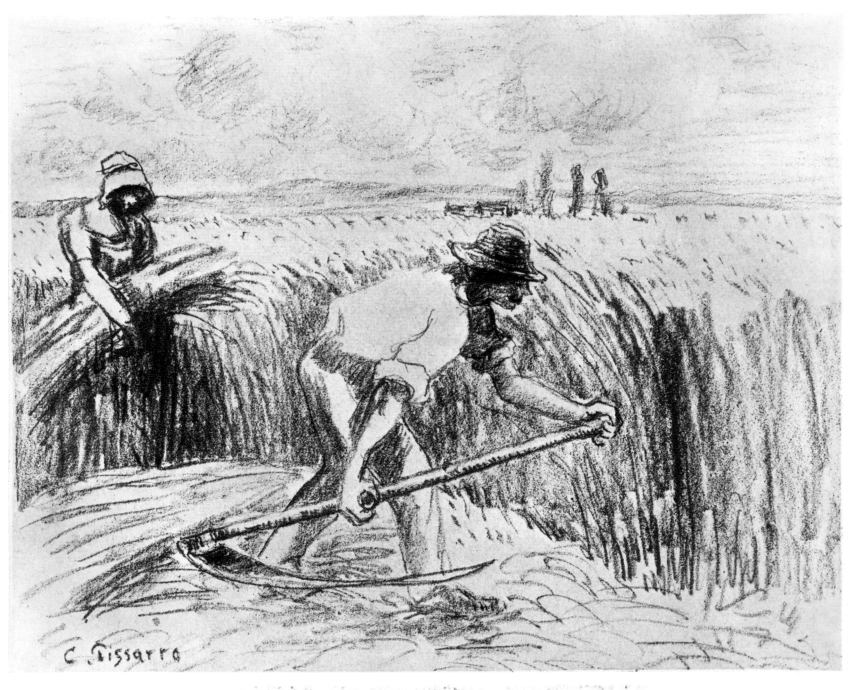

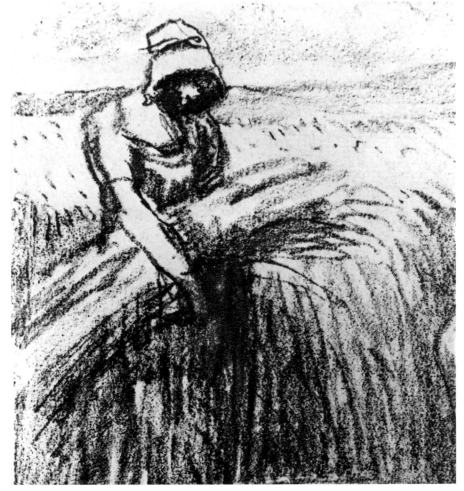

P. 154

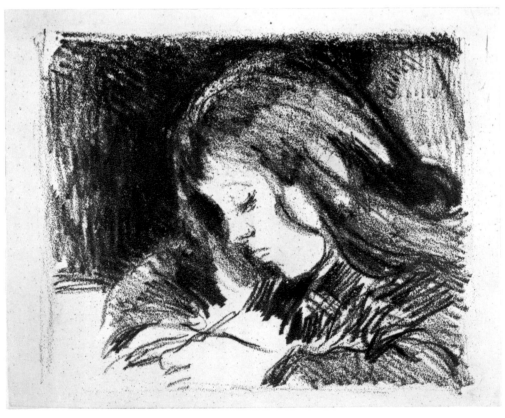

P. 155, 156

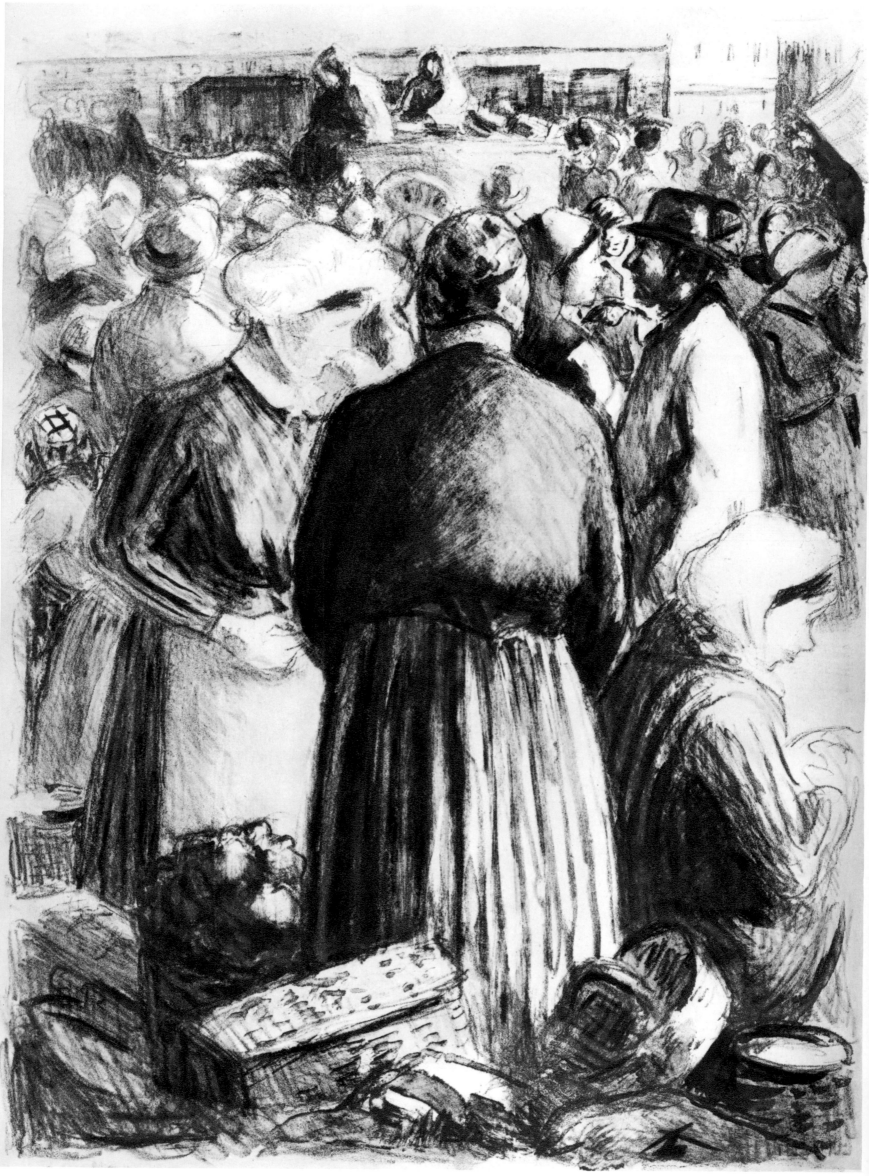

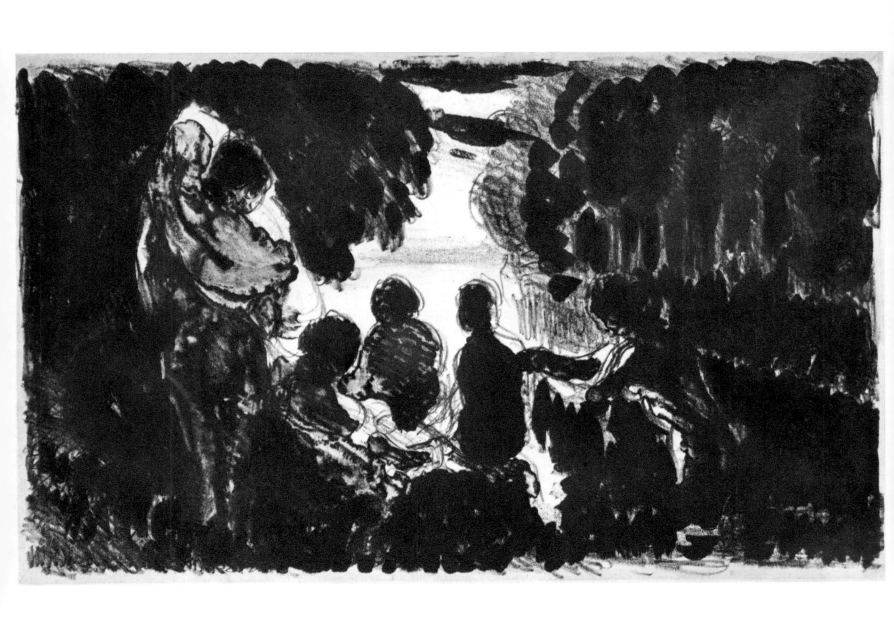

P. 158

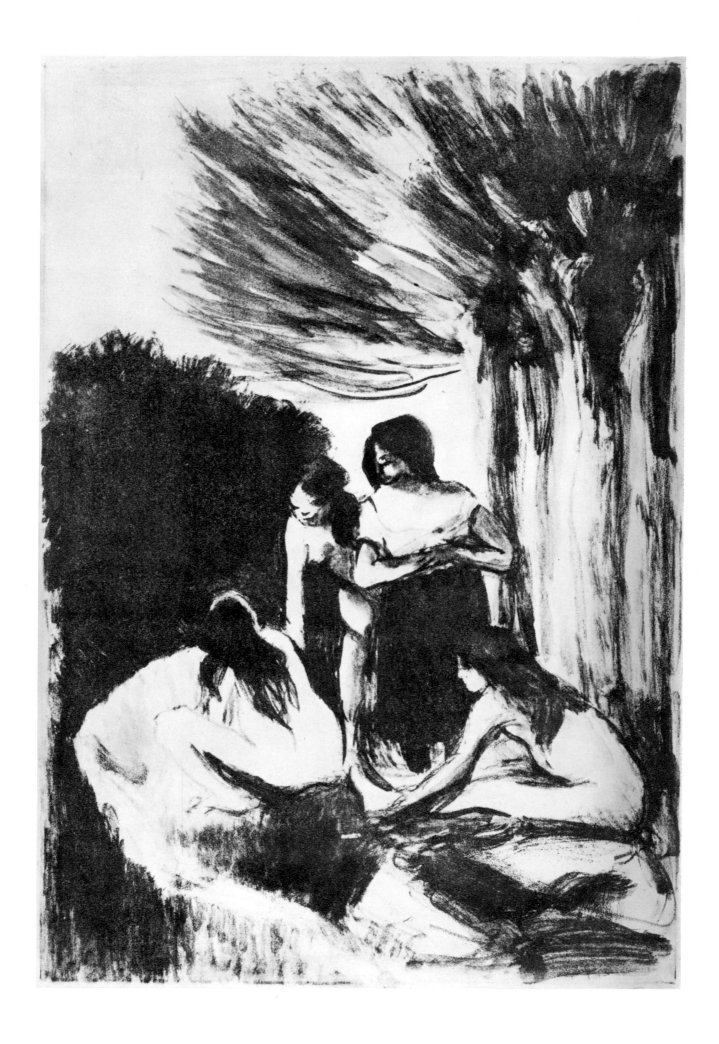

P. 159

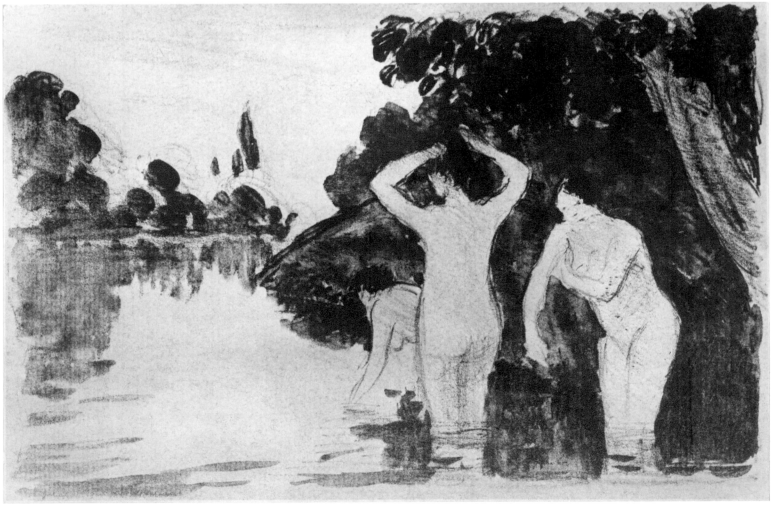

P. 160, 161

P. 164

P. 165

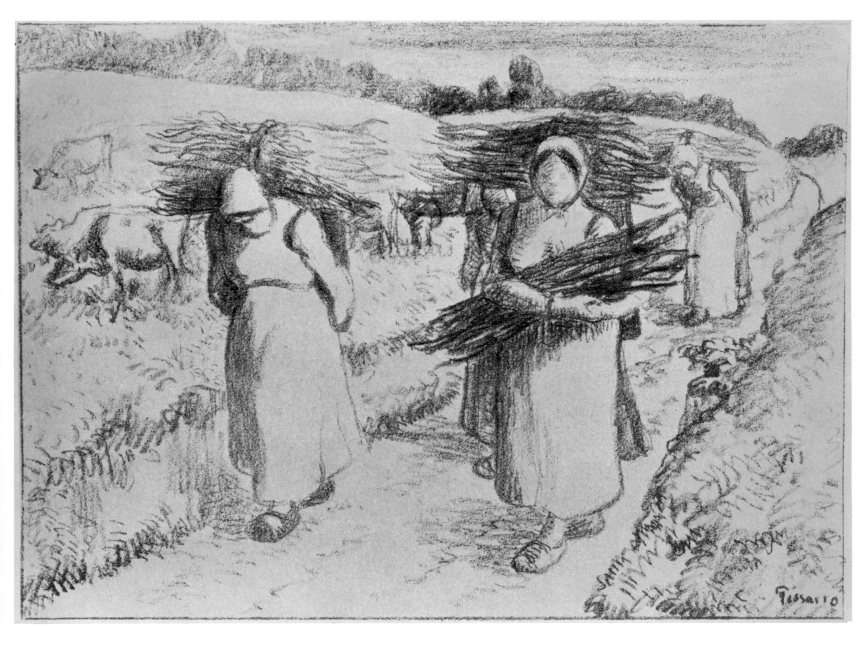

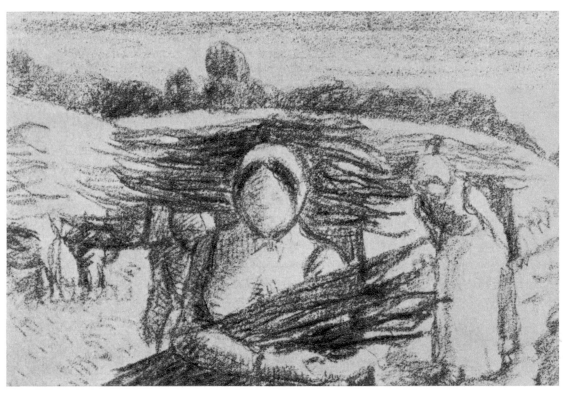

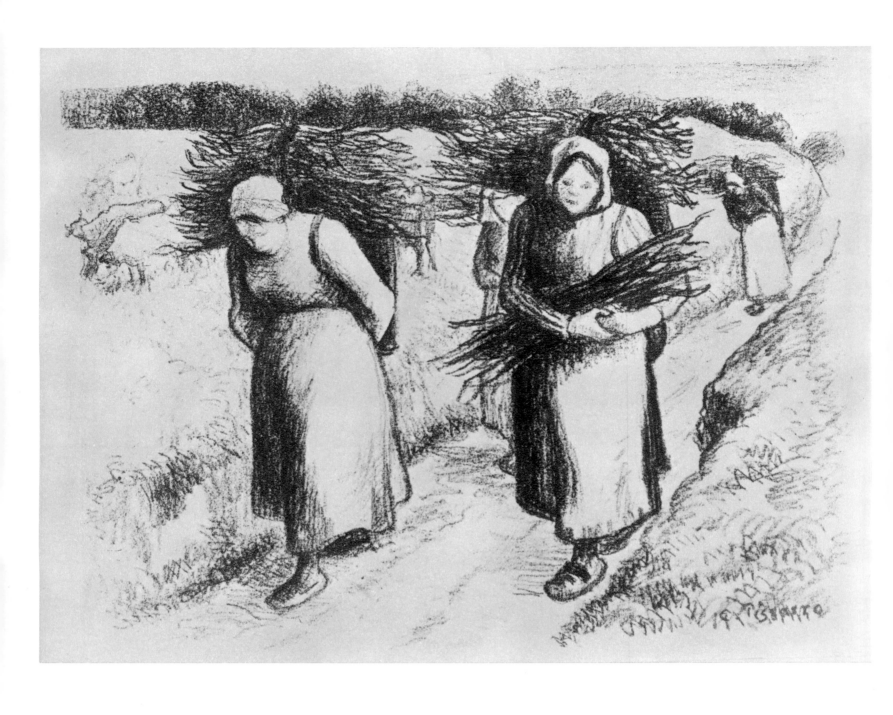

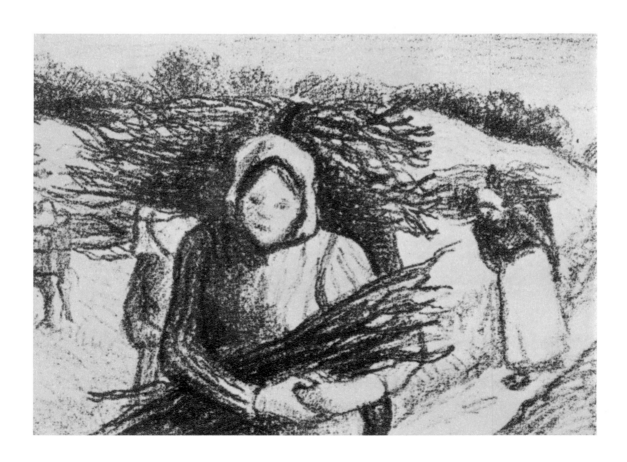

P. 174

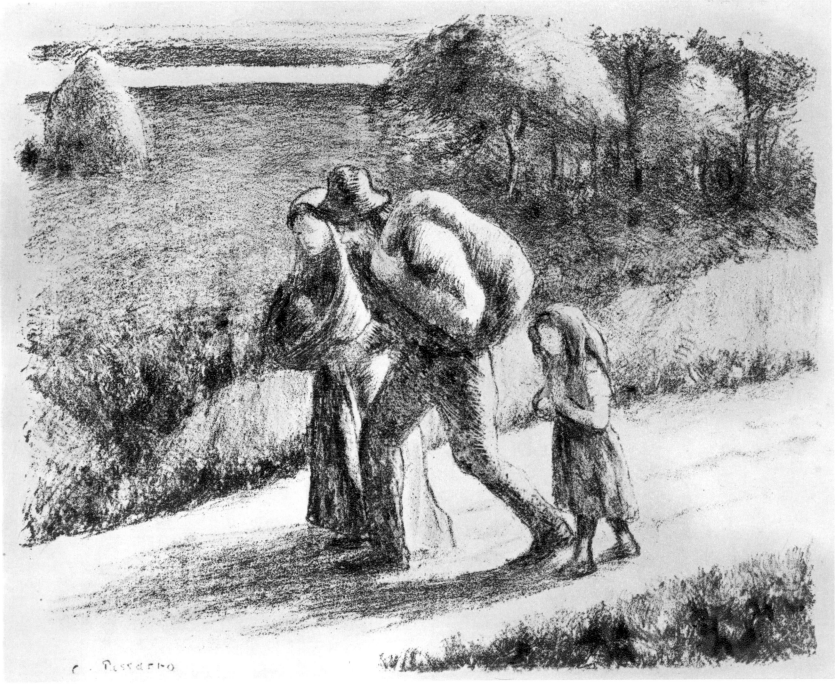

C. Pissarro

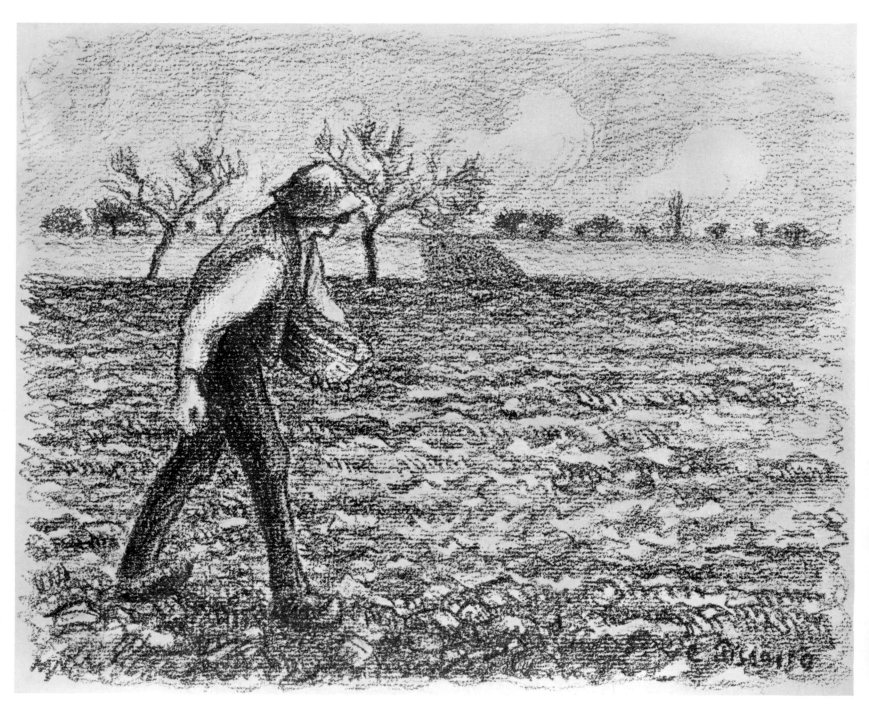

P. 176

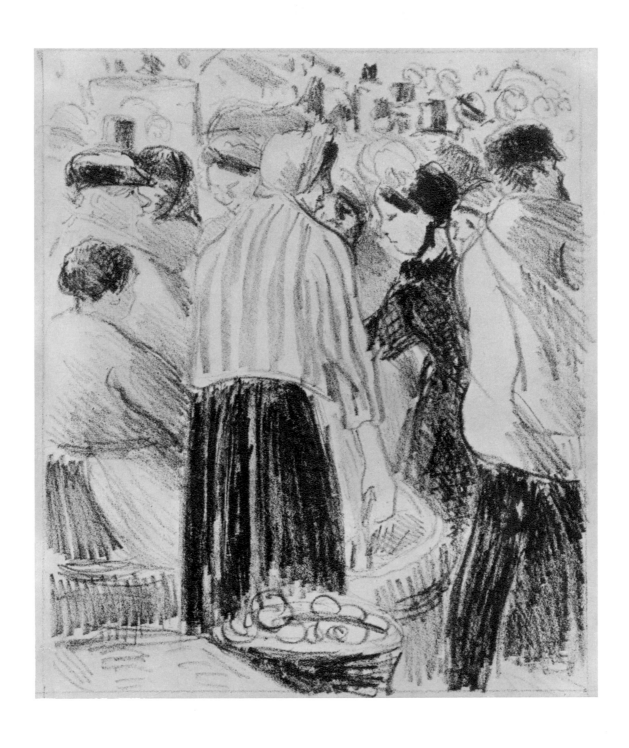

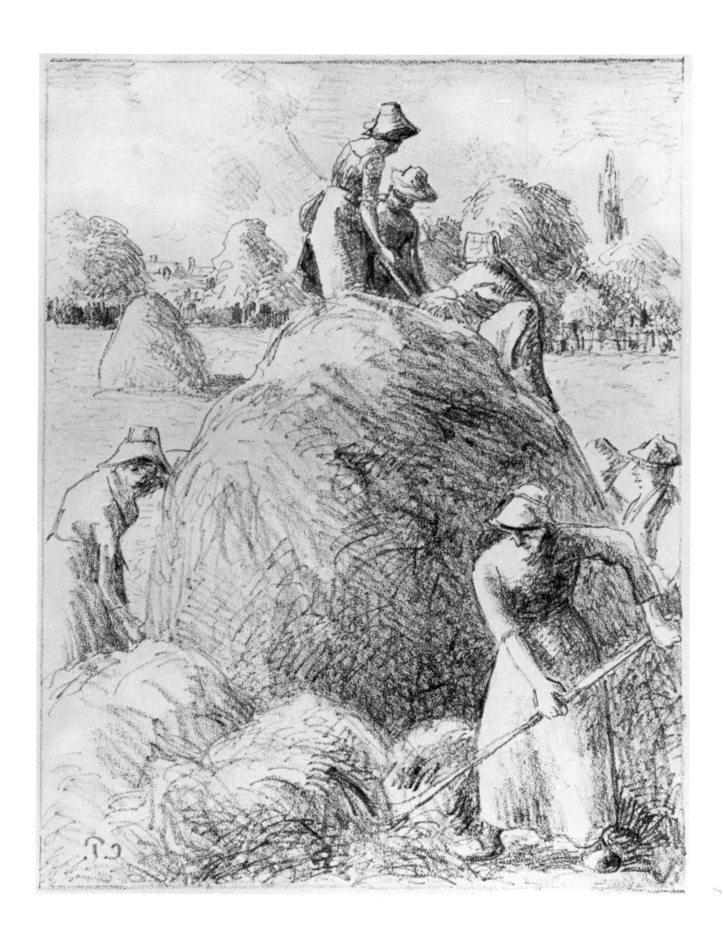

P. 179, 180

P. 184, 185

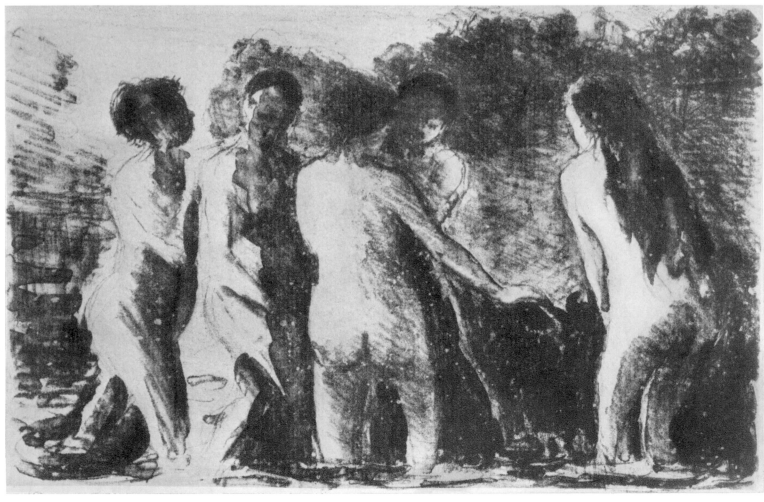

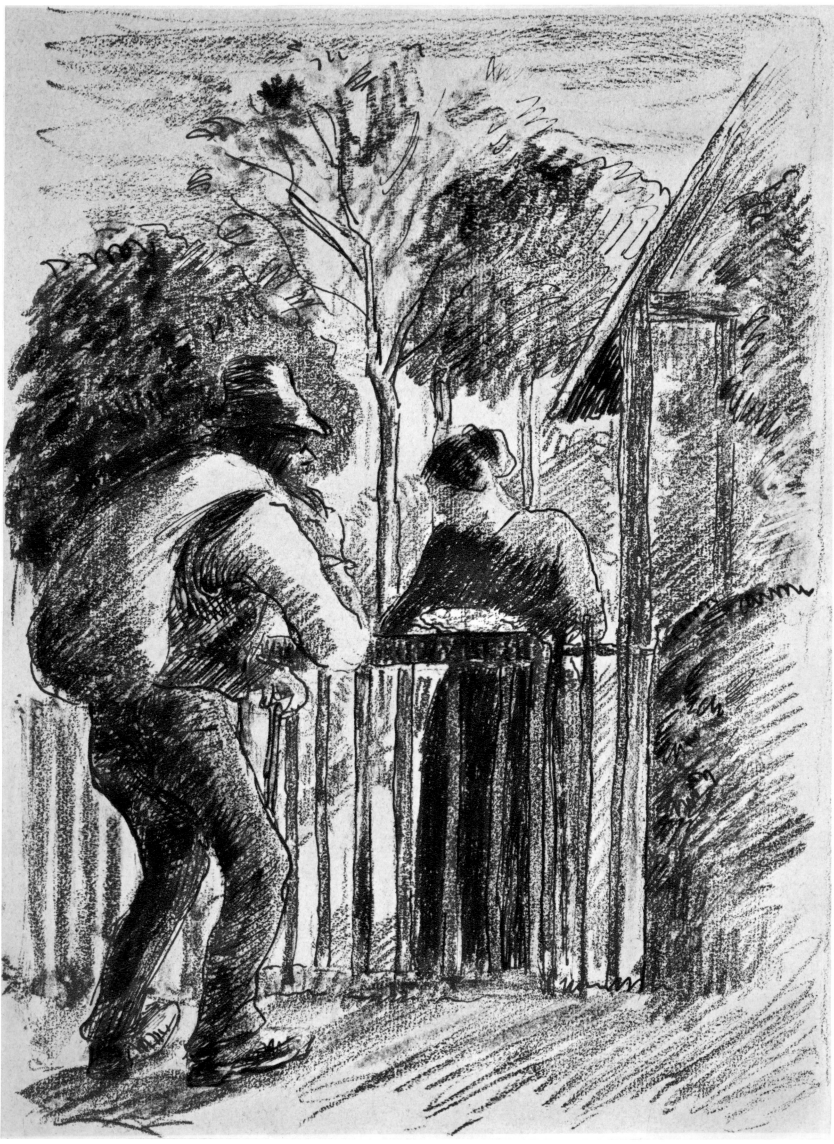

P. 186

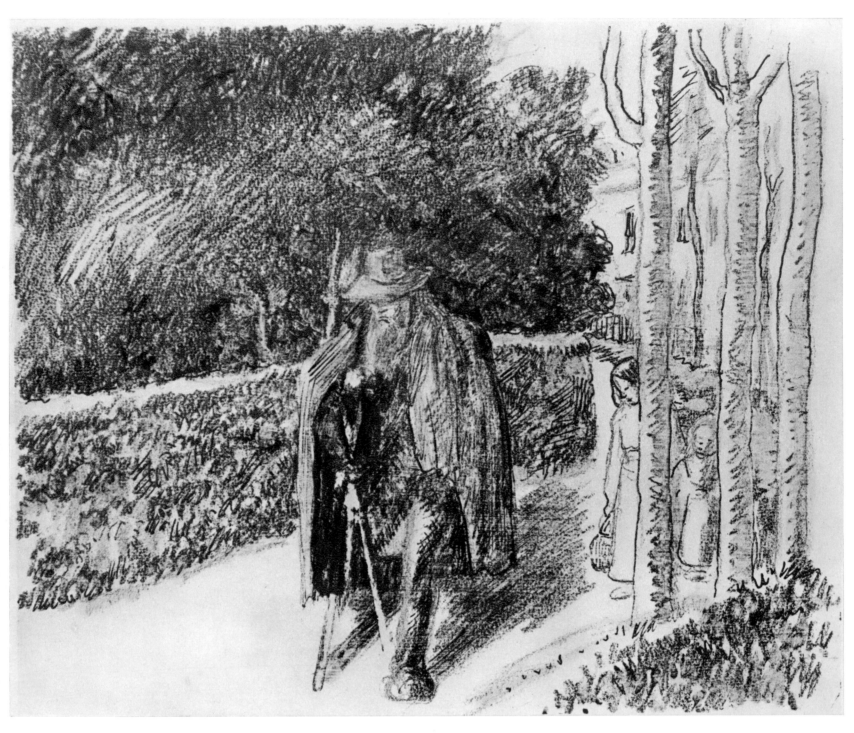

P. 187

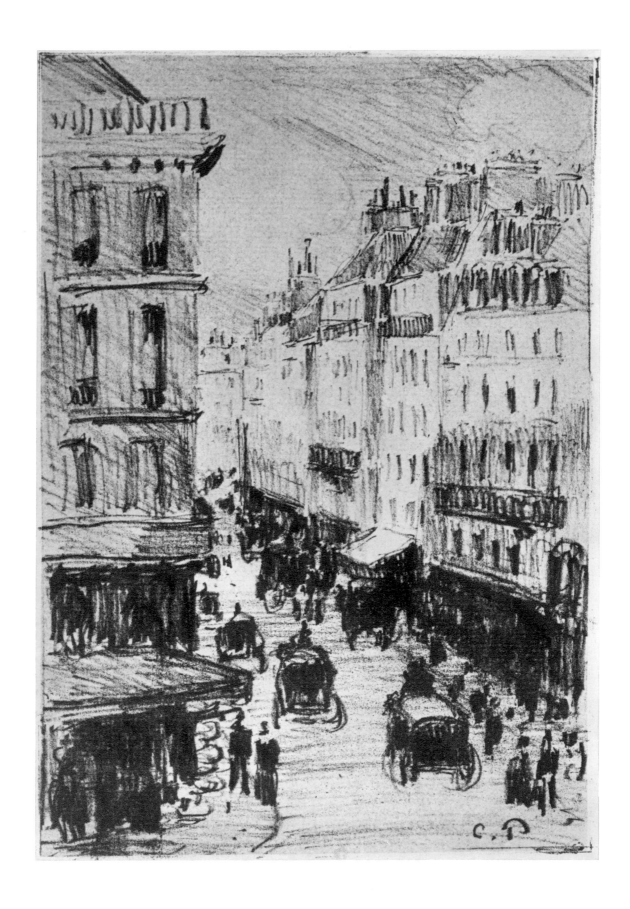

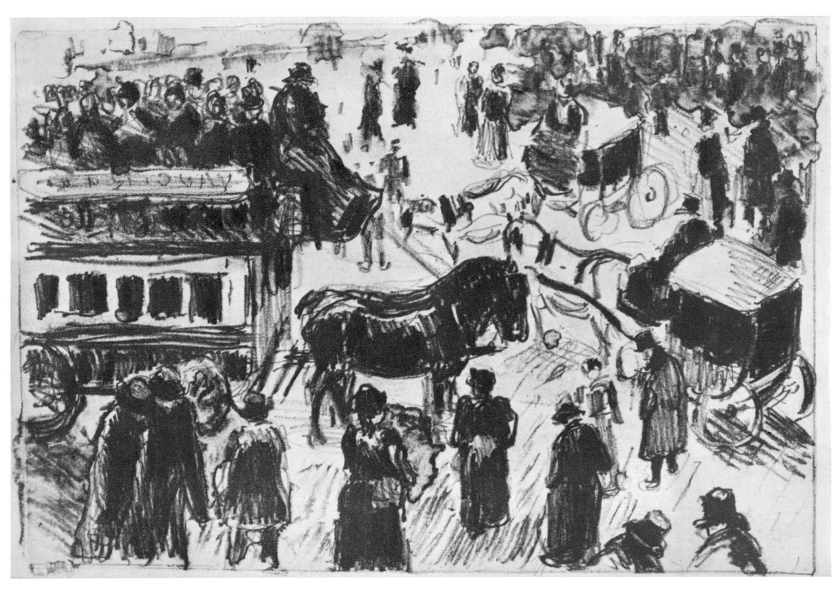

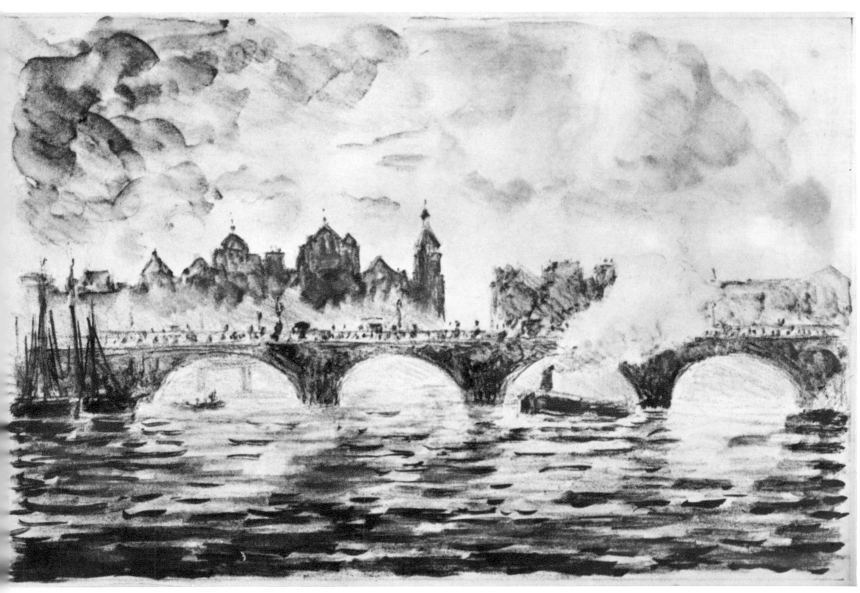

P. 189, 190

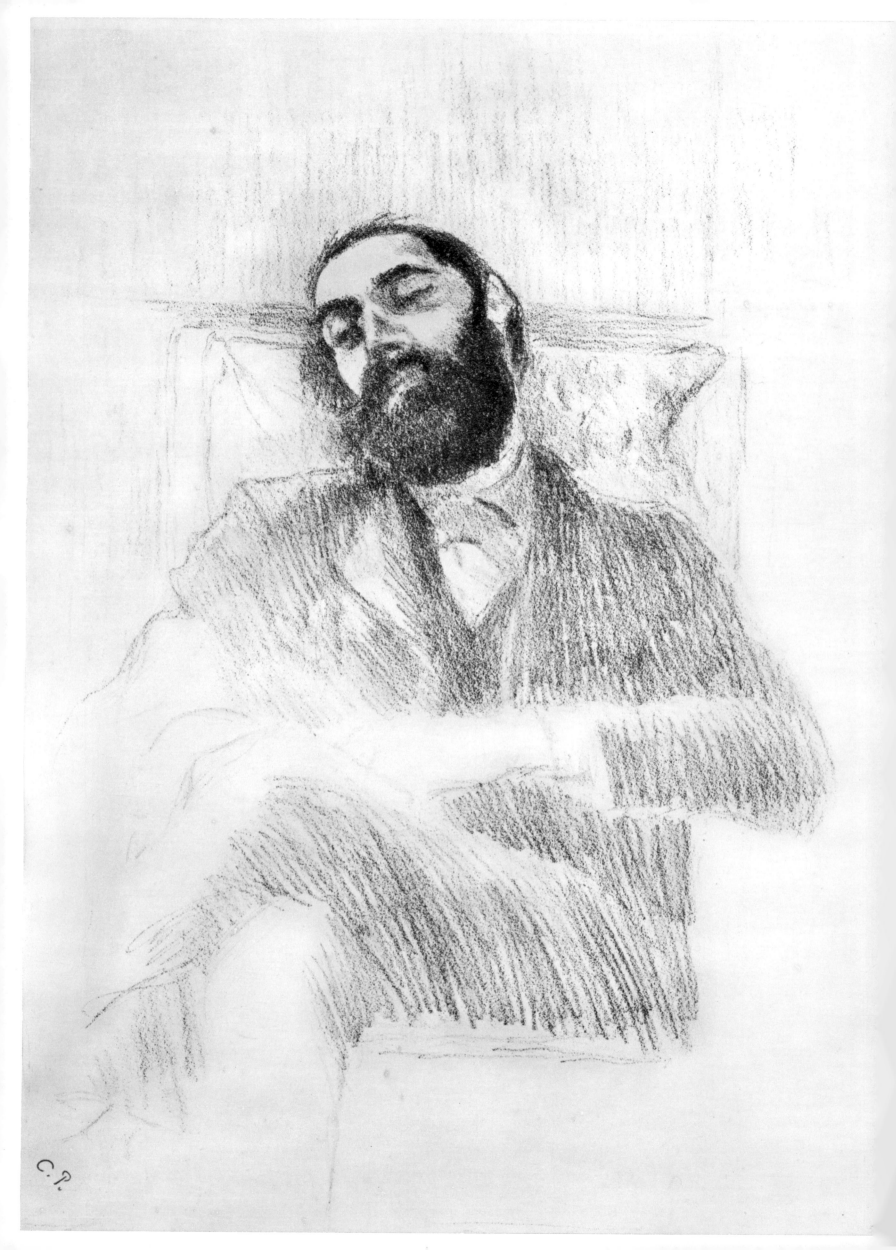

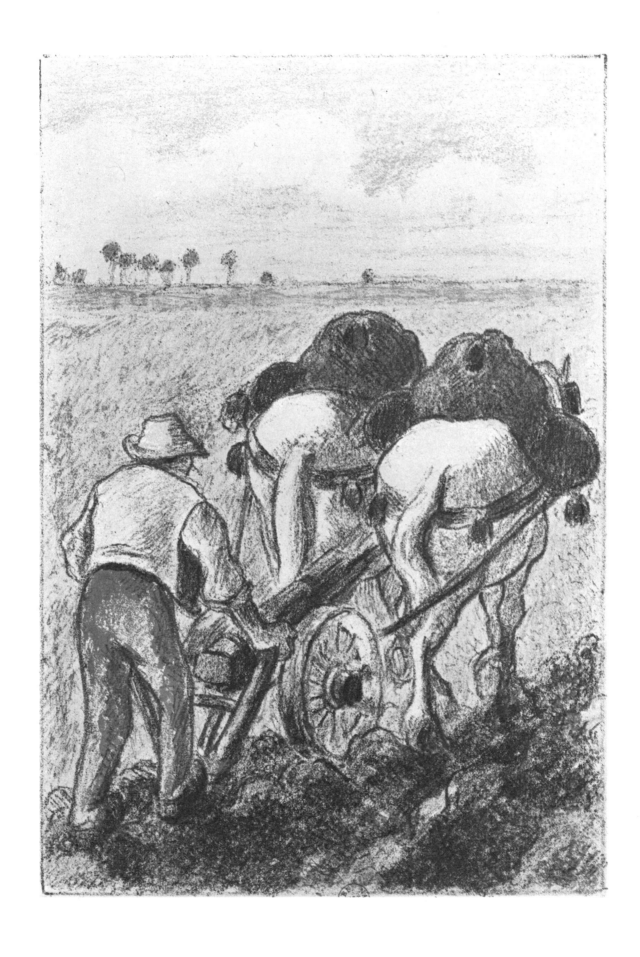

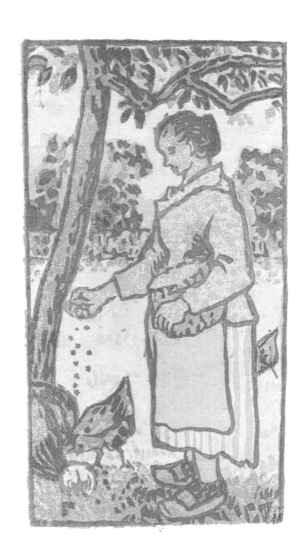

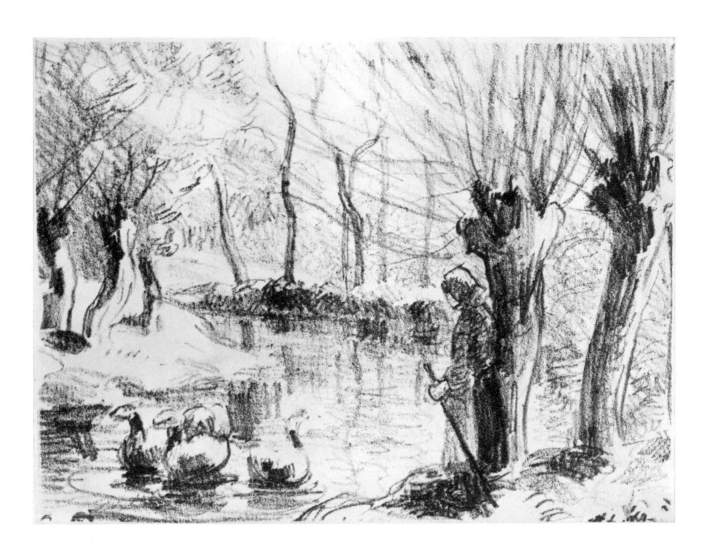

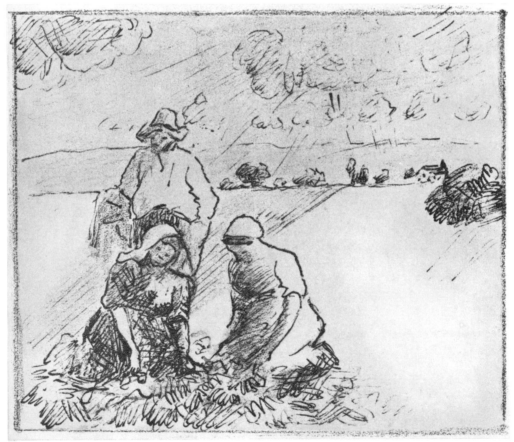

P. 193, 194

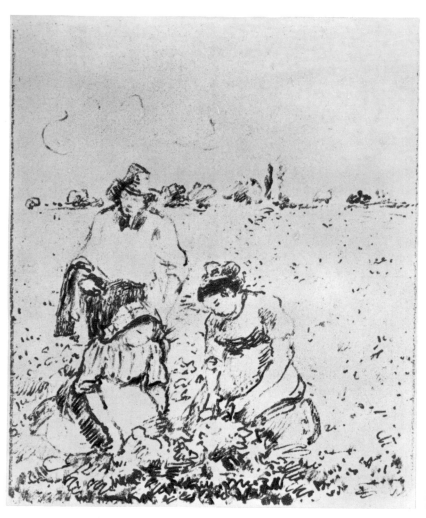

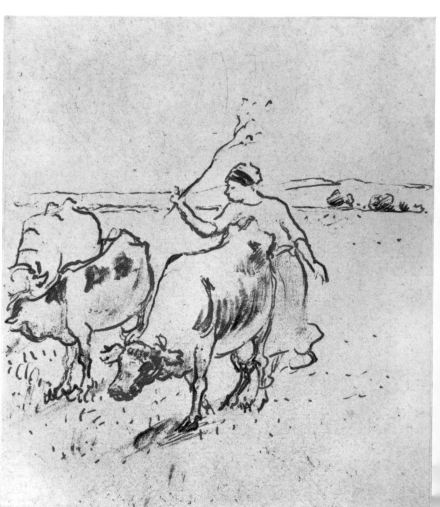

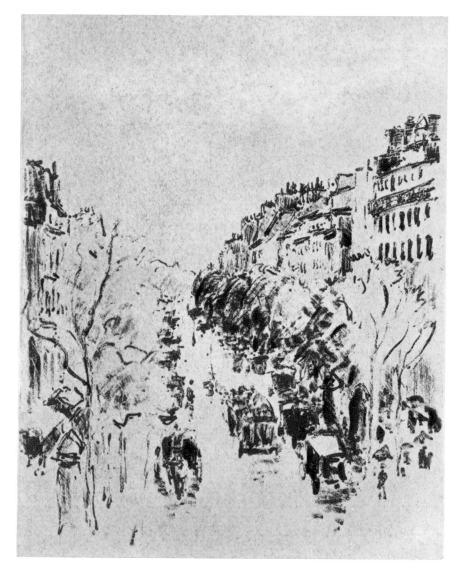

P. 195, 196, 197

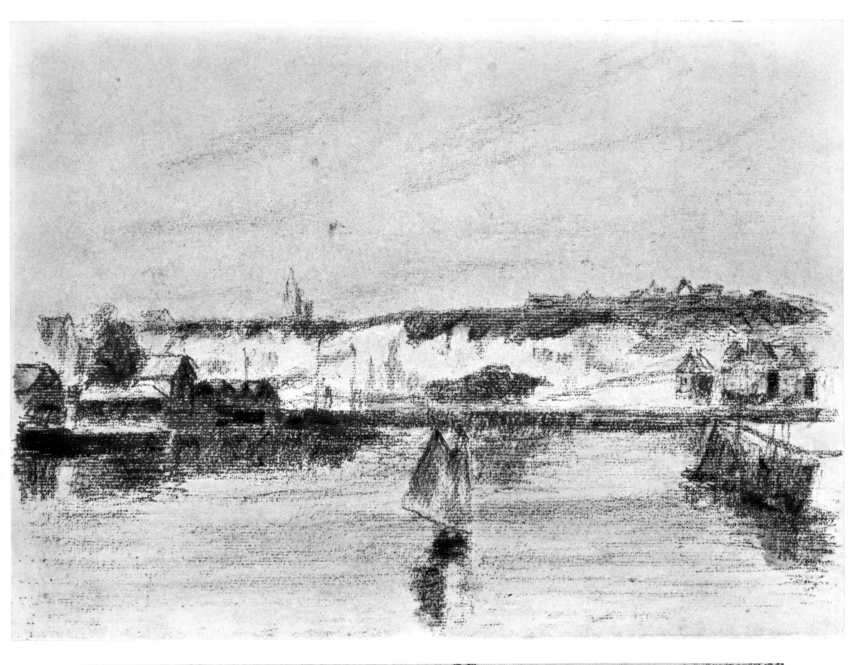

P. 198

P. 199, 200

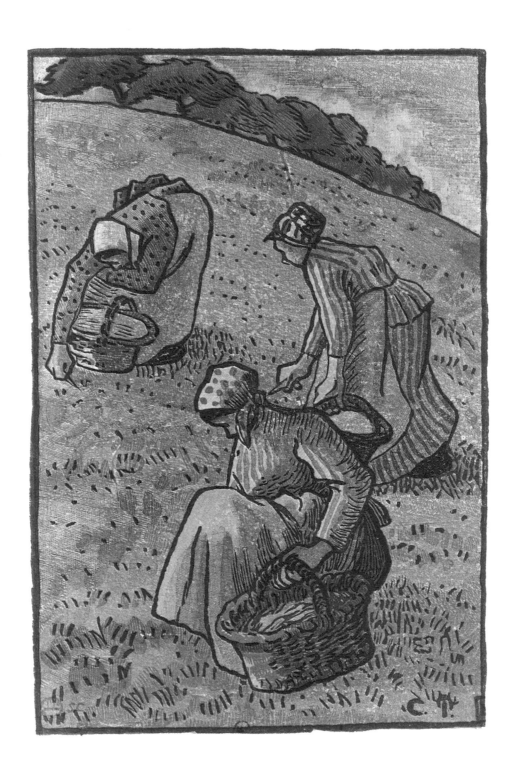

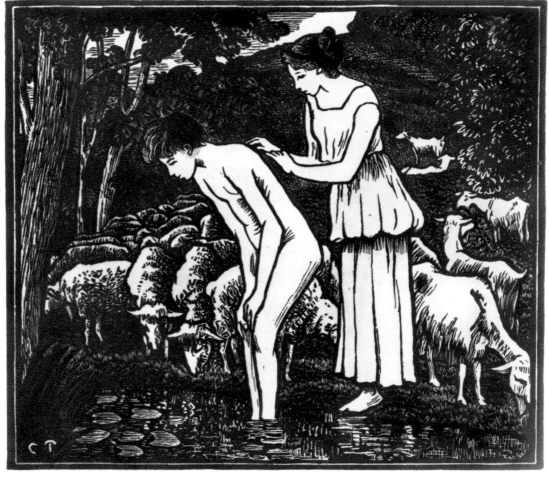

P. 205, 206

Renoir

R. 1

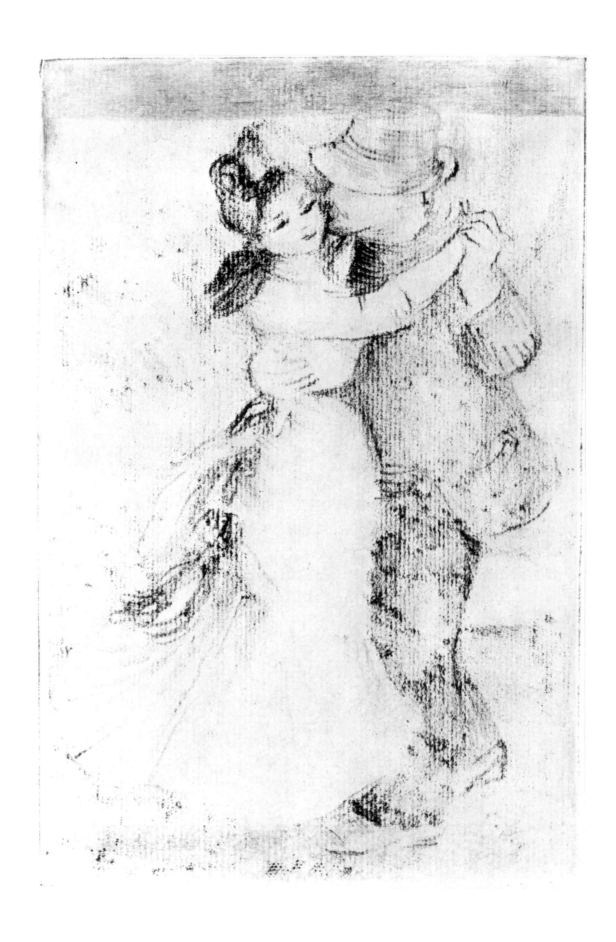

R. 2

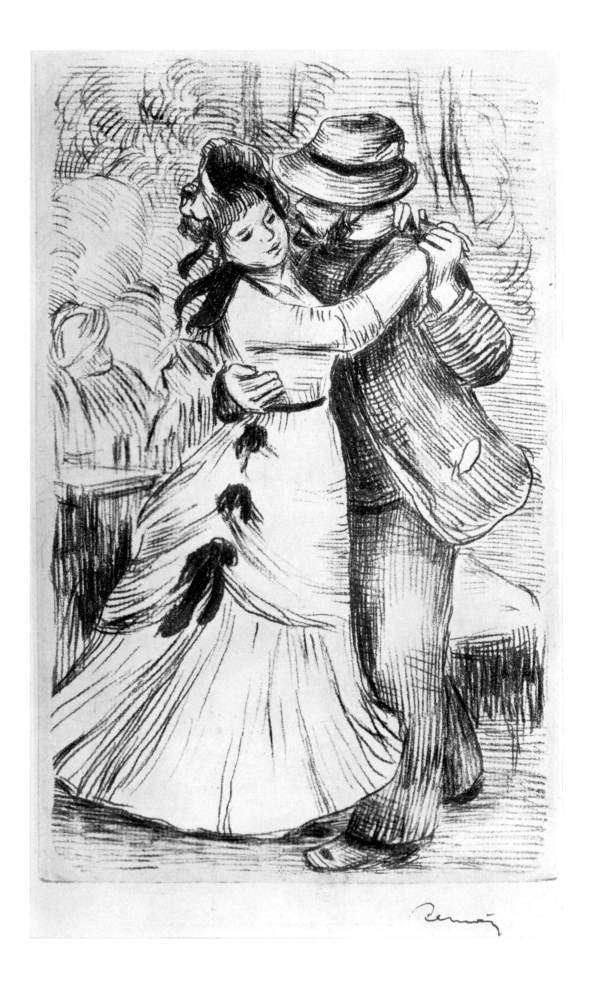

R. 3

R. 4, 5, 6, 7

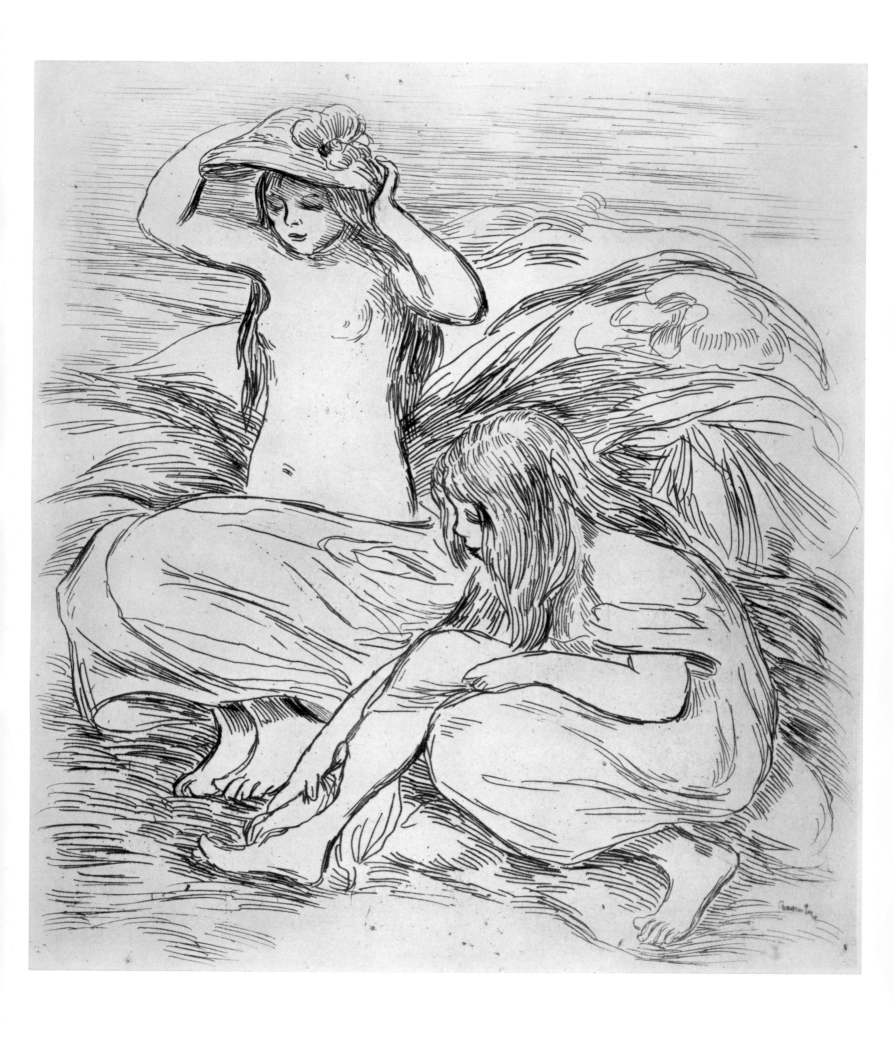

R. 9

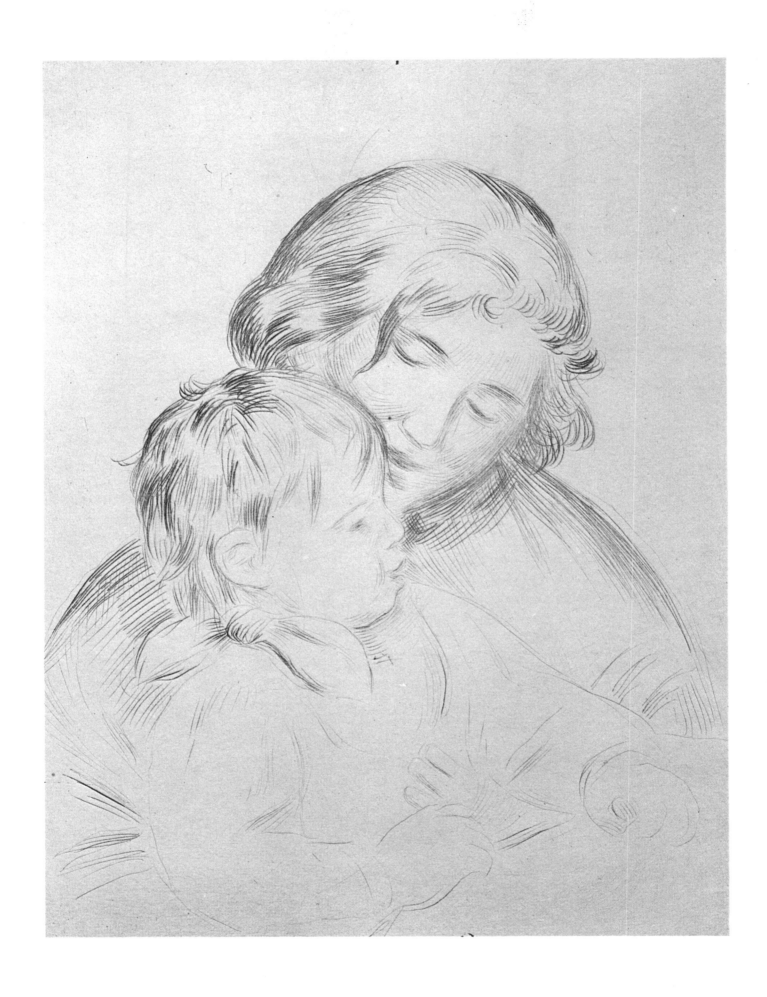

R. 10

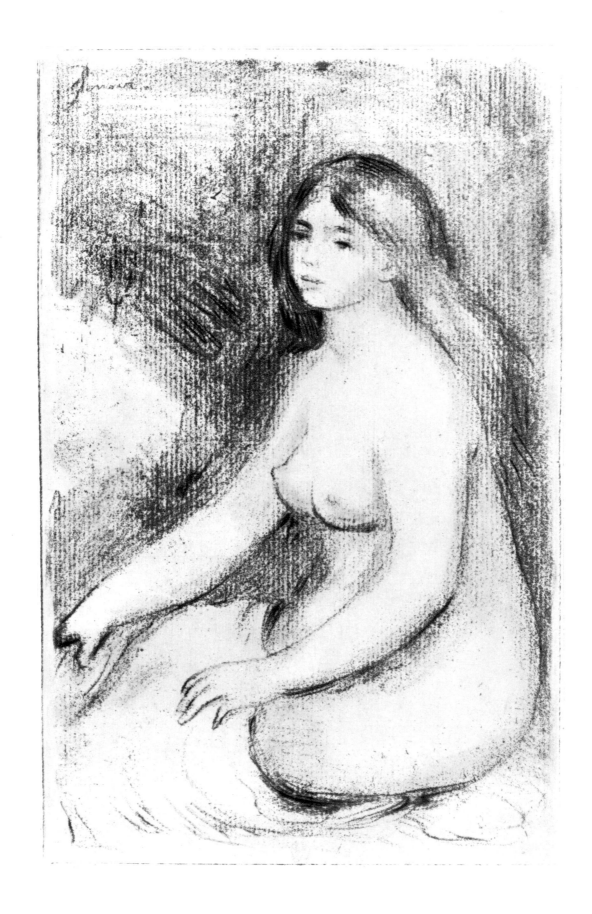

R. 11

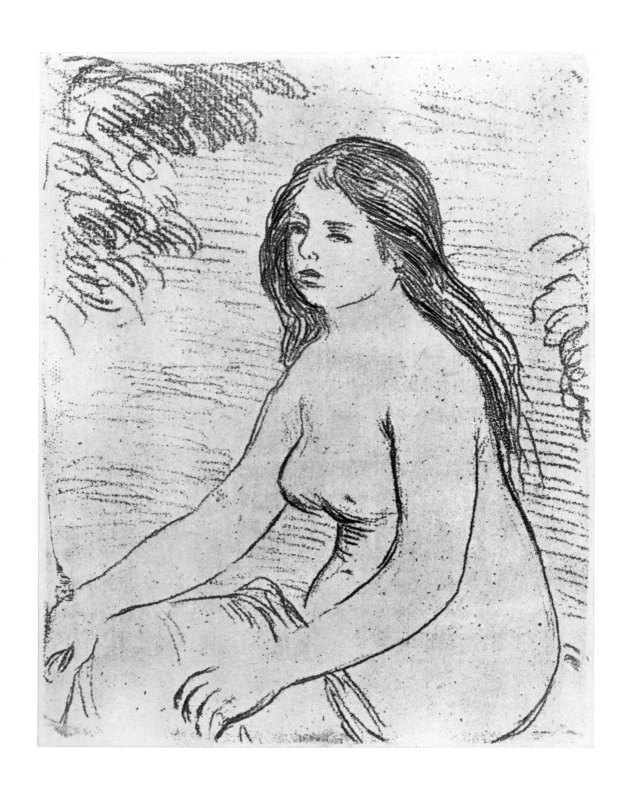

R. 12

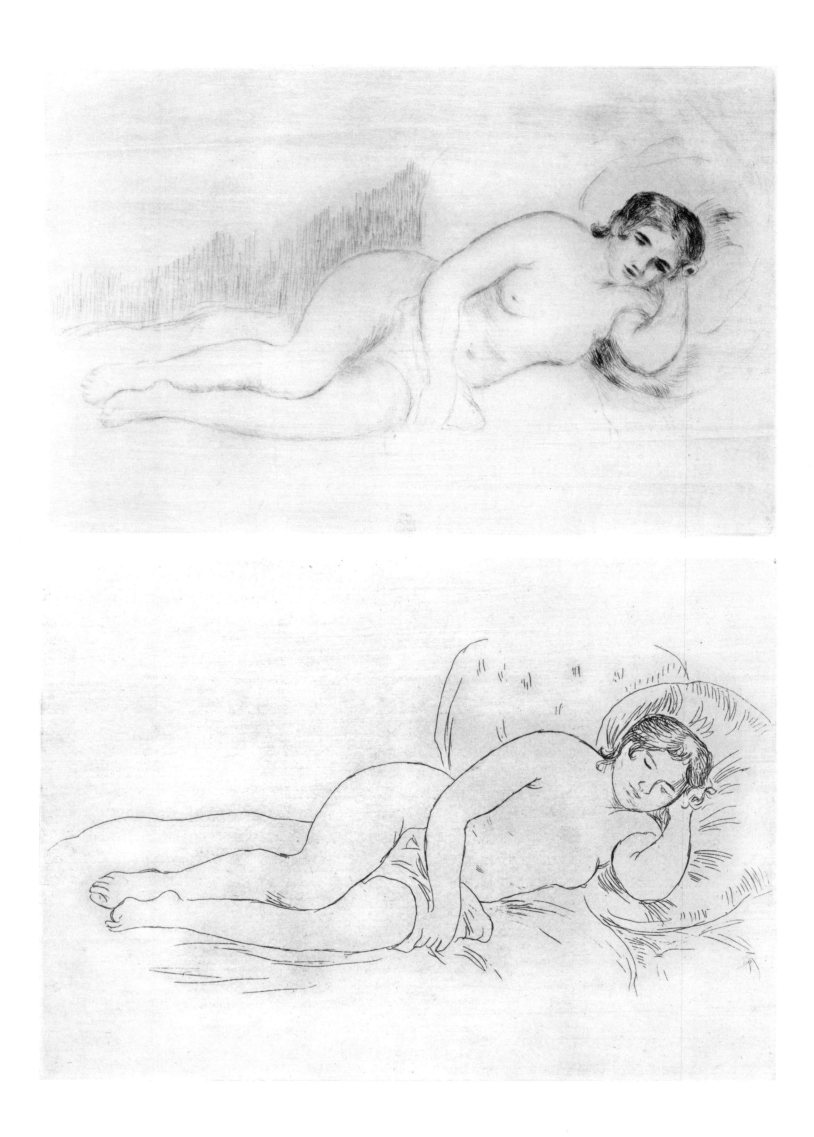

R. 13, 14

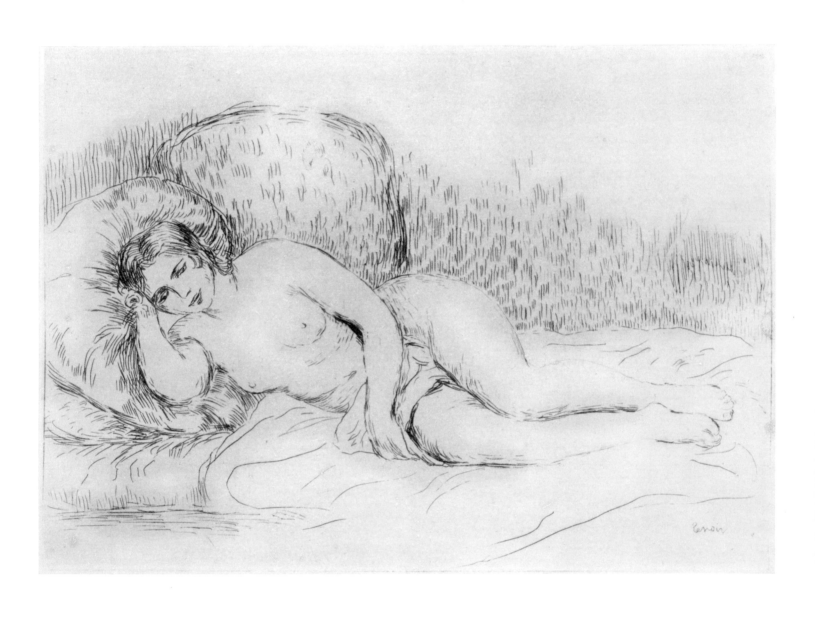

R. 15

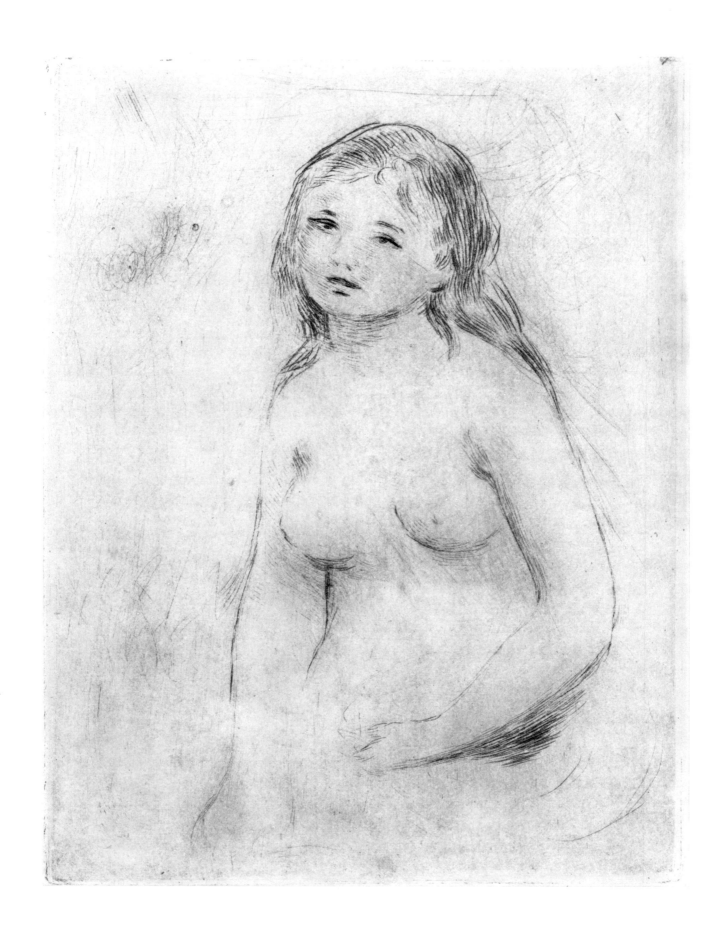

R. 16

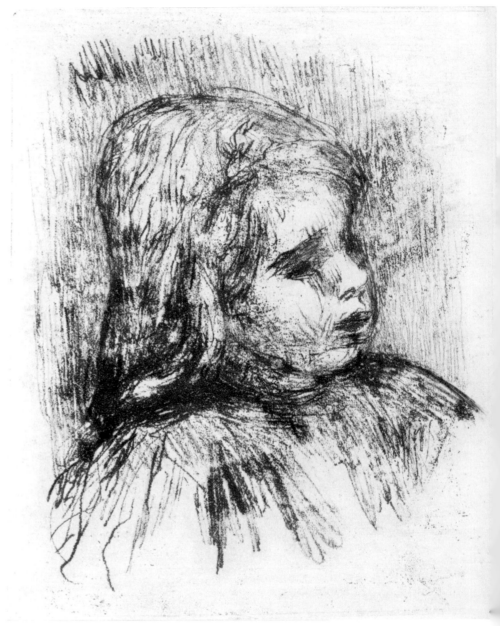

R. 17, 18

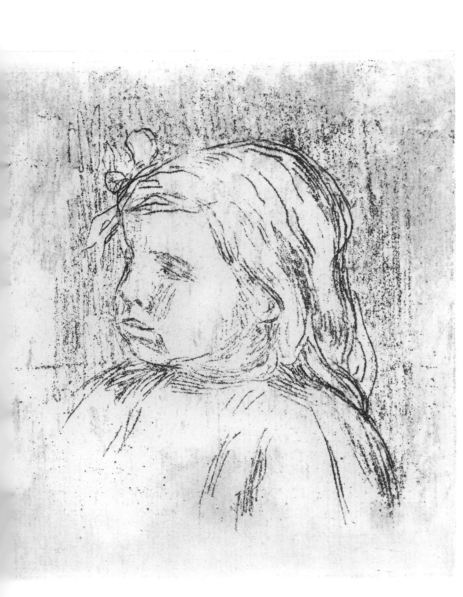 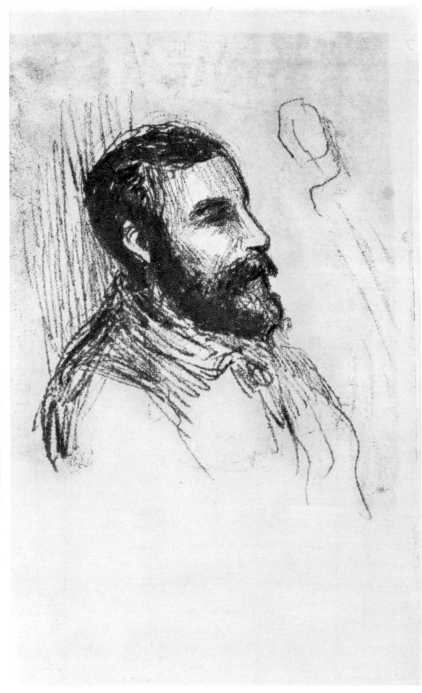

19, 20

R. 21, 22, 23

R. 24

R. 25

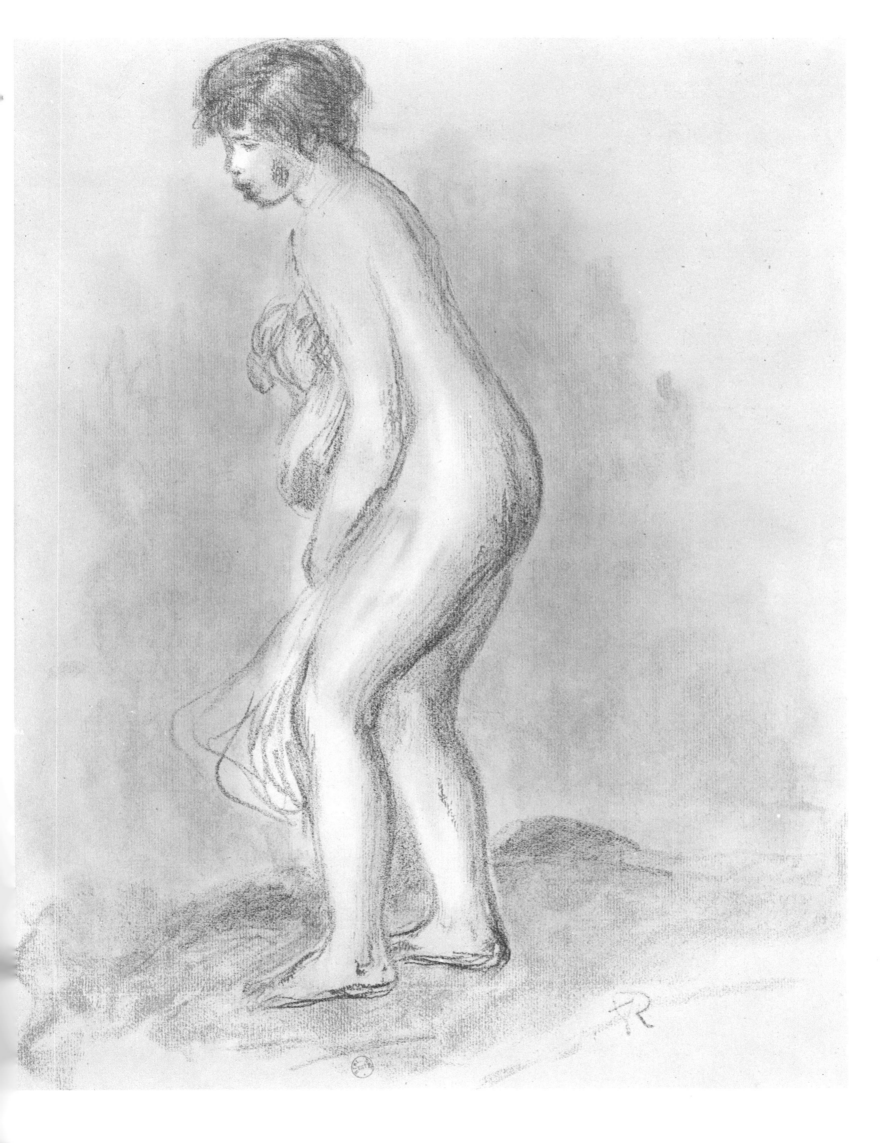

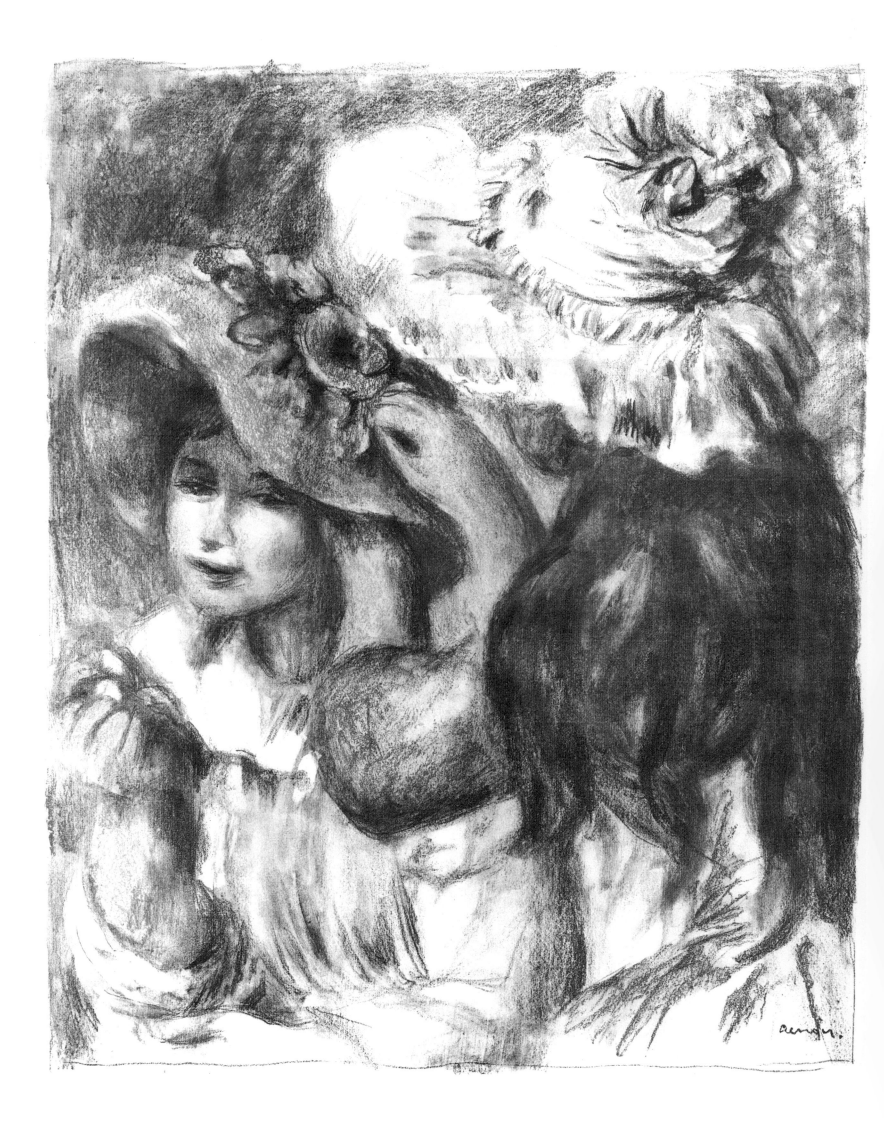

R. 29

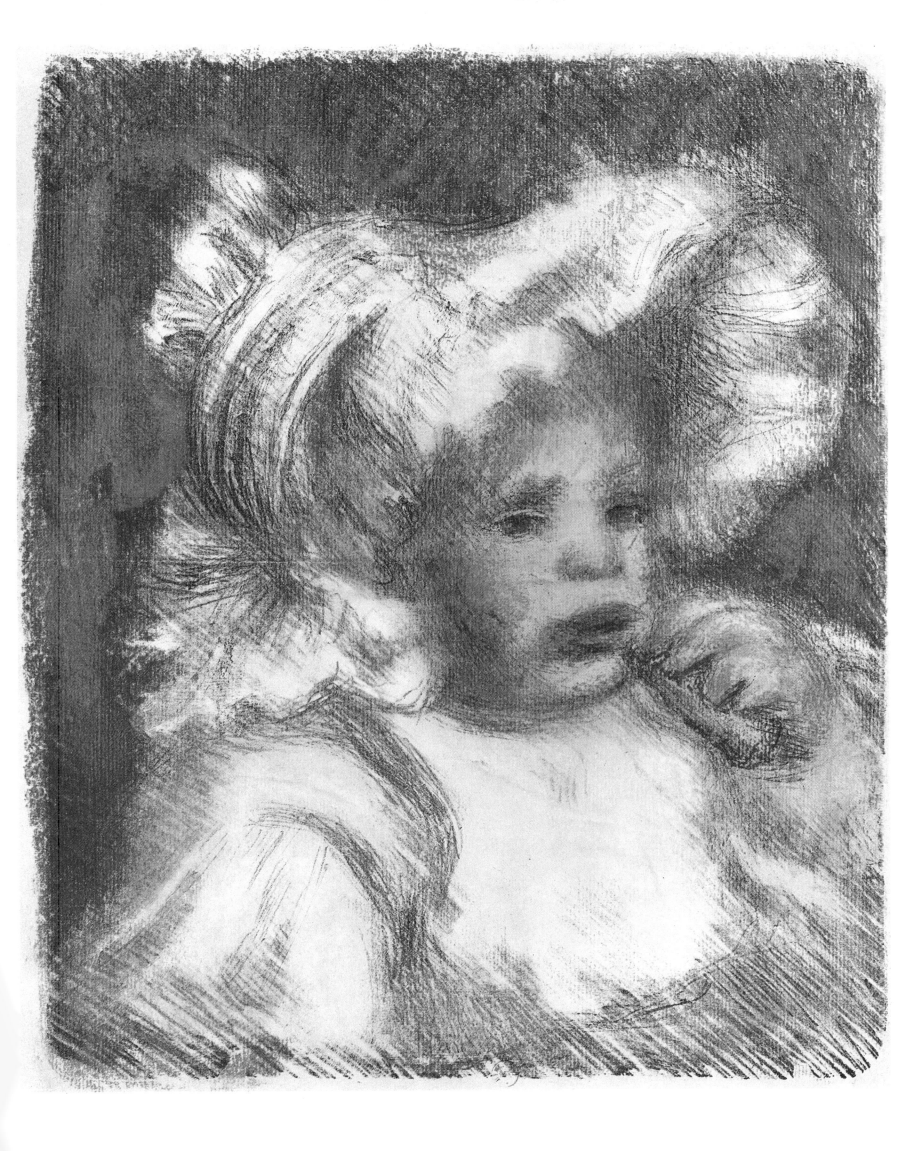

R. 30

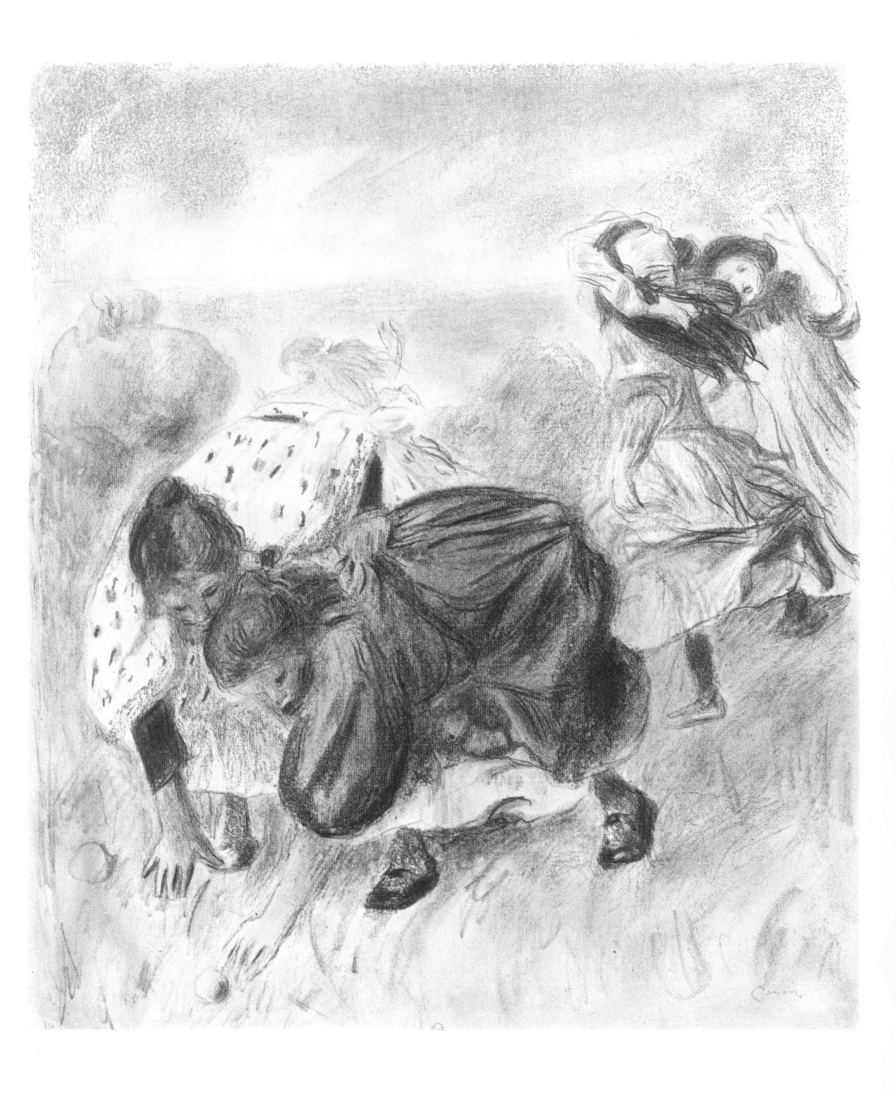

R. 31

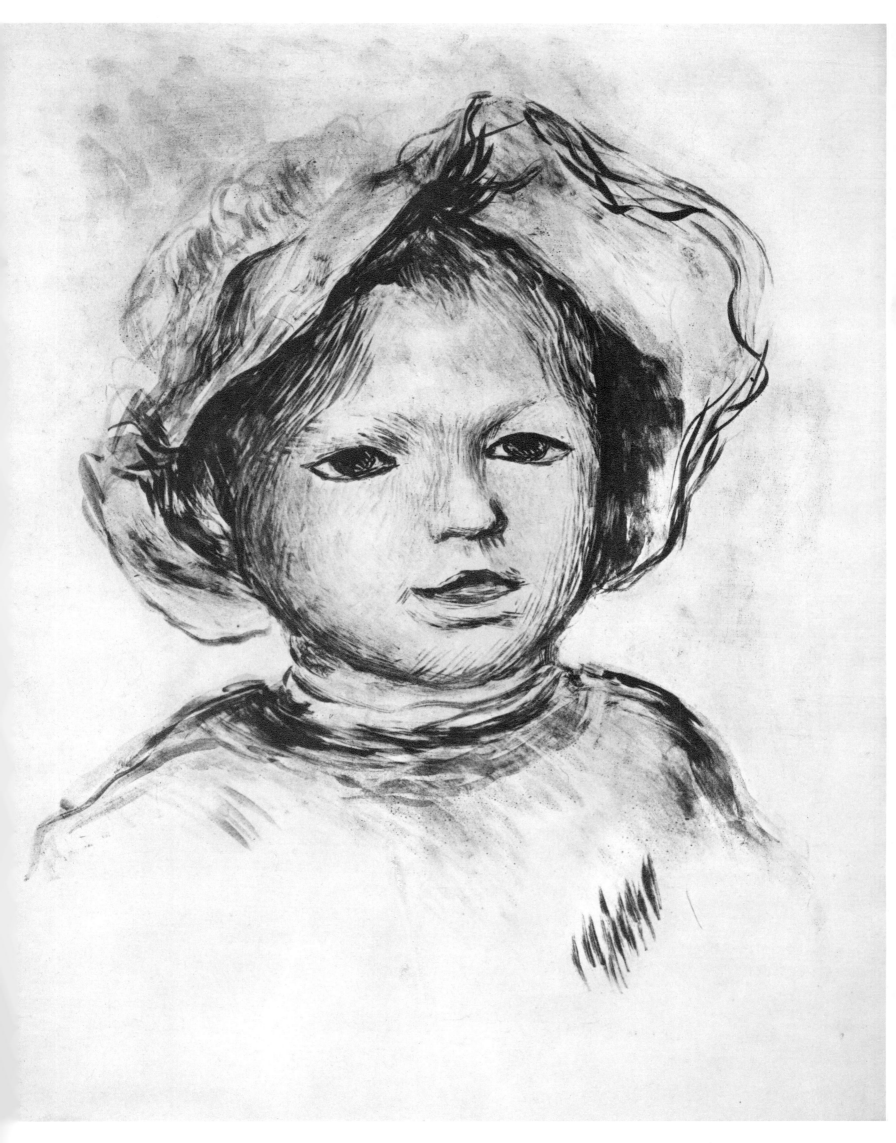

R. 26

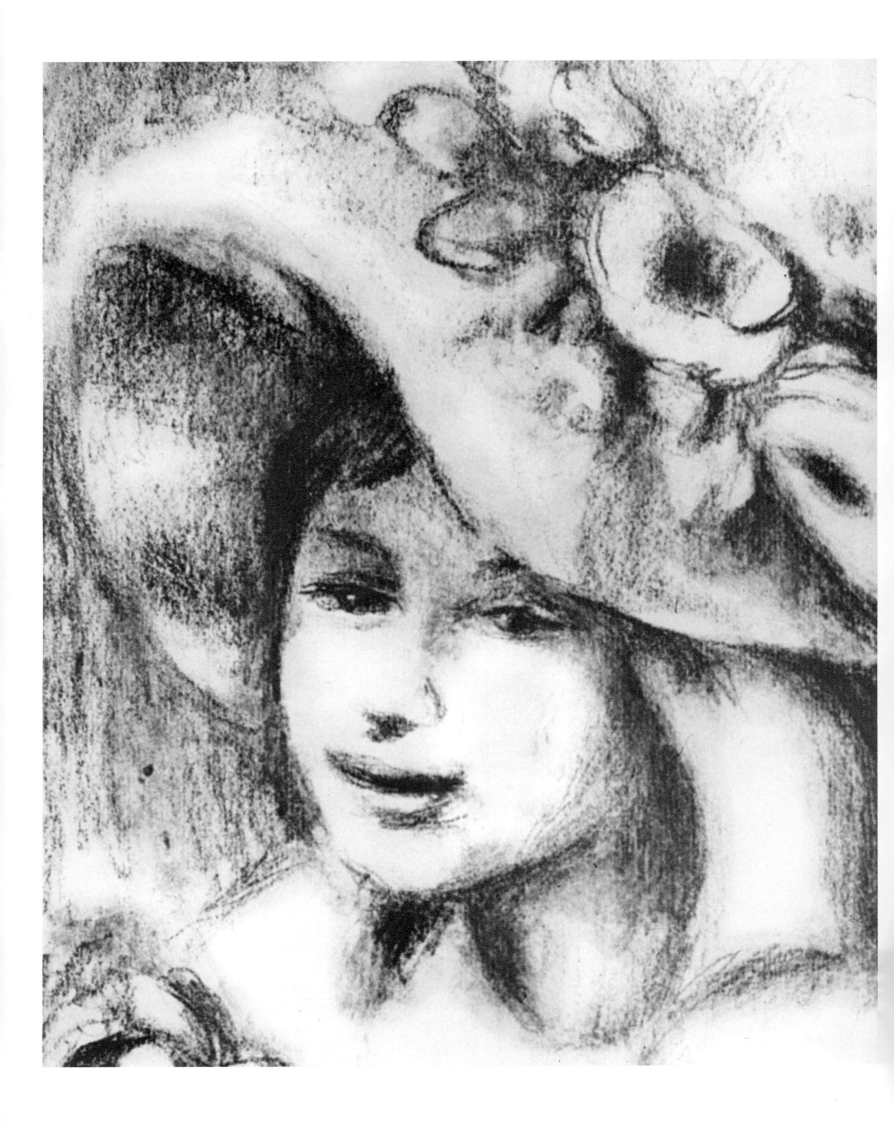

R. 28 detail

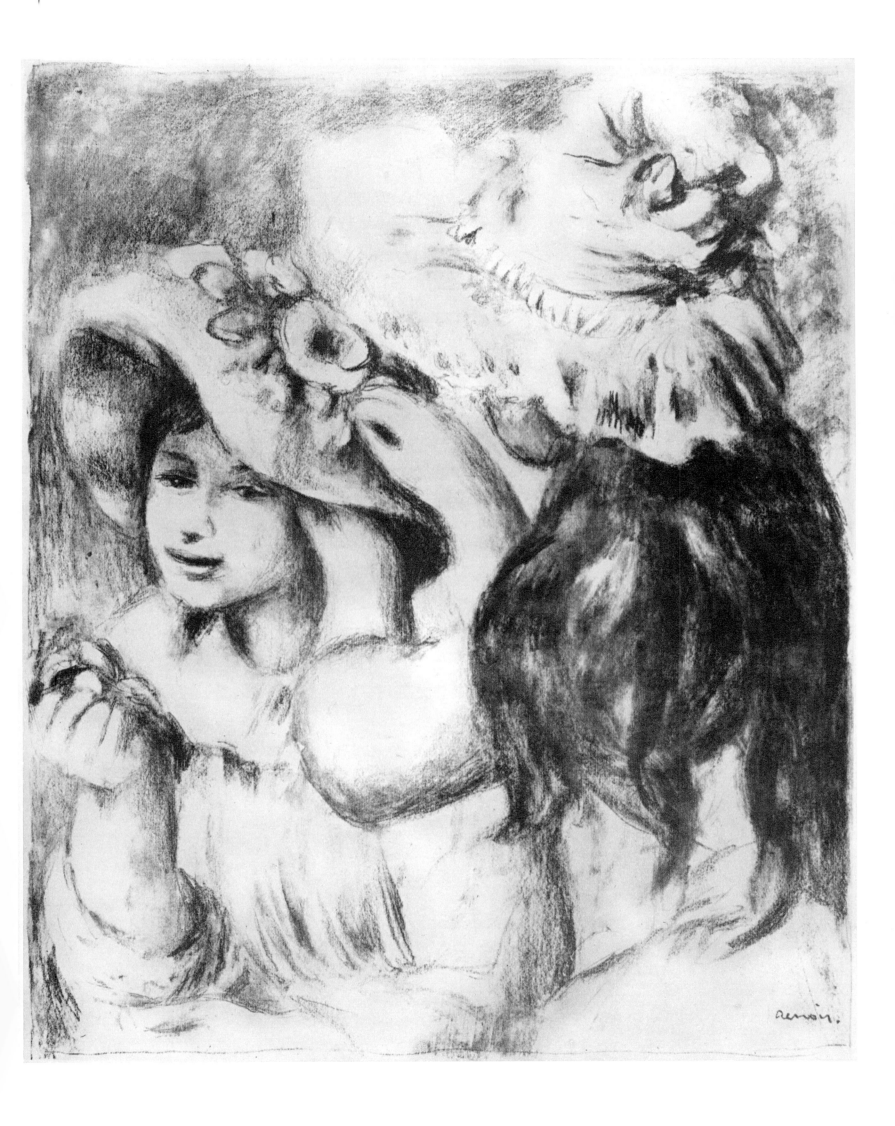

R. 28

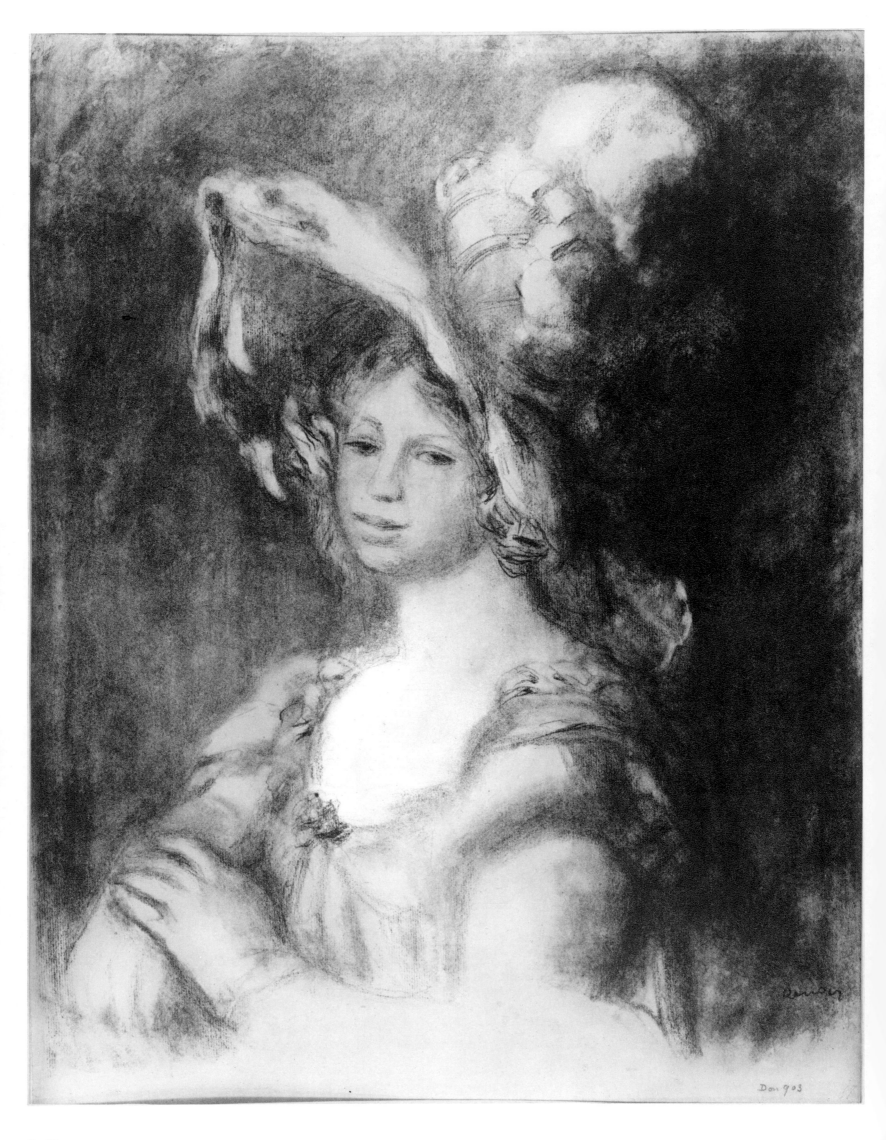

R. 32

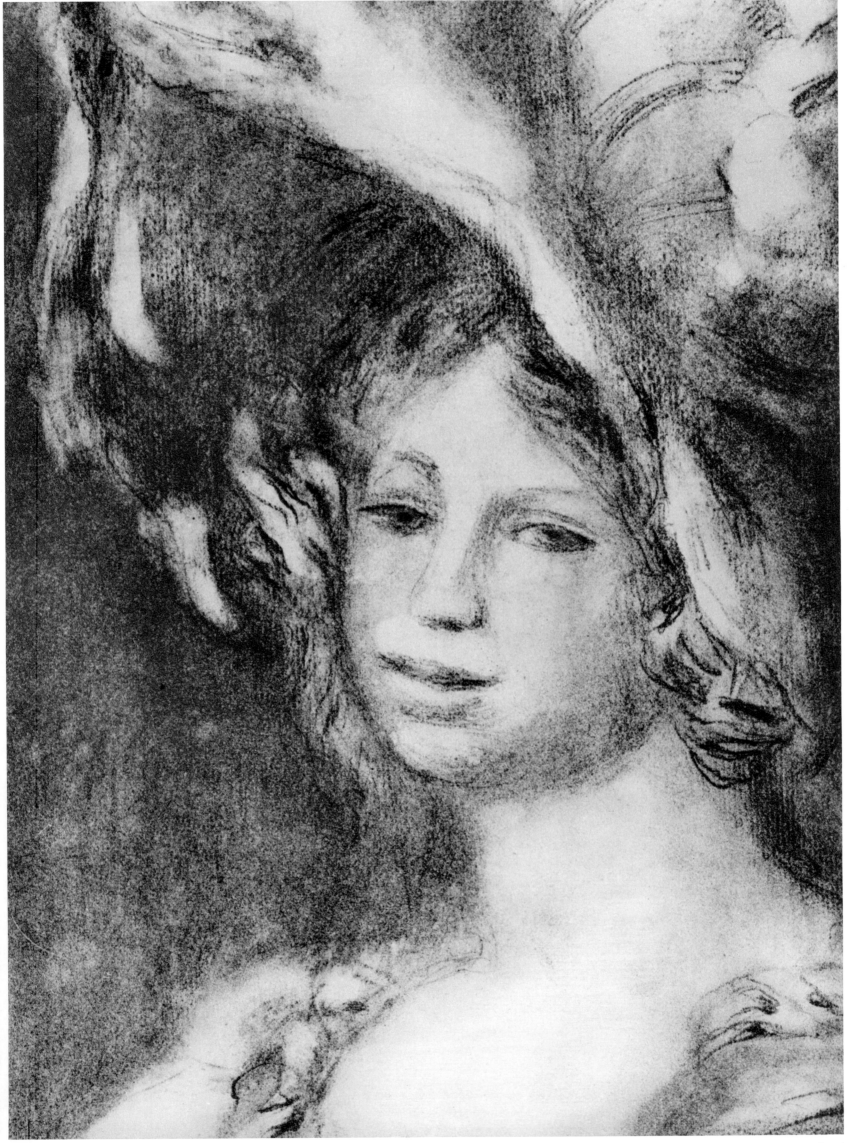

R. 32 detail

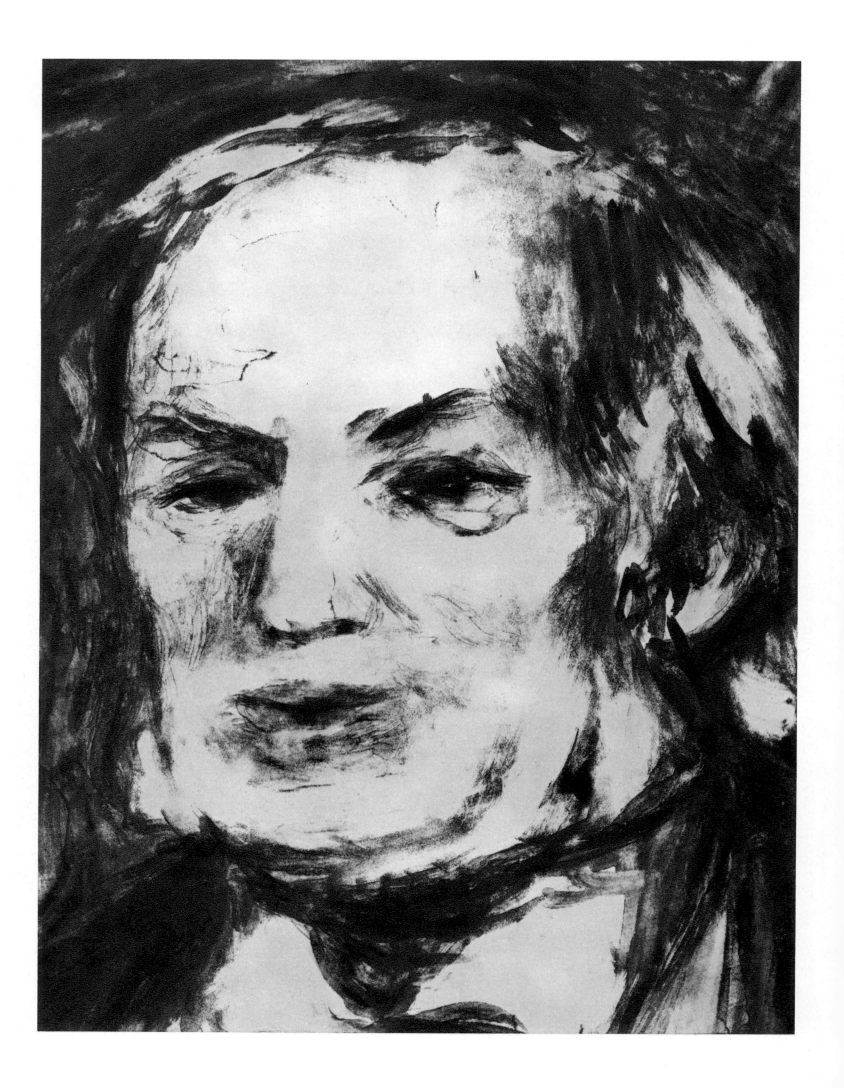

R. 33 detail

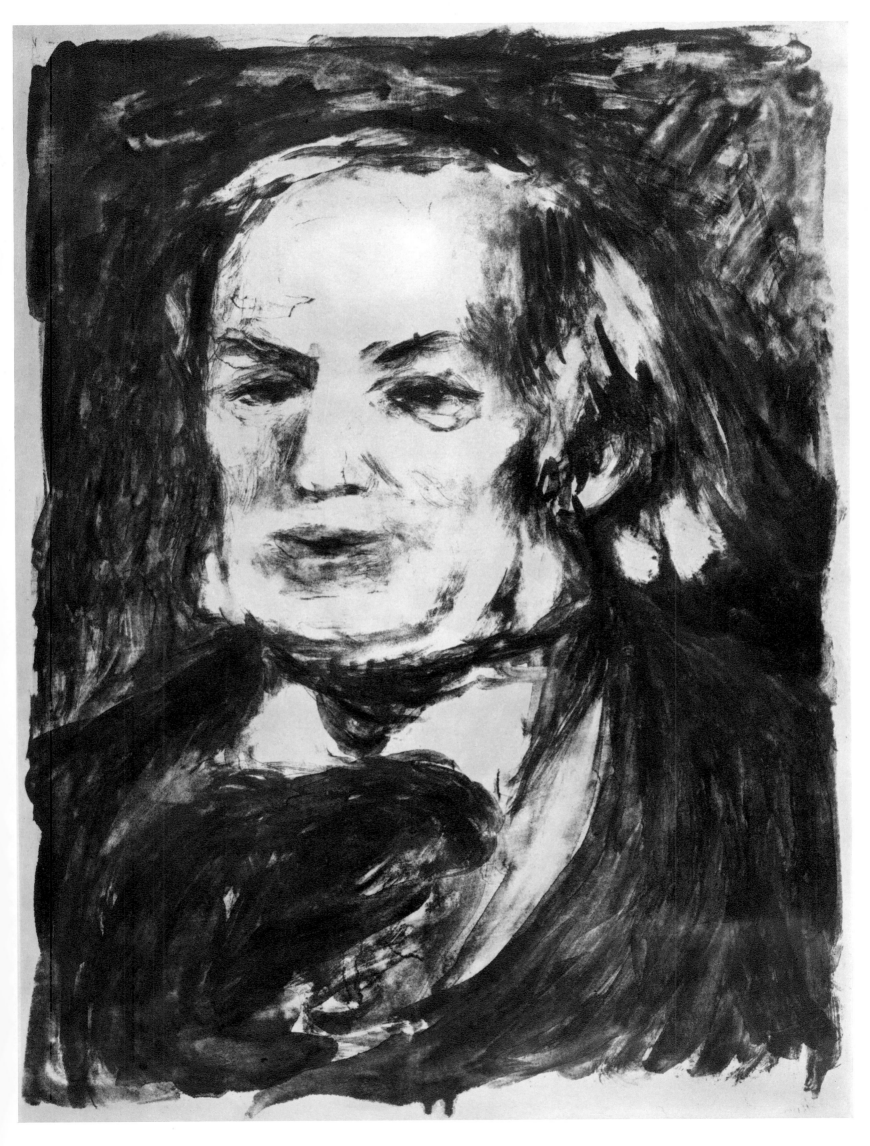

R. 33

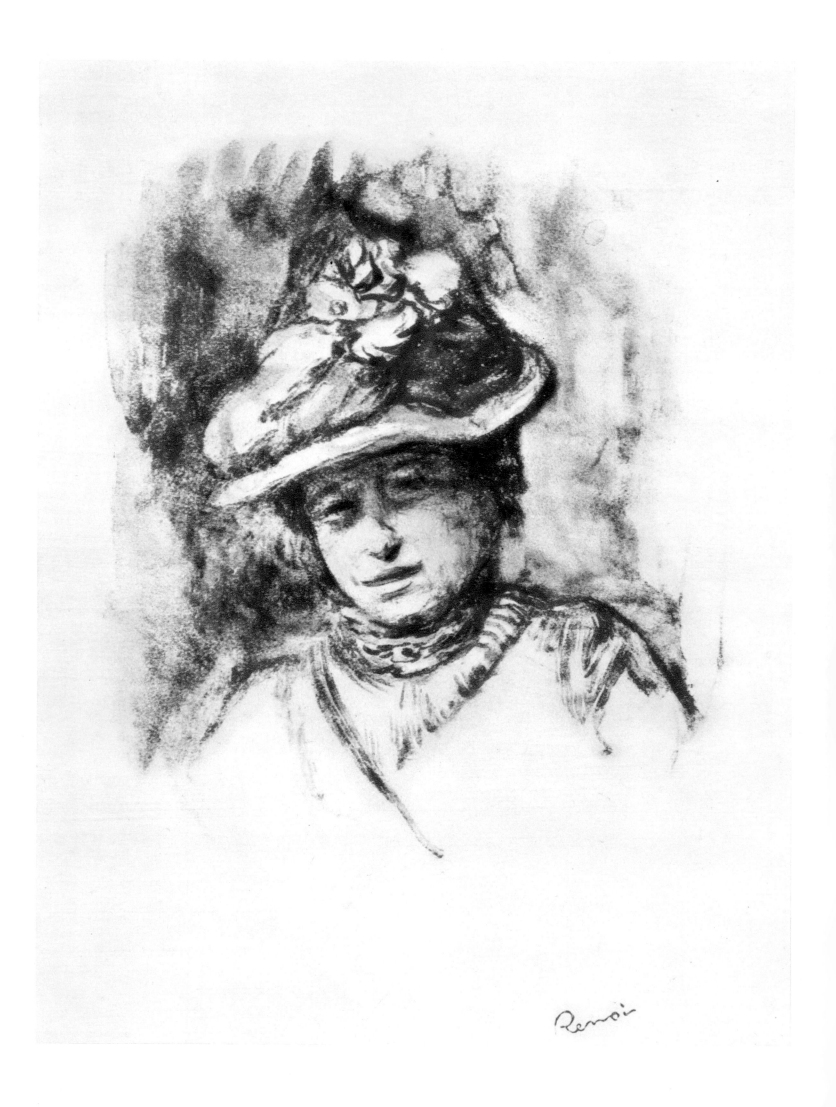

R. 34

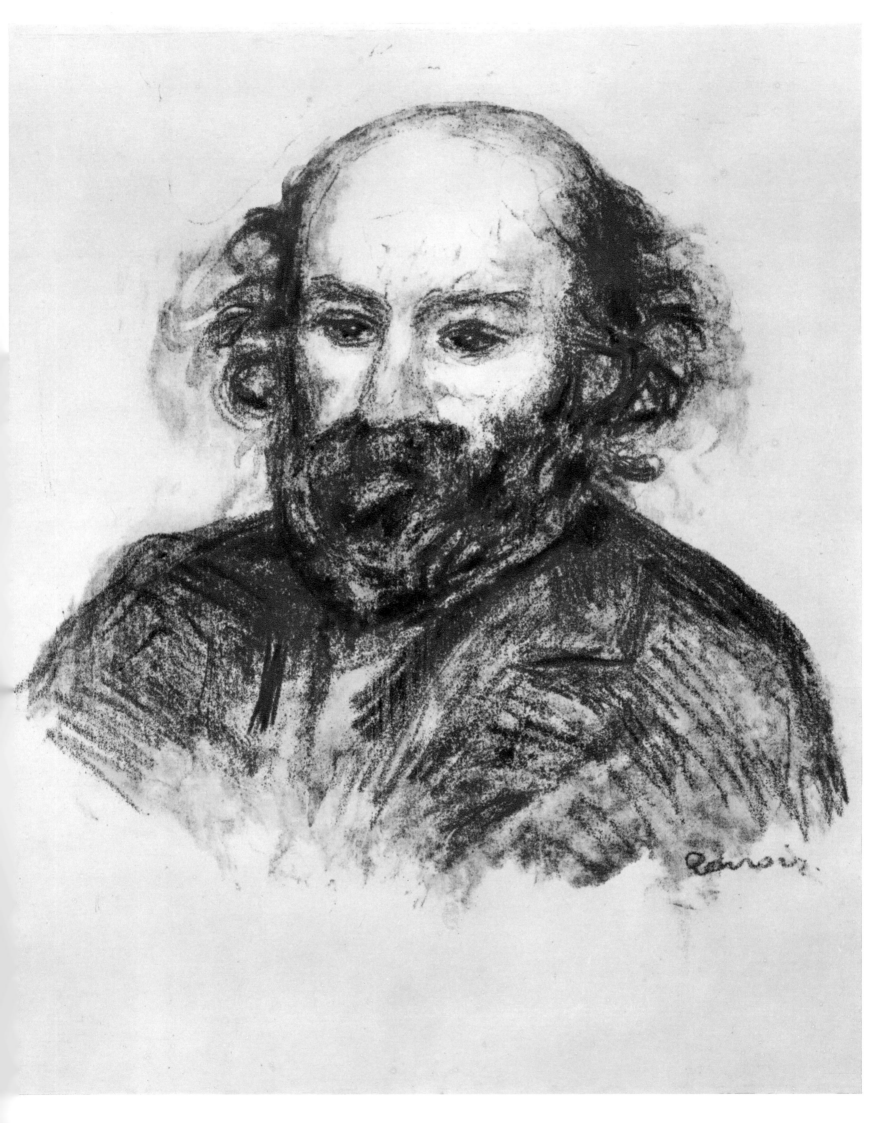

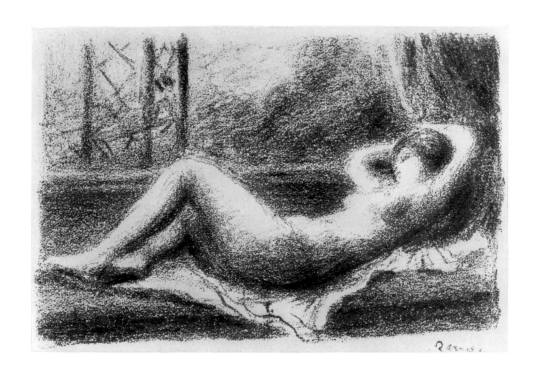

R. 36

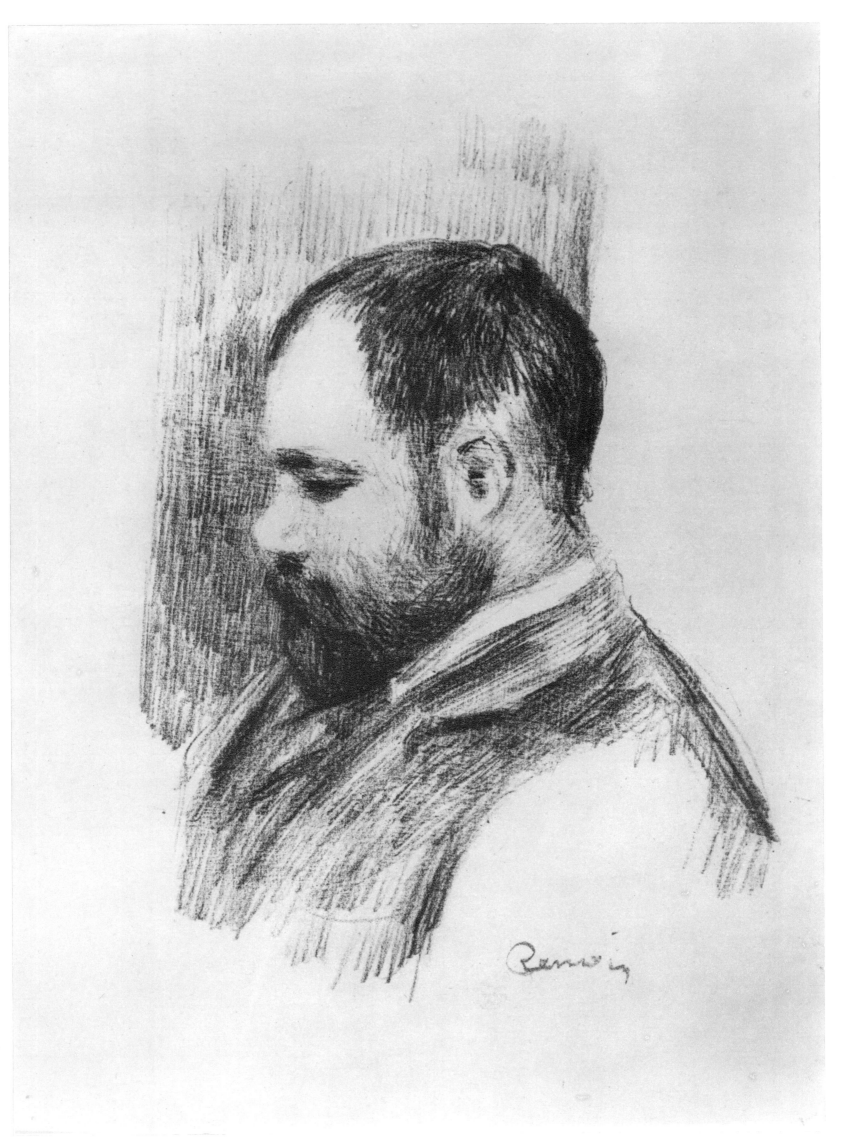

Renoir

R. 37

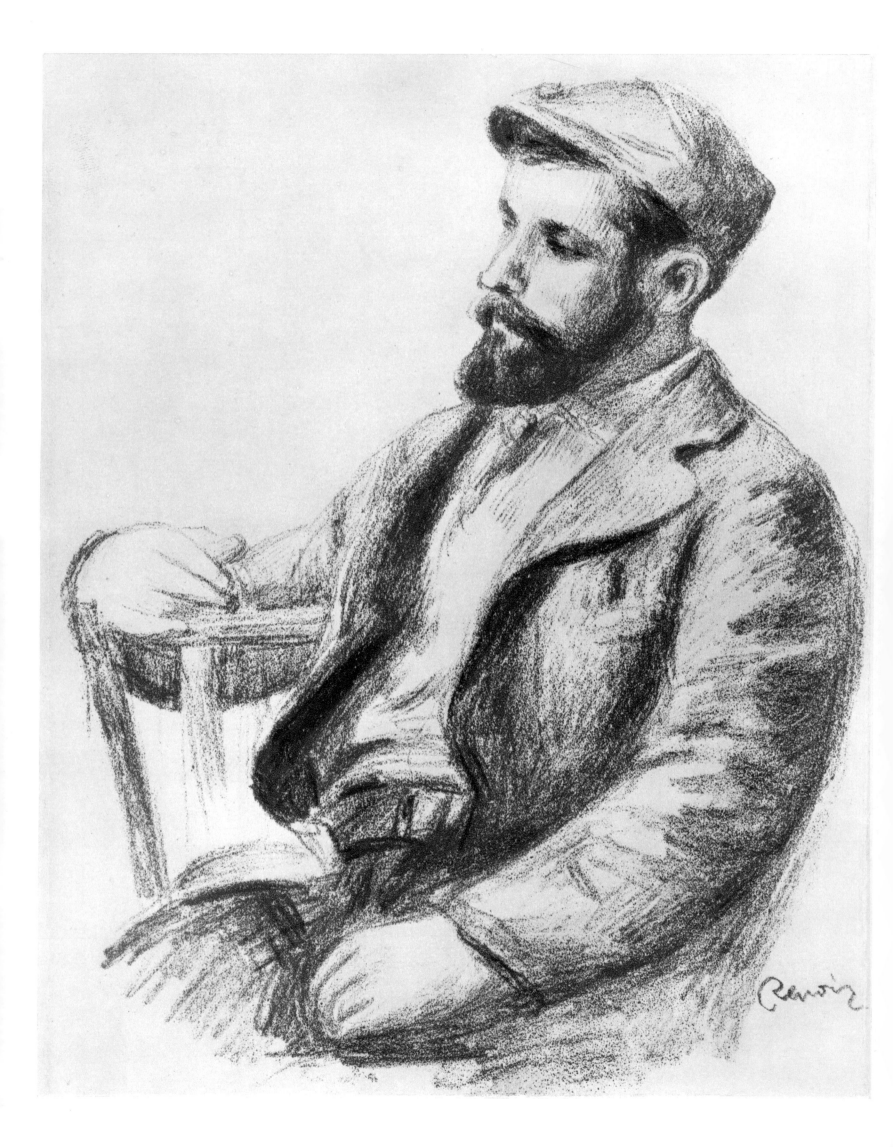

Renoir

R. 38

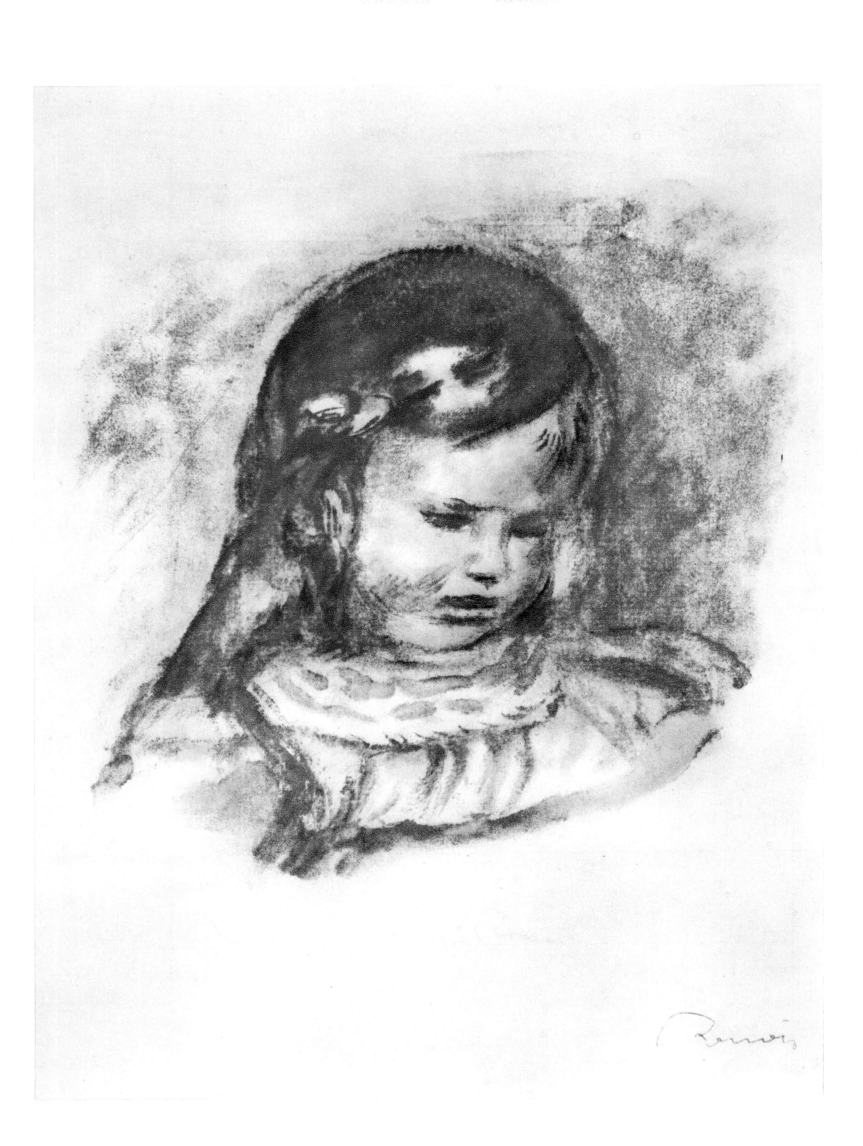

R. 39

R. 40

R. 40

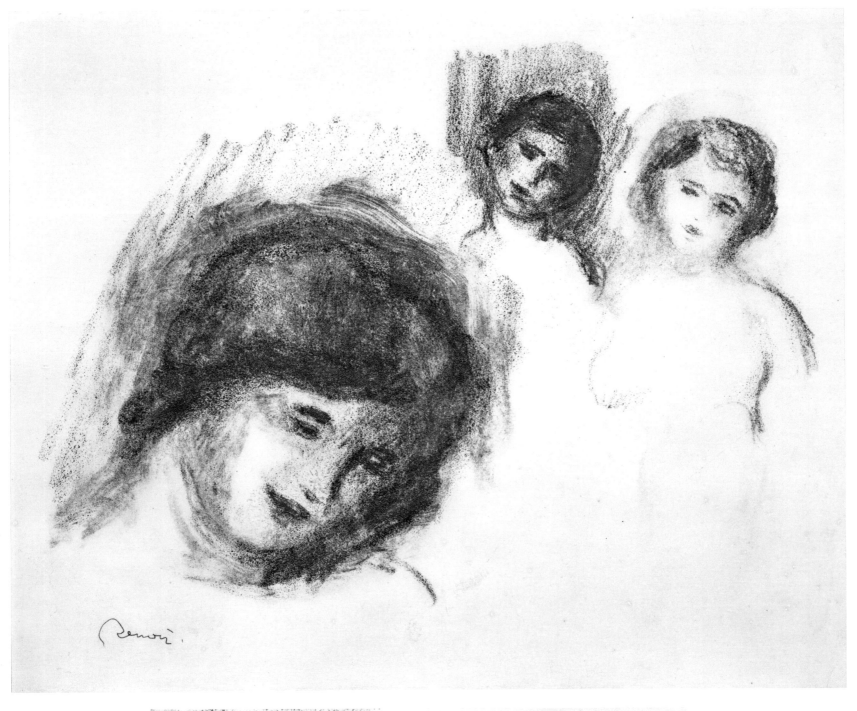

R. 41

R. 42

R. 43

R. 44

R. 45

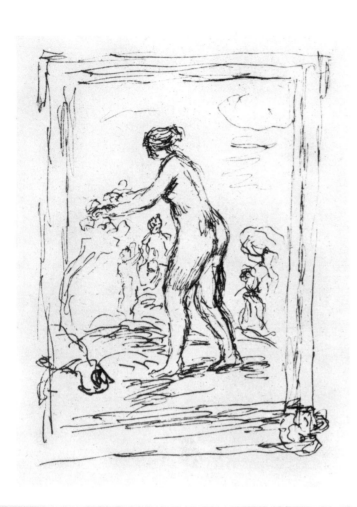

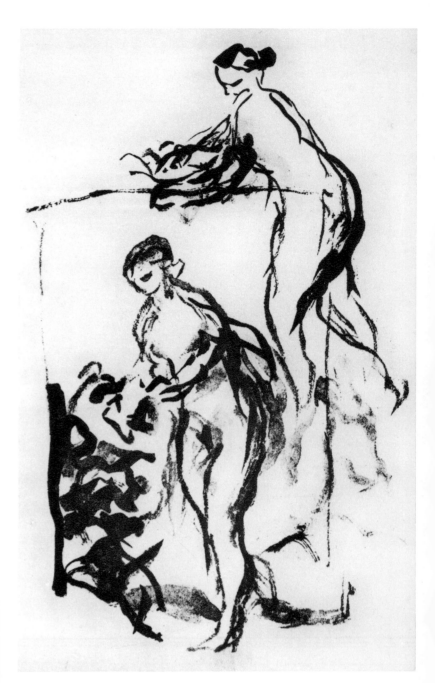

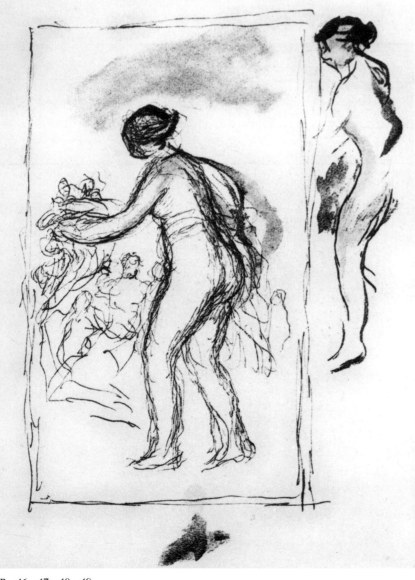

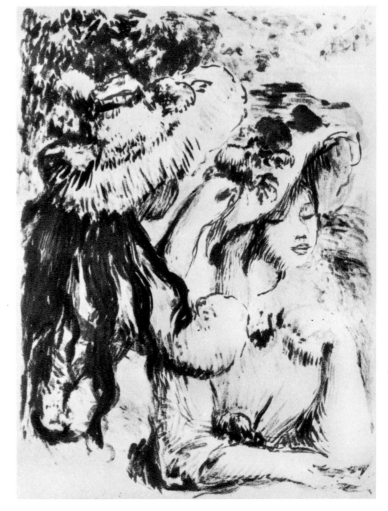

R. 46, 47, 48, 49

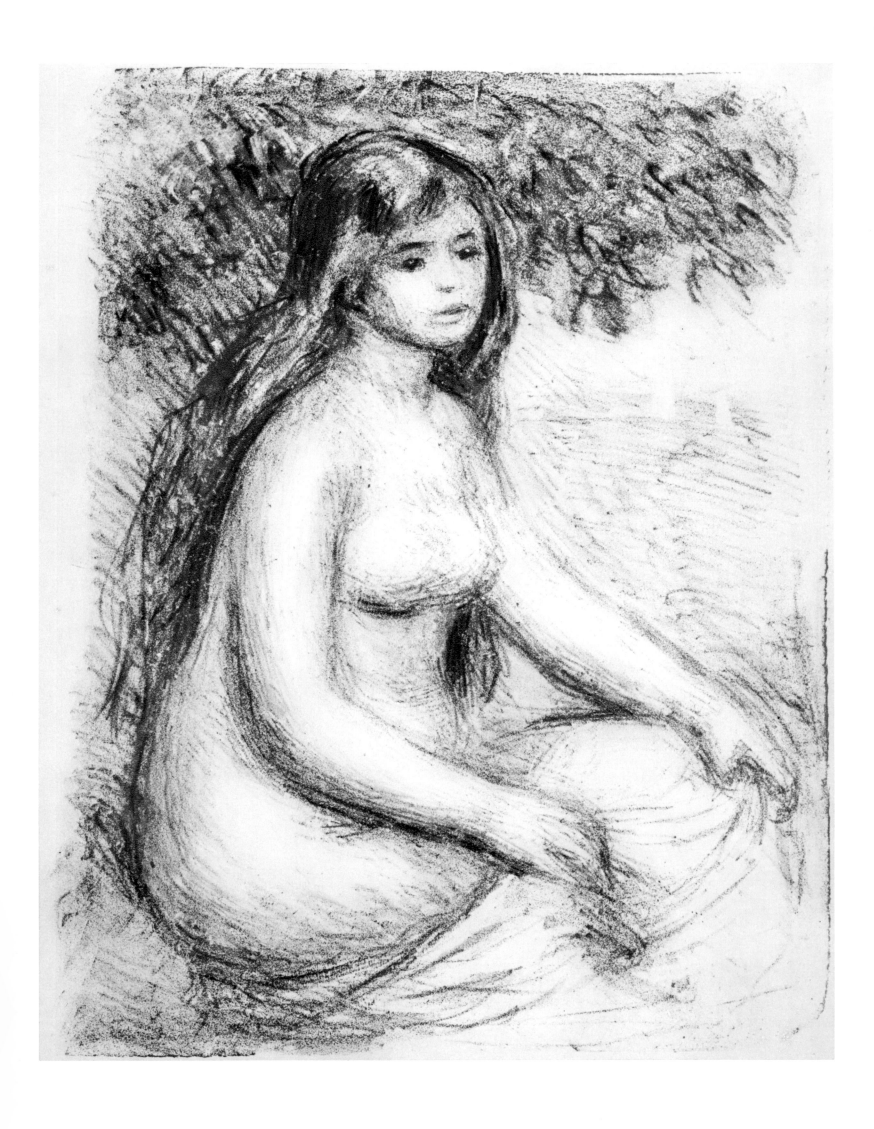

R. 49

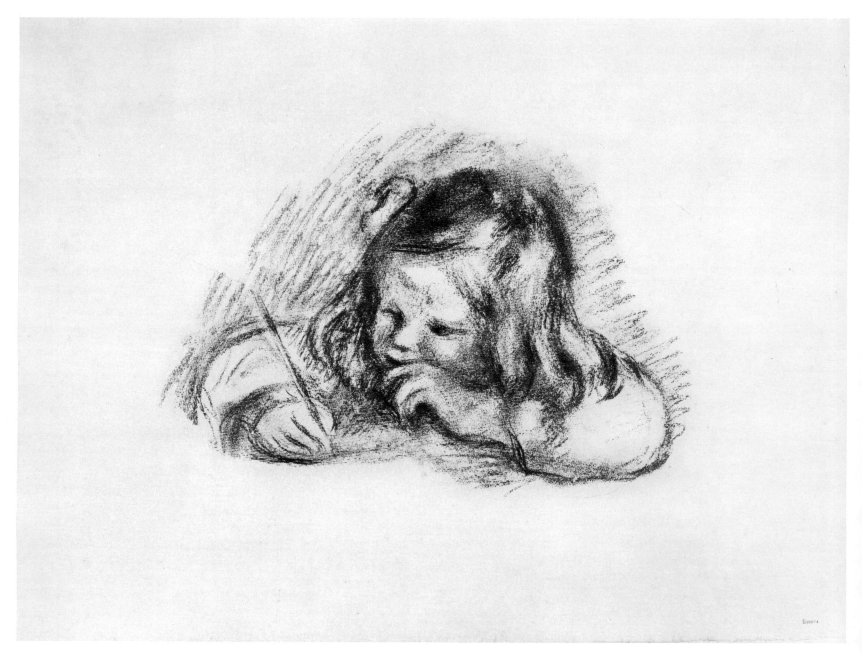

R. 50

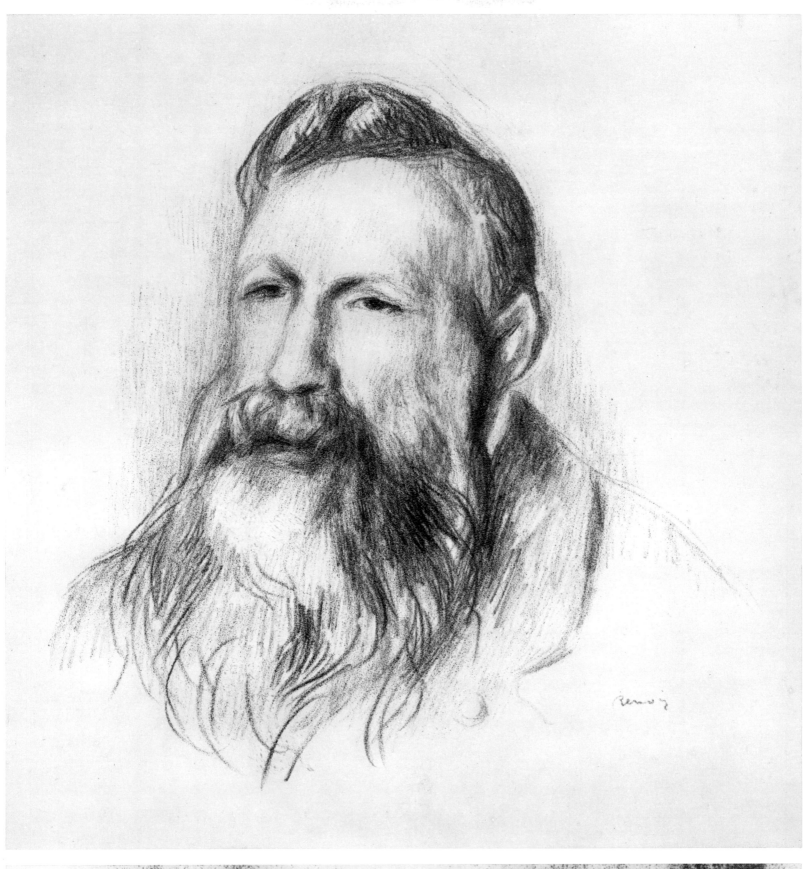

R. 51

R. 52

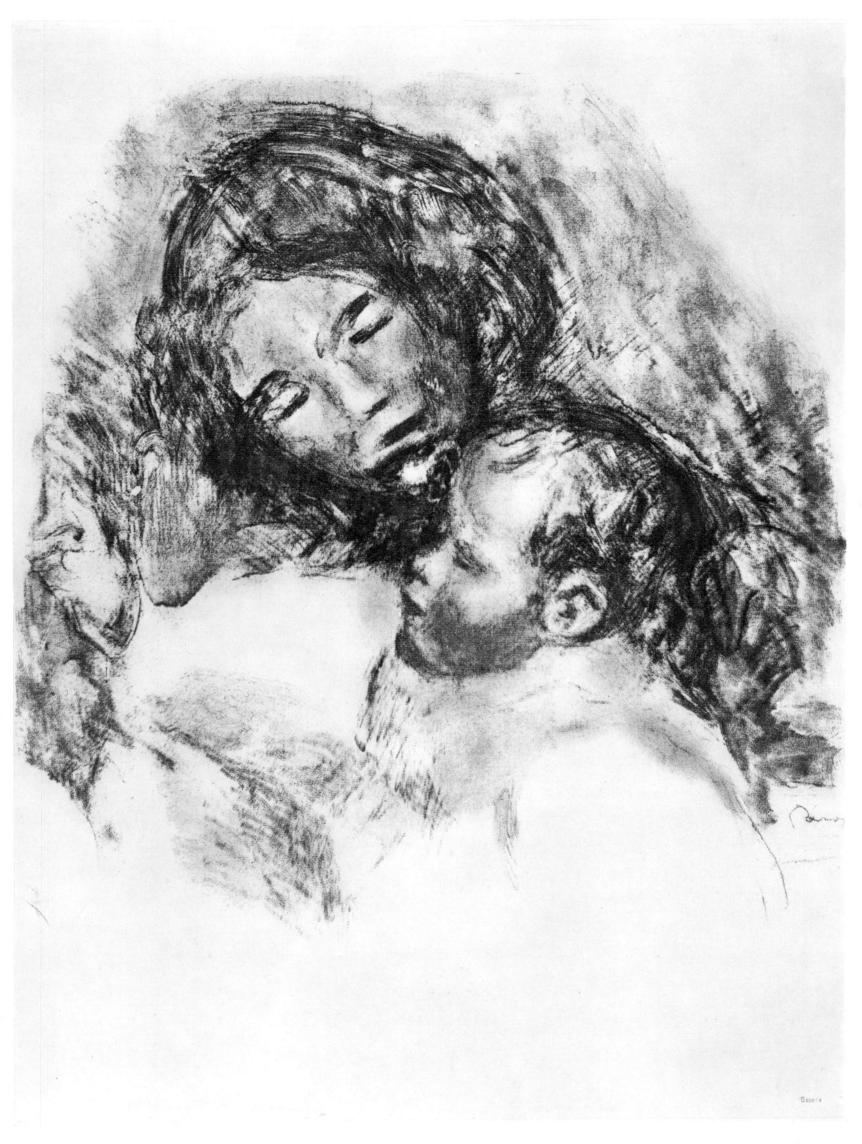

R. 53

R. 53 detail

R. 54

R. 55

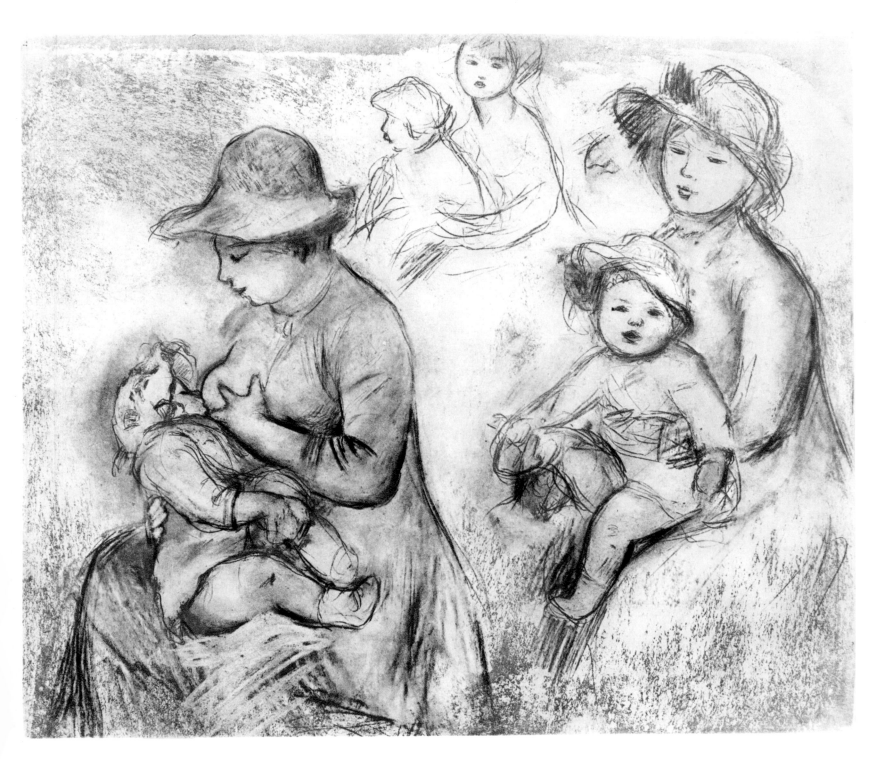

R. 56

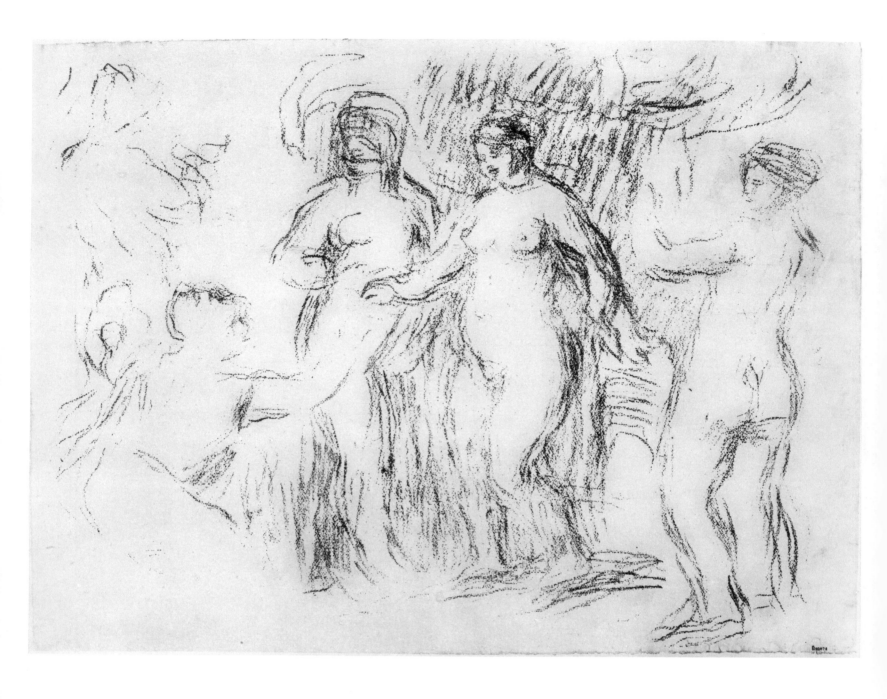

R. 57

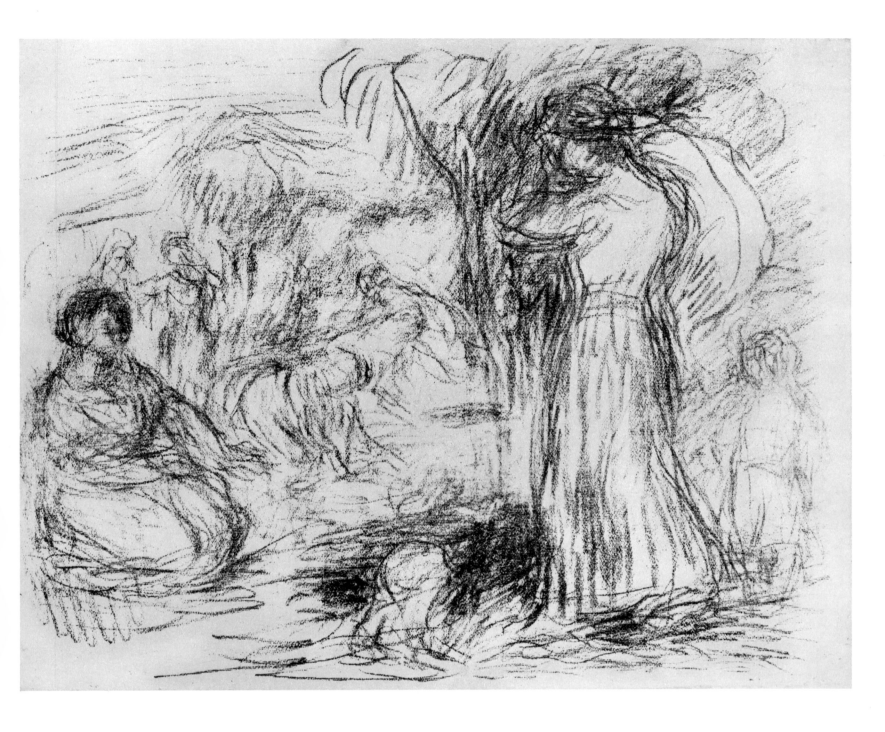

R. 58

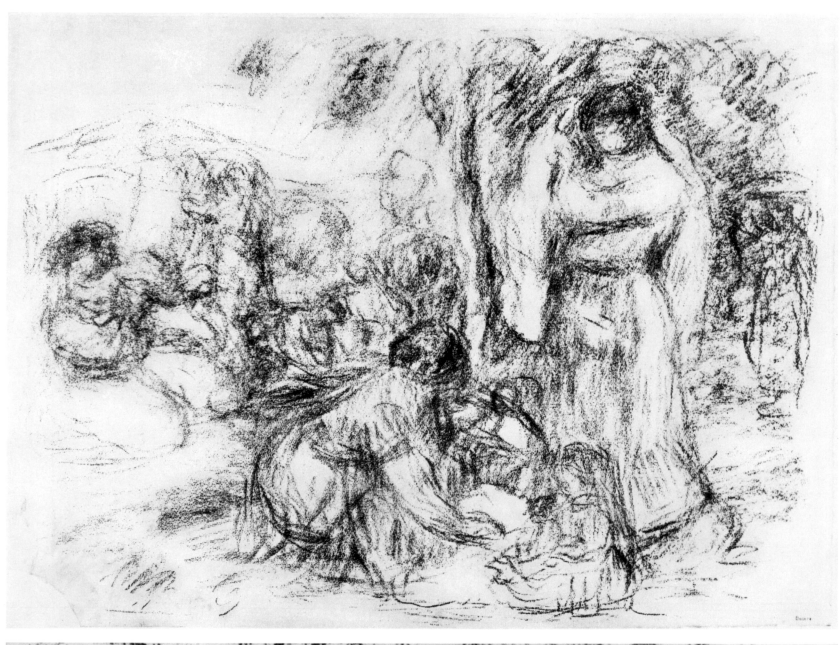

R. 59

Cézanne and Sisley

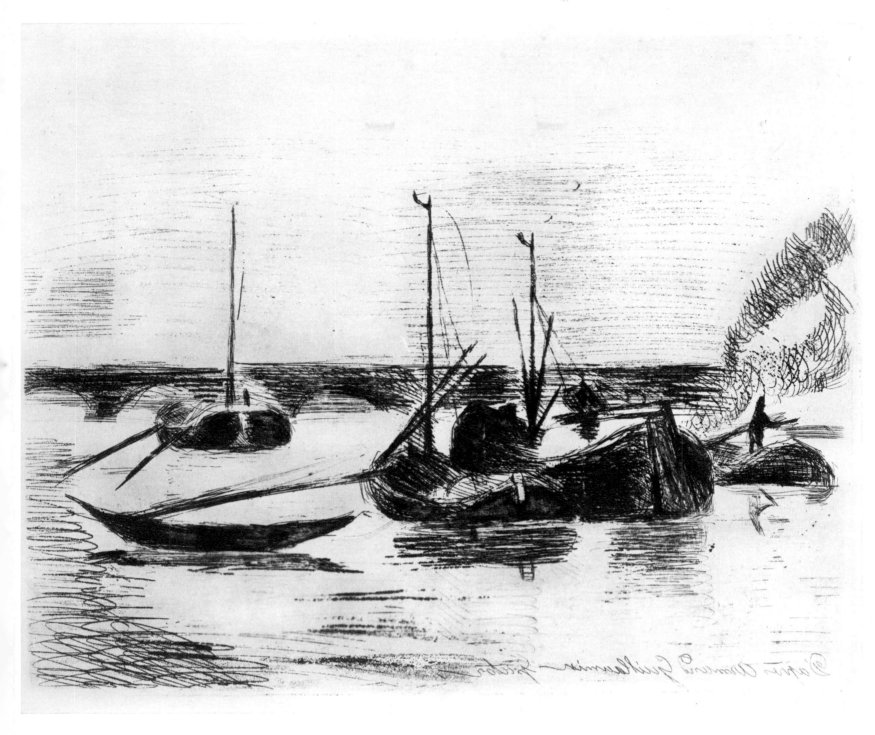

Jean Baptiste Armand Guillaumin — Péniches

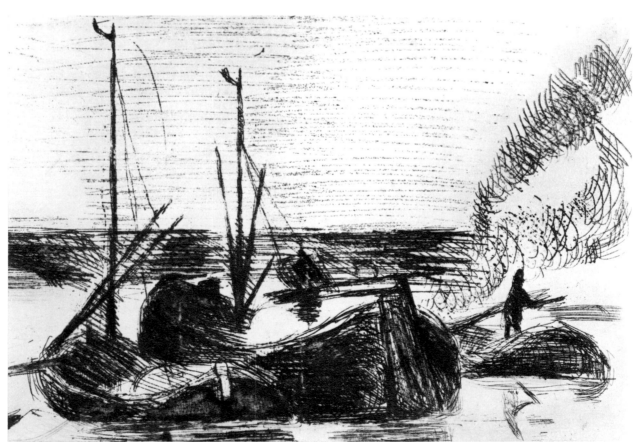

C. 2, 3

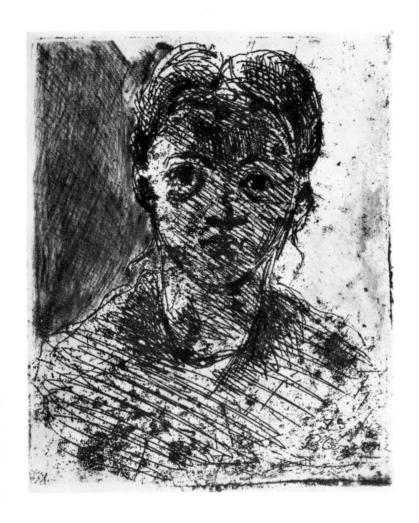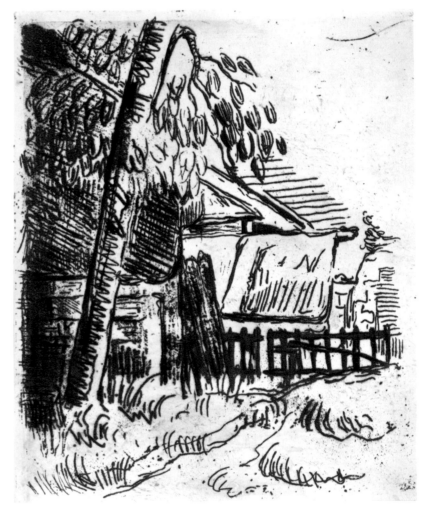

C. 4, 5

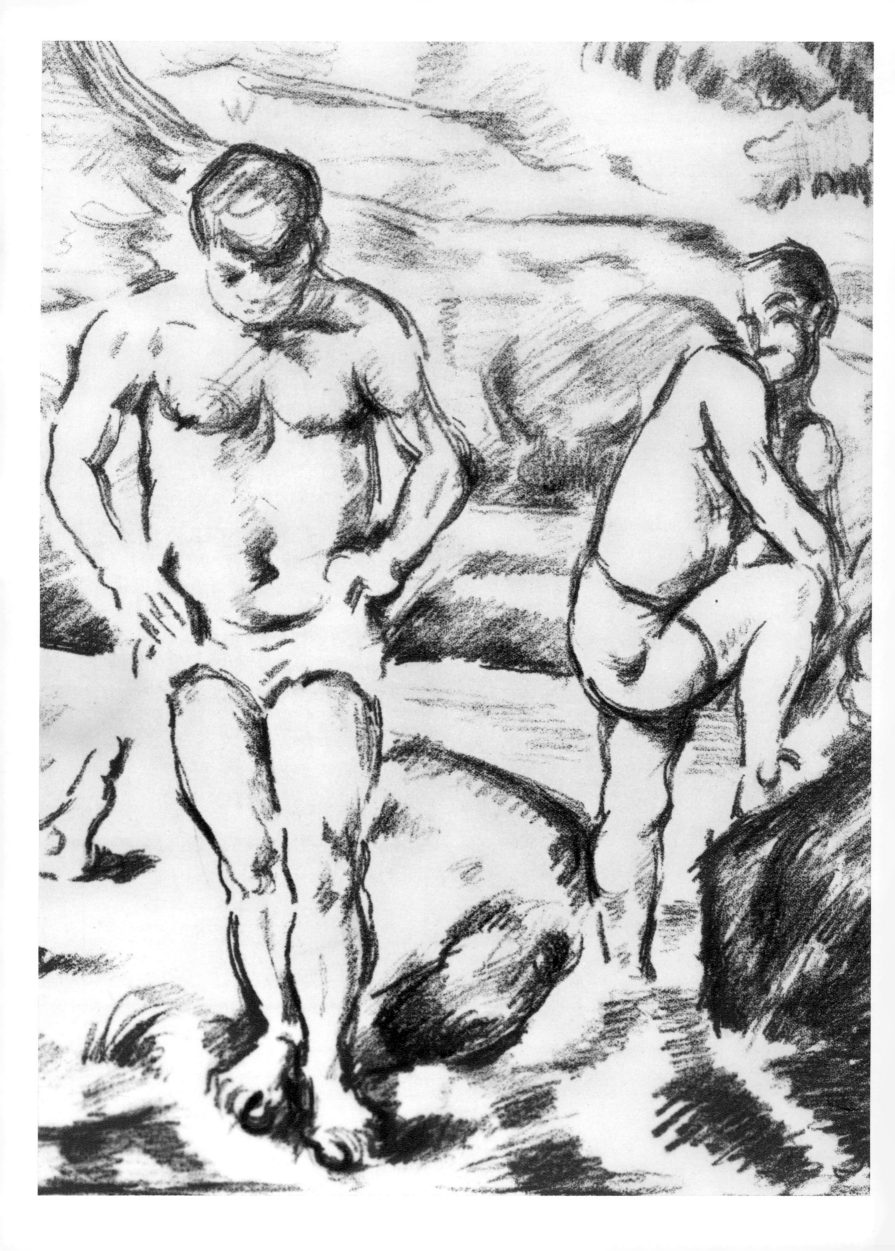

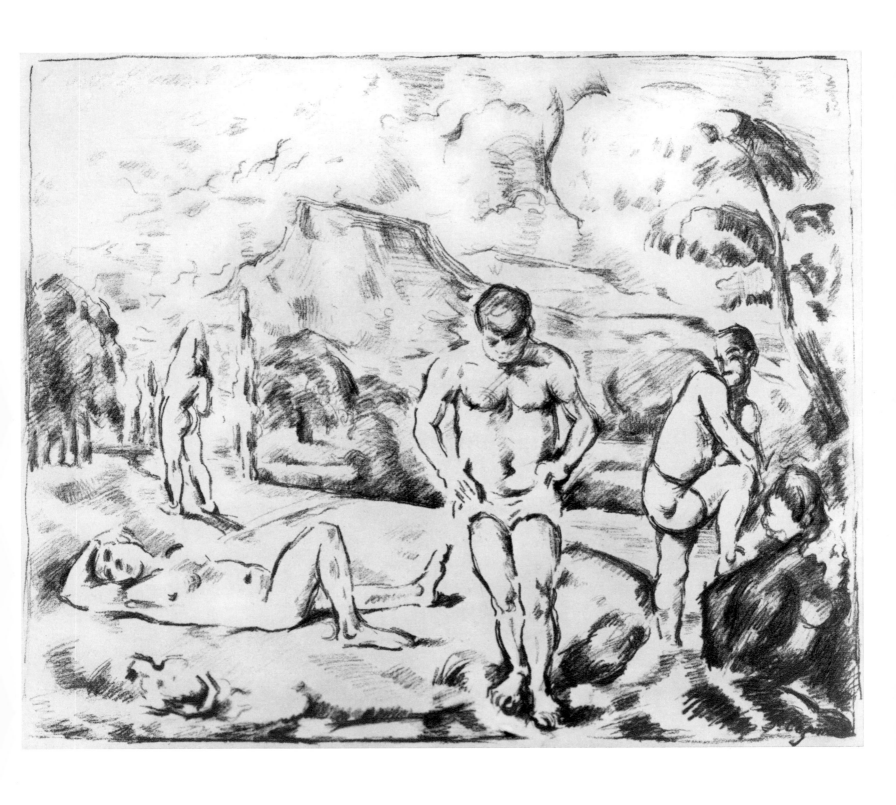

C. 6

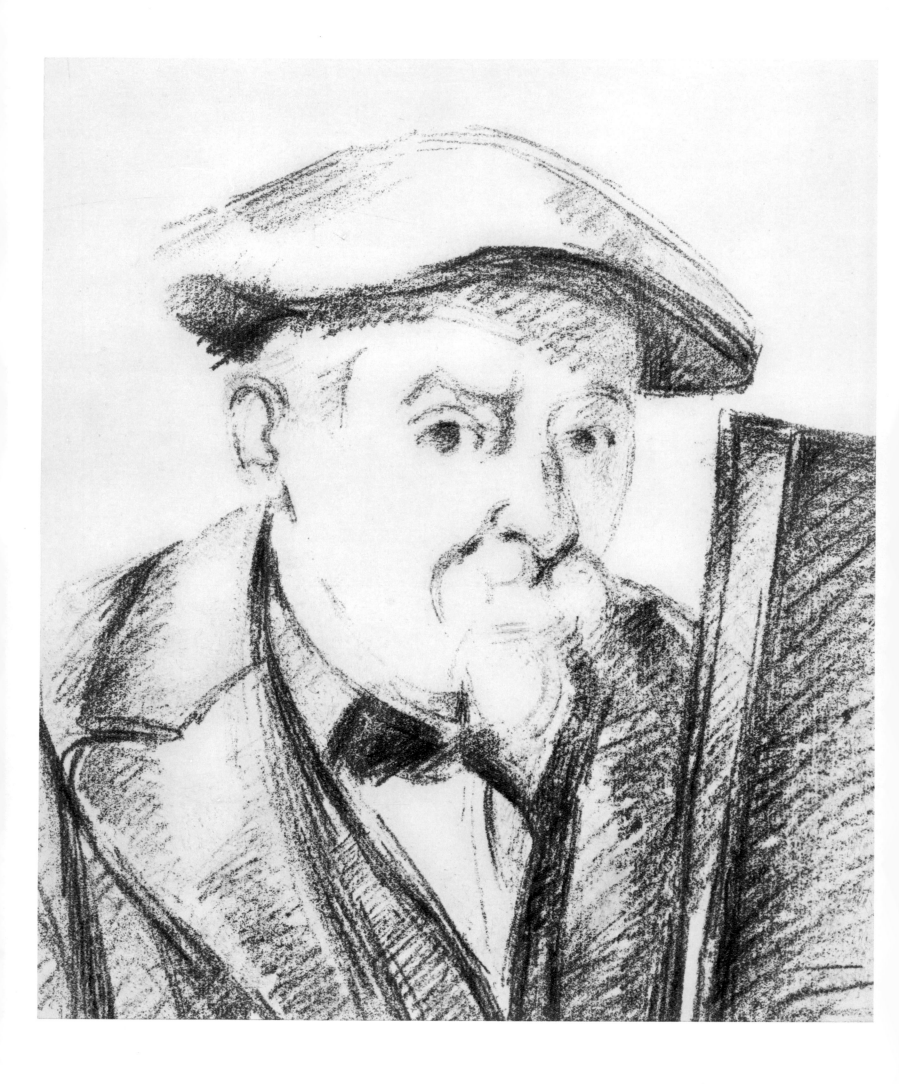

C. 7 detail

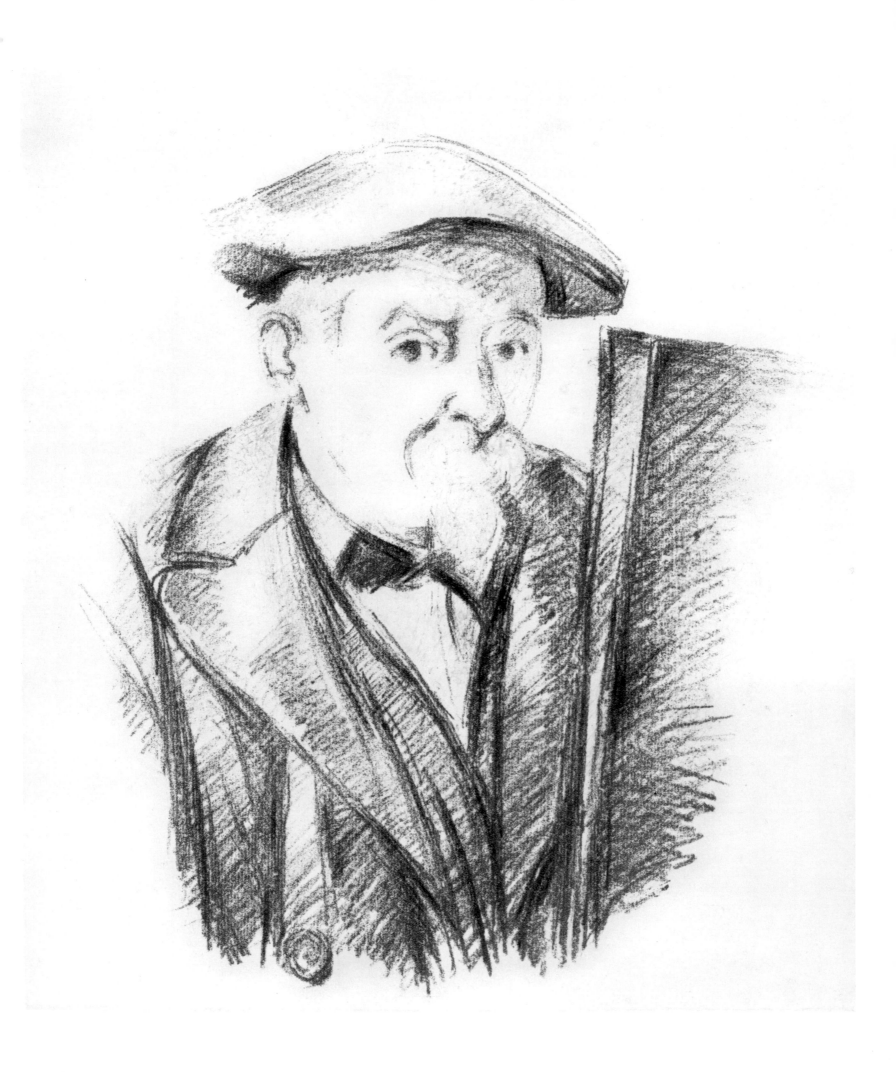

C. 7

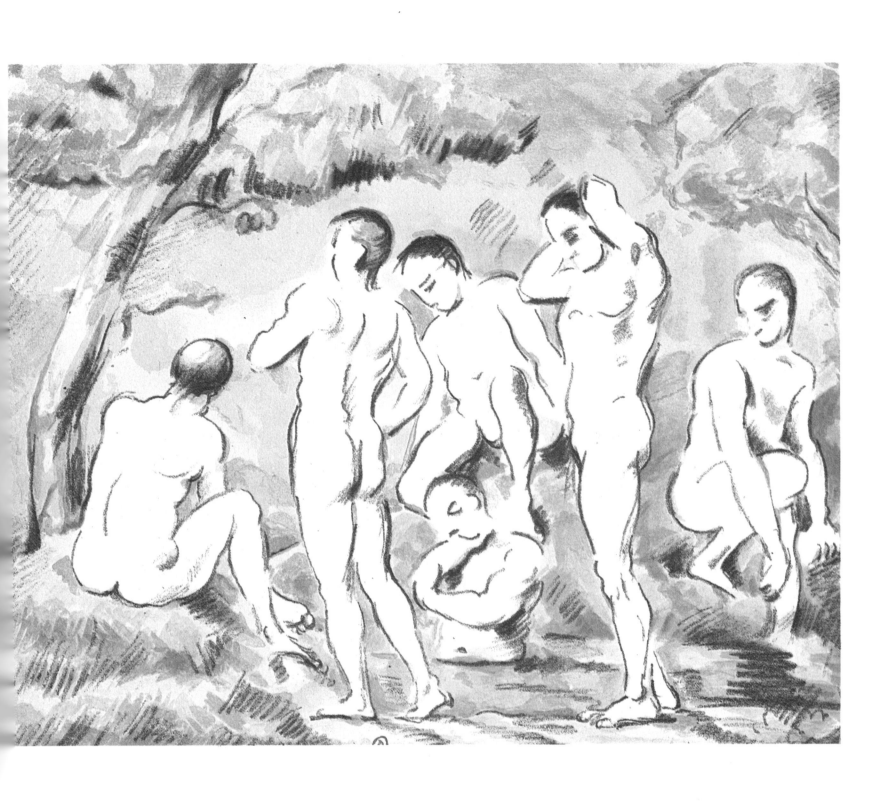

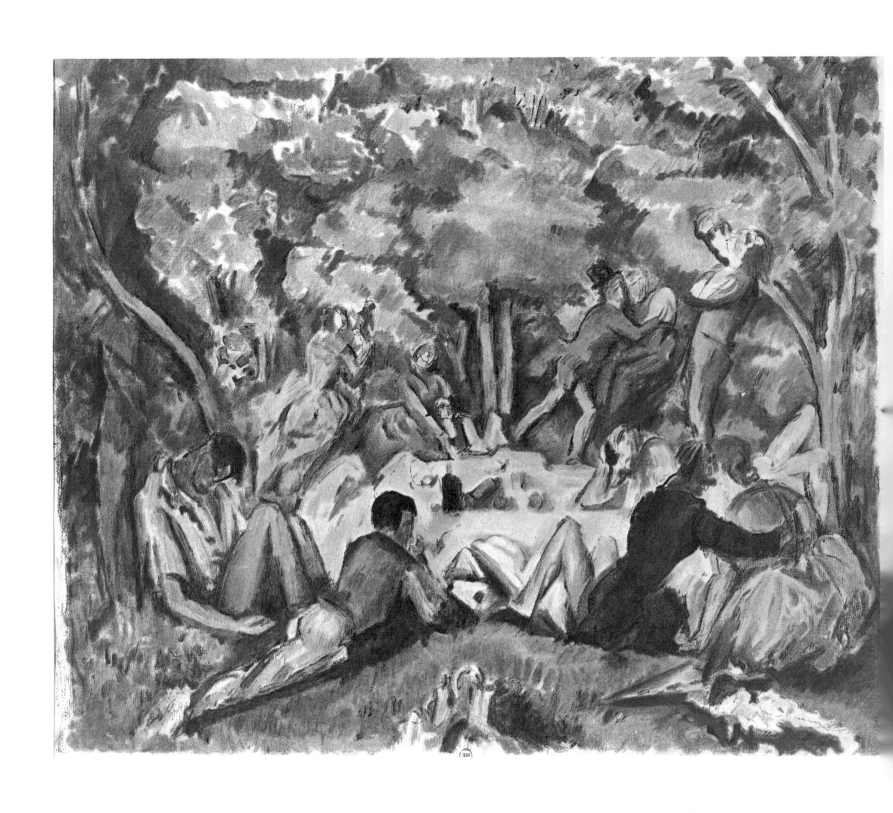

C. 9

S. 1

S. 2

S. 3

S. 4, 5

S. 6

Catalogue of the Engravings

The historiography of impressionist engraving has suffered from many misapprehensions. First, the notable absence of Claude Monet from the ranks of the painter-engravers has without doubt helped to prejudice their chances of reaching a wider public. Second, even though critics have been fascinated by impressionist painting, the graphic works have long been neglected. And finally, histories of engraving, which deal mainly with the revival of etching after 1860, either make only passing reference to the impressionist engravers, who were in any case only minimally concerned in this movement, or it is implied that they include them in their general argument.

Manet was the only one of the group to work for Cadart; this was when he first started engraving and in fact he published only two engravings in Cadart's albums. Pissarro and Degas rarely published their work and received little exposure to the public through exhibitions. Pissarro did not exhibit any engravings until the fifth impressionist exhibition in 1880, and then not until the exhibitions of the Société des Peintres-Graveurs, from 1889 onwards. It is not therefore surprising that these works went unremarked by contemporary critics, and have often been neglected by the critics of today. The engravings were conceived as experiments, very few proofs were printed and these were given to friends. They did not turn up in any quantity until the posthumous sales of the artists' work.

The critics of the generation of Baudelaire and Gautier noted the revival of etching and the appearance of the early Manet engravings, without as yet being able to see their connexion with what, in ten years time, was to become impressionism. In Zola, there are no lengthy expositions of engraving. Duranty devotes to it no more than a paragraph in his *Nouvelle Peinture* (1876). In 1879, Huysmans refers only to Desboutin. The great critic of graphic art, Philippe Burty, died too early, in 1891, and was more interested in Bracquemond than in the impressionists. Certainly Bracquemond exerted a great influence; he exhibited his engravings in the Salon des Refusés in 1863, and was present from the very first exhibition of the group in 1874. However his style is far removed from that of the 'impressionist-engravers' who followed him, who encouraged the idea of themselves as solitary figures and, when dissatisfied with their efforts, would often claim to be mere dilettantes in the art. To date, only one album of reproductions devoted specifically to impressionist engravings has been published. This is *Etchings of the French Impressionists* (New York, Hyperion Press, 1946), which includes a brief introduction by E. T. Chase. It has been one of the functions of the Société des Peintres-Graveurs, renamed since 1891 Société des Peintres-Graveurs français, to give prominence today to the artists who dignified its early exhibitions: see the retrospective section in the catalogue of the Society's thirty-sixth exhibition (8–24 November 1950) and the preface by Jean Adhémar, 'L'Estampe impressioniste'; and also the catalogue of the forty-sixth exhibition (14 March–13 April 1963) and the preface by Claude Roger-Marx, 'Pissarro'.

Of the engravers included in this catalogue, Manet has undoubtedly received most attention. There exist already a number of catalogues of his engravings. First, Béraldi, in volume IX of his *Graveurs du XIXe siècle* (Paris, 1889); then a corrected version by Moreau-Nélaton, *Manet graveur et lithographe* (Paris, 1906); which in turn was corrected by Marcel Guérin in *L'Œuvre gravé de Manet* (Paris, 1944). These incomplete catalogues have now been brought up to date by Miss Jean Harris in her thesis, *Edouard Manet, Graphic works: a definitive catalogue raisonné* (New York, Collectors edition, 1970). Still a

useful work of reference is the excellent catalogue of the Manet exhibition (Philadelphia Museum of Arts, 1966) by Miss Ann Coffin Hanson. Also useful are the many entries and the preface, 'Manet's graphic work of the Sixties', by Miss J. Harris in the catalogue of the exhibition, 'Manet and Spain' (organized by Joel Isaacson, 19 January–2 March 1969, Museum of Art of the University of Michigan, Ann Arbor).

Léon Rosenthal has written a good book on the subject, *Manet aquafortiste et lithographe* (Paris, 1925). There are also a number of good articles: by Henri Focillon, 'Manet en blanc et noir' (*Gazette des Beaux-Arts*, volume LXIX, 1927, pp. 335–46; reprinted in *Maîtres de l'Estampe*, Paris, 1930; new edition by Arts et Métiers Graphiques, Paris, 1969); by C. Zigrosser, 'Manet's etchings and lithographs' (*Print Connoisseur*, volume I, 1921, pp. 380–98); and by Claude Roger-Marx, 'Manet: etcher, lithographer and illustrator' (*Print Collector's Quarterly*, volume XXIII, no. 4, October 1936, pp. 303–22).

There is an early article by A. Tabarant, 'Une histoire inconnue du Polichinelle' (*Bulletin de la Vie Artistique*, volume IV, 1923, pp. 365–9). To this should be added the more recent notes by Jean Adhémar, 'Les portraits de Baudelaire par Manet' (*Revue des Arts*, no. 4, 1952, pp. 240–4), and 'Manet et l'estampe' (*Nouvelles de l'Estampe*, no. 7, 1965, pp. 230–5); also the important remarks by Theodore Reff, 'The symbolism of Manet's frontispiece etching' (*Burlington Magazine*, volume CIV, 1962, pp. 182–6), and 'Manet's frontispiece etchings' (*Bulletin of the New York Public Library*, 1962, pp. 143–8). Worth mentioning, more for what it has to say on Manet's influence in Germany than on his etchings, is an early article by the German painter Max Liebermann, 'Zwei original Holzschnitte von Manet' (*Kunst und Künstler*, year 3, 1905, book 4, pp. 140–4).

The considerable body of work by Camille Pissarro has in contrast been unjustifiably neglected. The only article specifically devoted to him was written as long ago as 1908. It was however by Arthur Hind, 'Camille Pissarro Graphische Arbeiten' (*Die Graphischen Kunst*, volume XXXI, 1908, pp. 34–48), and is the only really penetrating essay on the problem of impressionist engraving. There is an entry on Pissarro in the short selection, *Graveurs Français nouveaux* (Paris, 1929 – little of this is text), by Claude Roger-Marx, who also wrote the preface to the catalogue of the exhibition of Pissarro's etchings at the Max Bine gallery (10 March–10 April 1927).

Of the catalogues in existence, volume XVII of *Le Peintre Graveur illustré* by Loys Delteil, published in 1923, is still indispensable to a study of Pissarro's work. It was followed, in 1939, by a catalogue of Pissarro's paintings by his son Ludovic-Rodo and Lionello Venturi, and the edition by John Rewald of *Lettres de Pissarro à son fils Lucien* (New York, Pantheon Books, 1943; French edition, Paris, Albin Michel, 1950). Also by John Rewald is an article 'L. Pissarro, letters from London 1883–1891' (*Burlington Magazine*, volume 99, no. 556, July 1949, pp. 188–92). These later works are the source of most of the corrections to Delteil, whose inaccuracies are mostly confined to the period at the end of Pissarro's life. Further corrections have been supplied by two articles which appeared in *Print Collector's Quarterly*: one by Ludovic-Rodo Pissarro, 'The etched and lithographed work of Camille Pissarro' (volume IX, 1922, pp. 275–301); and the other by Jean Cailac, who organized the major sales of Pissarro's work in December 1928 and April 1929, 'The prints of Camille Pissarro, a supplement to the catalogue by Loys Delteil' (volume XIX, 1932, pp. 75–86).

Renoir has scarcely fared any better. Delteil's catalogue (volume XVII) is the main source, but it is incomplete and has here been augmented to provide a comprehensive record. Additional information on the lithographs has been supplied by Claude Roger-Marx's catalogue (Sauret, Monaco, 1952).

Again for Sisley, the only source is this same volume of Delteil. In the first volume of his catalogue of paintings exhibited by Durand-Ruel, M. François Daulte announces the projected publication of a catalogue of Sisley's engravings.

Cézanne's engravings have been catalogued twice: by Lionello Venturi in his major work, *Cézanne, son art, son œuvre* (2 vols., Paris, P. Rosenberg, 1936); and by Jean Adhémar in *L'Inventaire du fonds francais du Cabinet des Estampes de la Bibliothèque nationale, graveurs après 1800* (volume IV, 1949). Jean Goriany, who has announced plans for a further catalogue, has published an article 'Cézanne's lithograph "the Small Bathers" ' (*Gazette des Beaux-Arts*, February 1943, pp. 123–4). Paul Gachet has written an interesting monograph on Cézanne's etchings, *Cézanne à Auvers, Cézanne graveur* (Paris, Les Beaux-Arts, 1952).

Michel Melot

PLATEAU), 1862. Etching, first state of two. 220 × 145 (8⅝ × 5¾). G.15, M.N.66. Bibliothèque Nationale, Paris.
Léon Leenhoff is again the model here (de L.155). This subject recurs bottom left of Manet's picture *Spanish Cavaliers*, a copy of a painting then attributed to Velazquez; it occurs again in *The Balcony* and in *Fantasy in the manner of Velazquez*, now in the Musée de Lyon. There is a watercolour of the same subject in the Phillips collection, Washington.

M 26 THE STREET BOY (LE GAMIN), 1862. Etching, second and last state. 205 × 145 (8⅛ × 5¾). G.27, M.N.11. Bibliothèque Nationale, Paris.
Inspired by a picture which Durand-Ruel bought in 1870 for 1,500 francs (J.W.73) – cf. lithograph M 70. It appears that Léon Leenhoff is once again the model. René Huyghe believes that Murillo was Manet's source of inspiration for this theme. In a letter of 1861, published from a copy by Jean Adhémar, Manet makes a reference to an etching of this title. As this letter also refers to an exhibition it is possible that the date on the copy is incorrect and should be 1863, the date of the exhibition staged by Martinet.

M 27 LOLA DE VALENCE, 1862. Etching, third and last state. 230 × 158 (9 × 6¼). G.23, M.N.3. Bibliothèque Nationale, Paris.
The quatrain at the foot of the etching is by Baudelaire. Lola de Valence was the *première danseuse* of the Spanish Ballet, which came to the Hippodrome in the autumn of 1862 and enjoyed enormous success. Baudelaire, as well as Manet, was struck by their performance (cf. lithograph M 71). Manet also did a painting of the subject which was bought by Camondo and passed with the rest of his collection to the Louvre (J.W.46). This etching was originally intended for the album of 1862 but, like M 28, was left out. It was published by Cadart in October 1863 as part of the work of the Société des Aquafortistes (de L.178, 179).

M 28 THE SPANISH DANCER (LE BAILARIN), 1862. Etching, only state. 254 × 156 (10 × 6⅛). G.24, M.N.31. Bibliothèque Nationale, Paris.
A portrait of Mariano Camprubi, *premier danseur* of the 'Royal Theatre of Madrid', which performed in Paris in 1862 (cf. M 27). There is also a painting of Camprubi (Collection S. Stralem, New York, J.W. 47). This plate was originally intended for the 1862 album, but in the event was not included (de L.180).

M 29 L'ESPADA, 1862. Etching, second and last state. 304 × 235 (12 × 9¼). G.32, M.N.7. Bibliothèque Nationale, Paris.
A portrait of Victorine Meurend in matador's costume. The painting from which the etching was taken was shown in the Salon des Refusés in 1863. Today it is in the Metropolitan Museum of Art, New York (J.W.123, de L.181).

M 30 TRIAL VERSION OF A FRONTISPIECE for an 'album of etchings' (ESSAI DE FRONTISPICE pour un 'cahier d'eaux-fortes'), 1862. Etching, only state. 268 × 190 (10½ × 7⅜). G.28, M.N.49. New York Public Library.
This trial version of a frontispiece for the albums of Manet's work, published by Cadart, was never used. It is not clear whether it was intended for the 1862 edition or that of 1874.

M 31 FRONTISPIECE for 'an album of etchings' (FRONTISPICE pour 'un cahier d'eaux-fortes'), 1862. Etching, only state. 295 × 211 (11⅝ × 8¼). G.29, M.N.48. New York Public Library.
For a discussion of the symbolism of the frontispiece,

see the article by Theodore Reff, *Burlington Magazine*, vol. CIV, May 1962.

M 32 HAT AND GUITAR (CHAPEAU ET GUITARE), 1862. Etching, third and last state. 223 × 210 (8¾ × 8¼). G.62, M.N.1. Bibliothèque Nationale, Paris.
This was used as the frontispiece for the 'album of fourteen etchings' published by Cadart in 1874. There is a preparatory drawing in the New York Public Library, also the draft list of contents of the album – annotated by Theodore Reff, *Bulletin of the New York Public Library*, 1962, p. 143 (de L.219).

M 33 THE SPANISH INN (LA POSADA), 1863. Etching, only state. 245 × 413 (9⅝ × 16¼). G.47, M.N.71. New York Public Library. There is also a painting of the same subject (Hill Stead Museum, Farmington, USA; J.W.123), and a watercolour (J.W.123). This is the only known proof (de L.213).

M 34 SEASCAPE (MARINE), 1864. Etching, only state. 122 × 180 (4¾ × 7⅛). G.35, M.N.39. Bibliothèque Nationale, Paris.
In 1864, the date of *The Engagement between the Kearsage and the Alabama*, Manet painted a number of seascapes. In 1867 he submitted to the Salon a picture, now lost, *Fishing Boat Sailing before the Wind*, on which this etching was based (de L.201).

M 35 THE BEAR TRAINER (LE MONTREUR D'OURS), c. 1865. Etching, only state. 180 × 250 (7⅛ × 9¾). G.41, M.N.65. Bibliothèque Nationale, Paris.
There is a pencil and wash preparatory drawing for this etching in the Bibliothèque Nationale, Paris (de L.216).

M 36 CHRIST WITH THE ANGELS (LE CHRIST AUX ANGES), c. 1865. Etching, third state. 328 × 270 (12⅞ × 10⅝). G.34, M.N.59. Bibliothèque Nationale, Paris.
After a Manet picture which was shown in the Salon of 1864 and is now in the Metropolitan Museum of Art, New York (J.W.85). A proof of a fourth state exists, in the Claude Roger-Marx collection, also a pen and watercolour sketch, formerly in the collection of Madame Zola and now in the Drawings Collection at the Louvre (de L.198).

M 37 AT THE PRADO (AU PRADO), 1865. First plate. Etching, second and last state. 180 × 118 (7⅛ × 4⅝). G.45, M.N.63. Kunsthalle, Hamburg.
Either this or the following plate was exhibited at the 1869 Salon, together with M 41, M 49 and M 51.

M 38 AT THE PRADO (AU PRADO), 1865. Second plate. Etching, second and last state. 213 × 148 (8⅜ × 5⅞). G.46, M.N.62. Bibliothèque Nationale, Paris.
A dozen or so proofs of this etching were printed by Porcabeuf, grandson of the printer Salmon, who handled most of Bracquemond's engraved work.

M 39 FÉLIX BRACQUEMOND – PORTRAIT, 1865. Etching, only state. 160 × 105 (6¼ × 4⅛). G.42, M.N.60. Bibliothèque Nationale, Paris.
Pen drawing on copperplate. Manet was guided in this experiment by Bracquemond, who invented the process. The drawing is made directly on the plate, which is then varnished and plunged in water. The varnish is softened by the ink and, when the plate is cleaned, comes away where it is in contact with the drawing; the plate is then bitten with acid as for a conventional etching (de L.214).

M 40 MAN DRINKING WATER (LE BUVEUR D'EAU), 1865. Etching, only state. 182 × 138 (7⅛ × 5½). G.22, M.N.32. Bibliothèque Nationale, Paris.

In 1884, Guérard published in the *Gazette des Beaux-Arts* a print from this etching. The motif is taken from the picture *The Gipsies*. Guérin suggests 1861 as the date of this etching, but a preparatory drawing is dated 1865 (de L.177).

M 41 CHARLES BAUDELAIRE, FULL FACE (CHARLES BAUDELAIRE DE FACE), 1865. First plate. Etching, second and last state. 98 × 77 (3 ⅞ × 3). G.36, M.N.58. Bibliothèque Nationale, Paris.
There are only two known proofs of this etching. See the article by Jean Adhémar, 'Le Portrait de Baudelaire gravé par Manet', *Revue des Arts*, no. 4, 1952, pp. 240–242. The plate is after a photograph taken by Nadar.

M 42 THE PHILOSOPHER (LE PHILOSOPHE), 1865. Etching, only state. 270 × 162 (10 ⅝ × 6 ⅜) G.43, M.N.35. Bibliothèque Nationale, Paris.
A reproduction of a picture of his brother, Eugène, painted by Manet in 1865 (The Art Institute of Chicago, J.W.111). Duret points out that Manet 'introduces zigzag lines in the manner of Canaletto, which he admired for its fluidity and charm'. Goya's similar handling of his series of 'Philosophers' (after Velazquez) should also be noted, as they were certainly a direct source of inspiration to Manet.

M 43 THE TRAGIC ACTOR (L'ACTEUR TRAGIQUE), 1865. Etching, second and last state. 292 × 160 (11 ½ × 6 ¼). G.44, M.N.38. Bibliothèque Nationale, Paris.
A portrait of Philibert Rouvière as Hamlet. This was the motif of a painting rejected by the Salon of 1866 (J.W.125), inspired by the *Portrait of a Famous Actor at the time of Philip IV* attributed to Velazquez (de L.466).

M 44 OLYMPIA, 1865 or 1867. First plate. Etching, third and last state. 130 × 183 (5 ⅛ × 7 ¼). G.40, M.N.37. Bibliothèque Nationale, Paris.
Miss Harris rejects the order adopted by the old catalogues, and believes that this plate was executed shortly before the painting of 1865. The second plate (M 45) would then have been executed later, in time for the publication of Zola's book (de L.195, 196).

M 45 OLYMPIA, 1865 or 1867. Second plate. Etching, sixth and last state. 85 × 172 (3 ⅜ × 6 ¾). G.39, M.N.37. Bibliothèque Nationale, Paris.
A reproduction of a picture exhibited in the Salon of 1865 (J.W.82). Bracquemond helped Manet with the printing of this plate, which was published in Zola's booklet *Édouard Manet, Étude biographique et critique*, Paris, Dentu, 1867.

M 46 MAN SMOKING (LE FUMEUR), 1866. Sketch. Etching, only state. Motif: 140 × 130 (5 ½ × 5 ⅛). Plate: 239 × 152 (9 ⅜ × 6). G.48, M.N.34. Bibliothèque Nationale, Paris.
Moreau-Nélaton and Rosenthal differ as to the identity of the model; one takes him to be Gall, the model for *The Reader*, the other believes he is Janvier, a professional model.

M 47 MAN SMOKING (LE FUMEUR), 1866. Etching, second and last state. 152 × 128 (6 × 5). G.49, M.N.33. Bibliothèque Nationale, Paris.
Reproduction of Manet picture of 1866, *The Good Pipe*, exhibited at the Avenue Montaigne in 1867, and today in the Tribune Gallery, New York (J.W.133).

M 48 THE RABBIT (LE LAPIN), 1866–9. Etching, only state. 134 × 100 (5 ¼ × 4). G.50, M.N.64. Private collection, Paris.
There is also a painting of this subject (J.W.129).

M 49 THE DEAD TORERO (LE TORERO MORT), 1868.

Etching, third state of six. 95 × 193 (3 ¾ × 7 ⅝). G.33, M.N.13. Bibliothèque Nationale, Paris.
Manet was helped with this plate by Bracquemond who prepared the aquatint ground. Manet did a sketch of this same subject (for the *Album autographique*, part 7, 1867), and also a painting (National Gallery, Washington, J.W.83), based on the *Orlando Muerto* which is now in the National Gallery, London; in Manet's time it was in the Galerie Pourtalès, and was attributed to Velazquez (de L.200).
Note that Manet returns to this composition in the lithograph *Civil War* (M 78) which may possibly owe something to Daumier's *Rue Transnonnain*.

M 50 THE ODALISQUE (L'ODALISQUE), 1868. Etching, only state. 119 × 190 (4 ⅝ × 7 ½). G.64, M.N.20. Bibliothèque Nationale, Paris.
Rosenthal relates this undated plate to a drawing dated 1870, *The Sultan's Wife, standing* (J.W.200). This etching was published in 1884, together with *Woman Convalescing*, in Bazire's book on Manet (de L.193).

M 51 EXOTIC FLOWER (FLEUR EXOTIQUE), 1868. Etching, second and last state. 162 × 104 (6 ⅜ × 4 ⅛). G.51, M.N.18. Bibliothèque Nationale, Paris.
This etching was Manet's contribution to the album *Sonnets et eaux-fortes*, published by Lemerre in September 1868. As Duret pointed out, it is directly inspired by the fifteenth of Goya's *Caprichos*, *Bellos consejos*.

M 52 THE CATS (LES CHATS), 1868–9. Etching, only state. 165 × 210 (6 ½ × 8 ¼). G.52, M.N.43. Bibliothèque Nationale, Paris.
The cat on the left had already appeared, on a chair, in the picture *The Morning Meal* (Neue Staatgalerie, Munich). The Drawings Collection of the Louvre has a number of studies of cats by Manet, this being the theme of many drawings (de L.158, 225–31, 328, 329, 467–80, etc.).

M 53 CAT AND FLOWERS (LE CHAT ET LES FLEURS), 1869, Etching, second and last state. 173 × 124 (6 ⅞ × 4 ⅞). G.53, M.N.19. Bibliothèque Nationale, Paris.
Printed for Champfleury's *Les Chats*, this plate achieved a certain success, even notoriety, and was reproduced in the *Chronique parisienne*, 25 October 1869. Champfleury's book ran to three editions in 1868–9.

M 54 CHARLES BAUDELAIRE, PROFILE (CHARLES BAUDELAIRE DE PROFIL), 1869. Etching, second and last state. 100 × 79 (3 ⅞ × 3). G.31, M.N.15. Bibliothèque Nationale, Paris.
This second portrait was certainly executed after Baudelaire's death, no doubt with an eye to the publication of Asselineau's book (cf. M 55).

M 55 CHARLES BAUDELAIRE, FULL FACE (CHARLES BAUDELAIRE DE FACE), 1869. Second plate. Etching, only state. 112 × 93 (4 ⅜ × 3 ⅝). Bibliothèque Nationale, Paris.
At the time of Baudelaire's death, Manet wrote to Asselineau, who was working on his book on Baudelaire, to offer him the unused portraits in his possession. The publisher agreed to the idea but twice asked for changes to be made; hence these other, later, plates.

M 56 CHARLES BAUDELAIRE, FULL FACE (CHARLES BAUDELAIRE DE FACE), 1869. Etching, third state. Motif: 163 × 94 (6 ⅜ × 3 ⅝). G.38, M.N.16. Bibliothèque Nationale, Paris. (de L.224; draws attention to a drawing for *Les Fleurs du Mal* on one of the proofs.)
For the fourth state of this etching, which was published in Asselineau's book *Baudelaire, sa vie, son œuvre*, Paris, 1869, the plate was cut so that only the

portrait itself remained, without the decorative motif and the name, Charles Baudelaire.

M 57 CHILD BLOWING BUBBLES (L'ENFANT AUX BULLES DE SAVON), 1869. Etching, third and last state. Motif: 195 × 164 (7⅝ × 6½). Plate: 250 × 215 (9⅞ × 8½). G.54, M.N.36. The Art Institute of Chicago.
Reproduction of a portrait of the young Léon Leenhoff (Gulbenkian Foundation, J.W.148).

M 58 EVA GONZALÈS, RIGHT PROFILE (EVA GONZALÈS, PROFIL À DROITE), 1870. Etching, only state. 195 × 160 (7⅝ × 6¼). G.56, M.N.72a. Bibliothèque Nationale, Paris.
Henri Guérard made a copy of this plate (cf. M.N.72 for a description). Eva Gonzalès was a favourite pupil of Manet's and entered his atelier in August 1869. She married Henri Guérard, the young etcher who printed many of Manet's engravings.

M 59 EVA GONZALÈS, LEFT PROFILE (EVA GONZALÈS, PROFIL TOURNÉ À GAUCHE), 1870. Etching, only state. 237 × 153 (9¼ × 6). G.57, M.N.44. Bibliothèque Nationale, Paris.
Manet painted two oil portraits of Eva Gonzalès (J.W.173, 174). The first of these was exhibited in the May 1870 Salon, and is today in the National Gallery, London. Rosenthal suggests that the bold foreshortening of this etching was inspired by Japanese woodcuts.

M 60 THE QUEUE AT THE BUTCHER'S SHOP (LA QUEUE DEVANT LA BOUCHERIE), 1871. Etching, only state. 168 × 147 (6⅝ × 5⅞). G.58, M.N.45. Bibliothèque Nationale, Paris.
Scene during the siege of Paris in 1871.

M 61 BERTHE MORISOT, 1872. Etching, second and last state. 118 × 79 (4⅝ × 3⅛). G.59, M.N.41. Bibliothèque Nationale, Paris.
After Manet's portrait of Berthe Morisot (J.W.208). Manet painted several oil portraits of his sister-in-law for example, *Berthe Morisot holding a Bunch of Violets* in 1872 – and also made two lithographs (cf. M 79, M 80).

M 62 THE RIVER: DRAGON-FLY (LE FLEUVE: LIBELLULE), 1874. Etching. Motif: 33 × 58 (1¼ × 2¼). Plate: 40 × 60 (1⅝ × 2⅜). G.63a, M.N.23. Bibliothèque Nationale, Paris.
Illustrations for *Le Fleuve*, a poem by Charles Cros, published by the *Librairie de l'Eau-Forte* in 1874. An edition of one hundred was printed.

M 62a THE HEAD OF THE VALLEY (LA HAUTE VALLÉE), 1874. Etching. Motif: 85 × 107 (3⅜ × 4¼). Plate: 93 × 112 (3⅝ × 4⅜). G.63c, M.N.25. Bibliothèque Nationale, Paris.

M 62b THE MOUNTAIN (LA MONTAGNE), 1874. Etching. Motif: 72 × 95 (2⅞ × 3¾). Plate: 78 × 95 (3 × 3¾). G.63b, M.N.24. Bibliothèque Nationale, Paris.

M 62c THE PARAPET OF THE BRIDGE (LE PARAPET DU PONT), 1874. Etching. Motif: 70 × 123 (2¾ × 4⅞). Plate: 73 × 126 (2⅞ × 5). G.63e, M.N.27. Bibliothèque Nationale, Paris.

M 62d FLOODED FIELDS (LA RIVE EN PLAINE), 1874. Etching. Plate: 83 × 104 (3¼ × 4⅛). G.63d, M.N.26. Bibliothèque Nationale, Paris.

M 62e THE ARCH OF THE BRIDGE (L'ARCHE DU PONT), 1874. Etching. Motif: 110 × 152 (4⅜ × 6). Plate:

117 × 158 (4⅝ × 6¼). G.63f, M.N.28. Bibliothèque Nationale, Paris.

M 62f SWALLOWS (HIRONDELLES), 1874. Etching. 40 × 56 (1½ × 2¼). G.63h, M.N.30. Bibliothèque Nationale, Paris.

M 62g THE RIVER: DRAGON-FLY. REJECTED ILLUSTRATION (PIÈCE REFUSÉE POUR LE FLEUVE: LIBELLULE), 1874. Etching, only state. 46 × 60 (1¾ × 2⅜). G.63i, M.N.73. Bibliothèque Nationale, Paris.

M 62h THE RIVER: THE MOUNTAIN. REJECTED ILLUSTRATION (PIÈCE REFUSÉE POUR LE FLEUVE: LA MONTAGNE), 1874. Etching, only state. Motif: 103 × 79 (4 × 3⅛). Plate: 130 × 146 (5⅛ × 5¾). G.63j, M.N.74. Bibliothèque Nationale, Paris.

M 62i THE SEA (LA MER), 1874. Etching. Motif: 76 × 133 (3 × 5¼). Plate: 84 × 140 (3⅜ × 5½). G.63g, M.N.29. Bibliothèque Nationale, Paris.

M 62j THE RIVER: FLOODED FIELDS. REJECTED ILLUSTRATION (PIÈCE REFUSÉE POUR LE FLEUVE: LA RIVE EN PLAINE), 1874. Etching, only state. 119 × 90 (4⅝ × 3½). G.63k, M.N. –. Bibliothèque Nationale, Paris.

M 62k THE RIVER: THE ARCH OF THE BRIDGE. REJECTED ILLUSTRATION. (PIÈCE REFUSÉE POUR LE FLEUVE: L'ARCHE DU PONT), 1874. Etching, only state. 132 × 136 (5⅛ × 5⅜). G.63l, M.N.75. Bibliothèque Nationale, Paris.

M 63 THÉODORE DE BANVILLE, FACING RIGHT (THÉODORE DE BANVILLE, TOURNÉ À DROITE), 1874. First plate of THE SAILOR'S DREAM (LE RÊVE DU MARIN). Etching, only state. 235 × 154 (9¼ × 5⅞). G.60, M.N.67. Bibliothèque Nationale, Paris.
Two preparatory drawings for this study exist, one in the Louvre, the other in the Rouart collection (de L.421, 422).

M 64 THÉODORE DE BANVILLE, FACING LEFT (THÉODORE DE BANVILLE, TOURNÉ À GAUCHE), 1874. Etching, only state. 238 × 155 (9⅜ × 6). G.61, M.N.42. Bibliothèque Nationale, Paris.
Intended as an illustration for *Les Ballades*, 1874.

M 65 WOMAN CONVALESCING (LA CONVALESCENTE), 1876. Etching, third and last state. 127 × 100 (5 × 3⅞). G.65, M.N.21. Bibliothèque Nationale, Paris.
Appeared with *The Odalisque* in Bazire's book *Manet*, published by Quantin in 1884 (de L.453).

M 66 JEANNE: THE SPRING (JEANNE: LE PRINTEMPS), 1882. Etching, only state. 155 × 105 (6⅛ × 4⅛). G.66, M.N.47. Bibliothèque Nationale, Paris.
Manet exhibited the portrait of Mademoiselle Jeanne Demarsy at the Salon of 1882 now in a private collection, New York. (de L.588.) No doubt it is to this plate that Manet refers in a letter to Guérard, postal date 3 May 1882: 'Thank you, my dear Guérard. Etching is decidedly not for me. Give this plate a good working over with the burin and my regards. E. Manet.' This letter, kindly made available by Monsieur J. Guérard, marks Manet's farewell to engraving.
The plate was bitten by Guérard, an engraver since 1874, who had become Manet's favourite printer. The plate was published in the *Gazette des Beaux-Arts*, vol. XXVIII, 1902, p. 428 (de L.588).

M 67 CARICATURE OF ÉMILE OLLIVIER (PORTRAIT-CHARGE D'ÉMILE OLLIVIER), 1860. Lithograph,

only state. 375 × 265 (14¾ × 10½). G.67, M.N. –. Bibliothèque Nationale, Paris.

Appeared in the *Diogène*, no. 6, 14 April 1860. This was Manet's first attempt at lithography.

M 68 THE BALLOON (LE BALLON), 1862. Lithograph, only state. 410 × 510 (16⅛ × 20). G.68, M.N.76. Bibliothèque Nationale, Paris.

When Cadart decided to promote a revival of original lithography, he sent stone blocks to several artists. Manet then produced this lithograph. The publisher and Lemercier, the printer, refused to publish the print, on the grounds that it was not good enough; both were horrified by its freedom of treatment.

M 69 MOORISH LAMENT (PLAINTE MORESQUE), 1862. Lithograph, state after letters. 300 × 240 (11⅞ × 9½). G.70, M.N.78. Bibliothèque Nationale, Paris.

Manet produced this cover illustration for a romance for J. Bosch, the guitarist of the Spanish Ballet (de L.169). Compare this with M 12.

M 70 THE STREET BOY (LE GAMIN), 1862. Lithograph, state after letters. 290 × 230 (11⅜ × 9). G.71, M.N.86. Bibliothèque Nationale, Paris.

Cf. the etching of the same date and subject, M 26.

M 71 LOLA DE VALENCE, 1862. Lithograph, state after letters. 335 × 215 (13⅛ × 8½). G.69, M.N.77. Bibliothèque Nationale, Paris.

Cf. the etching of autumn 1862, M 27. This lithograph, for a serenade by Zacharie Astruc, takes up the subject of the etching for a half-length portrait. Astruc, who encouraged Manet to visit Spain, wrote a poem on the picture *Olympia* and sculpted a bronze bust of Manet.

M 72 THE RACES (LES COURSES), 1864–5. Lithograph, first state of two. 360 × 510 (14⅛ × 20) G.72, M.N.85. Bibliothèque Nationale, Paris.

There are four pictures by Manet on this theme. The first, dated 1864, which is of the races at Longchamp, is in the Art Institute of Chicago (J.W.202) and was the basis for this lithograph. A number of preparatory sketches are also in existence (de L.203–5).

M 73 THE EXECUTION OF THE EMPEROR MAXIMILIAN (L'EXÉCUTION DE L'EMPEREUR MAXIMILIEN), 1867. Lithograph, state after letters. 330 × 435 (13 × 17⅛). G.73, M.N.79. Bibliothèque Nationale, Paris.

After the events of 19 June 1867, Manet made a first sketch of this subject, based on photographs (Museum of Fine Arts, Boston, J.W.138); he also painted a number of pictures: there are two fragments of one painting (National Gallery, London, J.W.139), a further canvas (Ny Carlsberg Glyptotek, Copenhagen, J.W.141), and a final version in oils (Städtische Kunsthalle, Mannheim, J.W.140), which was suppressed by the government. Manet then decided to make a lithograph of the same subject, but this too was banned and was not printed until after his death (de L.343).

M 74 THE CATS' RENDEZ-VOUS (LE RENDEZ-VOUS DES CHATS), 1868. Lithograph, state after letters. 525 × 415 (20⅝ × 16¼). G.74, M.N. 80. Bibliothèque Nationale, Paris.

A poster used in 1869 to publicize the fourth edition of Champfleury's *Les Chats*, which appeared in 1870 (de L.227).

M 75 THE CAFÉ (LE CAFÉ), 1869. First plate. Autograph, only state. 279 × 353 (11 × 13⅞). G.80, M.N. –. New York Public Library.

This and the following autograph were taken from a drawing (Fogg Art Museum, Harvard) dated 1869 (de L.283).

M 76 THE CAFÉ (LE CAFÉ), 1869. Second plate. Autograph, only state. 264 × 334 (10⅜ × 13⅛). G.81, M.N.88. Museum of Fine Arts, Boston, gift of W. G. Russell Allen.

M 77 THE BARRICADE (LA BARRICADE), 1871. Lithograph, state after letters. 465 × 330 (18¼ × 13). G.76, M.N.82. Bibliothèque Nationale, Paris.

A scene of the Paris Commune (de L.342).

M 78 CIVIL WAR (GUERRE CIVILE), 1871. Lithograph, state after letters. 400 × 520 (15¾ × 20½). G.75, M.N.81. Bibliothèque Nationale, Paris.

This and the following subject were executed by Manet after sketches from life which he made in March 1870, when he returned to Paris after his stay in Tours (de L.200). Compare this with M 49.

M 79 BERTHE MORISOT, 1872. First plate. Lithograph, state after letters. 203 × 140 (8 × 5½). G.77, M.N.83. Bibliothèque Nationale, Paris.

After a portrait of Berthe Morisot, painted by Manet in 1872, on which the etching on the same theme was also based (J.W.208, Coll. Rouart).

M 80 BERTHE MORISOT, 1872. Second plate. Lithograph, state after letters. 220 × 165 (8⅝ × 6½). G.78, M.N.84. Bibliothèque Nationale, Paris.

M 81 THE RAVEN, front view (LE CORBEAU, de face), 1875. Autograph, only state. 145 × 138 (5¾ × 5⅜). G.84, M.N.96. Bibliothèque Nationale, Paris.

Trial versions of a publisher's poster, see below (de L.442). Cf. also de L.447–9 for the sketches of Théodore Duret's Japanese dog, Tama, which Guérin points out on some of the proofs.

M 82 THE RAVEN, profile (LE CORBEAU, profil), 1875. Autograph, state after letters. 164 × 158 (6½ × 6¼). G.85, M.N.95. Bibliothèque Nationale, Paris.

Poster for the 1875 edition of Edgar Allan Poe's poem *The Raven*. One printing was in red and black. The dimensions of the poster: 500 × 360 (19¾ × 14¼).

M 83 PUNCH (POLICHINELLE), 1874–6. Colour lithograph, state after letters. 480 × 320 (18⅞ × 12⅝). G.79, M.N.87. Bibliothèque Nationale, Paris.

A watercolour of this subject was exhibited in the Salon of 1874 (de L.416). An edition of twenty-five was printed of this lithograph, which was one of the first attempts to revive the process of colour lithography. The accompanying couplet is by Théodore de Banville and was chosen by Manet from a number of couplets commissioned from his poet friends. Tabarant saw in this print a caricature of Mac-Mahon.

M 84 THE RAVEN: ex libris (LE CORBEAU: ex-libris), 1875. Autograph. 61 × 240 (2⅜ × 9½). G.86, M.N.90. Bibliothèque Nationale, Paris.

Illustrations for Stéphane Mallarmé's translation of the poem by Edgar Allan Poe, published by Leschide in 1875 (de L.440–5).

Compare also with de L.437–9.

M 84a THE RAVEN: in the lamplight (LE CORBEAU: sous la lampe), 1875. Autograph. 270 × 385 (10⅝ × 15⅛). G.86a, M.N.91. Bibliothèque Nationale, Paris.

M 84b THE RAVEN: on a bust (LE CORBEAU: sur la buste), 1875. Autograph, second and last state. 530 × 365 (20⅞ × 14⅜). G.86b, M.N.92. Bibliothèque Nationale, Paris.

M 84c THE RAVEN: by the window (LE CORBEAU: à la fenêtre), 1875. Autograph, second and last state. 400×300 (15¾×11⅞). G.86c, M.N.93. Bibliothèque Nationale, Paris.

M 84d THE RAVEN: the chair (LE CORBEAU: la chaise), 1875. Autograph. 290×280 (11½×11). G.86d, M.N.94. Bibliothèque Nationale, Paris.

M 84e THE RAVEN: by the window (LE CORBEAU: à la fenêtre), 1875. Autograph, only state. 400×270 (15¾×10⅝). G.86e, M.N. –. Bibliothèque Nationale, Paris.
Variation on M 84c. This is the only known proof.

M 85 THE GODS (AU PARADIS), 1880. Autograph, state after letters. Frame: 243×340 (9⅝×13⅜). G.82, M.N.89. Bibliothèque Nationale, Paris. (de L.483. Cf. also de L.338.)

M 86 THE POLISH BEAUTY (LA BELLE POLONAISE). Ink wash autograph. 285×265 (11¼×10½). G.83, M.N. –. Collection Le Garrec.
Referred to in *La Lithographie*, July 1867, p. 7. (de L.459, 460).

M 87 OLYMPIA, 1865. Wood engraving by Prunaire, drawn by Manet. 110×160 (4⅜×6¼). G.87, M.N. –. Bibliothèque Nationale, Paris.
There is another wood engraving of the Olympia by Moller (G.88, M.N.97), but this is only a reproduction. There is no reason to include it in a catalogue of Manet's engravings.

M 88 THE RAILWAY (LE CHEMIN DE FER), 1874. Wood engraving. 186×230 (7⅜×9⅛). G.89, M.N. Bibliothèque Nationale, Paris.
Wood engraved by Prunaire. A picture by Manet on this subject was exhibited in the Salon of 1874.

M 89 THE PARISIENNE (LA PARISIENNE), 1874. First plate. Wood engraving. 100×150 (3⅞×5⅞). G.90. Bibliothèque Nationale, Paris.

M 90 THE PARISIENNE (LA PARISIENNE), 1874. Second plate. Wood engraving. 100×155 (3⅞×6⅛). G.91. Bibliothèque Nationale, Paris.

M 91 PORTRAIT OF MADAME CALLIAS, 1874. Wood engraving, second and last state. 100×72 (3⅞×2⅞). G.92. Bibliothèque Nationale, Paris.

M 92 THE AFTERNOON OF A FAUN (L'APRÈS-MIDI D'UN FAUNE), 1876. Wood engraving, only state. Four subjects on one page. Page: 400×295 (15¾×11⅝). G.93. Bibliothèque Nationale, Paris.
Used to illustrate Mallarmé's poem, published by Derenne in 1876. An edition of 195 was produced, some of the prints being heightened with watercolour. See M 92a–92d.

M 92a THE AFTERNOON OF A FAUN: FRONTISPIECE (L'APRÈS-MIDI D'UN FAUNE: FRONTISPICE), 1876. Wood engraving. 60×55 (2⅜×2⅛). G.93a. Bibliothèque Nationale, Paris.

M 92b THE AFTERNOON OF A FAUN: NYMPHS (L'APRÈS-MIDI D'UN FAUNE: NYMPHES), 1876. Wood engraving. 50×100 (2×4). G.93b, de L.457. Bibliothèque Nationale, Paris.

M 92c THE AFTERNOON OF A FAUN: FAUN (L'APRÈS-MIDI D'UN FAUNE: FAUNE), 1876. Wood engraving. 75×125 (3×4⅞). G.93c, de L.458. Bibliothèque Nationale, Paris.

M 92d THE AFTERNOON OF A FAUN: DECORATIVE MOTIF (L'APRÈS-MIDI D'UN FAUNE: CUL-DE-LAMPE), 1876. Wood engraving. 40×37 (1⅝×1½). G.93d. Bibliothèque Nationale, Paris.

PISSARRO

P 1 BY THE WATERSIDE (AU BORD DE L'EAU), c. 1863. First plate. Etching, first state of two. 292×216 (11½×8½). L.D.1. Bibliothèque Nationale, Paris.

P 2 BY THE WATERSIDE (AU BORD DE L'EAU), c. 1863. Second plate. Etching, only state. 283×217 (11⅛×8¼). L.D.2. Bibliothèque Nationale, Paris.
In fact it is impossible to say which of these two plates came first. Delteil has placed them as the earliest because of the clear influence of Corot, whose pupil Pissarro declared himself to be. There are three known proofs.

P 3 FIELD NEAR ASNIÈRES (PRAIRIE PRÈS D'ASNIÈRES), 1864. Etching, only state. 220×300 (8⅝×11¾). L.D.3. Bibliothèque Nationale, Paris.
Only one proof known to Delteil.

P 4 A STREET IN MONTMARTRE (UNE RUE A MONTMARTRE), 1865. Etching, only state. 138×115 (5½×4½). L.D.4.
Only one proof known to Delteil.

P 5 LA ROCHE-GUYON. c. 1866. Etching, second and last state. 271×224 (10⅝×8⅝). L.D.5. Bibliothèque Nationale, Paris.
Pissarro exhibited his etchings for the first time at the fifth impressionist exhibition in 1880. This plate may have been among those shown, in which case the second engraving of La Roche-Guyon (P 27) must have appeared under the title *Cow with Figure*. Other plates exhibited were P 19, 20, 21, 23, 28 and possibly P 15, 16 and 17.

P 6 THE NEGRESS (LA NÉGRESSE), 1867. Etching, first state of two. 305×217 (12×8½). L.D.6. Private collection, Paris.
A very rare print.

P 7 SLOPES AT PONTOISE (COTEAUX À PONTOISE), 1874. Etching, only state. 120×158 (4¾×6¼). L.D.8. Bibliothèque Nationale, Paris.
Probably as the result of a printer's error, Ludovic-Rodo gives 1878 as the date of this plate, in his article (*Print Collector's Quarterly*, vol. 9, no. 3, October 1922, p. 280); the date should read 1874.

P 8 LANDSCAPE AT PONTOISE, APPLE TREES (PAYSAGE À PONTOISE, POMMIERS), 1873. Etching, second state of three. 90×169 (3½×6⅝). L.D.8. Bibliothèque Nationale, Paris.
Based on the picture of 1872, *Apple Trees in Blossom*.

P 9 THE RIVER OISE AT PONTOISE (L'OISE À PONTOISE), 1874. Etching, only state. 75×116 (3×4⅝). L.D.9. Bibliothèque Nationale, Paris.
No contemporary proofs were taken from this plate. Like P 8 and P 10, it was rediscovered in Doctor Gachet's house in 1922. Six proofs were printed in 1923.

P 10 FACTORY AT PONTOISE (FABRIQUE À PONTOISE), 1874. Etching, only state. 73×115 (2⅞×4½). L.D.10. Bibliothèque Nationale, Paris.
There are five paintings of this subject (L.R.214–19), all dated 1873.

P 11 THE ROAD TO ROUEN: THE HILLS OF PONTOISE (ROUTE DE ROUEN: LES HAUTEURS DE PONTOISE), 1874. Etching, third and last state. 112 × 150 (4⅜ × 5⅞). L.D.11. Bibliothèque Nationale, Paris.
Only one proof is known to Delteil. Jean Cailac, however, describes three states in his supplement to Delteil's catalogue (*Print Collector's Quarterly*, vol. 19, no. 1, January 1932, p. 77).

P 12 PEASANT WOMAN FEEDING CHILD (PAYSANNE DONNANT À MANGER À UN ENFANT), 1874. Etching, second state of four. 121 × 119 (4¾ × 4⅝). L.D.12. Bibliothèque Nationale, Paris.

P 13 PAUL CÉZANNE, 1874. Etching, only state. 270 × 214 (10⅝ × 8⅜). L.D.13. Bibliothèque Nationale, Paris.
This plate, which is dated, was published in the book *Paul Cézanne* by Émile Bernard, in the series *Les hommes d'aujourd'hui* (cf. L.R.293). Twenty proofs were taken. There were two further editions: in 1911 three proofs, and in 1920 a further seventy-two. It was in 1872 that Cézanne stayed with Pissarro in Pontoise; they worked side by side and Cézanne painted views of the Hermitage. In 1873 Pissarro introduced Cézanne to Doctor Gachet.

P 14 IN THE FIELDS AT ENNERY (DANS LES CHAMPS À ENNERY), 1875. Dry-point, only state. 248 × 282 (9¾ × 11⅛). L.D.14. Bibliothèque Nationale, Paris.
Two proofs were taken. There were two further editions: in 1921 six proofs, and in 1923 a further six.

P 15 WOMAN SELLING CHESTNUTS (MARCHANDE DE MARRONS), 1878. Dry-point, second and last state. 210 × 170 (8¼ × 6¾). L.D.15. Bibliothèque Nationale, Paris.
Pissarro returned to this plate in 1896. A distemper painting of the same scene, but with the image reversed, is dated 1881 (L.R.1348).

P 16 WOODLANDS AT THE HERMITAGE (PAYSAGE SOUS BOIS À L'HERMITAGE), 1879. Etching, fifth and last state. 219 × 269 (8⅝ × 10⅝). L.D.16. Bibliothèque Nationale, Paris.
This etching was printed in 1880 as an illustration for the impressionist review *Le Jour et la Nuit*, of which only one issue appeared. The Hermitage was also the subject of many paintings by Pissarro in 1867 (L.R.52 and 56).

P 17 LANDSCAPE PANORAMA (PAYSAGE EN LONG), 1879. Etching, third and last state. 117 × 397 (4⅝ × 15⅝). L.D.17. British Museum.
Three or four proofs were taken, and in 1923 a further eighteen proofs were printed.

P 18 THE WOMAN ON THE ROAD (LA FEMME SUR LA ROUTE), 1879. Etching, fourth and last state. 158 × 210 (6¼ × 8¼). L.D.18. Bibliothèque Nationale, Paris.
In 1923 a further twelve proofs were printed.

P 19 WOODED LANE AT PONTOISE (CHEMIN SOUS BOIS À PONTOISE), 1879. Etching, sixth and last state. 163 × 212 (6⅜ × 8⅜). L.D.19. British Museum.

P 20 THE OLD COTTAGE (LA MASURE), 1879. Etching, eighth and last state. 167 × 170 (6⅝ × 6¾). L.D.20. Bibliothèque Nationale, Paris.
This etching was sold by Gutbier in September 1896 for one hundred francs. This was after Vollard had launched Pissarro's engravings at his exhibition in July of that year (cf. P 65). Pissarro printed only six proofs, but Degas took a number of impressions in colour.

P 21 SAINT MARTIN'S DAY FAIR AT PONTOISE (FOIRE DE LA SAINT-MARTIN À PONTOISE), 1879. Etching, fourth and last state. 119 × 160 (4¾ × 6¼). L.D.21. Bibliothèque Nationale, Paris.
The first three states are very different, the market place in the foreground being almost entirely deserted. Cf. lithograph P 133 and the painting of 1883 on this subject (L.R.1387).

P 22 DUSK WITH HAYRICKS (CRÉPUSCULE AVEC MEULES), 1879. Etching, third and last state. 105 × 177 (4⅛ × 7). L.D.23. Bibliothèque Nationale, Paris.
A few proofs of the second state were printed in colour.

P 23 RAIN EFFECT (EFFET DE PLUIE), 1879. Etching, sixth and last state. 162 × 213 (6⅜ × 8⅜). L.D.24. Bibliothèque Nationale, Paris.

P 24 PEASANT: LE PÈRE MELON (PAYSAN: LE PÈRE MELON), 1879. Etching, sixth and last state. 103 × 165 (4 × 6½). L.D.25. Bibliothèque Nationale, Paris.
In 1891 Pissarro recovered this and other plates that he had mislaid from Degas, who had found them while reorganizing his studio, where no doubt the first proofs had been printed. One proof is heightened with crayon (L.R.1542). There is also a painting of the same date on this subject (L.R.498).

P 25 TREE AND PLOUGHED FIELD (ARBRE ET TERRAIN LABOURÉ), c. 1879. Etching, only state. 118 × 160 (4⅝ × 6¼). L.D.26. Bibliothèque Nationale, Paris.

P 26 SETTING SUN (SOLEIL COUCHANT), 1879. Dry-point, fourth and last state. 115 × 160 (4½ × 6¼). L.D.22. Bibliothèque Nationale, Paris.
In March 1891, when Pissarro gave a proof of this engraving to his son, Lucien, he wrote: 'You know these proofs are rare, I have only eight, and they are not very good, it's a difficult plate to print.'

P 27 THE CASTLE OF LA ROCHE-GUYON (LE CHÂTEAU DE LA ROCHE-GUYON). Dry-point on zinc, only state. 168 × 247 (5⅝ × 9¾). L.D.27. Bibliothèque Nationale, Paris.
Two proofs are known to Delteil.

P 28 LANDSCAPE AT THE HERMITAGE, Pontoise (PAYSAGE À L'HERMITAGE, Pontoise), 1880. Dry-point, second state of three. 110 × 128 (4⅜ × 5). L.D.28. Bibliothèque Nationale, Paris.
There are two proofs of the second state and nineteen of the third; a further twelve proofs were printed in 1923.

P 29 THE CABBAGE FIELD (LE CHAMP DE CHOUX), c. 1880. Etching, only state. 247 × 173 (9¾ × 6⅞). L.D.29. Bibliothèque Nationale, Paris.

P 30 WOMAN IN THE KITCHEN-GARDEN (LA FEMME DANS LE POTAGER), c. 1880. Etching, second state of three. 248 × 169 (9¾ × 6⅝). L.D.30. Bibliothèque Nationale, Paris.

P 31 WOMAN EMPTYING A WHEELBARROW (FEMME VIDANT UNE BROUETTE), 1880. Etching, twelfth and last state. 319 × 235 (12½ × 9¼). L.D.31. Collection Cailac, Paris.
On 1 March 1891, Pissarro wrote to Lucien: '*The Woman Emptying a Wheelbarrow* is rare, you recall there are just two proofs, and only one – which I am sending to you – has come out well; this is the one in grey.'
Another proof of this etching is in the Rhode Island School of Design, Providence. There is also a gouache

of the same subject, with the image reversed (L.R. 1342).

P 32 PATH AT PONTOISE (SENTE DES POUILLEUX À PONTOISE), 1880. First plate. Dry-point, second and last state. 268 × 217 (10⅝ × 8½). L.D.32. Bibliothèque Nationale, Paris.

P 33 PATH AT PONTOISE (SENTE DES POUILLEUX À PONTOISE), 1883. Second plate. Dry-point, fourth and last state. 150 × 112 (5⅞ × 4⅜). L.D.33. Bibliothèque Nationale, Paris.
In 1883, at Osny, Pissarro made a complete series of dry-point engravings, which he planned to print when he returned to Paris in April. At that timè he had no press of his own and made use of the facilities of Degas, Charles Jacque, Salmon or Delâtre, although he accused the latter of over-inking.

P 34 PATHWAY, Pontoise (SENTE DES GROUETTES, Pontoise), 1883. Dry-point, only state. 142 × 109 (5⅝ × 4¼). L.D.34. The Art Institute of Chicago.

P 35 THE RONDEST HOUSE AT THE HERMITAGE (LA MAISON RONDEST À L'HERMITAGE), 1883. Etching, only state. 165 × 112 (6½ × 4⅜). L.D.35. Bibliothèque Nationale, Paris.

P 36 WOMAN WITH WHEELBARROW (FEMME À LA BROUETTE), 1883. Dry-point on zinc, only state. 245 × 169 (9⅝ × 6⅝). L.D.36. Museum of Arts, Rhode Island School of Design, Providence.
Four proofs were known to Delteil. Pissarro took up this composition again in a picture of 1892 (L.R.822).

P 37 THE RAILWAY BRIDGE AT PONTOISE (LE PONT DE CHEMIN DE FER À PONTOISE), 1883. Dry-point, first state of two. 129 × 247 (5⅛ × 9¾). L.D.37. Museum of Fine Arts, Boston, Lee M. Friedmann Fund.
There is only one proof of each state of this plate in existence.

P 38 MOTHER AND CHILD (MÈRE ET ENFANT), 1883. Dry-point and aquatint, seventh state of eight. 141 × 101 (5½ × 4). L.D.38. Bibliothèque Nationale, Paris.

P 39 CHILD AT HIS MOTHER'S BREAST (ENFANT TÉTANT SA MÈRE), 1883. Dry-point and aquatint, third and last state. 120 × 111 (4¾ × 4⅜). L.D.39. Bibliothèque Nationale, Paris.

P 40 LANDSCAPE WITH SHEPHERDS AND SHEEP, Osny (PAYSAGE AVEC BERGERS ET MOUTONS, Osny), 1883. Dry-point and aquatint, sixth and last state. 100 × 140 (4 × 5½). L.D.40. Bibliothèque Nationale, Paris.
In March 1883, encouraged by Braquemond, Pissarro worked at his dry-point engravings, taken from life at Osny and Pontoise. This was with a view to an exhibition with Duret in England.

P 41 OLD STREET IN ROUEN: RUE MALPALUE (VIEILLE RUE À ROUEN: RUE MALPALUE), 1883. Dry-point, second and last state. 124 × 121 (4⅞ × 4¾). L.D.41. Bibliothèque Nationale, Paris.
At the end of 1883, Pissarro went to work in Rouen where he made drawings for this and the six following engravings. He also painted a number of pictures (L.R.603–11).

P 42 THE HARBOUR NEAR THE CUSTOMS HOUSE AT ROUEN (LE PORT PRÈS DE LA DOUANE À ROUEN), 1883. Etching, second and last state. 111 × 141 (4⅜ × 5½). L.D.43. Bibliothèque Nationale, Paris.

P 43 STREET IN ROUEN: RUE DU GROS-HORLOGE (RUE DU GROS-HORLOGE À ROUEN), 1883. Etching, third and last state. 192 × 147 (7½ × 5¾). L.D.54. Bibliothèque Nationale, Paris.
While staying in Rouen in 1883, Pissaro made a drawing of this subject, attracted by the lithograph Bonington had made some fifty years earlier. Although Delteil gives 1885 as the date, a print of the etching in the S.P. Avery collection is signed and dated 1883.

P 44 A LANE IN ROUEN: RUE DES ARPENTS (UNE RUELLE À ROUEN: RUE DES ARPENTS), 1883. Etching, second and last state. 123 × 120 (4⅞ × 4¾). L.D.42. Bibliothèque Nationale, Paris.

P 45 SQUARE IN ROUEN: PLACE DE LA RÉPUBLIQUE (PLACE DE LA RÉPUBLIQUE À ROUEN), 1884? Etching, second and last state. 125 × 122 (4⅞ × 4¾). L.D.44. Bibliothèque Nationale, Paris.
Pissarro showed his engravings at the eighth impressionist exhibition, held between 15 May and 15 June 1886, on the corner of the rue Laffitte and the boulevard des Italiens. Degas, Guillaumin, Berthe Morisot and Mary Cassatt also exhibited. This etching appeared in company with plates P 53, P 55, P 57, P 61, P 62 and P 63.

P 46 THE HARBOUR AT ROUEN: SAINT SEVER (PORT DE ROUEN: SAINT SEVER), 1884. Etching, only state. 144 × 194 (5⅝ × 7⅝). L.D.45. Bibliothèque Nationale, Paris.
This etching should be compared with Pissarro's pictures of the same subject executed in 1896 (L.R.957, 970). Jean Cailac believes this etching, for which no plate is known to exist, is simply a state of the following plate.

P 47 PROMENADE IN ROUEN: COURS BOIELDIEU (COURS BOIELDIEU À ROUEN), 1884? Etching, second and last state. 143 × 192 (5⅝ × 7½). L.D.46. Bibliothèque Nationale, Paris.

P 48 RIVERSIDE AT ROUEN: CÔTE SAINTE-CATHERINE (CÔTE SAINTE-CATHERINE, ROUEN), 1884. Etching, sixth state of seven. 149 × 181 (5⅞ × 7⅛). L.D.48. Bibliothèque Nationale, Paris.
A further twelve proofs were printed in 1923.

P 49 BY THE SEINE AT ROUEN: COURS LA REINE (COURS LA REINE, AU BORD DE SEINE, À ROUEN), 1884. Etching, third and last state. 122 × 139 (4⅞ × 5½). L.D.49. Bibliothèque Nationale, Paris.
Cf. paintings L.R.602 and 603, and those of 1898, L.R.1044 and 1046.

P 50 VIEW OF ROUEN: COURS LA REINE (VUE DE ROUEN: COURS LA REINE), 1884. Etching, third and last state. 153 × 195 (6 × 7⅝). L.D.50. Bibliothèque Nationale, Paris. Cf. P 49.

P 51 THE FARM AT CHRISTMAS: OSNY (LA FERME À NOËL: OSNY), 1884. Etching, sixth and last state. 197 × 182 (7¾ × 7⅛). L.D.51. Bibliothèque de l'Institut d'Art et d'Archéologie, Paris.

P 52 STREET IN ROUEN: RUE DAMIETTE (RUE DAMIETTE À ROUEN), 1884. Etching, second and last state. 195 × 148 (7⅝ × 5⅞). L.D.52. Bibliothèque Nationale, Paris.

P 53 STREET IN ROUEN: RUE MALPALUE (LA RUE MAL-

PALUE À ROUEN), 1885. Etching, third and last state. 198 × 148 (7¾ × 5⅞). L.D.53. Bibliothèque Nationale, Paris.

P 54 LANDSCAPE AT ROUEN: CÔTE SAINT-CATHERINE (PAYSAGE À ROUEN: CÔTE SAINTE-CATHERINE), 1885. Etching, fourth and last state. 125 × 175 (3 × 4⅞). L.D.55. Bibliothèque Nationale, Paris.

P 55 THE HARBOUR AT ROUEN (PORT DE ROUEN), 1885. Etching, second and last state. 103 × 123 (4 × 4⅞). L.D.56. Bibliothèque Nationale, Paris.
On 13 December 1888, Pissarro urged Delâtre to 'take care over the sky of the Little Harbour of Rouen, which I have reworked. This sky must stay white and luminous, as young Jacques printed it, this is essential.'

P 56 THE HARBOUR AT ROUEN (PORT DE ROUEN), 1885. Etching, third and last state. 148 × 166 (5⅞ × 6⅝). L.D.57. Bibliothèque Nationale, Paris.
This etching was modelled on a picture of 1883 (L.R.611). Pissarro returned to this subject in painting in 1898 (L.R.1050-4).

P 57 COW AND LANDSCAPE (VACHE ET PAYSAGE), 1885. Etching, third and last state. 110 × 115 (4¼ × 4½). L.D.58. Bibliothèque Nationale, Paris.
Although Delteil suggests 1885 as its date, it is not impossible that this was the etching shown in the fifth impressionist exhibition, in 1880, under the title *Cow with Figure*. In that case the print exhibited under the title *La Roche-Guyon* would have been P 27, and P 5 would not have appeared at all; this would seem to be a more satisfactory explanation, but unfortunately it cannot be verified (cf. P 5).

P 58 FIELD AND MILL AT OSNY (PRAIRIE ET MOULIN À OSNY), 1885. Etching, sixth and last state. 160 × 240 (6¼ × 9⅜). L.D.59. Bibliothèque Nationale, Paris.
In 1891 Degas offered Pissarro his congratulations on this plate, which had been shown at the exhibition of the Peintres-Graveurs. Pissarro presented Lucien with a 'good proof', pointing out in a letter of 1 March 1891: 'There are only three proofs like this one. The steel-facing has obliterated the suppleness of the background, so I have only three proofs left; the third is for the Luxembourg Museum.'

P 59 VIEW OF PONTOISE (VUE DE PONTOISE), 1885. Etching, seventh and last state. 159 × 244 (6¼ × 9⅝). L.D.60. Bibliothèque Nationale, Paris.

P 60 PEASANT WOMAN AMONG THE CABBAGES (PAYSANNE DANS LES CHOUX), 1885. Etching, third and last state. 155 × 116 (6⅛ × 4⅝). L.D.61. Bibliothèque Nationale, Paris.

P 61 THE CHURCH AT OSNY, near Pontoise (ÉGLISE D'OSNY, près de Pontoise), 1885. Etching, fourth and last state. 116 × 155 4⅝ × 6⅛). L.D.62. Bibliothèque Nationale, Paris.

P 62 POTATO HARVEST (RÉCOLTE DES POMMES DE TERRE), 1886. Etching, seventh and last state. 275 × 215 (10⅞ × 8½). L.D.63. Bibliothèque Nationale, Paris.
One proof is heightened with pastel (L.R.1573).

P 63 STREET IN ROUEN: RUE DE L'ÉPICERIE (RUE DE L'ÉPICERIE À ROUEN), 1886. Etching, second and last state. 172 × 152 (6¾ × 6). L.D.64. Bibliothèque Nationale, Paris.
Pissarro was fond of this area which crops up again in paintings of 1898 (L.R.1036-8).

P 64 SQUARE IN ROUEN: PLACE DE LA RÉPUBLIQUE (PLACE DE LA RÉPUBLIQUE À ROUEN), 1886. Etching, second and last state. 145 × 165 (5¾ × 6½). L.D.65. Bibliothèque Nationale, Paris.
Lucien Pissarro relates the reactions of the painter Ricketts on seeing this plate. He claimed a distinct preference for many of the etchings by Lucien's father to those by Whistler, declaring that one would have to go back to Rembrandt to find another such etcher (cf. L.R.609, a picture of 1883).

P 65 THE STONE BRIDGE AT ROUEN (LE PONT DE PIERRE À ROUEN), 1887. Etching, second and last state. 149 × 198 (5⅞ × 7¾). L.D.66. Bibliothèque Nationale, Paris.
This etching was sold for seventy-five francs by Gutbier in September 1896 (cf. the painting of 1896 of this subject, L.R.961, and that of 1898, L.R.1043).

P 66 MEN WORKING IN THE HARBOUR AT ROUEN (LES OUVRIERS DU PORT À ROUEN), 1887. Etching, only state. 125 × 170 (4⅞ × 6¾). L.D.67. Bibliothèque Nationale, Paris.

P 67 A STREET IN ROUEN: RUE DES ARPENTS (UNE RUE À ROUEN: RUE DES ARPENTS), 1887. Etching, third and last state. 155 × 103 (6⅛ × 4). L.D.68. Bibliothèque Nationale, Paris.

P 68 ISLAND AT ROUEN: L'ÎLE LACROIX (L'ÎLE LACROIX À ROUEN), 1887. Etching, second and last state. 115 × 158 (4½ × 6¼). L.D.69. Bibliothèque Nationale, Paris.
A picture of this subject *Effects of Fog* (L.R.719) is dated 1888. Even so Pissarro does not appear to have visited Rouen in that year.

P 69 LANDSCAPE AT OSNY (PAYSAGE À OSNY), 1887. Etching, second and last state. 112 × 155 (4⅜ × 6⅛). L.D.70. Bibliothèque Nationale, Paris.

P 70 CHÂTEAU DE BUSAGNY, OSNY, 1887. Etching, fourth and last state. 98 × 140 (3⅞ × 5½). L.D.71. Bibliothèque Nationale, Paris.

P 71 WOMAN WEEDING (LA SARCLEUSE), 1887-8? Etching, second and last state. 161 × 109 (6⅜ × 4¼). L.D.72. Bibliothèque Nationale, Paris.

P 72 GRANDMOTHER IN HER ARMCHAIR: THE ARTIST'S MOTHER (GRAND-MÈRE DANS SON FAUTEUIL: MÈRE DE L'ARTISTE), 1888. Etching, fifth and last state. 99 × 61 (3⅞ × 2⅜). L.D.73. Bibliothèque Nationale, Paris.
Pissarro's mother was the model for both this plate and P 80.

P 73 THE MAID SHOPPING (LA BONNE FAISANT SON MARCHÉ), 1888. Etching, fourth and last state. 192 × 135 (7½ × 5⅜). L.D.74. Bibliothèque Nationale, Paris.
The first state was published in the *Revue Indépendante*, 1 February 1888, and the fourth state in the same publication, 1 May 1888.

P 74 THE GEESE (LES OIES), 1888. Etching, fourth and last state. 135 × 194 (5⅜ × 7⅝). L.D.76. Bibliothèque Nationale, Paris.
This etching was published in the *Revue Indépendante* and was admired by Lucien's friend, the English painter Ricketts. Pissarro made him a present of it, also P 96 and P 97, in the hope that they would be published in England in *The Dial*.

P 75 THE MARKET AT PONTOISE (MARCHÉ DE

PONTOISE), 1888. Etching, third and last state. 99 × 62 (3⅞ × 2⅜). L.D.75. Bibliothèque Nationale, Paris.

A gouache of this subject (L.R.1413) is dated June 1887. Pissarro painted several pictures in the market at Pontoise in 1885 (L.R.1401), and also in 1890 (L.R.1451).

P 76 WOMAN PICKING CABBAGES (FEMME CUEILLANT DES CHOUX), 1888. Etching, third state of seven. 100 × 61 (3⅞ × 2⅜). L.D.77. Bibliothèque Nationale, Paris.

It must have been towards the end of 1888 that Pissarro produced this etching and the two that follow. He said he was working on them 'every day', and was also retouching earlier engravings, having in mind an exhibition that did not in fact take place. They were printed by Delâtre.

P 77 COWS IN THE FIELDS AT ERAGNY, near Gisors (VACHES DANS LES PRAIRIES D'ERAGNY, près de Gisors), 1888. Etching, second and last state. 80 × 120 (3⅛ × 4¾). L.D.78. Bibliothèque Nationale, Paris.

P 78 FIELDS AT BAZINCOURT (PRAIRIES À BAZIN-COURT), 1888. Etching, fourth and last state. 72 × 110 (2⅞ × 4⅜). L.D.79. Bibliothèque Nationale, Paris.

P 79 YOUNG MAN READING: GEORGES PISSARRO (JEUNE HOMME LISANT: GEORGES PISSARRO), 1889. Etching, only state. 132 × 114 (5¼ × 4½). L.D. 81. Bibliothèque Nationale, Paris.

Georges was Pissarro's third child, born at Louveciennes on 22 November 1871. From 1895 onwards he painted under the name Manzana, the maiden name of Pissarro's mother.

P 80 GRANDMOTHER: THE ARTIST'S MOTHER (GRAND-MÈRE: MÈRE DE L'ARTISTE), 1889. Etching, fourth state of seven. 171 × 253 (6¾ × 10). L.D.80. Bibliothèque Nationale, Paris.

P 81 THE SHEPHERD'S RETURN (LA RENTRÉE DU BERGER), 1889. Etching, only state. 76 × 109 (3 × 4¼). L.D.82. Bibliothèque Nationale, Paris.

In 1889 Pissarro worked hard at his engravings, which he printed and had mounted immediately, in spite of his apprehension about selling them.

P 82 FATHER PASCAL (PÈRE PASCAL), 1889. Etching, third and last state. 100 × 63 (3⅞ × 2½). L.D.83. Bibliothèque Nationale, Paris.

P 83 WOMAN AT A GATE (FEMME À LA BARRIÈRE), 1889. Etching, eleventh and last state. 160 × 110 (6¼ × 4⅜). L.D.84. Bibliothèque Nationale, Paris.

Mr John Rewald possesses a preparatory drawing for this etching. Pissarro seems to have found his inspiration for this plate in a picture of 1886, Shepherdess Bringing home her Sheep (L.R.692).

P 84 PEASANT WOMAN CARRYING BUCKETS (PAY-SANNE PORTANT DES SEAUX), 1889. Etching, seventh and last state. 153 × 110 (6 × 4⅜). L.D.85. Bibliothèque Nationale, Paris.

P 85 PEASANT WOMAN WALKING (PAYSANNE MAR-CHANT), 1889. Etching, first state of three. 132 × 108 (5¼ × 4¼). L.D.86. Bibliothèque Nationale, Paris.
Aquatint is used for the third state of this etching.

P 86 PEASANT WOMAN FORKING THE GROUND (PAY-SANNE À LA FOURCHE), 1889. Etching, fifth and last state. 118 × 73 (4⅝ × 2⅞). L.D.87. Bibliothèque Nationale, Paris.

P 87 WOMEN MINDING COWS (FEMMES GARDANT LES VACHES), 1889. Etching, third and last state. 62 × 100 (2⅜ × 3⅞). L.D.88. Bibliothèque Nationale, Paris.

P 88 CHILDREN TALKING (ENFANTS CAUSANT), 1889. Etching, third and last state. 60 × 100 (2⅜ × 3⅞). L.D.89. Bibliothèque Nationale, Paris.

P 89 CAMILLE PISSARRO, A SELF-PORTRAIT (CAMILLE PISSARRO PAR LUI-MÊME), 1890. Etching, second and last state. 185 × 175 (7¼ × 6⅞). L.D.90. Bibliothèque de l'Institut d'Art et d'Archéologie, Paris.
Pissarro, aged sixty. He painted a similar self-portrait in 1903 (L.R.1316).

P 90 LUCIEN PISSARRO, 1890. Etching, second and last state. 175 × 150 (6⅞ × 5⅞). L.D.91. Bibliothèque Nationale, Paris.
Lucien Pissarro was the artist's eldest son. He too was a painter and engraver. He went to live in England where he produced fine quality wood engravings, sometimes after drawings by his father. A further twelve proofs were printed in 1923.

P 91 CHURCH AND FARM AT ERAGNY (ÉGLISE ET FERME D'ERAGNY), 1890. Etching in colour, sixth and last state. 156 × 243 (6⅛ × 9½). L.D.96. Bibliothèque Nationale, Paris.
In 1895 Pissarro used this subject for a painting (L.R.929). Two further editions were printed: seven black and white prints in 1923, and eleven colour prints in 1930.

P 92 PAUL SIGNAC, c. 1890. Etching, only state. 228 × 213 (9 × 8⅜). L.D.92. Washington National Gallery of Art, Rosenwald Collection.
Paul Signac was Pissarro's friend; he shared his views on politics and aesthetics and regarded him as his master. After he had abandoned pointillism, Pissarro severely criticized Signac's work, without however any detrimental effect on their friendship.

P 93 GIRL MINDING COWS BY THE WATERSIDE (VACHÈRE AU BORD DE L'EAU), 1890. Etching, eighth and last state. 190 × 125 (7½ × 4⅞). L.D.93. Bibliothèque Nationale, Paris.
From 1890 Pissarro had his own press and printed his engravings himself; the press was however 'so bad, that it is hardly an encouragement'. There is a preparatory drawing in existence. The etching was published in the Gazette des Beaux-Arts, May 1904, p. 395, together with an article by Théodore Duret.

P 94 WOMEN TOSSING THE HAY (FANEUSES), 1890. Etching, twelfth and last state. 196 × 133 (7¾ × 5¼). L.D.94. Bibliothèque Nationale, Paris.
A year later Pissarro painted a picture of the harvest at Eragny (L.R.771). The etching was reprinted as an illustration for the 1906 edition of Duret's Peintres Impressionistes.

P 95 PEASANT WOMAN DIGGING (PAYSANNE BÊCHANT), 1890. Etching, tenth and last state. 159 × 122 (6¼ × 4¾). L.D.95. Bibliothèque Nationale, Paris.

P 96 VEGETABLE MARKET AT PONTOISE (MARCHÉ AUX LÉGUMES À PONTOISE), 1891. Etching, second and last state. 255 × 200 (10 × 7⅞). L.D.97. Bibliothèque Nationale, Paris.
In 1891 Pissarro's engravings began to sell in America. In June, he announced to his son his intention of executing a whole series of engravings of markets. In 1923 a further forty-five proofs were printed.

P 97 POULTRY MARKET AT GISORS (MARCHÉ À LA VOLAILLE À GISORS), 1891. Etching, second and last state. 250 × 193 (9 ⅞ × 7 ⅝). L.D.98. Bibliothèque Nationale, Paris.
Madame Lucien Pissarro owned a pen and ink drawing of this composition. It was reproduced on page 55 of the edition by John Rewald of the letters from Pissarro to his son, Lucien. This plate was much admired by Degas. There are several paintings of the market (L.R.1465, painted in 1891; L.R.1473, in 1893; L.R.1400, in 1885; L.R.1437, in 1889; and L.R.1388, in 1884).

P 98 A PEACEFUL SUNDAY IN THE WOODS (REPOS DU DIMANCHE DANS LES BOIS), 1891. Etching, fourth and last state. 170 × 289 (6 ¾ × 11 ⅜). L.D.99. Bibliothèque Nationale, Paris.
This plate and those that follow were finished in March 1891, in preparation for Durand-Ruel's exhibition, which opened on 3 April. This coincided with the exhibition of the Société des Peintres-Graveurs, in which Pissarro refused to take part that year, because he habitually took too few proofs and did not want to give one to the society.

P 99 PEASANT WOMAN AT THE WELL (PAYSANNE AU PUITS), 1891. Study, etching, only state. 317 × 225 (12 ½ × 8 ⅞). L.D.100. Bibliothèque de l'Institut d'Art et d'Archéologie, Paris.
Proofs of this study are very rare. Pissarro believes that his peasant woman comes from Brittany.

P 100 PEASANT WOMAN AT THE WELL (PAYSANNE AU PUITS), 1891. Etching, third and last state. 233 × 193 (9 ⅛ × 7 ⅝). L.D.101. Bibliothèque Nationale, Paris.
One proof is heightened with pastel (L.R.1591).

P 101 PEASANT WOMEN IN A FIELD OF BEANS (PAYSANNES DANS UN CHAMP DE HARICOTS), 1891. Etching, only state. 248 × 151 (9 ¾ × 6). L.D.103. Bibliothèque Nationale, Paris.

P 102 THE PEASANT WOMAN (LA PAYSANNE), c. 1891. Etching, only state. 120 × 80 (4 ¾ × 3 ⅛). L.D.102. Bibliothèque Nationale, Paris.
A further twenty-four proofs were printed in 1923.

P 103 PEASANTS IN THE FIELDS (PAYSANS DANS LES CHAMPS), 1891. Etching, only state. 72 × 150 (2 ⅞ × 5 ⅞) L.D.104. Bibliothèque Nationale, Paris.

P 104 QUAY IN ROUEN: QUAI DE PARIS (QUAI DE PARIS À ROUEN), c. 1891. Etching, only state. 83 × 122 (3 ¼ × 4 ¾). L.D.105. Bibliothèque Nationale, Paris.
This plate was abandoned. In 1923 a further eighteen proofs were printed.

P 105 KEW GARDENS (JARDINS DE KEW), 1893. Etching, second and last state. 163 × 192 (6 ⅜ × 7 ½). L.D.106. Bibliothèque Nationale, Paris.
Lucien's marriage in 1892 brought Pissarro to London. While staying at Kew, from April to May, he executed his Kew Gardens series (L.R.794–803).

P 106 THE BANKS OF THE RIVER IN ROUEN (LES BERGES ROUEN), c. 1893. Etching, only state. 155 × 195 (6 ⅛ × 7 ⅝). L.D.107. Bibliothèque Nationale, Paris.

P 107 TWO WOMEN BATHING (LES DEUX BAIGNEUSES), 1894. Etching, ninth and last state. 180 × 127 (7 ⅛ × 5). L.D.116. Bibliothèque Nationale, Paris.
One proof is heightened with pastel (L.R.1600). On 21 January 1894, Pissarro wrote to Lucien: 'I have just had printed two etchings of Women Bathing, magnificent, you will see! Perhaps too true to life, they

are well-covered peasant women – well-covered with firm flesh! I fear they will offend the delicate spirits, but I think they are the best things I have done, that is, unless I deliberately deceive myself. . . .' He probably refers here to this plate and the one that follows, the most realistic of the series. Delteil's date of 1895 should therefore be corrected.

P 108 THREE WOMEN BATHING (LES TROIS BAIGNEUSES), 1894. Etching, second and last state. 170 × 127 (6 ¾ × 5). L.D.117. Bibliothèque Nationale, Paris.

P 109 QUAY IN BRUGES: QUAI DES MÉNÉTRIERS (QUAI DES MÉNÉTRIERS À BRUGES), 1894. Etching, tenth and last state. 116 × 158 (4 ½ × 6 ¼). L.D.108. Bibliothèque Nationale, Paris.
A picture dated 1903, entitled The Old Bridge at Bruges (L.R.1277) has the same subject, reversed.

P 110 NOTRE-DAME, BRUGES, 1894. Etching, sixth and last state. 214 × 142 (8 ⅜ × 5 ⅝). L.D.109. Bibliothèque Nationale, Paris.
Pissarro went to Belgium in June 1894 at the invitation of his friend Théo Van Rysselberghe, the neo-impressionist painter and disciple of Seurat. He made only a brief stay in Brussels as his chief wish was to paint watercolours in Bruges, where he went at the beginning of July. His journey was dictated by reasons of security. Following the assassination of President Carnot, Pissarro's anarchist friends were in trouble with the authorities. Luce had been arrested, Steinlein and Mirbeau, like Pissarro, had fled.

P 111 BEGGAR WOMAN (MENDIANTES), May 1894. Etching in colour, second and last state. 200 × 150 (7 ⅞ × 5 ⅞). L.D.110. Bibliothèque Nationale, Paris.
Delteil's date can be established precisely, as Pissarro wrote to Lucien on 26 May 1894: 'I have started doing etchings in colour.' He produced this and the two following plates in 1894 and 1895.
There is a proof of the second state printed in colour, like a monotype.
In 1930 there was a further edition of seventeen colour prints. The etching was modelled on a gouache (L.R.1445) signed and dated Eragny 1890.

P 112 THE MARKET AT GISORS: RUE CAPPEVILLE (MARCHÉ DE GISORS; RUE CAPPEVILLE), late 1894–early 1895. Etching in colour, seventh and last state. 170 × 110 (6 ¾ × 4 ⅜). L.D.112. Bibliothèque Nationale, Paris.
Pissarro wrote of this etching: 'A Market in black and white, heightened with tints, I believe some excellent things can be done in this way. It is nothing like Miss Cassatt's work, it is heightening, pure and simple. I already have a few good proofs. It is difficult to find just the right colours.' In 1923 eight black and white proofs were printed, and in 1930 there was a further edition of sixteen colour prints (cf. paintings L.R.690, in 1885).

P 113 PEASANT WOMAN WEEDING THE GRASS (PAYSANNES À L'HERBE), 1895. Etching in colour, only state. 98 × 140 (3 ⅞ × 5 ½). L.D.111. Bibliothèque Nationale, Paris.
Delteil's date can be established precisely as Pissarro notes, on 18 January 1895, that he has had this and the following plate returned from steel-facing. He was engaged on printing them up to March. When these etchings in colour were exhibited by Vollard in June 1886, they enjoyed much success. In 1930 there was a further edition of eleven colour prints.

P 114 WOMEN BATHING WHILE MINDING THE GEESE (BAIGNEUSES GARDEUSES D'OIES), c. 1895. Etching

M 84c THE RAVEN: by the window (LE CORBEAU: à la
fenêtre), 1875. Autograph, second and last state.
400 × 300 (15 ¾ × 11 ⅞). G.86c, M.N.93. Biblio-
thèque Nationale, Paris.

M 84d THE RAVEN: the chair (LE CORBEAU: la chaise),
1875. Autograph. 290 × 280 (11 ½ × 11). G.86d,
M.N.94. Bibliothèque Nationale, Paris.

M 84e THE RAVEN: by the window (LE CORBEAU: à la
fenêtre), 1875. Autograph, only state. 400 × 270
(15 ¾ × 10 ⅝). G.86e, M.N. –. Bibliothèque
Nationale, Paris.
Variation on M 84c. This is the only known proof.

M 85 THE GODS (AU PARADIS), 1880. Autograph, state
after letters. Frame: 243 × 340 (9 ⅝ × 13 ⅜). G.82,
M.N.89. Bibliothèque Nationale, Paris. (de L.483.
Cf. also de L.338.)

M 86 THE POLISH BEAUTY (LA BELLE POLONAISE). Ink
wash autograph. 285 × 265 (11 ¼ × 10 ½). G.83, M.N.
–. Collection Le Garrec.
Referred to in La Lithographie, July 1867, p. 7. (de
L.459, 460).

M 87 OLYMPIA, 1865. Wood engraving by Prunaire,
drawn by Manet. 110 × 160 (4 ⅜ × 6 ¼). G.87, M.N.
–. Bibliothèque Nationale, Paris.
There is another wood engraving of the Olympia by
Moller (G.88, M.N.97), but this is only a reproduc-
tion. There is no reason to include it in a catalogue of
Manet's engravings.

M 88 THE RAILWAY (LE CHEMIN DE FER), 1874. Wood
engraving. 186 × 230 (7 ⅜ × 9 ⅛). G.89, M.N. Biblio-
thèque Nationale, Paris.
Wood engraved by Prunaire. A picture by Manet on
this subject was exhibited in the Salon of 1874.

M 89 THE PARISIENNE (LA PARISIENNE), 1874. First
plate. Wood engraving. 100 × 150 (3 ⅞ × 5 ⅞). G.90.
Bibliothèque Nationale, Paris.

M 90 THE PARISIENNE (LA PARISIENNE), 1874. Second
plate. Wood engraving. 100 × 155 (3 ⅞ × 6 ⅛). G.91.
Bibliothèque Nationale, Paris.

M 91 PORTRAIT OF MADAME CALLIAS, 1874. Wood
engraving, second and last state. 100 × 72 (3 ⅞ × 2 ⅞).
G.92. Bibliothèque Nationale, Paris.

M 92 THE AFTERNOON OF A FAUN (L'APRÈS-MIDI D'UN
FAUNE), 1876. Wood engraving, only state. Four
subjects on one page. Page: 400 × 295 (15 ¾ × 11 ⅝).
G.93. Bibliothèque Nationale, Paris.
Used to illustrate Mallarmé's poem, published by
Derenne in 1876. An edition of 195 was produced,
some of the prints being heightened with watercolour.
See M 92a–92d.

M 92a THE AFTERNOON OF A FAUN: FRONTISPIECE
(L'APRÈS-MIDI D'UN FAUNE: FRONTISPICE), 1876.
Wood engraving. 60 × 55 (2 ⅜ × 2 ⅛). G.93a. Biblio-
thèque Nationale, Paris.

M 92b THE AFTERNOON OF A FAUN: NYMPHS (L'APRÈS-
MIDI D'UN FAUNE: NYMPHES), 1876. Wood en-
graving. 50 × 100 (2 × 4). G.93b, de L.457. Biblio-
thèque Nationale, Paris.

M 92c THE AFTERNOON OF A FAUN: FAUN (L'APRÈS-
MIDI D'UN FAUNE: FAUNE), 1876. Wood en-
graving. 75 × 125 (3 × 4 ⅞). G.93c, de L.458. Biblio-
thèque Nationale, Paris.

M 92d THE AFTERNOON OF A FAUN: DECORATIVE MOTIF
(L'APRÈS-MIDI D'UN FAUNE: CUL-DE-LAMPE),
1876. Wood engraving. 40 × 37 (1 ⅝ × 1 ½). G.93d.
Bibliothèque Nationale, Paris.

PISSARRO

P 1 BY THE WATERSIDE (AU BORD DE L'EAU), c. 1863.
First plate. Etching, first state of two. 292 × 216 (11 ½
× 8 ½). L.D.1. Bibliothèque Nationale, Paris.

P 2 BY THE WATERSIDE (AU BORD DE L'EAU), c. 1863.
Second plate. Etching, only state. 283 × 217 (11 ⅛ ×
8 ¼). L.D.2. Bibliothèque Nationale, Paris.
In fact it is impossible to say which of these two plates
came first. Delteil has placed them as the earliest be-
cause of the clear influence of Corot, whose pupil
Pissarro declared himself to be. There are three known
proofs.

P 3 FIELD NEAR ASNIÈRES (PRAIRIE PRÈS
D'ASNIÈRES), 1864. Etching, only state. 220 × 300
(8 ⅝ × 11 ¾). L.D.3. Bibliothèque Nationale, Paris.
Only one proof known to Delteil.

P 4 A STREET IN MONTMARTRE (UNE RUE A
MONTMARTRE), 1865. Etching, only state. 138 × 115
(5 ½ × 4 ½). L.D.4.
Only one proof known to Delteil.

P 5 LA ROCHE-GUYON. c. 1866. Etching, second and last
state. 271 × 224 (10 ⅝ × 8 ⅝). L.D.5. Bibliothèque
Nationale, Paris.
Pissarro exhibited his etchings for the first time at the
fifth impressionist exhibition in 1880. This plate may
have been among those shown, in which case the
second engraving of La Roche-Guyon (P 27) must
have appeared under the title Cow with Figure. Other
plates exhibited were P 19, 20, 21, 23, 28 and possibly
P 15, 16 and 17.

P 6 THE NEGRESS (LA NÉGRESSE), 1867. Etching, first
state of two. 305 × 217 (12 × 8 ½). L.D.6. Private
collection, Paris.
A very rare print.

P 7 SLOPES AT PONTOISE (COTEAUX À PONTOISE),
1874. Etching, only state. 120 × 158 (4 ¾ × 6 ¼).
L.D.8. Bibliothèque Nationale, Paris.
Probably as the result of a printer's error, Ludovic-
Rodo gives 1878 as the date of this plate, in his article
(Print Collector's Quarterly, vol. 9, no. 3, October 1922,
p. 280); the date should read 1874.

P 8 LANDSCAPE AT PONTOISE, APPLE TREES
(PAYSAGE À PONTOISE, POMMIERS), 1873. Etching,
second state of three. 90 × 169 (3 ½ × 6 ⅝). L.D.8.
Bibliothèque Nationale, Paris.
Based on the picture of 1872, Apple Trees in Blossom.

P 9 THE RIVER OISE AT PONTOISE (L'OISE
À PONTOISE), 1874. Etching, only state. 75 × 116
(3 × 4 ⅝). L.D.9. Bibliothèque Nationale, Paris.
No contemporary proofs were taken from this plate.
Like P 8 and P 10, it was rediscovered in Doctor
Gachet's house in 1922. Six proofs were printed in
1923.

P 10 FACTORY AT PONTOISE (FABRIQUE À PONTOISE),
1874. Etching, only state. 73 × 115 (2 ⅞ × 4 ½). L.D.10.
Bibliothèque Nationale, Paris.
There are five paintings of this subject (L.R.214–19),
all dated 1873.

P 11 THE ROAD TO ROUEN: THE HILLS OF PONTOISE (ROUTE DE ROUEN: LES HAUTEURS DE PONTOISE), 1874. Etching, third and last state. 112 × 150 (4⅜ × 5⅞). L.D.11. Bibliothèque Nationale, Paris.
Only one proof is known to Delteil. Jean Cailac, however, describes three states in his supplement to Delteil's catalogue (*Print Collector's Quarterly*, vol. 19, no. 1, January 1932, p. 77).

P 12 PEASANT WOMAN FEEDING CHILD (PAYSANNE DONNANT À MANGER À UN ENFANT), 1874. Etching, second state of four. 121 × 119 (4¾ × 4⅝). L.D.12. Bibliothèque Nationale, Paris.

P 13 PAUL CÉZANNE, 1874. Etching, only state. 270 × 214 (10⅝ × 8⅜). L.D.13. Bibliothèque Nationale, Paris.
This plate, which is dated, was published in the book *Paul Cézanne* by Émile Bernard, in the series *Les hommes d'aujourd'hui* (cf. L.R.293). Twenty proofs were taken. There were two further editions: in 1911 three proofs, and in 1920 a further seventy-two. It was in 1872 that Cézanne stayed with Pissarro in Pontoise; they worked side by side and Cézanne painted views of the Hermitage. In 1873 Pissarro introduced Cézanne to Doctor Gachet.

P 14 IN THE FIELDS AT ENNERY (DANS LES CHAMPS À ENNERY), 1875. Dry-point, only state. 248 × 282 (9¾ × 11⅛). L.D.14. Bibliothèque Nationale, Paris.
Two proofs were taken. There were two further editions: in 1921 six proofs, and in 1923 a further six.

P 15 WOMAN SELLING CHESTNUTS (MARCHANDE DE MARRONS), 1878. Dry-point, second and last state. 210 × 170 (8¼ × 6¾). L.D.15. Bibliothèque Nationale, Paris.
Pissarro returned to this plate in 1896. A distemper painting of the same scene, but with the image reversed, is dated 1881 (L.R.1348).

P 16 WOODLANDS AT THE HERMITAGE (PAYSAGE SOUS BOIS À L'HERMITAGE), 1879. Etching, fifth and last state. 219 × 269 (8⅝ × 10⅝). L.D.16. Bibliothèque Nationale, Paris.
This etching was printed in 1880 as an illustration for the impressionist review *Le Jour et la Nuit*, of which only one issue appeared. The Hermitage was also the subject of many paintings by Pissarro in 1867 (L.R.52 and 56).

P 17 LANDSCAPE PANORAMA (PAYSAGE EN LONG), 1879. Etching, third and last state. 117 × 397 (4⅝ × 15⅝). L.D.17. British Museum.
Three or four proofs were taken, and in 1923 a further eighteen proofs were printed.

P 18 THE WOMAN ON THE ROAD (LA FEMME SUR LA ROUTE), 1879. Etching, fourth and last state. 158 × 210 (6¼ × 8¼). L.D.18. Bibliothèque Nationale, Paris.
In 1923 a further twelve proofs were printed.

P 19 WOODED LANE AT PONTOISE (CHEMIN SOUS BOIS À PONTOISE), 1879. Etching, sixth and last state. 163 × 212 (6⅜ × 8⅜). L.D.19. British Museum.

P 20 THE OLD COTTAGE (LA MASURE), 1879. Etching, eighth and last state. 167 × 170 (6⅝ × 6¾). L.D.20. Bibliothèque Nationale, Paris.
This etching was sold by Gutbier in September 1896 for one hundred francs. This was after Vollard had launched Pissarro's engravings at his exhibition in July of that year (cf. P 65). Pissarro printed only six proofs, but Degas took a number of impressions in colour.

P 21 SAINT MARTIN'S DAY FAIR AT PONTOISE (FOIRE DE LA SAINT-MARTIN À PONTOISE), 1879. Etching, fourth and last state. 119 × 160 (4¾ × 6¼). L.D.21. Bibliothèque Nationale, Paris.
The first three states are very different, the market place in the foreground being almost entirely deserted. Cf. lithograph P 133 and the painting of 1883 on this subject (L.R.1387).

P 22 DUSK WITH HAYRICKS (CRÉPUSCULE AVEC MEULES), 1879. Etching, third and last state. 105 × 177 (4⅛ × 7). L.D.23. Bibliothèque Nationale, Paris.
A few proofs of the second state were printed in colour.

P 23 RAIN EFFECT (EFFET DE PLUIE), 1879. Etching, sixth and last state. 162 × 213 (6⅜ × 8⅜). L.D.24. Bibliothèque Nationale, Paris.

P 24 PEASANT: LE PÈRE MELON (PAYSAN: LE PÈRE MELON), 1879. Etching, sixth and last state. 103 × 165 (4 × 6½). L.D.25. Bibliothèque Nationale, Paris.
In 1891 Pissarro recovered this and other plates that he had mislaid from Degas, who had found them while reorganizing his studio, where no doubt the first proofs had been printed. One proof is heightened with crayon (L.R.1542). There is also a painting of the same date on this subject (L.R.498).

P 25 TREE AND PLOUGHED FIELD (ARBRE ET TERRAIN LABOURÉ), c. 1879. Etching, only state. 118 × 160 (4⅝ × 6¼). L.D.26. Bibliothèque Nationale, Paris.

P 26 SETTING SUN (SOLEIL COUCHANT), 1879. Dry-point, fourth and last state. 115 × 160 (4½ × 6¼). L.D.22. Bibliothèque Nationale, Paris.
In March 1891, when Pissarro gave a proof of this engraving to his son, Lucien, he wrote: 'You know these proofs are rare, I have only eight, and they are not very good, it's a difficult plate to print.'

P 27 THE CASTLE OF LA ROCHE-GUYON (LE CHÂTEAU DE LA ROCHE-GUYON). Dry-point on zinc, only state. 168 × 247 (5⅝ × 9¾). L.D.27. Bibliothèque Nationale, Paris.
Two proofs are known to Delteil.

P 28 LANDSCAPE AT THE HERMITAGE, Pontoise (PAYSAGE À L'HERMITAGE, Pontoise), 1880. Dry-point, second state of three. 110 × 128 (4⅜ × 5). L.D.28. Bibliothèque Nationale, Paris.
There are two proofs of the second state and nineteen of the third; a further twelve proofs were printed in 1923.

P 29 THE CABBAGE FIELD (LE CHAMP DE CHOUX), c. 1880. Etching, only state. 247 × 173 (9¾ × 6⅞). L.D.29. Bibliothèque Nationale, Paris.

P 30 WOMAN IN THE KITCHEN-GARDEN (LA FEMME DANS LE POTAGER), c. 1880. Etching, second state of three. 248 × 169 (9¾ × 6⅝). L.D.30. Bibliothèque Nationale, Paris.

P 31 WOMAN EMPTYING A WHEELBARROW (FEMME VIDANT UNE BROUETTE), 1880. Etching, twelfth and last state. 319 × 235 (12½ × 9¼). L.D.31. Collection Cailac, Paris.
On 1 March 1891, Pissarro wrote to Lucien: 'The *Woman Emptying a Wheelbarrow* is rare, you recall there are just two proofs, and only one – which I am sending to you – has come out well; this is the one in grey.'
Another proof of this etching is in the Rhode Island School of Design, Providence. There is also a gouache

of the same subject, with the image reversed (L.R. 1342).

P 32 PATH AT PONTOISE (SENTE DES POUILLEUX À PONTOISE), 1880. First plate. Dry-point, second and last state. 268 × 217 (10 ⅝ × 8 ½). L.D.32. Bibliothèque Nationale, Paris.

P 33 PATH AT PONTOISE (SENTE DES POUILLEUX À PONTOISE), 1883. Second plate. Dry-point, fourth and last state. 150 × 112 (5 ⅞ × 4 ⅜). L.D.33. Bibliothèque Nationale, Paris.
In 1883, at Osny, Pissarro made a complete series of dry-point engravings, which he planned to print when he returned to Paris in April. At that time he had no press of his own and made use of the facilities of Degas, Charles Jacque, Salmon or Delâtre, although he accused the latter of over-inking.

P 34 PATHWAY, Pontoise (SENTE DES GROUETTES, Pontoise), 1883. Dry-point, only state. 142 × 109 (5 ⅝ × 4 ¼). L.D.34. The Art Institute of Chicago.

P 35 THE RONDEST HOUSE AT THE HERMITAGE (LA MAISON RONDEST À L'HERMITAGE), 1883. Etching, only state. 165 × 112 (6 ½ × 4 ⅜). L.D.35. Bibliothèque Nationale, Paris.

P 36 WOMAN WITH WHEELBARROW (FEMME À LA BROUETTE), 1883. Dry-point on zinc, only state. 245 × 169 (9 ⅝ × 6 ⅝). L.D.36. Museum of Arts, Rhode Island School of Design, Providence.
Four proofs were known to Delteil. Pissarro took up this composition again in a picture of 1892 (L.R.822).

P 37 THE RAILWAY BRIDGE AT PONTOISE (LE PONT DE CHEMIN DE FER À PONTOISE), 1883. Dry-point, first state of two. 129 × 247 (5 ⅛ × 9 ¾). L.D.37. Museum of Fine Arts, Boston, Lee M. Friedmann Fund.
There is only one proof of each state of this plate in existence.

P 38 MOTHER AND CHILD (MÈRE ET ENFANT), 1883. Dry-point and aquatint, seventh state of eight. 141 × 101 (5 ½ × 4). L.D.38. Bibliothèque Nationale, Paris.

P 39 CHILD AT HIS MOTHER'S BREAST (ENFANT TÉTANT SA MÈRE), 1883. Dry-point and aquatint, third and last state. 120 × 111 (4 ¾ × 4 ⅜). L.D.39. Bibliothèque Nationale, Paris.

P 40 LANDSCAPE WITH SHEPHERDS AND SHEEP, Osny (PAYSAGE AVEC BERGERS ET MOUTONS, Osny), 1883. Dry-point and aquatint, sixth and last state. 100 × 140 (4 × 5 ½). L.D.40. Bibliothèque Nationale, Paris.
In March 1883, encouraged by Braquemond, Pissarro worked at his dry-point engravings, taken from life at Osny and Pontoise. This was with a view to an exhibition with Duret in England.

P 41 OLD STREET IN ROUEN: RUE MALPALUE (VIEILLE RUE À ROUEN: RUE MALPALUE), 1883. Dry-point, second and last state. 124 × 121 (4 ⅞ × 4 ¾). L.D.41. Bibliothèque Nationale, Paris.
At the end of 1883, Pissarro went to work in Rouen where he made drawings for this and the six following engravings. He also painted a number of pictures (L.R.603–11).

P 42 THE HARBOUR NEAR THE CUSTOMS HOUSE AT ROUEN (LE PORT PRÈS DE LA DOUANE À

ROUEN), 1883. Etching, second and last state. 111 × 141 (4 ⅜ × 5 ½). L.D.43. Bibliothèque Nationale, Paris.

P 43 STREET IN ROUEN: RUE DU GROS-HORLOGE (RUE DU GROS-HORLOGE À ROUEN), 1883. Etching, third and last state. 192 × 147 (7 ½ × 5 ¾). L.D.54. Bibliothèque Nationale, Paris.
While staying in Rouen in 1883, Pissarro made a drawing of this subject, attracted by the lithograph Bonington had made some fifty years earlier. Although Delteil gives 1885 as the date, a print of the etching in the S.P. Avery collection is signed and dated 1883.

P 44 A LANE IN ROUEN: RUE DES ARPENTS (UNE RUELLE À ROUEN: RUE DES ARPENTS), 1883. Etching, second and last state. 123 × 120 (4 ⅞ × 4 ¾). L.D.42. Bibliothèque Nationale, Paris.

P 45 SQUARE IN ROUEN: PLACE DE LA RÉPUBLIQUE (PLACE DE LA RÉPUBLIQUE À ROUEN), 1884? Etching, second and last state. 125 × 122 (4 ⅞ × 4 ¾). L.D.44. Bibliothèque Nationale, Paris.
Pissarro showed his engravings at the eighth impressionist exhibition, held between 15 May and 15 June 1886, on the corner of the rue Laffitte and the boulevard des Italiens. Degas, Guillaumin, Berthe Morisot and Mary Cassatt also exhibited. This etching appeared in company with plates P 53, P 55, P 57, P 61, P 62 and P 63.

P 46 THE HARBOUR AT ROUEN: SAINT SEVER (PORT DE ROUEN: SAINT SEVER), 1884. Etching, only state. 144 × 194 (5 ⅝ × 7 ⅝). L.D.45. Bibliothèque Nationale, Paris.
This etching should be compared with Pissarro's pictures of the same subject executed in 1896 (L.R.957, 970). Jean Cailac believes this etching, for which no plate is known to exist, is simply a state of the following plate.

P 47 PROMENADE IN ROUEN: COURS BOIELDIEU (COURS BOIELDIEU À ROUEN), 1884? Etching, second and last state. 143 × 192 (5 ⅝ × 7 ½). L.D.46. Bibliothèque Nationale, Paris.

P 48 RIVERSIDE AT ROUEN: CÔTE SAINTE-CATHERINE (CÔTE SAINTE-CATHERINE, ROUEN), 1884. Etching, sixth state of seven. 149 × 181 (5 ⅞ × 7 ⅛). L.D.48. Bibliothèque Nationale, Paris.
A further twelve proofs were printed in 1923.

P 49 BY THE SEINE AT ROUEN: COURS LA REINE (COURS LA REINE, AU BORD DE SEINE, À ROUEN), 1884. Etching, third and last state. 122 × 139 (4 ⅞ × 5 ½). L.D.49. Bibliothèque Nationale, Paris.
Cf. paintings L.R.602 and 603, and those of 1898, L.R.1044 and 1046.

P 50 VIEW OF ROUEN: COURS LA REINE (VUE DE ROUEN: COURS LA REINE), 1884. Etching, third and last state. 153 × 195 (6 × 7 ⅝). L.D.50. Bibliothèque Nationale, Paris. Cf. P 49.

P 51 THE FARM AT CHRISTMAS: OSNY (LA FERME À NOËL: OSNY), 1884. Etching, sixth and last state. 197 × 182 (7 ¾ × 7 ⅛). L.D.51. Bibliothèque de l'Institut d'Art et d'Archéologie, Paris.

P 52 STREET IN ROUEN: RUE DAMIETTE (RUE DAMIETTE À ROUEN), 1884. Etching, second and last state. 195 × 148 (7 ⅝ × 5 ⅞). L.D.52. Bibliothèque Nationale, Paris.

P 53 STREET IN ROUEN: RUE MALPALUE (LA RUE MAL-

PALUE À ROUEN), 1885. Etching, third and last state. 198 × 148 (7¾ × 5⅞). L.D.53. Bibliothèque Nationale, Paris.

P 54 LANDSCAPE AT ROUEN: CÔTE SAINT-CATHERINE (PAYSAGE À ROUEN: CÔTE SAINTE-CATHERINE), 1885. Etching, fourth and last state. 125 × 175 (3 × 4⅞). L.D.55. Bibliothèque Nationale, Paris.

P 55 THE HARBOUR AT ROUEN (PORT DE ROUEN), 1885. Etching, second and last state. 103 × 123 (4 × 4⅞). L.D.56. Bibliothèque Nationale, Paris.
On 13 December 1888, Pissarro urged Delâtre to 'take care over the sky of the Little Harbour of Rouen, which I have reworked. This sky must stay white and luminous, as young Jacques printed it, this is essential.'

P 56 THE HARBOUR AT ROUEN (PORT DE ROUEN), 1885. Etching, third and last state. 148 × 166 (5⅞ × 6⅝). L.D.57. Bibliothèque Nationale, Paris.
This etching was modelled on a picture of 1883 (L.R.611). Pissarro returned to this subject in painting in 1898 (L.R.1050–4).

P 57 COW AND LANDSCAPE (VACHE ET PAYSAGE), 1885. Etching, third and last state. 110 × 115 (4¼ × 4½). L.D.58. Bibliothèque Nationale, Paris.
Although Delteil suggests 1885 as its date, it is not impossible that this was the etching shown in the fifth impressionist exhibition, in 1880, under the title *Cow with Figure*. In that case the print exhibited under the title *La Roche-Guyon* would have been P 27, and P 5 would not have appeared at all; this would seem to be a more satisfactory explanation, but unfortunately it cannot be verified (cf. P 5).

P 58 FIELD AND MILL AT OSNY (PRAIRIE ET MOULIN À OSNY), 1885. Etching, sixth and last state. 160 × 240 (6¼ × 9⅜). L.D.59. Bibliothèque Nationale, Paris.
In 1891 Degas offered Pissarro his congratulations on this plate, which had been shown at the exhibition of the Peintres-Graveurs. Pissarro presented Lucien with a 'good proof', pointing out in a letter of 1 March 1891: 'There are only three proofs like this one. The steel-facing has obliterated the suppleness of the background, so I have only three proofs left; the third is for the Luxembourg Museum.'

P 59 VIEW OF PONTOISE (VUE DE PONTOISE), 1885. Etching, seventh and last state. 159 × 244 (6¼ × 9⅝). L.D.60. Bibliothèque Nationale, Paris.

P 60 PEASANT WOMAN AMONG THE CABBAGES (PAYSANNE DANS LES CHOUX), 1885. Etching, third and last state. 155 × 116 (6⅛ × 4⅝). L.D.61. Bibliothèque Nationale, Paris.

P 61 THE CHURCH AT OSNY, near Pontoise (ÉGLISE D'OSNY, près de Pontoise), 1885. Etching, fourth and last state. 116 × 155 4⅝ × 6⅛). L.D.62. Bibliothèque Nationale, Paris.

P 62 POTATO HARVEST (RÉCOLTE DES POMMES DE TERRE), 1886. Etching, seventh and last state. 275 × 215 (10⅞ × 8½). L.D.63. Bibliothèque Nationale, Paris.
One proof is heightened with pastel (L.R.1573).

P 63 STREET IN ROUEN: RUE DE L'ÉPICERIE (RUE DE L'ÉPICERIE À ROUEN), 1886. Etching, second and last state. 172 × 152 (6¾ × 6). L.D.64. Bibliothèque Nationale, Paris.
Pissarro was fond of this area which crops up again in paintings of 1898 (L.R.1036–8).

P 64 SQUARE IN ROUEN: PLACE DE LA RÉPUBLIQUE (PLACE DE LA RÉPUBLIQUE À ROUEN), 1886. Etching, second and last state. 145 × 165 (5¾ × 6½). L.D.65. Bibliothèque Nationale, Paris.
Lucien Pissarro relates the reactions of the painter Ricketts on seeing this plate. He claimed a distinct preference for many of the etchings by Lucien's father to those by Whistler, declaring that one would have to go back to Rembrandt to find another such etcher (cf. L.R.609, a picture of 1883).

P 65 THE STONE BRIDGE AT ROUEN (LE PONT DE PIERRE À ROUEN), 1887. Etching, second and last state. 149 × 198 (5⅞ × 7¾). L.D.66. Bibliothèque Nationale, Paris.
This etching was sold for seventy-five francs by Gutbier in September 1896 (cf. the painting of 1896 of this subject, L.R.961, and that of 1898, L.R.1043).

P 66 MEN WORKING IN THE HARBOUR AT ROUEN (LES OUVRIERS DU PORT À ROUEN), 1887. Etching, only state. 125 × 170 (4⅞ × 6¾). L.D.67. Bibliothèque Nationale, Paris.

P 67 A STREET IN ROUEN: RUE DES ARPENTS (UNE RUE À ROUEN: RUE DES ARPENTS), 1887. Etching, third and last state. 155 × 103 (6⅛ × 4). L.D.68. Bibliothèque Nationale, Paris.

P 68 ISLAND AT ROUEN: L'ÎLE LACROIX (L'ÎLE LACROIX À ROUEN), 1887. Etching, second and last state. 115 × 158 (4½ × 6¼). L.D.69. Bibliothèque Nationale, Paris.
A picture of this subject *Effects of Fog* (L.R.719) is dated 1888. Even so Pissarro does not appear to have visited Rouen in that year.

P 69 LANDSCAPE AT OSNY (PAYSAGE À OSNY), 1887. Etching, second and last state. 112 × 155 (4⅜ × 6⅛). L.D.70. Bibliothèque Nationale, Paris.

P 70 CHÂTEAU DE BUSAGNY, OSNY, 1887. Etching, fourth and last state. 98 × 140 (3⅞ × 5½). L.D.71. Bibliothèque Nationale, Paris.

P 71 WOMAN WEEDING (LA SARCLEUSE), 1887–8? Etching, second and last state. 161 × 109 (6⅜ × 4¼). L.D.72. Bibliothèque Nationale, Paris.

P 72 GRANDMOTHER IN HER ARMCHAIR: THE ARTIST'S MOTHER (GRAND-MÈRE DANS SON FAUTEUIL: MÈRE DE L'ARTISTE), 1888. Etching, fifth and last state. 99 × 61 (3⅞ × 2⅜). L.D.73. Bibliothèque Nationale, Paris.
Pissarro's mother was the model for both this plate and P 80.

P 73 THE MAID SHOPPING (LA BONNE FAISANT SON MARCHÉ), 1888. Etching, fourth and last state. 192 × 135 (7½ × 5⅜). L.D.74. Bibliothèque Nationale, Paris.
The first state was published in the *Revue Indépendante*, 1 February 1888, and the fourth state in the same publication, 1 May 1888.

P 74 THE GEESE (LES OIES), 1888. Etching, fourth and last state. 135 × 194 (5⅜ × 7⅝). L.D.76. Bibliothèque Nationale, Paris.
This etching was published in the *Revue Indépendante* and was admired by Lucien's friend, the English painter Ricketts. Pissarro made him a present of it, also P 96 and P 97, in the hope that they would be published in England in *The Dial*.

P 75 THE MARKET AT PONTOISE (MARCHÉ DE

PONTOISE), 1888. Etching, third and last state. 99 × 62 (3 ⅞ × 2 ⅜). L.D.75. Bibliothèque Nationale, Paris.

A gouache of this subject (L.R.1413) is dated June 1887. Pissarro painted several pictures in the market at Pontoise in 1885 (L.R.1401), and also in 1890 (L.R.1451).

P 76 WOMAN PICKING CABBAGES (FEMME CUEILLANT DES CHOUX), 1888. Etching, third state of seven. 100 × 61 (3 ⅞ × 2 ⅜). L.D.77. Bibliothèque Nationale, Paris.

It must have been towards the end of 1888 that Pissarro produced this etching and the two that follow. He said he was working on them 'every day', and was also retouching earlier engravings, having in mind an exhibition that did not in fact take place. They were printed by Delâtre.

P 77 COWS IN THE FIELDS AT ERAGNY, near Gisors (VACHES DANS LES PRAIRIES D'ERAGNY, près de Gisors), 1888. Etching, second and last state. 80 × 120 (3 ⅛ × 4 ¾). L.D.78. Bibliothèque Nationale, Paris.

P 78 FIELDS AT BAZINCOURT (PRAIRIES À BAZIN-COURT), 1888. Etching, fourth and last state. 72 × 110 (2 ⅞ × 4 ⅜). L.D.79. Bibliothèque Nationale, Paris.

P 79 YOUNG MAN READING: GEORGES PISSARRO (JEUNE HOMME LISANT: GEORGES PISSARRO), 1889. Etching, only state. 132 × 114 (5 ¼ × 4 ½). L.D. 81. Bibliothèque Nationale, Paris.

Georges was Pissarro's third child, born at Louveciennes on 22 November 1871. From 1895 onwards he painted under the name Manzana, the maiden name of Pissarro's mother.

P 80 GRANDMOTHER: THE ARTIST'S MOTHER (GRAND-MÈRE: MÈRE DE L'ARTISTE), 1889. Etching, fourth state of seven. 171 × 253 (6 ¾ × 10). L.D.80. Bibliothèque Nationale, Paris.

P 81 THE SHEPHERD'S RETURN (LA RENTRÉE DU BERGER), 1889. Etching, only state. 76 × 109 (3 × 4 ¼). L.D.82. Bibliothèque Nationale, Paris.

In 1889 Pissarro worked hard at his engravings, which he printed and had mounted immediately, in spite of his apprehension about selling them.

P 82 FATHER PASCAL (PÈRE PASCAL), 1889. Etching, third and last state. 100 × 63 (3 ⅞ × 2 ½). L.D.83. Bibliothèque Nationale, Paris.

P 83 WOMAN AT A GATE (FEMME À LA BARRIÈRE), 1889. Etching, eleventh and last state. 160 × 110 (6 ¼ × 4 ⅜). L.D.84. Bibliothèque Nationale, Paris.

Mr John Rewald possesses a preparatory drawing for this etching. Pissarro seems to have found his inspiration for this plate in a picture of 1886, Shepherdess Bringing home her Sheep (L.R.692).

P 84 PEASANT WOMAN CARRYING BUCKETS (PAY-SANNE PORTANT DES SEAUX), 1889. Etching, seventh and last state. 153 × 110 (6 × 4 ⅜). L.D.85. Bibliothèque Nationale, Paris.

P 85 PEASANT WOMAN WALKING (PAYSANNE MAR-CHANT), 1889. Etching, first state of three. 132 × 108 (5 ¼ × 4 ¼). L.D.86. Bibliothèque Nationale, Paris.

Aquatint is used for the third state of this etching.

P 86 PEASANT WOMAN FORKING THE GROUND (PAY-SANNE À LA FOURCHE), 1889. Etching, fifth and last state. 118 × 73 (4 ⅝ × 2 ⅞). L.D.87. Bibliothèque Nationale, Paris.

P 87 WOMEN MINDING COWS (FEMMES GARDANT LES VACHES), 1889. Etching, third and last state. 62 × 100 (2 ⅜ × 3 ⅞). L.D.88. Bibliothèque Nationale, Paris.

P 88 CHILDREN TALKING (ENFANTS CAUSANT), 1889. Etching, third and last state. 60 × 100 (2 ⅜ × 3 ⅞). L.D.89. Bibliothèque Nationale, Paris.

P 89 CAMILLE PISSARRO, A SELF-PORTRAIT (CAMILLE PISSARRO PAR LUI-MÊME), 1890. Etching, second and last state. 185 × 175 (7 ¼ × 6 ⅞). L.D.90. Bibliothèque de l'Institut d'Art et d'Archéologie, Paris.

Pissarro, aged sixty. He painted a similar self-portrait in 1903 (L.R.1316).

P 90 LUCIEN PISSARRO, 1890. Etching, second and last state. 175 × 150 (6 ⅞ × 5 ⅞). L.D.91. Bibliothèque Nationale, Paris.

Lucien Pissarro was the artist's eldest son. He too was a painter and engraver. He went to live in England where he produced fine quality wood engravings, sometimes after drawings by his father. A further twelve proofs were printed in 1923.

P 91 CHURCH AND FARM AT ERAGNY (ÉGLISE ET FERME D'ERAGNY), 1890. Etching in colour, sixth and last state. 156 × 243 (6 ⅛ × 9 ½). L.D.96. Bibliothèque Nationale, Paris.

In 1895 Pissarro used this subject for a painting (L.R.929). Two further editions were printed: seven black and white prints in 1923, and eleven colour prints in 1930.

P 92 PAUL SIGNAC, c. 1890. Etching, only state. 228 × 213 (9 × 8 ⅜). L.D.92. Washington National Gallery of Art, Rosenwald Collection.

Paul Signac was Pissarro's friend; he shared his views on politics and aesthetics and regarded him as his master. After he had abandoned pointillism, Pissarro severely criticized Signac's work, without however any detrimental effect on their friendship.

P 93 GIRL MINDING COWS BY THE WATERSIDE (VACHÈRE AU BORD DE L'EAU), 1890. Etching, eighth and last state. 190 × 125 (7 ½ × 4 ⅞). L.D.93. Bibliothèque Nationale, Paris.

From 1890 Pissarro had his own press and printed his engravings himself; the press was however 'so bad, that it is hardly an encouragement'. There is a pre-paratory drawing in existence. The etching was published in the Gazette des Beaux-Arts, May 1904, p. 395, together with an article by Théodore Duret.

P 94 WOMEN TOSSING THE HAY (FANEUSES), 1890. Etching, twelfth and last state. 196 × 133 (7 ¾ × 5 ¼). L.D.94. Bibliothèque Nationale, Paris.

A year later Pissarro painted a picture of the harvest at Eragny (L.R.771). The etching was reprinted as an illustration for the 1906 edition of Duret's Peintres Impressionistes.

P 95 PEASANT WOMAN DIGGING (PAYSANNE BÊCHANT), 1890. Etching, tenth and last state. 159 × 122 (6 ¼ × 4 ¾). L.D.95. Bibliothèque Nationale, Paris.

P 96 VEGETABLE MARKET AT PONTOISE (MARCHÉ AUX LÉGUMES À PONTOISE), 1891. Etching, second and last state. 255 × 200 (10 × 7 ⅞). L.D.97. Bibliothèque Nationale, Paris.

In 1891 Pissarro's engravings began to sell in America. In June, he announced to his son his intention of executing a whole series of engravings of markets. In 1923 a further forty-five proofs were printed.

P 97 POULTRY MARKET AT GISORS (MARCHÉ À LA VOLAILLE À GISORS), 1891. Etching, second and last state. 250 × 193 (9⅞ × 7⅝). L.D.98. Bibliothèque Nationale, Paris.
Madame Lucien Pissarro owned a pen and ink drawing of this composition. It was reproduced on page 55 of the edition by John Rewald of the letters from Pissarro to his son, Lucien. This plate was much admired by Degas. There are several paintings of the market (L.R.1465, painted in 1891; L.R.1473, in 1893; L.R.1400, in 1885; L.R.1437, in 1889; and L.R.1388, in 1884).

P 98 A PEACEFUL SUNDAY IN THE WOODS (REPOS DU DIMANCHE DANS LES BOIS), 1891. Etching, fourth and last state. 170 × 289 (6¾ × 11⅜). L.D.99. Bibliothèque Nationale, Paris.
This plate and those that follow were finished in March 1891, in preparation for Durand-Ruel's exhibition, which opened on 3 April. This coincided with the exhibition of the Société des Peintres-Graveurs, in which Pissarro refused to take part that year, because he habitually took too few proofs and did not want to give one to the society.

P 99 PEASANT WOMAN AT THE WELL (PAYSANNE AU PUITS), 1891. Study, etching, only state. 317 × 225 (12½ × 8⅞). L.D.100. Bibliothèque de l'Institut d'Art et d'Archéologie, Paris.
Proofs of this study are very rare. Pissarro believes that his peasant woman comes from Brittany.

P 100 PEASANT WOMAN AT THE WELL (PAYSANNE AU PUITS), 1891. Etching, third and last state. 233 × 193 (9⅛ × 7⅝). L.D.101. Bibliothèque Nationale, Paris.
One proof is heightened with pastel (L.R.1591).

P 101 PEASANT WOMEN IN A FIELD OF BEANS (PAYSANNES DANS UN CHAMP DE HARICOTS), 1891. Etching, only state. 248 × 151 (9¾ × 6). L.D.103. Bibliothèque Nationale, Paris.

P 102 THE PEASANT WOMAN (LA PAYSANNE), c. 1891. Etching, only state. 120 × 80 (4¾ × 3⅛). L.D.102. Bibliothèque Nationale, Paris.
A further twenty-four proofs were printed in 1923.

P 103 PEASANTS IN THE FIELDS (PAYSANS DANS LES CHAMPS), 1891. Etching, only state. 72 × 150 (2⅞ × 5⅞) L.D.104. Bibliothèque Nationale, Paris.

P 104 QUAY IN ROUEN: QUAI DE PARIS (QUAI DE PARIS À ROUEN), c. 1891. Etching, only state. 83 × 122 (3¼ × 4¾). L.D.105. Bibliothèque Nationale, Paris.
This plate was abandoned. In 1923 a further eighteen proofs were printed.

P 105 KEW GARDENS (JARDINS DE KEW), 1893. Etching, second and last state. 163 × 192 (6⅜ × 7½). L.D.106. Bibliothèque Nationale, Paris.
Lucien's marriage in 1892 brought Pissarro to London. While staying at Kew, from April to May, he executed his Kew Gardens series (L.R.794–803).

P 106 THE BANKS OF THE RIVER IN ROUEN (LES BERGES ROUEN), c. 1893. Etching, only state. 155 × 195 (6⅛ × 7⅝). L.D.107. Bibliothèque Nationale, Paris.

P 107 TWO WOMEN BATHING (LES DEUX BAIGNEUSES), 1894. Etching, ninth and last state. 180 × 127 (7⅛ × 5). L.D.116. Bibliothèque Nationale, Paris.
One proof is heightened with pastel (L.R.1600). On 21 January 1894, Pissarro wrote to Lucien: 'I have just had printed two etchings of Women Bathing, magnificent, you will see! Perhaps too true to life, they

are well-covered peasant women – well-covered with firm flesh! I fear they will offend the delicate spirits, but I think they are the best things I have done, that is, unless I deliberately deceive myself. . . .' He probably refers here to this plate and the one that follows, the most realistic of the series. Delteil's date of 1895 should therefore be corrected.

P 108 THREE WOMEN BATHING (LES TROIS BAIGNEUSES), 1894. Etching, second and last state. 170 × 127 (6¾ × 5). L.D.117. Bibliothèque Nationale, Paris.

P 109 QUAY IN BRUGES: QUAI DES MÉNÉTRIERS (QUAI DES MÉNÉTRIERS À BRUGES), 1894. Etching, tenth and last state. 116 × 158 (4½ × 6¼). L.D.108. Bibliothèque Nationale, Paris.
A picture dated 1903, entitled *The Old Bridge at Bruges* (L.R.1277) has the same subject, reversed.

P 110 NOTRE-DAME, BRUGES, 1894. Etching, sixth and last state. 214 × 142 (8⅜ × 5⅝). L.D.109. Bibliothèque Nationale, Paris.
Pissarro went to Belgium in June 1894 at the invitation of his friend Théo Van Rysselberghe, the neo-impressionist painter and disciple of Seurat. He made only a brief stay in Brussels as his chief wish was to paint watercolours in Bruges, where he went at the beginning of July. His journey was dictated by reasons of security. Following the assassination of President Carnot, Pissarro's anarchist friends were in trouble with the authorities. Luce had been arrested, Steinlein and Mirbeau, like Pissarro, had fled.

P 111 BEGGAR WOMAN (MENDIANTES), May 1894. Etching in colour, second and last state. 200 × 150 (7⅞ × 5⅞). L.D.110. Bibliothèque Nationale, Paris.
Delteil's date can be established precisely, as Pissarro wrote to Lucien on 26 May 1894: 'I have started doing etchings in colour.' He produced this and the two following plates in 1894 and 1895.
There is a proof of the second state printed in colour, like a monotype.
In 1930 there was a further edition of seventeen colour prints. The etching was modelled on a gouache (L.R.1445) signed and dated Eragny 1890.

P 112 THE MARKET AT GISORS: RUE CAPPEVILLE (MARCHÉ DE GISORS; RUE CAPPEVILLE), late 1894–early 1895. Etching in colour, seventh and last state. 170 × 110 (6¾ × 4⅜). L.D.112. Bibliothèque Nationale, Paris.
Pissarro wrote of this etching: 'A *Market* in black and white, heightened with tints, I believe some excellent things can be done in this way. It is nothing like Miss Cassatt's work, it is heightening, pure and simple. I already have a few good proofs. It is difficult to find just the right colours.' In 1923 eight black and white proofs were printed, and in 1930 there was a further edition of sixteen colour prints (cf. paintings L.R.690, in 1885).

P 113 PEASANT WOMAN WEEDING THE GRASS (PAYSANNES À L'HERBE), 1895. Etching in colour, only state. 98 × 140 (3⅞ × 5½). L.D.111. Bibliothèque Nationale, Paris.
Delteil's date can be established precisely as Pissarro notes, on 18 January 1895, that he has had this and the following plate returned from steel-facing. He was engaged on printing them up to March. When these etchings in colour were exhibited by Vollard in June 1886, they enjoyed much success. In 1930 there was a further edition of eleven colour prints.

P 114 WOMEN BATHING WHILE MINDING THE GEESE (BAIGNEUSES GARDEUSES D'OIES), c. 1895. Etching

in colour, ninth and last state. 90 × 150 (3 ½ × 5 ⅞). L.D.119. Bibliothèque Nationale, Paris.
In 1930 a further thirteen colour prints were made.

P 115 WOMAN BATHING: PUTTING ON HER STOCKINGS (BAIGNEUSE METTANT SES BAS), 1895. Etching, second and last state. 80 × 114 (3 ⅛ × 4 ½). L.D.113. Bibliothèque Nationale, Paris.
Delteil gives 1895 as the date of the series of 'women bathing' (P 112–18). In fact it was begun in January 1894, but the press which Pissarro was trying out on this series (bought from Delâtre for three hundred francs) broke down, and he was obliged to interrupt his work.

P 116 WOMAN BATHING, SEEN FROM BEHIND (BAIGNEUSE VUE DE DOS), 1895. Etching, fifth and last state. 87 × 73 (3 ⅜ × 2 ⅞). L.D.114. Bibliothèque Nationale, Paris.

P 117 WOMAN BATHING: WITH GEESE (BAIGNEUSE AUX OIES), 1895. Etching, tenth state of sixteen. 127 × 173 (5 × 6 ⅞). L.D.115. British Museum.
The British Museum also has a sepia study for this etching.

P 118 FOUR WOMEN BATHING (LES QUATRE BAIGNEUSES), 1895. Etching, second and last state. 220 × 179 (8 ⅝ × 7). L.D.118. Bibliothèque Nationale, Paris.

P 119 STREET IN ROUEN: RUE GÉRICAULT (RUE GÉRICAULT À ROUEN), February 1896. Etching, seventh and last state. 189 × 132 (7 ½ × 5 ¼). L.D.120. Bibliothèque Nationale, Paris.
During his visit to Rouen in February and March 1896, Pissarro executed his series of old streets. He was staying at the Hôtel de Paris, which gave directly onto the harbour (cf. lithograph P 162 onwards).

P 120 OLD ROUEN: RUE MOLIÈRE (LE VIEUX ROUEN: RUE MOLIÈRE), February 1896. Etching, only state. 224 × 148 (8 ⅞ × 5 ⅞). L.D.121. Bibliothèque Nationale, Paris.
Cf. lithograph P 163.

P 121 NARROW STREET IN ROUEN (PETITE RUE NATIONALE À ROUEN), February 1896. Etching, third and last state. 168 × 128 (6 ⅝ × 5). L.D.122. Bibliothèque Nationale, Paris.

P 122 QUAY AT ROUEN: QUAI DE PARIS (QUAI DE PARIS À ROUEN), February 1896. Etching, eighth and last state. 180 × 175 (7 ⅛ × 6 ⅞). L.D.123. Bibliothèque Nationale, Paris.
Cf. lithographs P 170 and P 171.

P 123 PROMENADE IN ROUEN: COURS BOIELDIEU (COURS BOIELDIEU À ROUEN), September 1896. Etching. 198 × 149 (7 ¾ × 5 ⅞). L.D.47. Bibliothèque Nationale, Paris.
In September Pissarro returned to Rouen to work and, to vary his subject matter, stayed in the Hôtel d'Angleterre, cours Boieldieu. There was a further edition of this etching in 1923.

P 124 THE COURTYARD OF THE CHOIR SCHOOL AT ROUEN CATHEDRAL (LA COUR DE LA MAÎTRISE DANS LA CATHÉDRALE DE ROUEN).
On 2 October 1896, Pissarro wrote to Lucien: 'I have also made haste to do a corner of the cathedral choir school, which is to be pulled down, a magnificent etching.' This work has never been found and may not even have been printed.

P 125 WOMAN HAYMAKER AT ERAGNY (FANEUSE D'ERAGNY), 1897. Etching, third and last state. 201 × 151 (7 ⅞ × 5 ⅞). L.D.124. Bibliothèque Nationale, Paris.
Published in Art et Nature by L. Roger Miles.

P 126 PEASANT COUPLE (COUPLE DE PAYSANS), c. 1899. Etching, only state. 120 × 79 (4 ¾ × 3 ⅛). L.D.125. Bibliothèque Nationale, Paris.
No contemporary edition was produced. The plate was found in the artist's studio in 1922. In 1923 an edition of sixteen was printed. There is also a monotype of this subject in bistre and colour, with the initials C.P. on the right-hand side (J. Cailac, op. cit.).

P 127 PEASANTS CARRYING HAY (PAYSANS PORTANT DU FOIN), 1900. Etching, eighth and last state. 119 × 81 (4 ⅝ × 3 ⅛). L.D.126. Washington National Gallery of Art, Rosenwald Collection.

P 128 THE EGG MARKET (MARCHÉ AUX OEUFS), 1902. Uncompleted plate. Etching, only state. 268 × 221 (10 ½ × 8 ¾). L.D.127. Bibliothèque Nationale, Paris.
This was the theme of a picture of 1884 (L.R.1396).

P 129 PEASANT WOMAN UNDER A TREE (PAYSANNE SOUS UN ARBRE). Etching, only state. 187 × 122 (7 ⅜ × 4 ¾). L.D. –.
This plate is not known to Delteil, although there is a reference to it in the proceedings of the sale organized by Jean Cailac between December 1928 and April 1929. No proofs have in fact been discovered.

P 130 PEASANT WOMAN CARRYING A BASKET (PAYSANNE PORTANT UNE CORBEILLE). Etching, only state. 125 × 115 (4 ⅞ × 4 ½). L.D. –.
This plate is not known to Delteil, although there is a reference to it in the proceedings of the Cailac sale, held between December 1928 and April 1929, which indicates the existence of a proof heightened with watercolour, signed Camille Pissarro. In fact no proofs have been discovered

P 131 VIEW OF ROUEN: L'ÎLE LACROIX (VUE DE ROUEN: L'ÎLE LACROIX). Aquatint, only state. 128 × 175 (5 × 6 ⅞). L.D. –. Bibliothèque Nationale, Paris.
This plate was abandoned after the first coat of aquatint, and it has therefore been left to the end of this catalogue of etchings (Delteil does not include it). It is probably a trial run for P 68, in which this motif is used in reverse. The date may therefore be the same, 1887.

P 132 PORTRAIT: LUCIEN PISSARRO, 1874. Lithograph, only state. 210 × 295 (8 ¼ × 11 ⅝). L.D.128. New York Public Library.
Pissarro's first twelve lithographs were executed in 1874; it was not until twenty years later that he returned to the process. He printed his lithographs in Paris using a press belonging to Taillardat, who kept one proof for himself.

P 133 DEAD CHILD (ENFANT MORT), 3 February 1874. Lithograph, only state. 215 × 275 (8 ½ × 10 ⅞). L.D. 129. Bibliothèque Nationale, Paris.

P 134 A ROAD THROUGH THE PASTURES IN PONTOISE (UNE RUE AUX PÂTURES À PONTOISE), 1874. Lithograph, only state. 265 × 220 (10 ⅜ × 8 ⅝). L.D.130. Collection Michel, Paris.

P 135 SAINT MARTIN'S DAY FAIR AT PONTOISE (FOIRE DE LA SAINT-MARTIN À PONTOISE), 1874. Lithograph, only state. 215 × 273 (8 ½ × 11). L.D.131. Bibliothèque Nationale, Paris.

This is the only proof in existence. Cf. the etching P 21, and the painting L.R.1387, c. 1883.

P 136 THE RIVER OISE AT PONTOISE (L'OISE À PONTOISE), 1874. Ink-drawn lithograph, only state. 218 × 278 (8⅝ × 11). L.D.132. British Museum.

P 137 HOUSE AT THE HERMITAGE (MAISON À L'HERMITAGE), c. 1874. Ink-drawn lithograph, only state. 210 × 280 (8¼ × 11). L.D.133. Private collection, Paris.

P 138 WOMEN CARRYING HAY ON A HURDLE (FEMMES PORTANT DU FOIN SUR UNE CIVIÈRE), c. 1874. Lithograph, only state. 215 × 292 (8½ × 11½). L.D. 134. Bibliothèque Nationale, Paris.

P 139 WOMAN AND CHILD IN THE FIELDS (FEMME ET ENFANT DANS LES CHAMPS), 1874. Lithograph, only state. 140 × 192 (5½ × 7½). L.D.135. New York Public Library.

P 140 WOMAN HAYMAKER (FANEUSE), c. 1874. Lithograph, only state. 199 × 194 (7¾ × 7⅝). L.D.136. Bibliothèque Nationale, Paris.
There is only one proof known to Delteil.

P 141 WOMAN RAKING THE HAY (FEMME RATISSANT DU FOIN), c. 1874. Ink-drawn lithograph. 263 × 210 (10⅜ × 8¼). L.D.137. Private collection, Paris.
Proofs of this lithograph are very rare.

P 142 WOMAN SITTING BY A POND (FEMME ASSISE AU BORD D'UN ÉTANG), c. 1874. Lithograph, only state. 272 × 260 (10¾ × 10¼). L.D.138.

P 143 BIRD-LIME (LA GLU), c. 1874. Lithograph, only state. 203 × 185 (8 × 7¼). L.D.139.
A scheme for the cover of a romance by the musician Cabaner, friend of the impressionist artists.

P 144 WOMEN BATHING IN THE SHADE OF WOODED BANKS (BAIGNEUSES À L'OMBRE DES BERGES BOISÉES), 24 January 1894. Lithograph, second and last state. 159 × 217 (6¼ × 8½). L.D.142. Bibliothèque Nationale, Paris.
Published in an edition of one hundred in L'Estampe Originale, March 1894. This plate is one of the series of 'women bathing' on which Pissarro worked early in 1894. They had been commissioned on 3 March 1893 by Marty, who had been introduced to him by Toulouse-Lautrec. The lithograph was printed in January 1894.

P 145 NUDE WOMEN (FEMMES NUES), 1894. Lithograph, only state. 212 × 280 (8⅜ × 11). L.D.157. Collection Cailac, Paris.
There were two further editions: in 1922 ten proofs, and in 1923 eighteen proofs.
Contrary to what Delteil says, this series of women bathing, and the five following plates, were already in existence by January 1894, when Pissarro wrote to his son: 'I am having a few lithos on zinc printed by Taillardat, women jostling and playing in the water.' See the following plates which belong to the same series.

P 146 WOMAN BATHING: NEAR A WOOD (BAIGNEUSE PRÈS D'UN BOIS), 1894. Lithograph, first state of four. 216 × 132 (8½ × 5¼). L.D.158. British Museum.

P 147 WOMEN BATHING: JOSTLING WITH EACH OTHER (BAIGNEUSES LUTTANT), 1894. Lithograph, first state of three. 185 × 233 (7¼ × 9⅛). L.D.159. British Museum.

P 148 WOMEN BATHING: JOSTLING WITH EACH OTHER (BAIGNEUSES LUTTANT), 1894. Lithograph, only state. 180 × 260 (7⅛ × 10¼). L.D.160. Washington National Gallery of Art, Rosenwald Collection.

P 149 NUDE PEASANT WOMAN CHASING GEESE (PAYSANNE NUE CHASSANT DES OIES), 1894. Lithograph, third and last state. 180 × 231 (7⅛ × 9⅛). L.D.161. Collection Claude Roger-Marx.
A few prints were made in 1923.

P 150 PEASANT WOMAN CHURNING MILK (PAYSANNE BARATTANT), 1894. Lithograph, only state. 241 × 163 (9½ × 6⅜). L.D.162. Bibliothèque Nationale, Paris.

P 151 TRAMPS (LES CHEMINEAUX), c. 1894. Lithograph, only state. 224 × 280 (8¾ × 11). L.D.140. Collection Cailac, Paris.

P 152 THE REAPER (LE FAUCHEUR), c. 1894. Lithograph, only state. 250 × 330 (9⅞ × 13). L.D.141. Collection Michel, Paris.
Cf. a painting of this subject and of about this date (L.R.1474).

P 153 GRANDMOTHER: THE ARTIST'S WIFE (GRANDMÈRE: LA FEMME DE L'ARTISTE), c. 1895. Lithograph, only state, with sketch added. 235 × 115 (9¼ × 4½). L.D.143. Bibliothèque Nationale, Paris.
There was a second edition of six proofs in 1923. The sketch at the foot probably represents the artist's daughter, Jeanne. At the time she was fourteen years old.

P 154 PORTRAIT: JEANNE PISSARRO, c. 1895. Lithograph, only state. 275 × 215 (10⅞ × 8½). L.D.144. Private collection, Paris.
Jeanne was the sixth of Pissarro's seven children; she was born 27 April 1881, and died July 1948.

P 155 YOUNG MAN WRITING, PORTRAIT OF RODO (JEUNE HOMME LISANT, PORTRAIT DE RODO), c. 1895. Lithograph, only state. 122 × 120 (4¾ × 4¾). L.D.145. Bibliothèque Nationale, Paris.
Ludovic-Rodolphe, known as Rodo, was Pissarro's fifth child, born 21 November 1878. He was a painter and engraver, and edited the catalogue of his father's paintings.
Three editions were printed: two or three proofs c. 1895, a further six proofs in 1922, and a further eighteen in 1923.

P 156 PAUL-ÉMILE PISSARRO, c. 1895. Lithograph, only state. 102 × 129 (4 × 5⅛). L.D.146. New York Public Library.
Paul-Émile was Pissarro's seventh and last child, born 22 August 1884. Like his father and brothers he became a painter, under the name Paulemile. In 1895 eleven proofs of this lithograph were printed, a further six in 1922, and a further eighteen in 1923.

P 157 THE MARKET AT GISORS (MARCHÉ À GISORS), 1895. Lithograph, third and last state. 308 × 227 (12⅛ × 8⅞). L.D.147. Bibliothèque Nationale, Paris.
Pissarro was working on this stone in April 1895. These are his comments: 'I've messed it about with wash, I've scraped it, I've rubbed it with sand-paper; what it will achieve I do not know, it was stupid of me to do a market scene, I should have stuck to the Women Bathing.' Delteil gave this plate the title The Market at Pontoise but it is certainly Gisors that is depicted, as the picture of that date bears out (L.R. 932).

P 158 WOMEN BATHING AT THE EDGE OF A POND

(BAIGNEUSES AU BORD D'UN ÉTANG), 1895. Lithograph, only state. 150 × 246 (5⅞ × 9¾). L.D.148. British Museum.
There are five or six proofs. After the market, Pissarro followed his inclination and did indeed do a series of women bathing, on zinc. This he found 'a far more practical proposition'.

P 159 GROUP OF WOMEN BATHING (GROUPE DE BAIGNEUSES), 1895. Lithograph, second and last state. 243 × 167 (9⅝ × 6⅝). L.D.149. Bibliothèque Nationale, Paris.

P 160 WOMAN BATHING: EVENING (BAIGNEUSE, LE SOIR), 1895. Lithograph, only state. 133 × 163 (5¼ × 6⅜). L.D.150. Collection Michel, Paris.

P 161 WOMEN BATHING: DAY (BAIGNEUSES, LE JOUR), 1895. Lithograph, only state. 132 × 202 (5¼ × 8). L.D.151. Collection Claude Roger-Marx.
There is one other proof in the Art Institute of Chicago.

P 162 STREET IN ROUEN: RUE GÉRICAULT (RUE GÉRI-CAULT À ROUEN), February 1896. Lithograph, only state. 186 × 138 (7¼ × 5⅜). L.D.173. Bibliothèque Nationale, Paris.
In February 1896, Pissarro began his series of views of Rouen streets. He bemoaned the way these old areas of the town were disappearing, to be replaced by modern architecture which appalled him. He had prepared zinc plates sent to him from Paris (cf. etching P 119).

P 163 STREET IN ROUEN: RUE MOLIÈRE (RUE MOLIÈRE À ROUEN), February 1896. Lithograph, second and last state. 188 × 140 (7⅜ × 5½). L.D.174. Collection Claude Roger-Marx.
Cf. etching P 120.

P 164 STREET IN ROUEN: RUE EUGÈNE-DUTUIT (RUE EUGÈNE-DUTUIT, À ROUEN), February 1896. Litho-graph, only state. 225 × 152 (8⅞ × 6). L.D.175. Collection Cailac, Paris.

P 165 STREET IN ROUEN: RUE SAINT-ROMAIN (RUE SAINT-ROMAIN À ROUEN), February 1896. First plate. Lithograph, second and last state. 190 × 145 (7½ × 5⅝). L.D.176. British Museum.
As his letter to Lucien of 6 February shows, Pissarro was particularly fond of the rue Saint-Romain, which he made the subject of four plates. 'If only you could see the rue Saint-Romain, it is magnificent, I hope it will arouse some interest.'

P 166 STREET IN ROUEN: RUE SAINT-ROMAIN (RUE SAINT-ROMAIN À ROUEN), 1896. Second plate. Lithograph, second and last state. 190 × 143 (7½ × 5⅝). L.D.177. Collection Claude Roger-Marx.

P 167 STREET IN ROUEN: RUE SAINT-ROMAIN (RUE SAINT-ROMAIN À ROUEN), 1896. Third plate. Lithograph, only state. 189 × 142 (7⅜ × 5⅝). L.D. 178. Bibliothèque Nationale, Paris.

P 168 STREET IN ROUEN: RUE SAINT-ROMAIN (RUE SAINT-ROMAN À ROUEN), 1896. Fourth plate. Lithograph, only state. 190 × 142 (7½ × 5⅝). L.D. 179. British Museum.

P 169 QUAY IN ROUEN: QUAI BOIELDIEU (QUAI BOIEL-DIEU À ROUEN), March 1896. Lithograph, only state. 175 × 224 (6⅞ × 8⅞). L.D.169. British Museum.
Contrary to the order adopted by Delteil, it was not until Pissarro had completed the series of old streets

that he began his studies of the quai Boieldieu and the pont Corneille. He could see the bridge from his hotel window and used to observe the effects of rain falling upon it. There were six proofs in the first edition, and two further editions: in 1920 ten proofs, and in 1923 fourteen proofs.

P 170 BRIDGE IN ROUEN: PONT CORNEILLE (PONT CORNEILLE À ROUEN), March 1896. Lithograph, only state. 215 × 300 (8½ × 11⅞). L.D.170. British Museum.
Cf. the etching of the same subject, P 122. At the same date Pissarro executed a painting of this subject (L.R.962).

P 171 PONT CORNEILLE, left bank, with inset (PONT CORNEILLE, rive gauche avec un médaillon), March 1896. Lithograph, only state. 127 × 164 (5 × 6½). Inset: 45 × 51 (1¾ × 2). L.D.171. Bibliothèque Nationale, Paris.

P 172 QUAY IN ROUEN, MAIN BRIDGE (QUAI À ROUEN, GRAND PONT), March 1896. Lithograph, only state. 217 × 300 (8½ × 11⅞). L.D.172. British Museum.

P 173 PEASANT WOMAN CARRYING FAGGOTS (PAY-SANNE PORTANT DES FAGOTS), 1896. Lithograph, only state. 210 × 286 (8¼ × 11¼). L.D.152. Collec-tion Michel, Paris.
A trial version of the following plate.

P 174 WOMEN CARRYING FAGGOTS (PORTEUSES DE FAGOTS), 1896. Lithograph, only state. 222 × 300 (8⅝ × 11¾). L.D.153. Bibliothèque Nationale, Paris.
In 1896, Jean Grave, a friend of Pissarro and editor of the magazine La Révolte, founded an anarchist weekly, Les Temps Nouveaux. In it were published two full-page lithographs by Pissarro, P 174 and P 175. (Cf. P 192).

P 175 THE VAGABONDS (LES TRIMARDEURS), 1896. Lithograph, fifth and last state. 250 × 304 (9⅞ × 12). L.D.154. Bibliothèque Nationale, Paris.

P 176 THE SOWER (SEMEUR), 1896. Lithograph, only state. 216 × 270 (8½ × 10⅝). L.D.155. British Museum.
There were two further editions, in 1922 and 1923.

P 177 THE FRUIT MARKET (MARCHÉ AUX FRUITS), c. 1896. Lithograph, only state. 170 × 147 (6¾ × 5¾). L.D.156. Collection Claude Roger-Marx.

P 178 WOMEN HAYMAKERS AT ERAGNY (FANEUSES D'ERAGNY), c. 1896. Lithograph, only state. 220 × 170 (8⅝ × 6¾). L.D.163. Collection Michel, Paris.
Cf. the painting of 1884 (L.R.1394), and that of 1901 (L.R.1207). Two further editions were printed: in 1922 ten proofs, and in 1923 fourteen proofs.

P 179 WOMEN GATHERING WOOD (BÛCHERONNES), c. 1896. Lithograph, only state. 130 × 103 (5⅛ × 4). L.D.164. British Museum.
In 1923 eighteen proofs were printed, on the same sheet as P 178.

P 180 GROUP OF PEASANT WOMEN (GROUPE DE PAY-SANNES), c. 1896. Lithograph, only state. 132 × 112 (5¼ × 4⅜). L.D.165. British Museum.

P 181 PEASANT WOMEN (PAYSANNES), c. 1896. Litho-graph, only state. 166 × 132 (6½ × 5¼). L.D.166. Bibliothèque Nationale, Paris.

P 182 FOUR PEASANT WOMEN TALKING (QUATRE PAY-SANNES CAUSANT), 1896. Lithograph, only state.

210 × 180 (8 ¼ × 7 ⅛). L.D.167. Bibliothèque Nationale, Paris.
Two proofs are known to Delteil.

P 183 PEASANT DIGGING (PAYSAN BÊCHANT), 1896. Lithograph, only state. 210 × 175 (8 ¼ × 6⅞). L.D. 168. Collection Claude Roger-Marx.

P 184 NUDE WOMAN MINDING THE GEESE (GARDEUSE D'OIES NUE), c. 1897. Lithograph, only state. 169 × 131 (6⅝ × 5 ⅛). L.D.180. Collection Cailac, Paris. Cf. the gouache of 1895 (L.R.1477). Three editions of this lithograph were printed: in 1897 five proofs, in 1922 a further six proofs, and in 1923 a further twenty-eight proofs.

P 185 LINE OF WOMEN BATHING (THÉORIE DE BAIGNEUSES), 1897. Lithograph, only state. 130 × 200 (5 ⅛ × 7⅞). L.D.181. Collection Michel, Paris. In 1896, between the 1895 series and this plate, Pissarro painted several pictures of women bathing (L.R.1478–81), also a gouache (L.R.1484).

P 186 BEGGAR AND PEASANT WOMAN (MENDIANT ET PAYSANNE), c. 1897. Lithograph, second and last state. 297 × 219 (11 ¾ × 8 ⅝). L.D.183. Museum of Fine Arts, Boston, Lee M. Friedmann Fund.

P 187 BEGGAR WITH CRUTCH (MENDIANT À LA BÉQUILLE), 1897. Lithograph, first state of two. 252 × 304 (9⅞ × 12). L.D.182. Collection Dr Z. Alexander Aarons, San Francisco.

P 188 STREET IN PARIS: RUE SAINT-LAZARE (RUE SAINT-LAZARE À PARIS), 1897. Lithograph, only state. 210 × 142 (8 ¼ × 5 ⅝). L.D.184. Bibliothèque Nationale, Paris.
Pissarro had already used this subject in 1893 (L.R. 836), and returned to it in February 1897. At the time he was staying at the Grand Hôtel de Russie, 1, rue Drouot, from where he painted the boulevard des Italiens.
Cf. the paintings of this subject of the same date (L.R.981–5).

P 189 SQUARE IN PARIS: PLACE DU HAVRE (PLACE DU HAVRE À PARIS), c. 1897. Lithograph, first state of two. 140 × 210 (5 ½ × 8 ¼). L.D.185. Collection Cailac, Paris.
Pissarro had already used this subject in February 1893, regarding it as 'very beautiful' (L.R.837–8). He also painted it in 1897 (L.R.982).

P 190 THE HOUSES OF PARLIAMENT, LONDON (LE PARLEMENT À LONDRES), 1897. Lithograph, only state. 149 × 225 (5⅝ × 8⅞). L.D.186. Collection Cailac, Paris.
In spring 1897, Lucien fell ill and Pissarro came to England. His pictures of Bedford Park (L.R.1005–9), where he was staying, and this lithograph, date from this visit. The title has been given in error as the lithograph in fact depicts Westminster Bridge. A further two proofs were printed in 1922.

P 191 CONVALESCENCE: LUCIEN PISSARRO, 1897. Lithograph, only state. 320 × 228 (12⅝ × 9). L.D.192. British Museum.
Lucien had been seriously ill in 1897 and came to spend the summer in Eragny. This plate was probably made during this period of convalescence as, although he returned to France in 1900, he was in excellent health on that occasion.
The eleven known proofs of this lithograph were printed in 1922, when the zinc plate was rediscovered.

P 192 PLOUGHING or THE PLOUGH (LE LABOUR OU LA CHARRUE). Lithograph in colour, second and last state. 222 × 150 (8 ¼ × 5 ⅞). L.D.194. Bibliothèque Nationale, Paris.
This lithograph was used as frontispiece for a booklet by Kropotkin in the series Les Temps Nouveaux, published by Jean Grave in 1898. See the article on this subject by R. and E. Herbert, 'Artists and Anarchism', (Burlington Magazine, November 1960, p. 473).
Cf. P 174 and P 175. Pissarro also painted a gouache of this subject (L.R.1493).

P 193 WOMAN MINDING THE GEESE (GARDEUSE D'OIES), c. 1898. Lithograph, only state. 130 × 169 (5 ⅛ × 6⅝). L.D.187. Bibliothèque Nationale, Paris.

P 194 GROUP OF PEASANTS (GROUPE DE PAYSANS), c. 1899. First plate. Lithograph on zinc, only state. 115 × 130 (4 ½ × 5 ⅛). L.D.188. Collection Claude Roger-Marx.

P 195 GROUP OF PEASANTS (GROUPE DE PAYSANS), c. 1899. Second plate. Lithograph, only state. 130 × 105 (5 ⅛ × 4 ⅛). L.D.189. British Museum.

P 196 WOMAN MINDING COWS (VACHÈRE), c. 1899. Lithograph, only state. 130 × 114 (5 ⅛ × 4 ½). L.D. 190. Metropolitan Museum of Art, New York.

P 197 BOULEVARD MONTMARTRE, c. 1899. Lithograph on zinc, only state. 143 × 110 (5⅝ × 4⅜). L.D.191. New York Public Library.
Cf. the series of pictures on this subject painted in 1897 (L.R.986–98).

P 198 THE OUTER HARBOUR AT DIEPPE (L'AVANT-PORT DE DIEPPE), c. 1900–2. Lithograph, only state. 228 × 308 (9 × 12 ⅛). L.D.193. Bibliothèque Nationale, Paris.
Between 1900 and 1902, Pissarro was a frequent visitor to Dieppe. In 1902 he notes that, from his window in the Hôtel de Commerce, he is making sketches for paintings of the subject (L.R.1241–7).

WORK IN THE FIELDS, First series (TRAVAUX DES CHAMPS, 1ʳᵉ série), woodcuts in line and colours, a portfolio containing 6 woodcuts designed and drawn on the wood by Camille Pissarro, engraved and printed by his son Lucien Pissarro. Vale Publications, 31 Beaufort Street, Chelsea, S.W. 1904.
Towards the end of his life, Pissarro finally allowed himself to be persuaded by his son to draw wood blocks, which Lucien would then engrave and print in the éditions de luxe he had established in England. Work in the Fields was the earliest of these projects, and one which was some time in coming to fruition; the series of drawings, which Pissarro made in the last years of his life, were not in the end published until after his death.

P 199 PLOUGHING (LE LABOUR). Wood engraving, only state. 118 × 170 (4⅝ × 6⅝). Bibliothèque Nationale, Paris.

P 200 WOMEN MINDING THE COWS (LES GARDEUSES DE VACHES). Wood engraving, only state. 118 × 170 (4⅝ × 6⅝). Bibliothèque Nationale, Paris.

P 201 WOMAN WITH CHICKENS (LA FEMME AUX POULES). Wood engraving in colour, only state. 130 × 70 (5 ⅛ × 2 ¾). Bibliothèque Nationale, Paris.

P 202 WOMEN WEEDING (LES SARCLEUSES). Wood engraving in colour, only state. 180 × 120 (7 ⅛ × 4 ¾). Bibliothèque Nationale, Paris.

P.203 WOMEN WEEDING THE GRASS (FEMMES FAISANT DE L'HERBE). Wood engraving in colour, only state. 180 × 120 (7 ⅛ × 4 ¾). Bibliothèque Nationale, Paris.

P 204 STUDIES (ÉTUDES). Wood engraving, only state. 210 × 170 (8 ¼ × 6 ⅝). Bibliothèque Nationale, Paris.

P 205 THE SOWER (LE SEMEUR). Wood engraving, only state. 123 × 175 (4 ⅞ × 6 ⅞). Bibliothèque Nationale, Paris.
Although this engraving, which is signed by Camille Pissarro, was not published in the first series of *Work in the Fields* it seems that originally the intention was to include it. Lucien may have kept it back for the second series (a second series being implied by the mention of a first), which he would presumably have completed alone. In fact the series was never produced.

P 206 DAPHNIS AND CHLOË (DAPHNIS ET CHLOË). Wood engraving, only state. Engraved by Lucien Pissarro. 123 × 140 (4 ⅞ × 5 ½). Bibliothèque Nationale, Paris.
Pissarro was still more reluctant to embark on the project of Daphnis and Chloë, a theme on which Maurice Denis also was working at the time. Pissarro said he had executed two drawings on wood blocks for this book, which in fact was never produced. It appears that only one block was actually engraved and printed by his son. Unlike the series of *Work in the Fields*, this project was never completed, being insufficiently advanced by the time of Pissarro's death, on 13 November 1903.
There are a number of other wood engravings bearing the initials C.P., in particular those at the British Museum. In this catalogue, only those engravings are included where it is established, from letters to his son, that Pissarro made a drawing specifically with a wood engraving in mind, and most probably directly onto the wood.

RENOIR

R 1 FRONTISPIECE FOR MALLARMÉ'S 'PAGES' (FRONTISPICE POUR 'PAGES' DE MALLARMÉ), 1890. Etching, only state. 198 × 107 (7 ¾ × 4 ¼). Bibliothèque Nationale, Paris.
Published as frontispiece to Mallarmé's Pages, in the edition brought out by D. Deman, Brussels, 1891. There are preparatory drawings in existence, entitled *Vénus*. 325 copies of the book were printed. When Renoir was asked to contribute to the second exhibition of the Peintres-Graveurs, he replied: 'I have a single etching which belongs to Mallarmé, ask him for it if you wish, it is a mere trifle.' Though it did not appear until 1891, the etching was therefore completed early in 1890, before The Country Dance. This is contrary to the order adopted by Delteil.

R 2 THE COUNTRY DANCE (LA DANSE À LA CAMPAGNE), 1890. First plate. Etching, only state. 220 × 140 (8 ⅝ × 5 ½). The Art Institute of Chicago.
There are two paintings of this subject, dated 1883, one in the Durand-Ruel collection, the other in the Museum of Fine Arts, Boston; also numerous drawings (Rewald, *Renoir drawings* nos. 13, 15, 16, 17, 18, Vollard catalogue nos. 53 and 77), all dated 1883. Suzanne Valadon and Edmond, Renoir's brother, were the models for these studies.

R 3 THE COUNTRY DANCE (LA DANSE À LA CAMPAGNE), 1890. Second plate. Etching, only state. 220 × 140 (8 ⅝ × 5 ½). Bibliothèque Nationale, Paris.

R 4 BERTHE MORISOT, c 1892. Etching, only state. 110 × 90 (4 ⅜ × 3 ½). Bibliothèque Nationale, Paris.
Berthe Morisot was one of the painter's most valued friends and was frequently visited by Renoir and Mallarmé. That Renoir felt very much in sympathy with her is evident from the many letters he wrote to her. He painted her portrait several times, sometimes with her children.

R 5 ON THE BEACH AT BERNEVAL (SUR LA PLAGE À BERNEVAL), c. 1892. Etching, third and last state. 140 × 90 (5 ½ × 3 ½). Bibliothèque Nationale, Paris.
From 1879 onwards, Renoir was frequently invited to stay at Wargemont, near Dieppe, where he used to paint scenes in Berneval. His hosts were Monsieur and Madame Bérard and their three children. He painted them on several occasions, and submitted to the Salon in 1880 Women searching for Mussels at Berneval.

R 6 HAT SECURED WITH A PIN (LE CHAPEAU ÉPINGLÉ), c. 1894. First plate. Etching, only state. 116 × 82 (4 ½ × 3 ¼). Bibliothèque Nationale, Paris.
Julie Manet, Berthe Morisot's daughter, and her young cousin, Paulette Gobillard, were the models for this subject to which Renoir frequently returned in his etchings (see plates below), his lithographs (R 28 and R 29), and in many pastel drawings and one painting (Vollard, vol. II, pp. 64, 76, 79, 87).

R 7 HAT SECURED WITH A PIN (LE CHAPEAU ÉPINGLÉ), c. 1894. Second plate. Etching, second and last state. 131 × 92 (5 ⅛ × 3 ⅝). Bibliothèque Nationale, Paris.

R 8 HAT SECURED WITH A PIN (LE CHAPEAU ÉPINGLÉ), 1894? Third plate. Etching, second and last state. 115 × 80 (4 ½ × 3 ⅛). Bibliothèque Nationale, Paris.

R 9 TWO WOMEN BATHING (LES DEUX BAGNEUSES), 1895. Etching, only state. 262 × 241 (10 ¼ × 9 ½). Nationale, Paris.
Published in L'Estampe Originale.

R 10 MOTHER AND CHILD [Jean Renoir] (MÈRE ET ENFANT [Jean Renoir]), 1896. Etching in colour, only state. 234 × 186 (9 ¼ × 7 ¼). Bibliothèque de l'Institut d'Art et d'Archéologie, Paris.
This was Renoir's only etching in colour. It was published in the 1896 album of the Peintres-Graveurs. At the time Jean was two years old.

R 11 WOMAN BATHING, SEATED (BAIGNEUSE ASSISE), c. 1905. First plate. Etching, only state. 217 × 135 (8 ½ × 5 ¼). Bibliothèque Nationale, Paris.
The drawing for this woman bathing is much earlier. There is one dated 1881 (Rewald, *Renoir drawings*, no. 28).

R 12 WOMAN BATHING, SEATED (BAIGNEUSE ASSISE), 1906. Second plate. Etching, only state. 182 × 142 (7 ⅛ × 5 ⅝). Bibliothèque Nationale, Paris.
This is a soft-ground etching. It was reprinted to illustrate the *éditions de luxe* of Vollard's book La Vie et l'Œuvre de P.-A. Renoir, Paris, 1919.

R 13 NUDE WOMAN RECLINING, FACING RIGHT (FEMME NUE COUCHÉE, TOURNÉE À DROITE), 1906. First plate. Etching, only state. 122 × 192 (4 ¾ × 7 ½). Bibliothèque Nationale, Paris.

R 14 NUDE WOMAN RECLINING, FACING RIGHT

(FEMME NUE COUCHÉE, TOURNÉE À DROITE), 1906. Second plate. Etching, only state. 137 × 193 (5 ⅜ × 7 ⅝). Bibliothèque Nationale, Paris.

R 15 NUDE WOMAN RECLINING, FACING LEFT (FEMME NUE COUCHÉE, TOURNÉE À GAUCHE), 1906. Etching, only state. 137 × 192 (5 ⅜ × 7 ½). Bibliothèque Nationale, Paris.

R 16 STUDY FOR WOMAN BATHING (ÉTUDE POUR UNE BAIGNEUSE), 1906? Etching, only state. 220 × 165 (8 ⅝ × 6 ½). Bibliothèque Nationale, Paris.
This study was published as a full page illustration in the *édition de luxe* of the Vollard catalogue *Tableaux, pastels et dessins de P.-A. Renoir*, Paris, 1918.

R 17 CLAUDE RENOIR, the artist's son, in profile (CLAUDE RENOIR, fils, de l'artiste, de profil), 1908. Etching, only state. 155 × 91 (6 ⅛ × 3 ⅝). Metropolitan Museum of Art, New York.
Claude Renoir, known as Coco, was born 4 August 1901 at Essoyes, when the artist was sixty years old. From that time onwards, Renoir concentrated more and more on subjects inspired by his family.

R 18 THREE-QUARTER-FACE PORTRAIT OF CLAUDE RENOIR, facing right (CLAUDE RENOIR, DE TROIS QUARTS, à droite), 1908. Etching, second and last state. 162 × 130 (6 ⅜ × 5 ⅛). Private collection, Paris.
The drawing for this etching was of course much earlier.

R 19 THREE-QUARTER-FACE PORTRAIT OF CLAUDE RENOIR, facing left (CLAUDE RENOIR, DE TROIS QUARTS, à gauche), 1908. Etching, only state. 138 × 120 (5 ⅜ × 4 ¾). Private collection, Paris.

R 20 THE ENGRAVER, V.-J. ROUX-CHAMPION (LE GRAVEUR V.-J. ROUX-CHAMPION), 1908. Etching, only state. 178 × 128 (7 × 5 ⅛).
Victor-Joseph Roux-Champion met Renoir at Cagnes. He printed many of Renoir's etchings in this period, and may even have suggested the subjects to Renoir (R 17, 18, 19, 20 and 21).

R 21 LANDSCAPE IN MINIATURE (LE PETIT PAYSAGE), 1908. Etching, only state. 89 × 155 (3 ½ × 6 ⅛). Metropolitan Museum of Art, New York.

R 22 HALF-LENGTH POTRAIT OF A CHILD, FACING RIGHT (BUSTE D'ENFANT TOURNÉ À DROITE), c. 1908. Etching, only state. 135 × 93 (5 ¼ × 3 ⅝). Bibliothèque Nationale, Paris.

R 23 WOMAN BATHING, STANDING UP TO HER KNEES IN WATER (BAIGNEUSE DEBOUT À MI-JAMBES), 1910. Etching, only state. 168 × 112 (6 ⅝ × 4 ⅜). Bibliothèque Nationale, Paris.

R 24 THE RIVER SCAMANDER (LE FLEUVE SCAMANDRE), c. 1900. First plate. Etching, on copper, only state. 227 × 170 (9 × 6 ¾). Private collection, Paris.
There is a red chalk drawing of this study entitled *The Rhône and the Saône*, c. 1910, which was used as the cartoon for a tapestry.

R 25 THE RIVER SCAMANDER (LE FLEUVE SCAMANDRE). Second plate. Etching, only state. 240 × 185 (9 ½ × 7 ¼) Bibliothèque Nationale, Paris.

R 26 PIRRE RENOIR, FULL FACE (PIERRE RENOIR, DE FACE), 1893. Lithograph, only state. 290 × 236 (11 ⅜ × 9 ¼). L.D.27. Bibliothèque Nationale, Paris.
Pierre was Renoir's eldest son, born in 1885. This first lithograph by Renoir was commissioned by Marty, who published it in his album *L'Estampe Originale*, October 1893.

R 27 WOMAN BATHING, STANDING, FULL LENGTH PORTRAIT (BAIGNEUSE DEBOUT, EN PIED), 1896.

Lithograph in colour, only state. 410 × 320 (16 ⅛ × 12 ⅝). L.D.28. Bibliothèque Nationale, Paris.
It was the printer Auguste Clot, of the rue du Cherche-Midi, who printed Renoir's lithographs.

R 28 HAT SECURED WITH A PIN (LE CHAPEAU ÉPINGLÉ), 1897. First plate. Lithograph only state. 620 × 495 (24 ⅜ × 19 ½). L.D.29. Bibliothèque Nationale, Paris.
The many studies of this subject (cf. R 6) precede the lithograph commissioned by Vollard, which was printed in an edition of two hundred.

R 29 HAT SECURED WITH A PIN (LE CHAPEAU ÉPINGLÉ), 1898. Second plate. Lithograph in colour, only state. 600 × 488 (23 ⅝ × 19 ¼). L.D.30. Bibliothèque Nationale, Paris.

R 30 CHILD WITH BISCUIT [Jean Renoir] (L'ENFANT AU BISCUIT [Jean Renoir]), 1898. Lithograph in colour, only state. 270 × 225 (10 ⅝ × 8 ⅞). L.D.31. Bibliothèque Nationale, Paris.
Jean, Renoir's second son, was born 15 September 1894 in the 'Château des brouillards', the house at the top of the hill of Montmartre where Renoir was then living.

R 31 CHILDREN PLAYING BALL (ENFANTS JOUANT À LA BALLE), 1898. Lithograph, in colour, only state. 533 × 476 (21 × 18 ¾). L.D.32. Bibliothèque Nationale, Paris.

R 32 HALF-LENGTH PORTRAIT OF A YOUNG WOMAN (JEUNE FEMME EN BUSTE), 1899. Lithograph, only state. 526 × 400 (20 ¾ × 15 ¾). L.D.26. Bibliothèque Nationale, Paris.
Portrait of Mademoiselle Dieterle, published in the album *Germinal* in 1899. This young woman was an actress and was also the model for other similar drawings (Vollard catalogue, vol. II, pp. 29 and 129). One hundred prints of this lithograph were made.

R 33 RICHARD WAGNER, c. 1900. Lithograph, only state. 435 × 320 (17 ⅛ × 12 ⅝). L.D.33. Bibliothèque Nationale, Paris.
In 1882, Renoir met Wagner in Palermo and managed to get him to pose for twenty-five minutes. Two pictures resulted (one in the Bibliothèque de l'Opéra, the other in the Alfred Cortot collection), also a number of drawings and, much later, this lithograph. See the article on this subject by E. Lockspeiser, 'The Renoir's portraits of Wagner', in *Music and Letter*, January 1937.

R 34 JEANNE BAUDOT, PORTRAIT, c. 1900. Lithograph, only state. 195 × 155 (7 ¾ × 6 ⅛). Private collection, Paris.
Jeanne Baudot was a doctor's daughter. In 1894, at the age of seventeen, she became one of Renoir's pupils. She wrote a book based on her recollections of him, *Renoir, ses amis, ses modèles*, Édition Littéraire de France, Paris, 1949.
This lithograph is not known to Delteil, but it was published by Claude Roger-Marx in his catalogue of Renoir's lithographs (Sauret 1952). Only one proof exists.

R 35 PAUL CÉZANNE, 1902. Lithograph, only state. 260 × 240 (10 ¼ × 9 ½). L.D.34. Bibliothèque Nationale, Paris.
This lithograph was based on a pastel drawing made in 1880 (in the Art Institute of Chicago), of which Cézanne himself made a copy (Venturi no. 372). On it was based a medallion for a fountain in Aix-en-Provence.

ACKNOWLEDGMENTS

All the photographs used in this work come from the photographic service of the Bibliothèque Nationale, Cabinet des Estampes, Paris, with the exception of the following:

Achenbach Foundation for Graphic Arts, San Francisco: P 187.
The Art Institute of Chicago: M 57, P 34, R 2.
The British Museum, Photographic service: P 17, P 19, P 117, P 136, P 146, P 147, P 158, P 165, P 168, P 169, P 170, P 171, P 176, P 179, P 180, P 191, P 195.
Cauvin, Paris: P 151, P 189, P 190.
Flammarion, Paris: M 48, M 86, P 6, P 31, P 51, P 89, P 99, P 134, P 137, P 141, P 145, P 149, P 152, P 154, P 160, P 161, P 163, P 164, P 166, P 173, P 177, P 178,
P 183, P 184, P 185, P 194, R 10, R 18, R 19, R 20, R 24, R 34, R 36, R 45, R 49, C 8, S 2.
Grunwald Arts Foundation, University of California, Los Angeles: R 54.
Kleinhempel (Ralph), Hamburg: M 37.
The Metropolitan Museum of Art, New York: P 196, R 17, R 21.
The Museum of Arts, Rhode Island, School of Design, Providence: P 36.
The Museum of Fine Arts, Boston: M 76, P 37, P 186.
The National Gallery of Art, Washington: P 92, P 127, P 148.
National Museum, Stockholm: M 21.
The New York Public Library: M 3, M 6, M 20, M 22, M 30, M 31, M 33, M 75, P 132. P 139. P 156, P 197.

Fold-out